中国出土壁画全集

徐光冀／主编

科学出版社

北 京

版 权 声 明

本书所有内容，包括文字内容（中英文）、图片内容、版面设计、内容分类以及其他任何本书信息，均受《中华人民共和国著作权法》保护，为相关权利人专属所有。未经本书相关权利人特别授权，任何人不得转载、复制、重制、改动或利用本书内容，否则我们将依法追究法律责任。特此声明！

图书在版编目（CIP）数据

中国出土壁画全集／徐光冀主编.—北京：科学出版社，2011
ISBN 978-7-03-030720-0

Ⅰ．①中... Ⅱ．①徐... Ⅲ．①墓室壁画-美术考古-中国-图集
Ⅳ．①K879.412

中国版本图书馆CIP数据核字（2011）第058079号

审图号：GS（2011）76号

责任编辑：闫向东／封面设计：黄华斌　陈　敬
责任印制：赵德静

科 学 出 版 社 出版
北京东黄城根北街16号
邮政编码：100717
http://www.sciencep.com

北京天时彩色印刷有限公司印刷
科学出版社发行　各地新华书店经销

＊

2012年1月第 一 版　　开本：889×1194　1/16
2012年1月第一次印刷　　印张：160
印数：1-2 000　　　字数：1280 000
定价：3980.00元
（如有印装质量问题，我社负责调换）

THE COMPLETE COLLECTION OF MURALS UNEARTHED IN CHINA

Xu Guangji

Science Press

Beijing

Science Press

16 Donghuangchenggen North Street, Beijing,

P.R.China, 100717

Copyright 2011, Science Press and Beijing Institute of Jade Culture

ISBN 978–7–03–030720–0

《中国出土壁画全集》编委会

凡　例

1. 《中国出土壁画全集》为"中国出土文物大系"之组成部分。

2. 全书共10册。出土壁画资料丰富的省区单独成册，或为上、下册；其余省、自治区、直辖市根据地域相近或所收数量多寡，编为3册。

3. 本书所选资料，均由各省、自治区、直辖市的文博、考古机构提供。选入的资料兼顾了壁画所属时代、壁画内容及分布区域。所收资料截至2009年。

4. 全书设前言、中国出土壁画分布示意图、中国出土壁画分布地点及时代一览表。每册有概述。

5. 关于图像的编辑排序、定名、时代、尺寸、图像说明：

编辑排序：图像排序时，以朝代先后为序；同一朝代中纪年明确的资料置于前面，无纪年的资料置于后面。

定　　名：每幅图像除有明确榜题外，均根据内容定名。如是局部图像，则在原图名后加"（局部）"；如是同一图像的不同部分，则在图名后加"（一）（二）（三）……"；临摹图像均注明"摹本"。

时　　代：先写朝代名称，再写公元纪年。

尺　　寸：单位为厘米。大部分表述壁画尺寸，少数表述具体物像尺寸，个别资料缺失的标明"尺寸不详"。

图像说明：包括墓向、位置、内容描述。个别未介绍墓向、位置者，因原始资料缺乏。

6. 本全集按照《中华人民共和国行政区划简册·2008》的排序编排卷册。卷册顺序优先排列单独成册的，多省市区合卷的图像资料亦按照地图排序编排。编委会的排序也按照图像排序编定。

《中国出土壁画全集》编委会

中国出土壁画全集

— ◆ 5 ◆ —

| 河南 |
HE NAN

主　编：孙新民　蔡全法
副主编：张松林　史家珍　朱　亮　孔德铭

Edited by Sun Xinmin, Cai Quanfa, Zhang Songlin, Shi Jiazhen, Zhu Liang, Kong Deming

科学出版社
Science Press

河南卷编委会名单

编　委

王三营　申明清　张文霞　孙　锦　陈万卿　高　虎　蔡　强　蔡孟轲

参编人员（以姓氏笔画为序）

王三营　孔德铭　申明清　史家珍　孙　锦　孙新民　张文霞　张松林　陈万卿
洛　博　高　虎　彭华士　蔡　强　蔡全法　蔡孟轲　魏殿臣

河南卷参编单位

河南省文物考古研究所	安阳市文物考古研究所
郑州市文物考古研究院	开封市文物考古研究所
洛阳市文物工作队	商丘市文物工作队
洛阳市第二文物工作队	

河南省出土壁画概述

孙新民　蔡全法

河南地处中原，历史悠久，文化灿烂，留下了丰富的古代壁画遗存。作为考古所见的河南古代墓葬壁画，上起西汉，历经新莽、东汉、魏、南北朝，乃至唐、宋、金、元、明各朝代。已发现60余座。这些地下墓室壁画，看似"事死如事生"的冥间题材，其实是人间生活的真实写照，亦是古代社会的形象缩影。

1.西汉壁画

河南古代壁画，目前最早可以追溯到商代。1975年在安阳殷墟出土的壁画残块，是"在白灰墙皮上，以红色绘出对称的图案"[1]。1957年在洛阳西郊发现的一座战国墓墓室，四壁折角处以红色涂成边饰，墓道西壁残存有红、黄、黑、白四色彩绘的图案[2]。汉以前的墓葬壁画发现较少，仅有简单的装饰图案，比较简略质朴。

河南的西汉、新莽时期墓葬壁画，主要分布在洛阳和商丘地区，以洛阳最多。这一时期的壁画墓较著名的有洛阳烧沟61号墓[3]、洛阳卜千秋壁画墓[4]、洛阳八里台壁画墓[5]、洛阳浅井头壁画墓[6]、新安县里河壁画墓[7]、洛阳金谷园新莽壁画墓[8]、偃师辛村新莽壁画墓[9]、永城柿园壁画墓[10]等。

永城柿园壁画墓，为凿山开洞的石室墓，年代为西汉早期。壁画位于墓室顶部，彩画青龙、白虎、朱雀等神禽异兽，周边绘几何形云纹图案。整个画面以红色为底，上用黑白两色描绘出流动的飞云，其构图丰满，充满动感，特别是带羽的青龙凌空飞动，具有巨大的艺术感染力和震撼力。这是目前所见最早的汉代壁画，在我国绘画史上占有较重要的地位。

洛阳卜千秋壁画墓，因墓内出土一枚"卜千秋印"而得名，年代为西汉昭帝至宣帝之间（公元前86~前49年）。在主室后壁绘有方相氏打鬼图，方相氏赤膊裸足，双目圆睁注视着墓门；其下绘青龙、白虎。主室顶脊绘升仙图，依次绘有女娲、月亮、持节方士、两青龙、两枭羊、朱雀、白虎、仙女、奔兔、

猎犬、蟾蜍、卜千秋夫妇、伏羲、太阳、黄蛇等，气势宏大。墓门上额绘人首鸟身像，与升仙图相联系，寓意墓主人死后升天和避邪。

洛阳烧沟61号墓，年代在西汉元帝至成帝之间（前48~前8年）。壁画的主要内容有野宴图、乘龙升天图、傩戏舞蹈图。主室两面墙梁上为"二桃杀三士"等历史故事，又有日月星云图，是目前发现最早的天文图壁画资料。墓门内额上为神虎吃旱魃图。

偃师辛村新莽墓壁画，彩绘壁画八幅：两耳室门外北侧各绘一幅执棨戟门吏；前室与中室门额，中央绘方相氏，其左绘常仪托月，其右绘羲和擎日；中室西壁南幅为庖厨图，北幅为六博宴饮图；中室东壁南幅绘宴饮舞乐图，北幅为宴饮图；中后室之间横额正中绘西王母壁画。该墓壁画所绘位置有所改变，并出现了与现实生活相关的内容，具有两汉之间承前启后的过渡性特点。

2.东汉壁画

河南的东汉墓葬壁画，更是丰富多彩，主要分布在洛阳和郑州两地区，洛阳东汉墓壁画基本上代表了当时绘画的最高水平。

洛阳地区东汉壁画墓主要有：1980年发掘的新安县铁塔山壁画墓[11]，1981年发掘的唐宫路玻璃厂壁画墓[12]，1984年发掘的偃师杏园壁画墓[13]，1987年发掘的洛阳道北石油站壁画墓[14]，1991年发掘的洛阳机车工厂壁画墓[15]，1991年发掘的洛阳朱村壁画墓等[16]。郑州地区发现的壁画墓有：1960年发掘的新密打虎亭2号壁画墓[17]，1963年发掘的新密后土郭壁画墓[18]，1995年因被盗发现并调查的荥阳苌村壁画墓等[19]。上述墓葬除石油站壁画墓为东汉早期，铁塔山壁画墓为东汉中期，朱村壁画墓为东汉末至曹魏时期，其余壁画墓均属于东汉晚期。东汉壁画墓的题材，以描绘墓主人生前地位、属吏、及出行车马仪卫和以表现宾朋宴饮、舞乐杂技的豪华场面为主，也

有居家生活、庖厨、仓厩、收租的内容。表现历史故事的内容仍有流行，各种怪异神兽相对减少。显然，东汉壁画正在脱离西汉壁画中那种企望死后升仙的主题，代之而起的是表现现实生活的题材，这是思想艺术发展的一大进步。

洛阳道北石油站壁画墓，在甬道两壁绘神荼、郁垒，中室东西两壁绘文吏，布局对称。墓顶以流畅起伏的红云为地纹，上绘四组画面：南为乘车驾龙图、北部为乘车驾鹿图，东部为羲和擎日图，西部绘常仪擎月图。此墓壁画画面宏大，气韵生动，色彩鲜艳协调，在一定程度上反映了当时人的宇宙观和阴阳五行观念。

新安铁塔山壁画墓，墓门两侧绘守门武士。后山墙上部绘墓主人肖像，左绘执金吾，右绘一名女仆作奉酒状。左右两壁线条粗犷，画面漫漶，从残存痕迹看，右壁为车骑出行图，左壁绘彩罐。墓顶绘太阳和月亮，并有北斗七星和彩云，还填绘飞奔的鹿和羊。该墓壁画不用白灰地，直接绘于砖壁。墓顶的星象图，也是国内较早的日月星象记录。

洛阳唐宫路玻璃厂壁画墓，壁画是在涂黄色底彩的白灰面上绘制的，北壁东端主仆二人，东壁画夫妇二人对坐。南壁东端绘一侍女，侍女身后绘两匹马，再后有马车一辆。偃师杏园村壁画墓，该墓壁画主要是墓主人车骑出行的场景，共计9乘安车，70余个人物，50余匹奔走行进的骑列，车骑队伍浩浩荡荡。

新密打虎亭2号壁画墓规模大，形制复杂，各耳室和甬道顶部壁画用墨绘，中室顶部和南、北、东三壁用彩绘。壁画内容大致分为三部分：一是对墓主人生前生活的描绘，主要绘于中室南、北两壁，下层绘各种人物，上层绘宴饮、舞乐百戏和车马出行迎宾图等。南、北、东各耳室绘迎宾、厨事烹饪和马厩等。二是反映墓主人希望成仙升天的内容，东壁绘仙人山聚图，券顶藻井两侧绘有各种珍禽异兽与活动于天上云气间的人物。三是中室顶部绘有格棂、莲花藻井和装饰性的边框云气图案。其中，中室南壁的车马出行图，再现了墓主人出行前导后从的壮观场景。中室北壁的舞乐百戏图，以长卷形式绘一排贵族一边饮宴作乐，一边看百戏，画面色彩富丽，人物众多，百戏表演惟妙惟肖，是一幅难得的艺术珍品。

荥阳苌村壁画墓，为砖石结构。甬道两侧和前室四壁及顶部满绘彩色壁画，总面积可达300平方米，其内容分别为：楼阙庭院、车马出行、人物故事、珍禽异兽、乐舞百戏。前室侧壁所绘以赤线为界，分上下四栏。车骑出行图，车骑队伍排列整齐，气势宏大。在众车旁分别用隶体墨书榜题，车辆类别有斧车、白盖轺车、皂盖车、皂盖朱左幡轺车、皂盖朱两幡轺车、赤盖轩车等多种。南壁后室门外侧彩绘有伎乐人物，西壁为珍禽瑞兽、车马出行。该墓规模之大，壁画内容之丰富，特别是较多的墨书榜题，都为其他汉墓壁画所不见，对于了解此时期壁画的内容提供了重要的依据。

3. 魏晋南北朝壁画

魏晋南北朝时期绘画艺术随着佛教艺术的传入，其题材、内容以及表现方法都发生了较大的变化。那种虚幻的神仙世界题材显著减少，描绘现实生活的内容成为主流，在构图上人大于山的情况较为普遍。少数民族文化和汉文化融为一体，外来的佛教艺术也对其产生重大影响，使绘画艺术得到了进一步的升华。1974年在洛阳市前海资村西南发现的北魏元乂墓[20]和1989年在孟津朝阳北陈村发现的北魏王温壁画墓[21]，虽然墓葬壁画篇幅不多，但仍能够窥见北朝绘画内容及艺术风格之一斑。

元乂墓为方形砖室墓，在墓室上壁和顶部施彩绘。四壁壁画已被破坏，仅存上栏四神图像残迹；墓顶的"星象图"保存完整，绘有银河贯穿南北，星辰300余颗，大多数有连线，绝大部分星宿可以辨认。据考证，图中的天象反映了当时的实际天象[22]。这是我国发现时代较早、幅度较大、星宿较多的一幅"天象图"，是研究我国古代天文的宝贵资料。

王温墓为单室土洞墓，在墓室东壁保存有壁画。画面中部为一四坡顶轿形帷屋，屋内有弯曲的屏风，端坐男、女二人。帷屋左侧有三女子作行进状，右侧有三女子站立作侍奉状。帷屋前一童子恭立，画面两侧绘有起伏的山峦和林木。该壁画动静交糅，景情融

汇，是一幅不可多得的北魏世俗生活画卷。

南阳邓县（今邓州市）学庄村发现一座南朝兼有壁画的彩色画像砖墓。在拱券形墓门的正面上部和左右两侧绘有彩色壁画。正上方绘一怪兽兽面，面目狰狞，口衔一长兵器。墓门中部两侧各绘一飞仙，门两侧各画一持剑门吏，作守卫之姿。这是河南仅有的一座有壁画的南朝墓葬，其画技精妙，十分珍贵。

4.隋唐壁画

隋唐时代是中国封建社会的鼎盛时期，经济空前繁荣，文化发达进步。唐代东都洛阳，是仅次于京城长安的重要都市，故而河南地区的唐代壁画墓多发现于洛阳。到目前为止，河南发现的唐代壁画墓共有四例。唐代壁画题材，除四神有所保留外，绝大部分都是依现实生活场景描绘。

1992年在洛阳市南郊龙门镇花园村发掘的唐睿宗贵妃豆卢氏墓[23]，葬于公元740年。在墓道两侧壁绘建筑、仕女和花草等。甬道两侧壁画分前后两段，西壁前段绘四个男仆双手捧物行进，人物之间均用花点缀；后段画面分为二组，前一组有九位仕女，后面一组画五人一马。东壁前段画一列男仆呈行进状；后段画面为14位仕女分三组作交谈状；墓室顶部和四壁也绘有壁画，内容有人物、云气和花草等。

2002年发掘的安阳市果品公司唐墓，为1座墓室平面呈长方形的土洞墓。在甬道两侧各有1个耳室，在耳室两侧彩绘男、女侍立图。墓室东壁被毁，墓室西壁保存基本完整，先用白灰涂抹作地，再用红线勾勒边框，形成三个长方形壁面。其中间一个壁面宽大，彩绘花鸟图案，两侧壁面较小，彩绘鸭戏和花鸟图。南壁西侧彩绘一仕女，北壁西侧用红线画成方格作窗棂状[24]。

2005年在洛阳洛南新区发现的唐安国相王孺人唐氏、崔氏两墓[25]，唐氏死于唐长寿二年（693年），崔氏埋葬于705~710年之间。两墓墓道以及过洞、天井、壁龛、甬道和墓室内均绘有壁画，但多数壁画上部残缺。两墓墓道所绘壁画内容相似，均为青龙、白虎及人物牵马和骆驼图，墓道北端绘门吏；唐氏墓墓道北壁还残存影作木结构阁楼建筑。过洞所绘壁画，

唐氏墓东西各绘一挎剑武士，武士身后有侏儒、乐伎等多种人物造型；崔氏墓过洞及天井两壁绘画均为武士形象。这批壁画的出土，使我们领略到唐代宫廷画家高超的绘画技艺和独特的艺术魅力。

5.北宋壁画

迄今河南境内已发现北宋壁画墓30多座，位居全国各省区之首。宋代绘画是中国古代绘画艺术史上的繁盛时期，宋代壁画墓在继承汉唐壁画墓优秀传统的基础上又有所创新：一是壁画内容写实，以描绘日常生活为主；二是绘画技巧成熟，注重色彩的合理搭配运用；三是造型严谨准确，注意细腻刻画人物衣饰、动作和神态。作为宋代绘画的重要组成部分，宋代墓室壁画真实再现了当时的社会生活面貌，反映出高超的绘画艺术水平。

宋代壁画墓往往是与仿木结构的砖雕结合在一起，多为砖砌单室墓，一般由竖穴或台阶式墓道、仿木结构门楼、砖券甬道和墓室四部分组成。墓室平面呈圆形和方形的时代较早，而等边多角形的时代较晚；单室的早于前、后两室的；墓室仿木结构简单的早于墓室结构复杂的；斗拱以"一斗三升"托替木或"把头绞项造"发展到五铺作重拱，从简单的叠顶发展为宝盖式盠顶藻井，从版门直棂窗变为雕花格子门。壁画位置主要在墓内甬道两侧、墓室周壁和顶部，题材大致分作墓主日常生活、孝行故事、天像与升仙、花卉装饰四大类。目前发现的纪年墓有巩义市滩沱村的咸平三年（1000年）宋太宗元德李后陵[26]、郑州市南关外的至和三年（1056年）胡进墓[27]、安阳市天禧镇熙宁十年（1077年）王用墓[28]、登封市黑山沟绍圣四年（1097年）李守贵墓[29]、禹州市白沙的元符二年（1099年）赵大翁墓[30]、新密市平陌大观二年（1108年）墓[31]和新安县李村靖康元年（1126年）宋四郎墓[32]七座，基本上反映出河南地区北宋壁画墓的发展演变脉络。

元德李皇后是宋太宗赵光义的妃子、宋真宗赵恒的生母，后陵地宫单室砖砌，墓室平面呈圆形，墓顶作穹窿状，环绕墓壁砖砌11根立柱，两立柱之间的壁面上皆有砖雕仿居室装饰。在立柱之上各有一组仿

木建筑结构的四铺作斗拱，斗拱表面用红、白二色刷饰，并间绘花纹。房檐之上的2.7米高度以内绘有楼阁图，再上至墓顶为星像图，星像图由银河和诸星宿组成，布满整个墓室顶部，气势恢宏。

郑州南关外胡进墓为近方形墓室，墓室四壁用砖雕成衣架、盆架、桌椅和灯檠，在四隅倚柱上砖砌斗拱，斗拱与斗拱之间及普柏枋上彩绘各种花纹图案。壁画主要绘于砖券甬道两侧题材有马和男侍。

安阳天禧镇王用墓的墓室平面呈方形，在墓室的左、右和后壁彩绘有人物壁画，内容为"散乐图"、墓主人夫妇对坐和送行图等。登封黑山沟李守贵墓的墓室平面呈八角形，墓室内富丽堂皇，彩绘壁画22幅，自下而上分为三部分。一是在墓室下部北壁砖砌假门，门上绘有卷起的竹帘；其余各壁彩绘壁画，内容分别为备宴图、伎乐图、宴饮图、育儿图、侍寝图和侍洗图，反映了墓主人的日常生活场景。二是在拱眼壁上绘有八幅孝行图，其中三幅榜题为："王武子"、"丁兰"和"王相"。三是在斗拱与垂花饰之间绘有壁画八幅，分别为仙女、菩萨、道士、道姑、宅院等与升仙有关的画面。该墓壁画内容丰富，为研究北宋晚期民间绘画和市井风俗提供了珍贵资料。

禹州白沙赵大翁墓有前、后两室，结构复杂。在甬道东壁彩绘三人，西壁彩绘三人一马，人物或持筒囊，或捧酒瓶，当是向墓主人贡奉财物。前室平面为横长方形，顶部为宝盖式盝顶藻井，东壁彩绘壁画，在卷帘和悬幔下绘有女乐伎11人，其中10人手持乐器，正中一人欠身扬袖起舞；西壁雕砖和绘画相结合，中间砖砌一桌二椅，桌上砌有注子、盏和盏托，墓主人夫妇各坐于椅上，背后立有侍女三人。后室平面为六角形，东北和西北两壁中间砖砌破子棂窗，两侧彩绘灯檠、剪刀、熨斗；北壁上绘悬幔，下砌假门和妇人掩门。东南壁绘三女二男，作进奉状；西南壁绘有五女，在侍奉主人化妆。该墓除砖雕和人物壁画外，还在墓门、甬道、过道和墓室内绘有大量的装饰彩画，其内容包括花卉、青草、果品、云朵、瑞禽等图案。

新密平陌大观二年墓为单室砖券墓，墓室呈八角形。墓室南壁为甬道，北壁砖砌假门，其余六壁彩绘家居图、梳妆图、备宴图和书写图等墓主人日常生活场景。在拱眼壁彩绘石榴花等花卉。在墓顶下部的梯形壁面内彩绘八幅孝行图和升仙图。新安李村靖康元年墓，甬道作拱形券顶，在两侧壁面上浮雕孝行图四幅。墓室平面为八角形，墓室壁面上饰有砖雕门窗和彩绘壁画，主要为墓主人宴饮图、伎乐图、庖厨图和牡丹图。该墓的题记上有墓主人姓名和埋葬年月，以及砌墓工匠的名字和室内壁画的作者等，是一个颇为难得的发现。

上述的宋代壁画均是在砖砌的墓壁上涂抹一层白灰，然后在白灰面上勾线平涂，即先用墨线勾勒出人物轮廓，然后依不同人物彩绘出不同服饰，再对人物的眼、唇、面颊进行细部点描。但对于一些花卉图案，则使用了以色彩描绘的没骨画法，即不用勾线，直接用色彩点染。在河南地区的宋代壁画墓中，还有一种是在土壁上直接刻划图案，颇为少见。如巩义市西村发现的一座土洞墓，在墓室西壁土墙上阴刻一幅壁画，高1.8米，宽1.9米，画面上部横列帐幔，幔下两侧垂有两条飘带，中间为卷头式供案，刻工精细，刀法娴熟[33]。这种在土壁上浮雕花纹图案的做法，也曾在三门峡市的三座宋墓中发现。其中的一座为带天井的砖室墓，在墓道北端和天井北壁的土壁上，自下而上浮雕有仿木结构的门窗、菱形的几何图形以及团团簇起的花卉图案。另外两座为土洞墓，浮雕图见于墓道北壁，也为房屋建筑和花卉图案[34]。土壁浮雕图的发现，为古代民间艺术的宝库又增添了新品种。

6.金代壁画

河南的金代纪年壁画墓发现2座，分别为林州市区文明街皇统三年（1143年）墓[35]和焦作市电厂金大定二十九年（1189年）墓[36]。林州市区金墓平面作八角形，八角攒尖顶，墓室东、西、北三壁相同，用砖砌成仿木结构的假门，中间设红色双扇半启的板门，各门均绘一启门外望的女子。东北和西北壁砖砌一直棂窗，东南和西南壁彩绘散乐图和庖厨图，甬道两侧各绘一武士。在北壁的假门之上还绘有墓主人对坐

图，其余七壁上部彩绘24幅孝行图，分别墨书有"郭巨埋子"、"王武子妻割股"、"刘明达卖子"、"董永还妻"等题记。焦作电厂金墓为一座仿木结构砖雕壁画墓，墓室平面呈不等边八角形，穹窿顶，墓室下部砌成须弥座，上砌倚柱、普柏枋和单抄四铺作斗拱。斗拱上施红、白两色，拱眼壁彩绘云纹与牡丹缠枝花卉，撩檐枋以上绘云纹图案，在东北和西北部各绘一只仙鹤。墓室的壁面上皆镶嵌砖雕，其中东壁和西壁为六扇四抹格子门，中间两扇有一女子作启门状；东南壁和西南壁砌假直棂窗；西北壁和东北壁浮雕一高足花瓶架，架上彩绘花瓶和插花；北壁则浮雕三幅孝行故事图。另外，金元之际的壁画墓在禹州、新乡和洛阳等地也有发现，墓室平面皆呈八角形，墓壁装饰以四抹格子门砖雕为主。禹州市坡街金墓是在格子门两侧彩绘狮子滚绣球和捧物的侍女，在西南和东南壁面上分别彩绘有"庭院备马图"和"客厅设宴图"，以砖雕和绘画相结合，使墓室更加富丽堂皇，别具一格[37]。

蒙元壁画墓在河南也有一些发现，宋金时期流行的仿木结构砖雕斗拱已趋简化，大致分作两种类型。一种墓室平面呈八角形，尖圆形顶，类似蒙古包状，在各壁面上涂一层白灰，彩绘人物画像。在焦作市老万庄发现的冯三翁墓，墓室壁画保存较好，北壁正中画墓主人像，其他各壁各绘一男或女侍，男者掌扇或捧印，女者抱琴或托巾，恭立侍奉，各有分工。冯三翁墓曾随葬铜质"合同契券"一方，落款为"戊午年十月二十二日"，发掘者认为该墓的上、下限年代约在金代两个戊午年，即1138~1198年之间。但也有学者把此墓定为元宪宗八年，即1258年[38]。登封市王上村壁画墓为八角形单室砖墓，在墓室各壁均绘一幅壁画，画幅高1.2米，宽1.05米，壁间以红褐色条带将画幅分开。其中，北壁绘梅竹双禽图，东北、西北壁绘三鹤图，东壁绘论道图，西壁绘升仙图，东南、西南壁绘三侍女图。甬道东、西壁各绘一男侍，墓室顶部绘有祥云和飞鹤。该墓壁画采用工笔与写意相结合的手法，线条细腻流畅，色彩浓淡分明，具有较高的艺术价值[39]。

另一种为无甬道的长方形券顶砖室墓，在墓室四壁彩绘画像。其中伊川县元东村的一座，北壁为墓主人夫妇对坐图，东、西壁为礼乐供奉图，南壁墓门两边各绘一门吏，墓顶绘牡丹、祥云和飞鹤。整个壁画绘制人物22个，有的服饰具有鲜明的蒙古族服饰特征[40]。尉氏县后大村的一座，在墓室后壁中间设"后土之神"小龛，两侧绘墓主人夫妇并坐图；东壁中间设"东仓"小龛，两侧分别绘孝子图和收粮图；西壁中间设"西库"小龛，两侧分别绘两幅孝子图。在砖雕斗拱的上方绘制有六幅飞天图像，墓室券顶部绘出12个小框，每小框内彩绘有菊花、莲花等花卉图案。由于该墓仅出土一件陶瓮和三枚北宋时期钱币，发掘者曾推测为宋代[41]。但有研究者从墓葬形制、壁画布局、仿木结构、人物服饰和墓门题记等方面进行对比分析，将该墓订正为元代[42]，颇有说服力。

7. 明代壁画

明代壁画墓发现较少，目前仅见两座。原武温穆王朱朝埨和元配张太妃的合葬墓，位于荥阳市瓦屋孙村东南。该墓为砖砌单室墓，平面为长方形，在北、东、西面三壁绘有彩色壁画。北壁正中为一释迦牟尼立像，左右立四只护法灵禽，最下层为海水波浪纹。东西壁均绘释迦佛结跏趺坐在莲花台上，背光带中有男女墓主人及亡亲故友五人。佛像左边是两排前来赴会的菩萨罗汉，上方祥云中还有殿堂、楼阁和仙鹤，墓顶绘日月星辰。该墓出土石墓志两合，志盖篆书《明册封周藩原武温穆王圹志铭》和《明册封周藩原武温穆王元配张太妃合葬圹志铭》[43]。原武温穆王朱朝埨，是明太祖第五子周定王的嫡孙、第六世原武王，生于嘉靖三十一年（1552年），死于万历三十五年（1607年）。墓内壁画以佛教内容为主题，其构图严谨协调，人景配合适当，具有较高的艺术价值。登封市卢店明嘉靖（1522~1531年）年李彪墓，也为单室砖券墓，在墓室四壁及墓门外两侧均绘有壁画，其中，墓门外两侧彩绘一瓶插花卉，墓门内两侧各绘一捧物侍女；墓室北壁绘堂屋，墓主夫妇端坐其中；

东、西两壁绘厢房，分绘两男、两女侍在忙碌备宴、备茶；墓室顶部东绘太阳，西绘月亮，以寓意天空[44]。上述壁画设色艳丽，形象生动，构成了一幅完整的侍奉场景。

注 释

[1] 杨建方：《汉以前的壁画之发现》，香港《美术家》第29期，1982年。

[2] 考古研究所洛阳发掘队：《洛阳西郊一号战国墓发掘记》，《考古》1959年第12期。

[3] 河南省文化局文物工作队：《洛阳西汉壁画墓发掘简报》，《考古学报》1964年第2期。

[4] 洛阳博物馆：《洛阳西汉卜千秋壁画墓发掘简报》，《文物》1977年第6期。

[5] 汤池译：《今藏美国波士顿的洛阳汉墓壁画》，《当代美术家》1986年第3期。

[6] 洛阳市第二文物工作队：《洛阳浅井头西汉壁画墓发掘简报》，《文物》1993年第5期。

[7] 沈天鹰：《洛阳出土一批汉代壁画空心砖》，《文物》2005年第3期。

[8] 梁晓景：《洛阳金谷园西汉墓发掘简报》，洛阳市第二文物工作队编：《洛阳考古发掘与研究》，《中原文物》1996年增刊号。

[9] 史家珍、樊有升、王万杰：《洛阳偃师县新莽壁画墓清理简报》，洛阳市第二文物工作队编：《洛阳考古发掘与研究》，《中原文物》1996年增刊号。

[10] 河南省商丘市文物管理委员会等：《芒砀山西汉梁王墓地》，文物出版社，2001年。

[11] 洛阳市文物工作队：《洛阳新安县铁塔山汉墓发掘报告》，《文物》2002年第5期。

[12] 黄明兰、郭引强：《洛阳汉墓壁画》，文物出版社，1996年。

[13] 中国社会科学院考古研究所河南第二工作队：《河南偃师杏园村东汉壁画墓》，《考古》1985年第1期。

[14] 洛阳市文物工作队：《河南洛阳北郊东汉壁画墓》，《考古》1991年第8期。

[15] 洛阳市文物工作队：《洛阳机车工厂东汉壁画墓》，《文物》1992年第3期。

[16] 史家珍：《洛阳市朱村东汉壁画墓发掘简报》，洛阳市第二文物工作队编：《洛阳考古发现与研究》，《中原文物》1996年增刊号。

[17] 河南省文物研究所：《新密打虎亭汉墓》，文物出版社，1993年。

[18] 河南省文物研究所：《密县后士郭汉画像石墓发掘简报》，《华夏考古》1987年第2期。

[19] 郑州市文物考古研究所、荥阳市文物保护管理所等：《河南荥阳苌村汉代壁画墓调查》，《文物》1996年第3期。

[20] 洛阳市博物馆：《洛阳北魏元乂墓调查》，《文物》1974年第12期。

[21] 洛阳市文物工作队：《洛阳孟津北陈村北魏壁画墓》，《文物》1995年第8期。

[22] 王车、陈徐：《洛阳北魏元乂墓的星象图》，《文物》1974年第12期。

[23] 洛阳市文物工作队：《唐睿宗贵妃豆卢氏墓发掘简报》，《文物》1995年第8期。

[24] 安阳市文物工作队发掘资料，待刊。

[25] 洛阳市第二文物工作队：《唐安国相王孺人唐氏、崔氏墓发掘简报》，《中原文物》2005年第6期。

[26] 河南省文物考古研究所：《北宋皇陵》，中州古籍出版社，1997年。

[27] 河南省文化局文物工作队第一队：《郑州南关外北宋砖室墓》，《文物参考资料》1958年第5期。

[28] 《河南省文化局调查安阳天禧镇宋墓》，《文物参考资料》1954年第8期。

[29] 郑州市文物考古研究所、登封市文物局：《河南登封黑山沟宋代壁画墓》，《文物》2001年第10期。

[30] 宿白：《白沙宋墓》，文物出版社，1957年。

[31] 郑州市文物考古研究所：《新密平陌宋代壁画墓》，《郑州宋金壁画墓》，科学出版社，2005年。

[32] 叶万松、余扶危：《新安县石寺李村的两座宋墓》，《中国考古学年鉴》(1985)，文物出版社，1986年。

[33] 巩县文物保管所、郑州市文物工作队：《巩县西村宋代石棺墓清理简报》，《中原文物》1988年第1期。

[34] 三门峡市文物工作队：《三门峡市宋墓发掘简报》，《华夏考古》1993年第2期。

[35]　张增午：《河南林县金墓清理简报》，《华夏考古》1998年第2期。

[36]　焦作市文物工作队：《焦作电厂金墓发掘简报》，《中原文物》1990年第4期。

[37]　河南省文物考古研究所、禹州市文管会：《禹州市坡街宋壁画墓清理简报》，《中原文物》1990年第4期。

[38]　河南省博物馆、焦作市博物馆：《焦作金代壁画墓发掘简报》，《中原文物》1980年第4期；中国社会科学院考古研究所编：《新中国的考古发现和研究》第607页，文物出版社，1984年。

[39]　郑州市文物工作队：《登封王上村壁画墓发掘简报》，《文物》1994年第10期。

[40]　洛阳市第二文物工作队：《洛阳伊川元墓发掘简报》，《文物》1993年第5期。

[41]　开封市文物工作队、尉氏县文物保护管理所：《河南尉氏县张氏镇宋墓发掘简报》，《华夏考古》2006年第3期。

[42]　刘未：《尉氏元代壁画墓札记》，《故宫博物院院刊》2007年第3期。

[43]　郑州市博物馆：《荥阳二十里铺明代原武温穆王壁画墓》，《中原文物》1984年第4期。

[44]　郑州市文物考古研究所、登封市文物局：《登封卢店明代壁画墓》，《中原文物》1999年第4期。

The Murals Unearthed in Henan Province

Sun Xinmin and Cai Quanfa

Located in the Central Plains, Henan has long history and splendid culture; the ancient murals in Henan present us a rich treasury of ancient art. So far, several dozens of ancient mural tombs have been excavated archaeologically in Henan, the date of which are from the Western Han Dynasty, via Wang Mang's Xin Dynasty, the Eastern Han, Three-Kingdoms, Southern and Northern Dynasties, to the Tang, Song, Jin, Yuan and Ming Dynasties. These tomb murals were painted as the way of "Serving the dead as they were alive", but they were the embodiments of the human lives of the times when they were created and the epitomes of the ancient societies.

1. The Murals of the Western Han Dynasty

The earliest murals in Henan could be tracked back to the Shang Dynasty at present. In 1975, fragments of murals were unearthed from Yinxu Site in Anyang, but they were only "red-painted symmetrical patterns on lime-coated wall"[1]. A tomb of the Warring-States Period found in western suburb of Luoyang City in 1957 had red margin on the corners of the grave, and traces of patterns painted with red, yellow, black and white colors on the west wall of passageway[2]. The tomb murals before the Han Dynasty were very rare and the motifs were only simple decorative patterns.

The mural tombs of the Western Han and Xin Dynasties were mainly distributed in Luoyang and Shangqiu areas, and most of them were in the vicinity of Luoyang. The famous ones of the mural tombs of this period were Tomb No. 61 of Shaogou Cemetery[3], Bu Qianqiu (Pu Ch'ien-ch'iu)'s Tomb[4], the mural tomb at Balitai[5], the mural tomb at Qianjingtou[6], the mural tomb at Lihe in Xin'an County[7], the mural tomb of the Xin Dynasty at Jinguyuan[8], the mural tomb of the Xin Dynasty at Xincun in Yanshi City[9], the mural tomb at Shiyuan in Yongcheng County[10] and so on.

The mural tomb at Shiyuan in Yongcheng County was a stone cave tomb cut out of a hill in early Western Han. Its mural was painted on the ceiling of the tomb chamber, the motifs of which were the Green Dragon, the White Tiger, the Scarlet Bird and other mythical animals painted with various colors and surrounded by geometric clouds. The background color of the mural was red and the flying clouds were painted with black and white color; the composition of the entire scene was substantial and dynamic, especially the feathered flying Green Dragon, showing the strong artistic appeal and shaking charm. This is the earliest Han mural seen to date, taking significant position in the history of Chinese painting.

Bu Qianqiu's tomb, which was named with the name "Bu Qianqiu" on a bronze seal unearthed from it, was built within the reigns of Emperors Zhaodi and Xuandi of the Western Han Dynasty (86-49 BCE). On the back wall of the main chamber was the scene of Fangxiang Shi (Regional Inspector of the Western Zhou Dynasty, but in the later times changed into legendary being) beating evils, the Fangxiang Shi in which was topless and bare-footed, and glaring to the direction of the entrance. Below this scene were the Green Dragon and the White Tiger. The middle ridge of the ceiling of the main chamber was decorated by the scene of "Ascending Fairyland", in which Nüwa, the Moon, the necromancer holding staff of authority, two dragons, two owl-goats, the Scarlet Bird, the White Tiger, the fairies, the rabbit and hound, the toad, Bu Qianqiu and his wife, Fuxi, the sun, the yellow snake, and so on are painted into a spectacular queue. Corresponding to the scene of "Ascending Fairyland", the figure of a dragon-bodied immortal was painted on the door lintel of the tomb entrance, implying the tomb occupants' ascending to the immortal world and getting rid of the evils.

Tomb No. 61 of Shaogou Cemetery was built in the reigns of Emperors Yuandi and Chengdi of the Western Han Dynasty (48-8 BCE). The main scenes of the murals in this tomb are the picnic feasting, ascending to the heaven on the dragon back, and the Great Nuo (exorcising evils) ceremony. On the beams of the walls of the main chamber were the scenes of the historic tales such as "Killing Three Brave Men by Serving Them Two Peaches" and the images of the sun, the moon, the stars and the Milky Way, which was the earliest case of murals with celestial bodies as contents. On the inner side of the door lintel of the tomb entrance was the scene of a spirit tiger eating Ba (drought evil).

The mural tomb of the Xin Dynasty (8-23 CE) at Xincun in Yanshi City had eight pieces of murals: to the north of each of the doors of the two side chambers, a petty official holding Qiji (a kind of tally or pass made of wood in the shape of halberd) was painted; in the middle of the door lintels of the antechamber and middle chamber was the figure of Fangxiang Shi flanked by Changyi on the left holding the moon and Xihe to the right holding the sun; on the south half of the west wall of the middle chamber was the cooking scene and the north half, the scenes of feasting and liubo game playing; on the south half of the east wall was the scene of feasting and music and dancing performance, and on the north half was the scene of feasting. In the middle of the beam between the middle and rear chambers was Xiwangmu (Queen Mother of the West) seated in purple canopy. The positions of murals in this tomb were somewhat different from that in the earlier mural tombs, and themes related to real life emerged in the murals. Both of these phenomena showed the transformative features between the mural arts of the Western Han and Eastern Han Dynasties.

2. The Murals of the Eastern Han Dynasty

The tomb murals of the Eastern Han Dynasty found in Henan are much more plentiful and gorgeous, most of which were distributed in Luoyang and Zhengzhou areas, and those in Luoyang area represented the top level of the painting art of that time.

The representative mural tombs of the Eastern Han Dynasty in Luoyang area were the one at Tietashan in Xin'an County excavated in 1980 [11], the one at Glass Factory on Tanggong Road excavated in 1981 [12], the one at Xingyuan Village in Yanshi City excavated in 1984 [13], the one at Petroleum Station in Daobei District excavated in 1987 [14], the one in Luoyang Locomotive Factory [15] and the one in Zhucun Village [16] excavated in 1991, etc.

The representative mural tombs of the Eastern Han Dynasty found in Zhengzhou area so far were the Tomb No. 2 at Dahuting Village excavated in 1960 [17] and the one at Houshiguo Village in 1963 [18], both in Xinmi City and another at Changcun Village in Xingyang City surveyed in 1995 because of a robbery [19].

Except for the one at Petroleum Station, which was built in early Eastern Han, the one at Tietashan, which was built in middle Eastern Han and the one in Zhucun, which was built around the end of Eastern Han and the Three-Kingdoms Period, all of these mural tombs were built in later Eastern Han Dynasty. The themes of these murals were mainly dedicated to showing the statuses of the tomb occupants, lines of subordinates and attendants, the scenes of chariots, infantry and cavalry processions, feastings and performances of dancing, music and acrobatics playing, as well as home life, cooking, storing and levying, and so on. The historic tale paintings were still popular but the mythical animals were reduced. Clearly, the themes reflecting the desires of ascending immortal in the tomb murals of the Western Han Dynasty were vanishing in that of the Eastern Han Dynasty and replaced by the themes showing the real lives. This is a significant progress on the artistic thoughts.

The mural tomb at Petroleum Station in Daobei District, Luoyang had the figures of Shenshu神荼 and Yulü郁垒 (the Door Gods) on the side walls of the corridor linking the passageway and the tomb chambers, and petty officials on the east and west walls of the middle chamber, both were symmetrical composition. On the square dome of the middle chamber, four scenes were painted on the background patterns of flying red clouds separated by the jointing lines: the south scene was an old man driving a chariot drawn by a flying dragon; the north scene was an old man driving a chariot drawn by a galloping deer; the east scene was Xihe holding the sun overhead and the west scene, Changyi holding the moon overhead. These scenes were magnificent, vivid and in brilliant and harmonious colors, somehow reflecting the cosmological and five-element ideas of the people at that time.

Flanking the entrance of the mural tomb at Tietashan in Xin'an County, figures of petty officials were painted. On the upper part of the back wall of the tomb chamber was the portrait of the tomb occupant, on the left of whom was a guard carrying a cudgel; on the right was a maid holding tray and cups as serving wine to the tomb occupant. The murals on the left and right walls were sketchy and smeared severely; the remaining traces showed that on the right wall had been procession scene of chariots and cavalry and that on the left wall, color-painted jars. On the ceiling of this tomb were the

sun, the moon, the Big Dipper constellation and auspicious clouds, among which were galloping deer and sheep. The murals in this tomb did not have plaster base but were directly painted on the brick wall. The celestial bodies painted on the ceiling was a rather early case of this kind of mural motifs in China. The murals of the tomb found in the Glass Factory on Tanggong Road were painted on the yellow-coated lime mortar base. On the east end of the north wall were the tomb occupant and a servant; on the east wall were the portraits of the couple of the tomb occupants seated side by side; on the east end of the south wall was a maid, behind whom were two horses and a horse-drawn carriage. The main contents of the mural tomb found at Xingyuan Village in Yanshi City were the procession scenes of the tomb occupant including nine anche (carriage with canopy), over 70 human figures and 50 advancing horses, all of which formed mighty formations.

The murals of the Tomb No. 2 at Dahuting Village had huge scale and complicated compositions; the ones in all of the side chambers and the vaults of the corridors were painted with ink and the ones on the ceiling and the south, north and east walls of the middle chamber were painted with various colors. The themes of these murals could roughly be classified into three parts: that of the first part, which were on the south and north walls of the middle chamber, were the depiction of the life of the tomb occupants when they were alive; they were arranged into two registers, the bottom of which were the human figures in different poses and costumes and the top of which were the scenes of feasting, acrobatics performance, chariot, infantry and cavalry processions, receiving guests, and so on. The murals in the south, north and east side chambers showed the scenes of greeting guests, cooking and feeding horses, etc. Those of the second part were reflecting the occupant's desire of ascending immortal, such as the immortals' gathering on the east wall, and the immortals and mystical animals in clouds on the both sides of the lotus motif in the center of the vaulted ceiling of the middle chamber. Those of the third part were the decorative patterns, such as the grid ceiling, the lotus motif in its center and the cloud patterns on the frames, and so on. The procession scene on the south wall of the middle chamber showed the grandiose formation of the tomb occupant when he was outgoing or receiving guests. In the style of a long scroll, the feasting and dancing and acrobatics performance scenes on the north wall of the middle chamber vividly recreated a row of aristocrats enjoying the performance while feasting in luxurious colors, the host, guests and the performers in which were all depicted true to life. This is a very rare masterpiece of the mural art of this period.

The mural tomb at Changcun Village in Xingyang City was a stone-and-brick structure. The two side walls of the corridor and all of the walls and ceiling of the antechamber were decorated with murals, covering areas of 300 sq m in total. Their motifs were mansions and courtyards, processions, human figures and tales, exotic and mythical animals and music, dancing and acrobatics performances. The murals on the side walls of the antechamber were divided into four registers with red lines, in which procession of vehicles of various types and cavalries. The vehicles had ink-written inscriptions showing their nomenclatural names, such as "fuche 斧车 ('ax chariot', as vanguard of the procession)", "baigai yaoche 白盖轺车 (light carriage with white canopy)", "zaogai che皂盖车 (chariot with black canopy)", "zaogai zhu zuo fan yaoche 皂盖朱左幡轺车 (yaoche with black canopy and left mud guard lacquered red", "zaogai zhu liang fan yaoche皂盖朱两幡轺车 (yaoche with black canopy and both mud guards lacquered red)", "chigai xuanche赤盖轩车 (spacious carriage with red canopy)" and so on. On the south wall, just outside the rear chamber, figures of performing musicians and dancers were painted; on the west wall were the exotic and mythical animals and procession scene. The large scale of tomb structure, the rich motifs of the mural especially the detailed ink-written inscriptions were all rare in other mural tombs of the Eastern Han Dynasty; they provided important data for the researches on the murals of this period.

3. The Murals of the Three-kingdoms to the Southern and Northern Dynasties

During the Three-Kingdoms through the Southern and Northern Dynasties Periods, the themes, contents and expression methods had significant changes along with the introduction of Buddhist art. The themes of immortal pursuit sharply reduced and that of real life became the mainstream. In the composition, the improper scale of depicting the human figures larger than the landscape was very popular. The fusion of the cultures of the nomadic ethnic groups and the Han people and the influences of the foreign Buddhist art made the mural art of this period rise to a new level.

Yuan Yi's tomb found to the southwest of Qian Haizi Village, Luoyang City in 1974 [20] and Wang Wen's tomb found at Beichen Village, Mengjin County in 1989 [21] had only some fragments of murals remaining, but they still could reflect the themes and artistic styles of the paintings in the Northern Dynasties Period.

Yuan Yi's tomb was a square brick-chamber tomb, the murals of which were painted on the walls and the ceiling. However, only the top parts of the murals on the walls, which were the images of the Four Supernatural Beings, were remaining; the "Star Map" on the ceiling was well preserved, through which was the Milky Way going from south to north among the over 300 stars, and most of the constellations could be identified. It has been verified that this star map reflected the real celestial phenomenon at that time [22]. It is a star map painted in relatively early time and large size and containing more celestial bodies, providing valuable data for the research on the astronomy history of China.

Wang Wen's tomb, which was a single-chamber earthen cave tomb, had mural fragment preserved on the east wall of the tomb chamber. In the middle of the scene was a canopy with a chamfered roof, in which were a man and a woman seated in front of a curved screen. To the left of the canopy were three maids advancing to it and to the right of the canopy, three maids standing as attending. In front of the canopy was a boy standing solemnly. Landscapes with undulating mountains and forests were painted beside this scene. The murals in this tomb organized human figures and landscapes harmoniously and composed a vivid secular life scene of the Northern Wei Dynasty.

A mural tomb of the Southern Dynasties found in Xuezhuang Village, Dengzhou City had also color-painted brick carvings decorated. On the top and two sides of the arched tomb entrance were color-painted murals: atop the entrance was a monster face holding a weapon in the mouth; at the springing lines of the arch were two flying immortals, below which were two door guards holding sword in the hands. This is the only mural tomb of the Southern Dynasties found so far in Henan, the masterly painting skills shown by which are very rare.

4. The Murals of the Sui and Tang Dynasties

The Sui and Tang Dynasties were the climax of the feudalism society of China, the economy of which was unprecedentedly prosperous and the culture was greatly developed. Luoyang, which was the Eastern Capital and the important metropolis of the Tang Dynasty only second to Chang'an, yielded the most mural tombs of the Tang Dynasty within Henan Province. To date, four mural tombs of the Tang Dynasty have been excavated in Henan; except for the Four Supernatural Beings, the themes of the tomb murals of the Tang Dynasty were mainly about the real life.

Ms. Doulu, the imperial concubine of Emperor Ruizong of the Tang Dynasty, was buried in 740 CE. In 1992, her tomb was excavated at Huayuan Village, Longmen Township in the southern suburb of Luoyang City [23]. On the walls of the passageway, architectures, beauties, flowers and herbs were painted. The murals on the side walls of the corridor between the passageway and the tomb chamber were divided into the front and rear sections: in the front section of the west wall were four servants holding stuffs in hands and walking outward, the spaces among whom were decorated with flowers; the figures in the mural of rear section of the west wall could be divided into two groups, the front one of which comprised nine beauties and the rear one, five servants and one horse. In the front section of the east wall were a line of servants walking outward, and in the rear section, 14 beauties were talking in three groups. The walls and ceiling of the tomb chamber were also decorated with murals, the motifs of which were human figures, clouds, flowers and herbs, etc.

The mural tomb of the Tang Dynasty discovered in the Anyang Municipal Fruit Company in 2002 was an earthen cave tomb in rectangular plan; on each of the two sides of the corridor was a side chamber. On the walls beside the side chambers, servants and maids standing solemnly as attending were painted. The east wall of the main chamber had collapsed before the excavation, but the west wall was well preserved. The wall was coated with lime stucco as the base, which was again partitioned into three bays with red belts. The central bay was wider, in the center of which was a begonia-shaped pool surrounded by ducks and bees and butterflies flying among flowers. The two side bays were narrower, in which were bird-and-flower scenes. On the west corner of the south wall was a standing beauty and on the west of the north wall, red grids as window lattice were painted [24].

The tombs of Ms. Tang and Ms. Cui, who were both the concubines of Imperial Prince Xiang (Emperor Ruizong before enthroned), were excavated in Luonan New District, Luoyang City in 2005 [25]. Ms. Tang died in the 2nd year of Changshou Era (693 CE) and Ms. Cui was buried between 705 and 710 CE. Their tombs were all decorated with murals on the walls of the passageways, tunnels, ventilating shafts, niches, corridors and tomb chambers, but the upper parts of most of them were damaged. The themes and their arrangements of the murals of the passageways of their tombs were similar: the Green Dragon and White Tiger were painted on the east and west walls, respectively, followed by horses and camels accompanied by grooms, petty officials were painted at the north ends of the passageways. On the north wall over the entrance of Ms. Tang's tomb, remains of wooden gate tower image were seen. On each of the tunnel walls of Ms. Tang's tomb, a warrior carrying a sword was painted, followed by dwarfs, musicians and other human figures in various costumes and poses; on the walls of the tunnel and ventilating shaft of Ms. Cui's tomb, figures of warriors were painted. The discoveries of these murals showed us the superb painting techniques and unique artistic charms of the court painters of the Tang Dynasty.

5. The Murals of the Northern Song Dynasty

To date, over 30 mural tombs of the Northern Song Dynasty have been found in Henan, which is the most in China. The Song Dynasty was the climax of the flourishing period for the painting art in ancient China, the tomb murals during which also had innovations based on the traditions of that of the Han through the Tang Dynasties: first, the themes were mainly the realistic ones reflecting daily life; second, the painting techniques were much mature and the applying and assemblage of colors were reasonable and appropriate; third, the shaping and scaling were cautious and accurate, and the details of the costumes, facial expressions, postures and moods were specially emphasized. As an important component of the paintings of the Song Dynasty, the tomb murals faithfully reproduced the social life of that time and reflected the high artistic level.

The murals in the tombs of the Song Dynasty were usually used together with brick carvings and imitation wooden structures; these tombs were mostly brick-chamber tombs consisting of the vertical shaft or stepped passageway, the imitation wooden structure gate tower as the entrance, the brick vaulted corridor and the tomb chamber, totally four parts. The earlier mural tombs were usually in circular or square (rectangular) plans, and the ones in regular polygonal plans were later, the single-chamber tombs were usually earlier than the double-chamber ones and the tombs with simpler imitation wooden structures were usually earlier than those with complex ones. The imitation dougong-bracket sets of "one principal dou (cap block) and three secondary dou supporting the auxiliary supporting plank of the purlin" or "three-prong rake-shaped bracket set" were developed into bracket sets of five-puzuo (the cap block, two steps of outward projection, the shuatou-nose and the eave purlin), the simple corbel dome-shaped ceilings developed into chamfered ceilings with luxurious decorations and the board door leaves and windows with vertical grills developed into the lattice doors and windows with openwork floral patterns. The murals were mainly painted on the two sides of the corridor and the walls and ceilings of the tomb chambers; the main themes were the daily lives of the tomb occupants, the tales of the "Twenty-Four Paragons of Filial Piety", the star map and ascending immortal, the flower-and-bird motifs and decorative patterns, and so on. At present, the mural tombs of the Song Dynasty with exact dates discovered in Henan are: the Mausoleum of Empress Yuande (nee Li, the wife of Emperor Taizong) at Hutuo Village, Gongyi City, which was built in the 3rd year of Xianping Era (1000 CE) [26], Hu Jin's tomb in the southern suburb of Zhengzhou City, which was built in the 3rd year of Zhihe Era (1056 CE) [27], Wang Yong's tomb at Tianxi Zhen, Anyang City, which was built in the 10th year of Xining Era (1077 CE) [28], Li Shougui's tomb at Heishangou, Dengfeng City, which was built in the 4th year of Shaosheng Era (1097 CE) [29], Zhao Daweng's tomb at Baisha in Yuzhou City, which was built in the 2nd year of Yuanfu Era (1099 CE) [30], a tomb built in the 2nd year of Daguan Era (1108 CE) at Pingmo in Xinmi City [31] and Song Silang's tomb at Licun, Xin'an County, which was built in the 1st year of Jingkang Era (1126 CE) [32]. Their dates roughly outlined the evolution sequence of the tomb murals in Henan during the Northern Song Dynasty.

The underground palace (tomb chamber) of Empress Yuande, who was the birth mother of Emperor Zhenzong of the Song Dynasty, was a brick chamber in circular plan with a hemisphere shaped ceiling; on the wall were eleven engaged

pillars separating the wall into eleven bays, each of which had living room settings made of brick carvings. Atop of each engaged pillar was an imitation wooden four-puzuo dougong-bracket set decorated with red and white colors and floral patterns. In the 2.7 m-high space over the bracket set, halls and pavilions were painted; above them was the star map covering the entire dome top, which was composed of the Milky Way and innumerable celestial bodies in a gorgeous air.

Hu Jin's tomb located in the southern suburb of Zhengzhou City was a brick chamber tomb in square plan, the walls of which were decorated with clothing racks, basin stands, tables, chairs, lamp stands, and so on made of brick carvings; on the four corners of the chamber, imitation wooden engaged pillars with dougong-bracket sets on top were made, the tie-beams linking the engaged pillars and the spaces between the dougong were all decorated with floral and other decorative patterns. The murals were seen on the walls of the brick-laid corridor between the passageway and the tomb chamber, which were the figures of horses and grooms.

Wang Yong's tomb located in Tianxi Township, Anyang City was in square plan, the left, back and right walls of which were decorated with murals, the contents of which were music band, the portraits of the couple of the tomb occupants seated beside the table and the scene of farewell, and so on. Li Shougui's tomb located at Heishangou, Dengfeng City was in an octagonal plan and decorated impressively with 22 murals. These murals were roughly arranged in three sections from bottom to top: the first section was the murals on the walls separated by the engaged pillars except for the north wall, which was bearing an imitation wooden door with rolling up bamboo curtain painted. The contents of these murals were preparing for feast, music performance, feasting, women playing with children, waiting on in the sleeping room and waiting on washing, all showing the scenes of the daily lives of the tomb occupants. The section was the eight murals on the "gongyan bi (the space between each two bracket sets)", all of which were the scene of the "Paragons of Filial Piety" and three bore the inscriptions of "Wang Wuzi", "Ding Lan" and "Wang Xiang". The third section was the eight murals painted on the eight triangular faces of the octagonal pyramidal ceiling over the bracket sets, all of which were related to ascending immortal, such as fairies, the bodhisattva, the Taoist priests and nuns, the architectural complex, and so on. The rich motifs and contents of the murals in this tomb provided invaluable materials for the researches on the folkloric painting and urban life of the late Northern Song Dynasty.

Zhao Daweng's tomb located at Baisha in Yuzhou City, which had the antechamber and rear chamber, was built in a very complex structure. On the east wall of the corridor were the figures of three people and on the west wall, three people and one horse; all of the people had bundles of pipe-shaped objects, packages or wine bottles in hands, as paying tributes to the tomb occupants. The antechamber was in a transverse rectangular plan with a chambered ceiling with floral decorative patterns; on the east wall was the scene of a performance of a 10-player music band and one dancer, all female below hanging mantle and curtain. The murals of the west wall was a combination of painting and brick carving; in the middle was a brick-laid table with teapot, teacups and saucers on it; beside the table were the couple of the tomb occupants seated on chairs and behind the table, one servant and three maids holding various utensils were standing. The rear chamber was in a hexagonal plan; in the middle of the northeast and northwest walls, windows with vertical grills, beside which were lamp stands, scissors or irons; on the top of the north wall was sagging mantle, below which was a brick-laid door opening ajar through which a woman watching outward. On the southeast wall were three women and two men carrying stuffs as attending or paying tributes and on the southwest wall, five maids were attending the tomb occupants to make up. In addition to the brick carvings and the murals, large amounts of decorative patterns were also painted on the tomb entrance, corridors from the passageway to the antechamber and from the antechamber to the rear chamber, as well as the tomb chambers, the motifs of which were florals and herbs, fruits, clouds and auspicious birds, and so on.

The tomb dated as the 2nd year of Daguan Era (1108 CE) at Pingmo, Xinmi City was a brick single-chamber tomb in an octagonal plan; the corridor leading to the entrance was on the south wall and an imitation wooden door was laid on the north wall. The other six walls were decorated with murals of house living, making up, preparing for feast, writing and other daily life scenes of the tomb occupants. On the gongyan bi, pomegranate flowers and other floral patterns were painted. On the eight trapezoid faces of the octagonal frustum-shaped ceiling, the scenes of the "Paragons of Filial Piety" tales and

ascending immortal were painted. The tomb dated as the 1st year of Jingkang Era (1126 CE) was also in an octagonal plan with a barrel vaulted corridor, on the two side walls of which four bas-relief scenes of the "Paragons of Filial Piety" tales were carved. On the walls of the tomb chamber, imitation wooden doors and windows and color painted murals were seen, the main contents of which were the scenes of feastings, music and dancing performances, cooking and peony flowers. In the inscriptions of this tomb, the name of the tomb occupant, the date of interment, and the names of the craftsmen building this tomb and the artists painting the murals were all recorded, which is a very rare discovery.

The murals of the Song Dynasty mentioned above were all painted on the lime stucco layer applied to the brick walls. At first, the outlines of the figures and other images were drawn with thin ink lines on the lime stucco bases and then colors were applied according to the costumes of the figures of various statuses and so on, and at last the eyes, lips and cheeks of the figures were carefully depicted. However, when some floral patterns were painted, the "boneless method" was applied by which no ink outlines were used but the whole pattern was directly painted with colors. In the mural tombs of the Song Dynasty in Henan, a special type of directly carving designs and patterns on the primary earthen walls of the tombs, which was seldom seen in other places and periods, is found. For example, on the west wall of an earthen cave tomb excavated at Xicun Village in Gongyi City, an intaglio mural 1.8 m in height and 1.9 m in width was found [33]: on the top of the mural, sagging mantle was carved, on each of the two ends of the mantle, a ribbon was hanging. Below the mantle and between the ribbons, an offering table with two upturning sides was carved. The carving techniques of this mural were skillful and exquisite. The murals carved with the same method have also been found in three tombs of the Song Dynasty in Sanmenxia City; one of them was a brick-chamber tomb with a ventilating shaft, on the earthen wall at the inner end of the tomb passageway and the north wall of the ventilating shaft of which doors and windows imitating wooden ones, rhombus patterns and clusters of floral designs were carved. The other two were pure earthen cave tombs, the intaglio murals of which were all on the inner end walls of their passageways, and were also wooden structure and floral designs [34]. Earthen intaglio murals presented a new type to the treasury of the folkloric art of ancient China.

6. The Murals of the Jin Dynasty

Two mural tombs of the Jin Dynasty with exact dates have been found so far in Henan, which were the one built in the third year of Huangtong Era (1143) found on Wenming Street at downtown Linzhou City [35] and the one built in the 29th year of Dading Era (1189) found in Jiaozuo Power Plant [36]. The tomb in Linzhou City was built in octagonal plan with a pyramidal ceiling; the east, west and north walls were built into doors imitating wooden structure, each had double leaves opening ajar from which a woman looking outward was painted. In the middle of the northeast and northwest walls was an imitation wooden window built with brick. On the southeast and southwest walls were scenes of music performance and cooking, and on each of the two sides of the corridor, a warrior was painted. Above the door on the north wall were the portraits of the couple of the tomb occupants seated face to face, and on the top of the other seven sides were the scenes of the tales of the "Twenty-Four Paragons of Filial Piety" with ink-written inscriptions of "Guo Ju Burying His Son", "Wang Wuzi's Wife Cutting Flesh from Her Own Thigh (as remedy for curing her mother-in-law)", "Liu Mingda Selling His Son", "Dong Yong Sending back His Wife" and so on. The Jin tomb in Jiaozuo Power Plant was an imitation wooden structure tomb decorated with both brick carvings and murals. It was built in an unequal octagonal plan with a dome-shaped ceiling; the dados of the tomb chamber walls were built into moldings in Sumeru Base shape, over which engaged pillars, tie-beams and dougong-bracket sets with one step extension were built out with carved and painted bricks. The bracket sets were decorated with red and white colors, the spaces in the gaps between which were decorated with cloud pattern and intertwined peonies and that above the eave purlins were decorated with cloud patterns; on the northeast and northwest parts, a flying crane was painted. The walls of the tomb chamber were all decorated with brick carvings: the east and west walls were six latticed door leaves with four rails, the central two leaves of which were open ajar by a woman looking outward; on the southeast and southwest walls, simulated windows with vertical grill were built; on each of the northwest and northeast walls, an embossed flower vase stand was carved, on which vases with flowers in it was painted. On the north

wall were three bas-reliefs of "Paragons of Filial Piety" tale scenes composed of brick carvings. In addition, mural tombs of the Jin Dynasty were also found in Yuzhou, Xinxiang and Luoyang; all of these tombs were in octagonal plan and the walls of most of them were decorated with brick latticed door leaves with four rails. The one found at Pojie, Yuzhou City had dancing lions and maids holding stuff painted beside the latticed doors, on the southwest and southeast walls were the "Scene of Saddling Horse" and "Preparing Banquet in Front Hall". The assemblage of brick carvings and murals made the tomb chamber more lavish and brilliant and showed a unique style [37].

Some mural tombs of the Yuan Dynasty have also been excavated in Henan; the imitation wooden structure popular in the Song and Jin Dynasties was simplified greatly in them. Generally, these mural tombs could be classified into two types: one was in octagonal plan with a dome-shaped ceiling as a yurt, all of the walls of which were coated with lime plaster as the mural base, and human figures were painted with various colors. Feng Sanweng's tomb found at Laowanzhuang in Jiaozuo City had well-preserved murals: in the middle of the north wall was the portrait of the tomb occupant, and on each of the other walls, a servant or maid was painted; the servants were holding fan or seal and the maids were holding zither or towel in the hands, all standing solemnly. In this tomb, a bronze "contract tally" was unearthed, the dates on which was "the 22nd day of the tenth month of the year of wuwu戊午"; the excavators thought that this "year of wuwu" would be one of the two years of wuwu of the Jin Dynasty, which were 1138 and 1198 CE; however, some scholars suggested that this year of wuwu would be the eighth year of Emperor Xianzong of the Yuan Dynasty, which was 1258 CE [38]. The mural tomb found at Wangshang Village in Dengfeng City was also an octagonal single-chamber tomb with a piece of mural on each wall, which were separated from each other with brownish-red strips, and every piece of mural was 1.2 m high and 1.05 m wide. Among them, the one on the north wall was a bird-and-flower scene with a blossoming plum tree, bamboos and a double of peacocks; the ones on the northeast and northwest walls were bamboos and three cranes; on the east wall was a scene of two Taoist hermits "discussing scriptures"; on the west wall was the scene of "ascending fairyland"; on the southeast and southwest walls were three attending maids; on the east and west walls of the corridor, a servant was painted. The ceiling of the tomb chamber was decorated with auspicious clouds and flying cranes. The lines of these murals are fine and smooth and the tints are applied properly, showing high artistic value [39].

The other type was in rectangular plan with a vaulted ceiling, and the walls were decorated with color-painted murals. In one case of this type found at Yuandong in Yichuan County, the portraits of the couple of the tomb occupants seated across the table were painted on the north wall, on the east and west walls were scenes of music performance and offering ceremony and flanking the entrance on the south wall, two door guards were painted. The ceiling of this tomb was painted with peonies, auspicious clouds and flying cranes. In total, there were 22 human figures painted in the murals of this tomb, some of which were in costumes bearing clear Mongolian features [40].

Another mural tomb of the Yuan Dynasty found at Houda Village in Weishi County had the niche of "the God of Land (or Soil)" in the center of the back wall, flanking which were the portraits of the tomb occupant couple seated abreast; in the center of the east wall, the niche of "East Granary" was set, flanking which were the scenes of the "Paragons of Filial Piety" tale and "levying grains into granary"; in the center of the west wall, the niche of "West Treasury" was set, flanking which were the scenes of two "Paragons of Filial Piety" tales. Above the imitation dougong-bracket sets were six figures of flying apsaras; on the ceiling were twelve square frames, in which floral designs such as chrysanthemum and lotus were painted. Because only one pottery urn and three bronze coins of the Northern Song Dynasty were unearthed from this tomb, the excavators have suggested that it was a tomb of the Song Dynasty [41]. However, referring to the tomb structure, the layout of the murals, the imitation wooden structure, the costumes of the human figures in the murals, the inscriptions on the tomb entrance and so on, the researchers verified the date of this tomb as the Yuan Dynasty [42], which is more convincing.

7. The Murals of the Ming Dynasty

Relatively fewer murals of the Ming Dynasty have been found so far; only two of them are published. The joint tomb of Commandery Prince Wenmu (whose personal name was Zhu Zhaolun) of Yuanwu Prefecture and his first wife was located

to the southeast of Wawusun Village, Xingyang City. It was a brick single-chamber tomb in rectangular plan, the north, east and west walls of which were decorated with color murals. In the middle of the north wall was a standing Sakyamuni Buddha image flanked by four Dharma-protecting birds, below which are sea waves. On the east and west walls were Sakyamuni Buddha seated with legs crossed on the lotus platform, in the nimbus behind whom were five human figures including the tomb occupant couple and their relatives. To the left of Buddha were two lines of bodhisattvas and arhats facing him; in the auspicious clouds over them, halls, pavilions and flying cranes could be seen. The sun, the moon and celestial bodies were painted on the ceiling of the tomb chamber. In this tomb, two sets of stone epitaphs were unearthed: one was that of Commandery Prince Wenmu of Yuanwu Prefecture entitled by the Ming court and the other was that of Commandery Princess Zhang who was the first wife of Commandery Prince Wenmu. [43] Commandery Prince Wenmu, whose name was Zhu Zhaolun, was a direct descendant of the fifth son of Emperor Taizu (the founding emperor) of the Ming Dynasty and the sixth generation of Commandery Prince of Yuanwu Prefecture; he was born in the 31st year of Jiajing Era (1552 CE) and died in the 35th year of Wanli Era (1607 CE). The themes of the murals in this tomb are mainly that of Buddhism; the compositions are compact and even and the arrangement of human figures and background landscapes are appropriate, all of which showing high artistic value. Li Biao's tomb (built in Jiajing Era of the Ming Dynasty, around 1522-1531CE) located in Ludian Township, Dengfeng City, which was also a single-chamber tomb with vaulted ceiling, had murals painted on the four walls and two sides of the entrance; on each of the outer sides of the entrance, a vase with flower bundle was painted and on each of the inner sides, a maid holding stuff is painted. On the north wall of the tomb chamber, the main hall was painted, in which were the portraits of the tomb occupant couple; on the east and west walls were the side rooms, in which were two servants or maids preparing for banquet or tea; on the ceiling, the sun was painted on the east and the moon was painted on the west, implying that this was the sky.[44] All of the murals were painted with bright colors and the figures in them were depicted vivid, composing a complete home life scene which expressed the longing for the life in this world.

References

[1] Yang Jianfang. 1982. The Discovery of the Murals before the Han Dynasty. Meishu Jia (Artists) , 29.

[2] The Luoyang Archaeological Team, IOA. 1959. Excavation of a Warring-States Tomb in the Western Suburb of Luoyang. Kaogu (Archaeology) , 12: 653-667.

[3] The Archaeological team, Bureau of Culture, Honan Province. 1964. Excavations of a Western Han Tomb with Wall Paintings at Loyang. Kaogu Xuebao (Acta Archaeologica Sinica), 2: 107-125.

[4] Museum of the City of Loyang. 1977. Excavation of the Western Han Tomb of Pu Ch'ien-ch'iu with Wall Paintings at Loyang. Wenwu (Cultural Relics), 6: 1-12.

[5] Tang Chi [tr]. 1986. Murals of the Han Dynasty from Luoyang Collected in Boston, United States. Dangdai Meishujia (Contemporary Artists), 3.

[6] The Second Team of Archaeology of Luoyang City. 1993. Excavation of the Tomb with Murals of Western Han Dynasty at Qianjingtou in Luoyang City. Wenwu, 5: 1-17.

[7] Shen Tianying. 2005. A Set of Painted Hollow Bricks of the Han Dynasty Unearthed from Luoyang. Wenwu, 3: 76-80.

[8] The Second Team of Archaeology of Luoyang City. 1987. Excavation of Xi Han Tomb of Jinguyuan in Luoyang. Zhongyuan Wenwu (Cultural Relics in Central China), 3: 27-30.

[9] The Second Team of Archaeology of Luoyang City. 1992. Excavation of the Tomb with Murals of Xin Dynasty (Wang Mang Period) in Yanshi County, Henan. Wenwu, 12: 1-14.

[10] Shangqiu Municipal Committee for Preservation of Ancient Monuments, et al. 2001. Prince of the State of Liang's

Mausoleums of the Western Han at Mount Mangdang. Beijing: Cultural Relics Press.

[11] Luoyang Municipal Archaeological Team. 2002. Excavation of Han Tombs at Iron Pagoda Hill, Xin'an County. Wenwu, 5: 33-8.

[12] Huang Minglan, Guo Yinqiang. 1996. Murals from Han Tombs at Luoyang. Beijing: Cultural Relics Press.

[13] Second Henan Archaeological Team, IA, CASS. 1985. Excavation of a [sic] Eastern Han Tomb with Mural Paintings at Xingyuan Village, Yanshi, Henan. Kaogu, 1: 18-22.

[14] Luoyang Municipal Archaeological Team. 1991. A Painted Tomb of the Eastern Han in the Northern Suburbs of Luoyang City, Henan. Kaogu, 8: 713-721, 768.

[15] Luoyang Municipal Archaeological Team. 1992. Excavation of the Tomb with Murals of Eastern Han Dynasty at Luoyang Locomotive Factory. Wenwu 3: 27-34.

[16] The Second Team of Archaeology of Luoyang City. 1992. Excavation of the Tomb with Murals of Eastern Han Dynasty at Zhucun in Luoyang City. Wenwu, 12: 15-20.

[17] Henan Provincial Institute of Cultural Relics and Archaeology. 1993. Han Dynasty Tombs at Dahuting Village in Mixian County. Beijing: Cultural Relics Press.

[18] Henan Provincial Institute of Cultural Relics and Archaeology. 1987. Excavation of a Han Dynasty Pictorial-stone-decorated Tombs (sic) at Houshiguo in Mixian County. Huaxia Kaogu (Huaxia Archaeology), 2: 96-159.

[19] Zhengzhou Municipal Institute of Cultural Relics and Archaeology, et al. 1996. A Han Dynasty Tomb Containing Mural Paintings Discovered at Xingyang, Henan. Wenwu, 3: 18-27, 97-98.

[20] The Luoyang Museum. 1974. Excavation of the Northern Wei Tomb of Yüan Yi in Loyang, Honan Province. Wenwu, 12: 53-55.

[21] Zhu Liang, et al. 1995. Excavation of a Mural Tomb of the Northern Wei Dynasty at Belchen Village, Mengjin, Luoyang. Wenwu, 8: 26-35.

[22] Wang Che, Chen Xu. 1974. The Star Map Found in the Northern Wei Tomb in Loyang. Wenwu, 12: 56-60.

[23] Fang Xiaolian, et al. 1995. Excavation of the Tomb of a Tang Royal Concubine. Wenwu, 8: 37-51.

[24] Forthcoming data.

[25] No. 2 Work Team of Cultural Relics in Luoyang. 2005. Excavations of the Tombs of the Concubines of Surname Tang and Cui of King Anguoxiang of Tang Dynasty. Zhongyuan Wenwu, 6: 19-36.

[26] Henan Provincial Institute of Cultural Relics and Archaeology. 1997. Imperial Tombs of the Northern Song Dynasty. Zhengzhou: Zhongzhou Guji Chubanshe.

[27] No. 1 Archaeological team, Bureau of Culture, Henan Province. 1958. A Brick-chamber Tomb of the Northern Song Dynasty to the South of the Southern Gate of Zhengzhou City. Wenwu, 5: 52-54.

[28] Henan Provincial Bureau of Culture. 1954. Henan Provincial Bureau of Culture Investigates a Tomb of the Song Dynasty at Tianxi Township, Anyang. Wenwu, 8: 143-146.

[29] Zhengzhou Municipal Institute of Antiquity and Archaeology, Denfeng Municipal Bureau of Antiquity. 2001. The Song Period Mural Tomb at Heishangou, Dengfeng, Henan Province. Wenwu, 10: 60-66.

[30] Su Bai. 1957. Brief Description of the Three Sung Dynasty Tombs Excavated at Pai-sha. Beijing: Cultural Relics Press.

[31] Zhengzhou Municipal Institute of Cultural Relics and Archaeology. 2005. A Mural Tomb of the Song Dynasty at Pingmo, Xinmi. in: Song-Jin Period Mural Tombs in Zhengzhou. Beijing: Science Press. 41-54.

[32] Ye Wansong, Yu Fuwei. 1986. Two Song Tombs in Shisili Village, Xin'an County. in: Yearbook of Chinese Archaeology, 1985. Beijing: Cultural Relics Press. 173.

[33] CPAM, Gongxian County, Zhengzhou Municipal Archaeological Team. 1988. Excavation of a Sarcophagus Tomb of the Song Dynasty at Xicun Village, Gongxian County. Zhongyuan Wenwu, 1: 34-36.

[34] Sanmenxia Municipal Archaeological Team. 1993. Excavation of Northern Song Tombs in Sanmenxia City. Huaxia

Kaogu, 2: 59-69.

[35] Zhang Zengwu. 1998. Excavation of a Jin Tomb in Linxian County, Henan. Huaxia Kaogu, 2: 35-53.

[36] Jiaozuo Municipal Archaeological Team. 1990. Excavation of a Tomb of the Jin Dynasty at Jiaozuo Power Plant. Zhongyuan Wenwu, 4: 97-101.

[37] Henan Provincial Institute of Cultural Relics and Archaeology, CPAM, Yuzhou City. 1990. Excavation of a Tomb with Murals of the Jin Dynasty at Pojie, Yuzhou City. Zhongyuan Wenwu, 4: 102-108.

[38] The Henan Museum, the Municipal Museum of Jiaozuo. 1980. Excavation of the Mural-tomb of the Jin Dynasty (1115-1234) at Jiaozuo. Henan Wenbo Tongxun (News Report of the Henan Historical Relics) 4: 1-6. Institute of Archaeology, Chinese Academy of Social Sciences [ed]. 1984. Archaeological Excavation and Researches in New China. Beijing: Cultural Relics Press. 607.

[39] Zhengzhou Archaeological Team. 1994. Excavation of the Tomb with Wall Painting at Wangshang in Dengfeng. Wenwu, 10: 4-9.

[40] No. 2 Work Team of Cultural Relics in Luoyang. 1993. Excavations of the Tombs of the Yuan Dynasty at Yichuan County, Luoyang. Wenwu, 5: 40-44.

[41] Liu Chunying, et al. 2006. Excavation of a Song Period Tomb at Zhangshi Town in Weishi County, Henan. Huaxia Kaogu 3: 13-8.

[42] Liu Wei. 2007. Notes on the Murals in the Yuan Dynasty Tomb in Weishi County. Gugong Bowuyuan Yuankan (Palace Museum Journal), 3: 40-52.

[43] The Museum of Zhengzhou City. 1984. Ming Tomb Containing Wall Paintings of Prince Mu-Yuan Wuwen Discovered at Ershilipu in Xingyang. Zhongyuan Wenwu , 4: 25-26.

[44] Zhengzhou Municipal Institute of Cultural Relics and Archaeology, Dengfeng Municipal Cultural Relics Bureau. 1999. A Fresco Tomb of the Ming Dynasty Found at Ludian, Dengfeng. Zhongyuan Wenwu, 4: 11-17.

目 录 CONTENTS

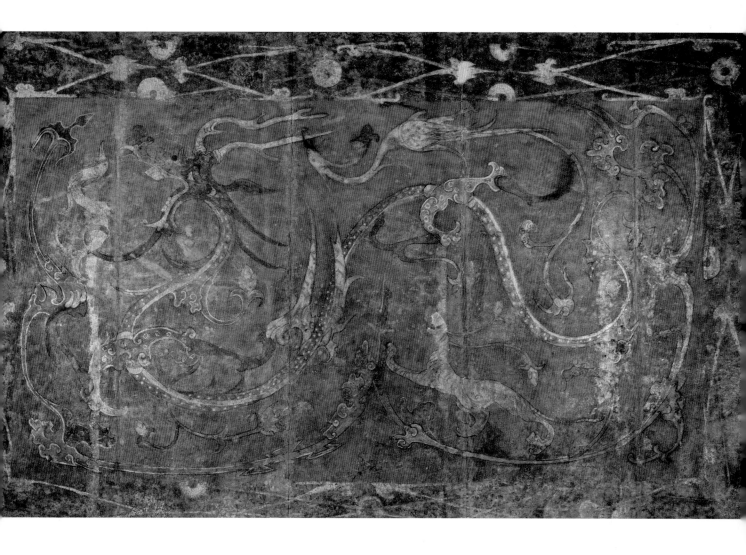

1.青龙壁画

西汉（前206～25年）

高350、宽550厘米

1987年河南省永城县芒砀山柿园汉墓出土。现存于河南博物院。

该墓为西北向。位于墓前室顶部。为巨幅青龙图像，画幅四周为灰色边框，框内以白色绘菱格穿璧纹。中部绘一条巨龙，头左尾右，呈连续的横S形。龙首有双角，张巨口，露出白色牙齿，头后飘动着长须，脊部绘出红色和白色斑纹，有四足与双翼。青龙上部有朱雀，尖喙衔龙角，长尾。身下有白虎，爪蹬流云，口衔仙草，作跨步行进状。还有一小龙，作向上游动状。另外周边有数组飘浮的彩云。

（撰文、摄影：蔡全法）

Green Dragon

Western Han (206 BCE-25 CE)

Height 300 cm; Width 550 cm

Unearthed from Han tomb at Shiyuan of Mangdangshan in Yongcheng, Henan, in 1978. Preserved on the original site.

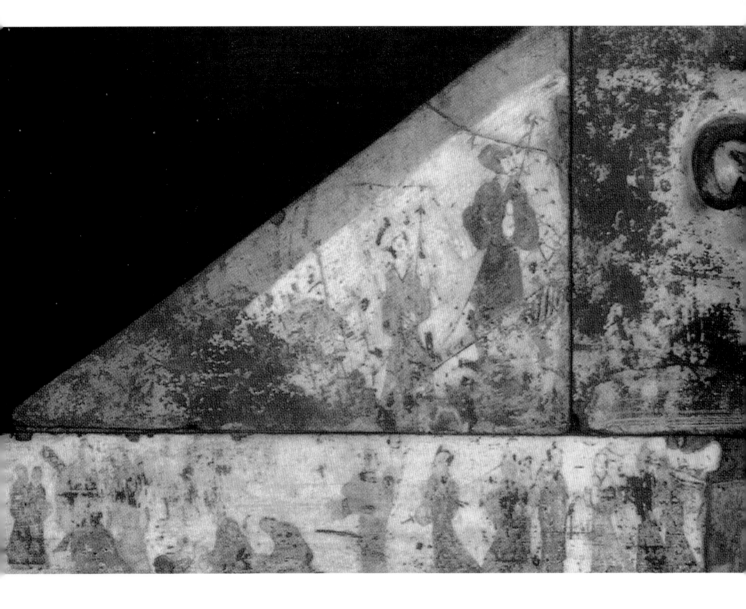

2.前山墙壁画全图

西汉（前206～25年）

高73.8、长240.7厘米

据传1916年在河南省"洛阳八里台"汉墓盗掘出土，后人考证当在洛阳烧沟和火车站一带。现存于美国波士顿美术馆。

位于墓室前山墙上，壁面呈盝顶形，上中部绘一羊首，左侧绘三男者，身后似蹲一动物。右侧绘三个男者，身后似蹲一熊。下部横幅绘有众多人物，有跪拜、有行进、还有交谈状者。

（撰文：蔡全法 摄影：周立、高虎）

Door Lintel and Pediment of a Hollow Brick Tomb

Western Han (206 BCE-25 CE)

Height 73.8 cm; Width 240.7 cm

Said to be resurrected from tomb at Balitai in Luoyang, Henan, in 1916. Based on textual research, it should be from the region around Shaogou and railway station of Luoyang. Preserved in Museum of Fine Arts in Boston, USA.

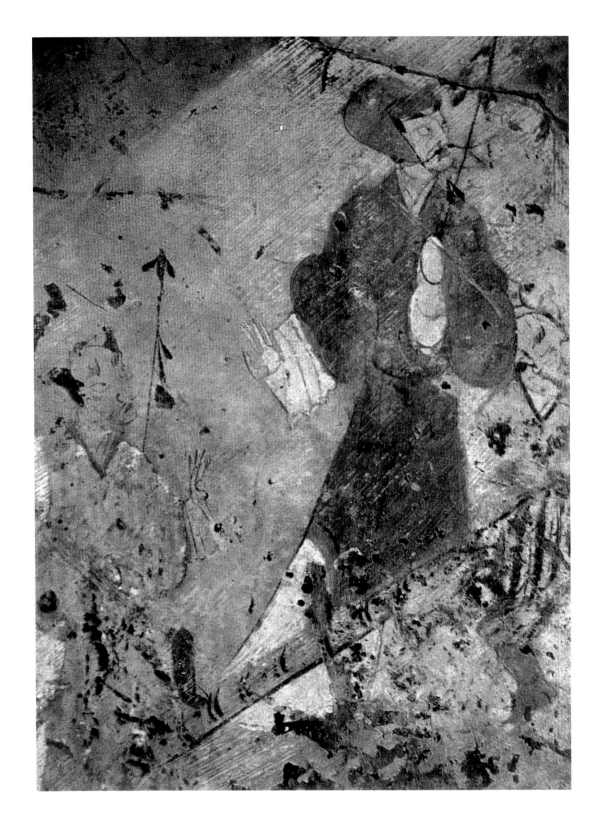

3.持节人物图

西汉（前206～25年）

传1916年河南省"洛阳八里台"汉墓出土。现存于美国波士顿美术馆。

位于墓室前山墙的左侧。右边为一男吏，头戴武冠，左手持节前视；着右衽袍、白裤。其后另一男吏，头梳双髻，长眉，八字须，侧目前视；身着素袍，脚蹬黑色长筒靴，右手持节，左手扬掌前伸，似拾梯而上。其右者袖后一人，正直视右前方。

（撰文：蔡全法　摄影：美国波士顿美术馆）

Officials Holding Staff of Authority

Western Han (206 BCE-25 CE)
Said to be unearthed from Han tomb at Balitai of Luoyang, Henan, in 1916. Preserved in Museum of Fine Arts in Boston, USA.

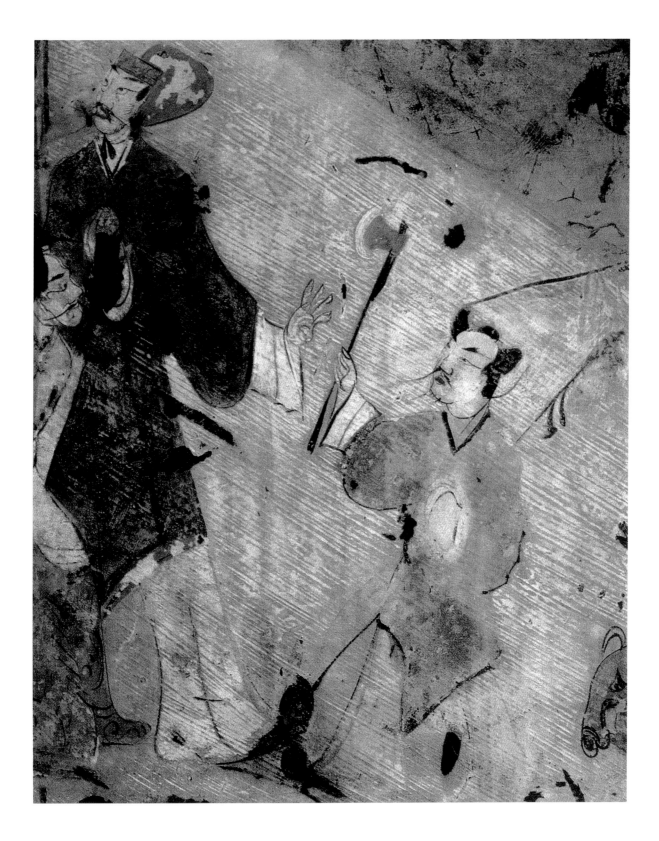

4.持斧人物图

西汉（前206～25年）

传1916年河南省"洛阳八里台"汉墓出土。现存于美国波士顿美术馆。位于墓室前山墙右侧。左侧一高大男吏，头戴武冠，着袍服，素色裤，右手放于胸前，左手伸指向右侧持斧人摆动示意。其右侧一人，半露身躯，素衣，穿长筒靴，怒视持斧人。右侧持斧人右手持斧，左手持节，跨步向前。

（撰文：蔡全法　摄影：美国波士顿美术馆）

Officials Holding Ax and Staff of Authority

Western Han (206 BCE-25 CE)
Said to be unearthed from Han tomb at Balitai of Luoyang, Henan, in 1916. Preserved in Museum of Fine Arts in Boston, USA.

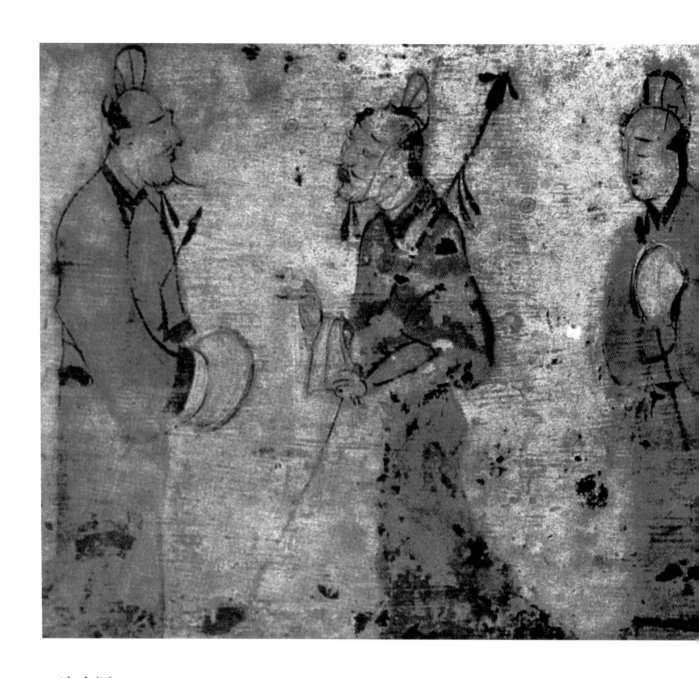

5.迎客图

西汉（前206~25年）

传1916年河南省"洛阳八里台"汉墓出土。现存于美国波士顿美术馆。

位于墓室前山墙下部横梁右侧。局部共五人，均戴小冠，着长袍，留胡须。左前一人，站立交袖，望着第二人。第二人持杖，似与第一人诉说什么。第三人作跟随状。第四人转身向后，与第五人相顾盼呼应。

（撰文：蔡全法 摄影：周立、高虎）

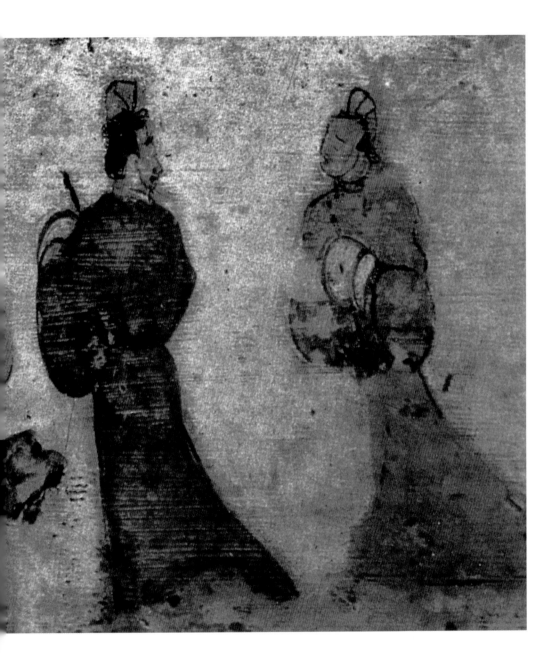

Greeting Guests

Western Han (206 BCE-25 CE)

Said to be unearthed from Han tomb at Balitai of Luoyang, Henan, in 1916. Preserved in Museum of Fine Arts in Boston, USA.

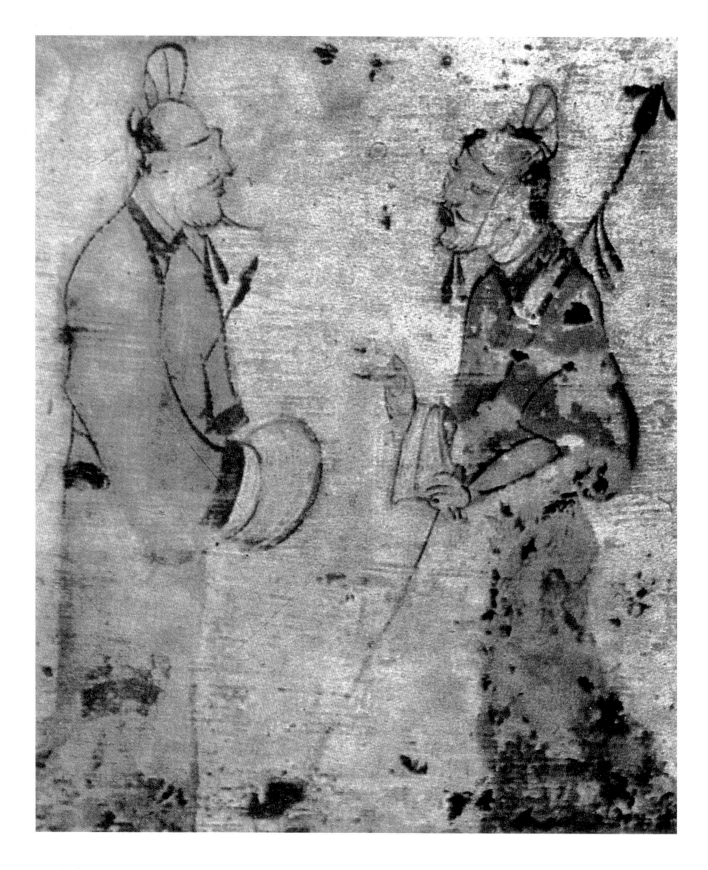

6. 迎客拜谒图

西汉（前206～25年）

传1916年河南省"洛阳八里台"汉墓出土。现存于美国波士顿美术馆。
位于墓室前山墙横梁右侧。画面为二男者，均戴小冠，着长袍，留长须。
二人相对站立，左者交袖恭立，右者持杖伸掌作询问状。

（撰文：蔡全法　摄影：美国波士顿美术馆）

Greeting Guests

Western Han (206 BCE-25 CE)

Said to be unearthed from Han tomb at Balitai of
Luoyang, Henan, in 1916. Preserved in Museum of
Fine Arts in Boston, USA.

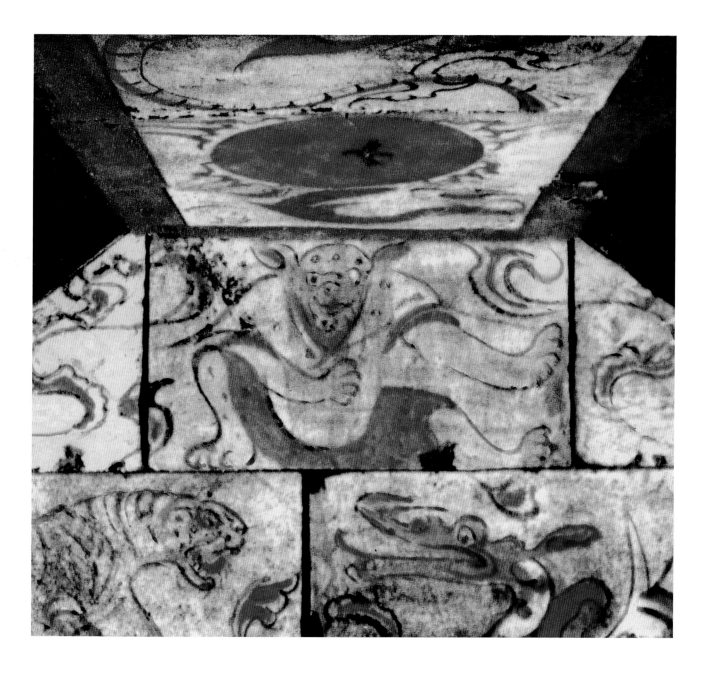

7. 方相氏、龙虎图

西汉（前206～25年）

1976年河南省洛阳市烧沟村西卜千秋墓出土。现存于洛阳古墓博物馆。

墓向100°。位于墓室后壁山墙正中。方相氏面似猪头，二目圆睁，上穿紫色短袖上衣，下着红色短裤，上肢舞动作推拿状。下部北侧绘一赤色青龙，南边绘一白虎。

（撰文、摄影：高虎）

Fangxiang Shi (Regional Inspector) and Dragon and Tiger

Western Han (206 BCE-25 CE)

Unearthed from Bu Qianqiu's tomb at Shaogoucun in Luoyang, Henan, in 1976. Preserved in Museum of Ancient Tombs in Luoyang.

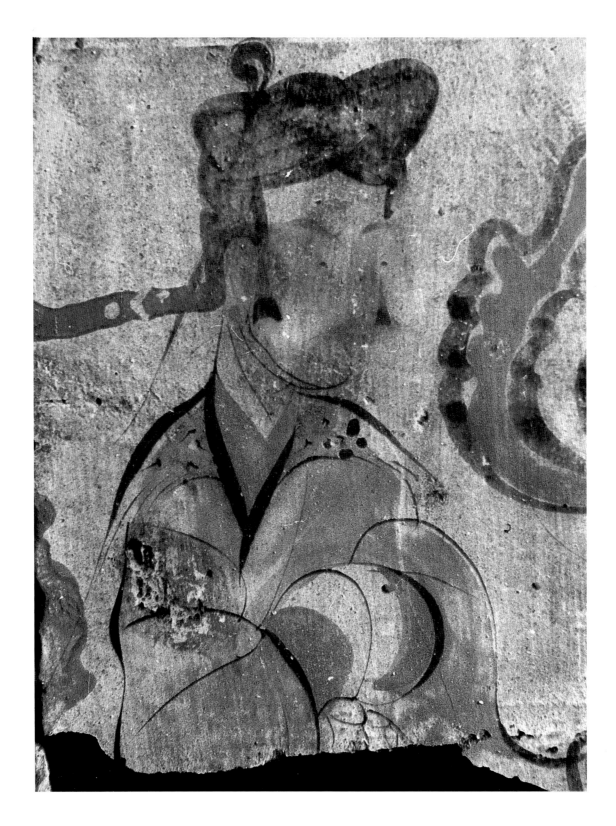

8.女娲图

西汉（前206～25年）

1976年河南省洛阳市烧沟村西卜千秋墓出土。现存于洛阳古墓博物馆。墓向100°。位于墓室顶脊。女娲人首蛇尾，头梳双角髻，上插云头簪，面目不甚清晰，柳叶眉，朱唇，两鬓垂长发，着右衽宽袖紫色衣，有绿色带毛垫肩，领、袖口为黑色，外露红色内衣领和袖口，侧身袖手，旁边有瑞云飘浮。

（撰文：史家珍 摄影：蔡孟轲）

Nüwa

Western Han (206 BCE-25 CE)
Unearthed from Bu Qianqiu's tomb at Shaogoucun in Luoyang, Henan, in 1976. Preserved in Museum of Ancient Tombs in Luoyang.

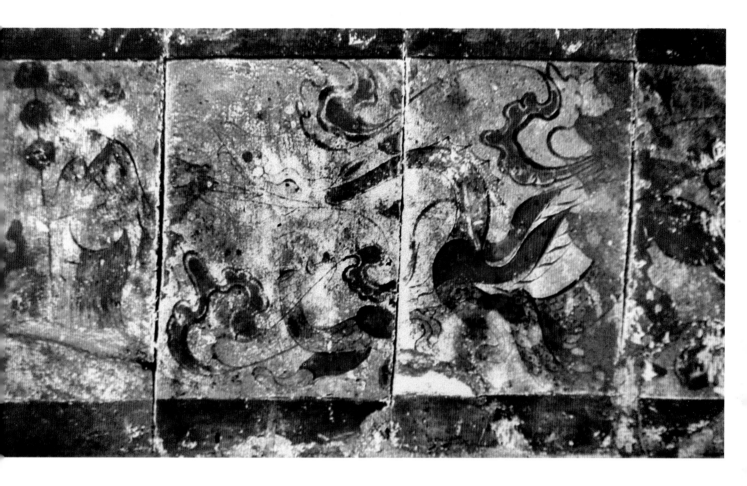

9.持节方士、双龙图

西汉（前206～25年）

1976年河南省洛阳市烧沟村西卜千秋墓出土。现存于洛阳古墓博物馆。

墓向100°。位于墓顶脊。左侧一方士披羽衣，着红裙，长发飘飞，双手持节于前，目视前方。方士身后有二条翼龙盘缠扭动，在云气中奔腾。

（撰文、摄影：高虎）

Double Dragons and Necromancer Holding Staff of Authority

Western Han (206 BCE-25 CE)

Unearthed from Bu Qianqiu's tomb at Shaogoucun in Luoyang, Henan, in 1976. Preserved in Museum of Ancient Tombs in Luoyang.

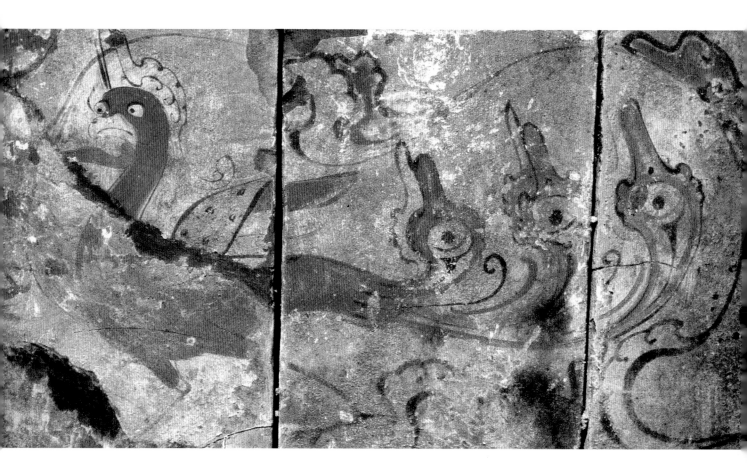

10.朱雀图

西汉（前206～25年）

1976年河南省洛阳市烧沟村西卜千秋墓出土。现存于洛阳古墓博物馆。

墓向100°。位于墓室顶脊部。所绘朱雀鹰头凤尾，顶有高冠，全身涂染朱色，紫色黑斑双羽，凤尾上卷似云朵状，墨色勾绘轮廓线，填朱，紫色并加点黑斑。周围有翻卷流动的彩云，作展翅飞翔状。

（撰文：史家珍 摄影：蔡孟轲）

Scarlet Bird

Han (206 BCE-25 CE)

Unearthed from Bu Qianqiu's tomb at Shaogoucun in Luoyang, Henan, in 1976. Preserved in Museum of Ancient Tombs in Luoyang.

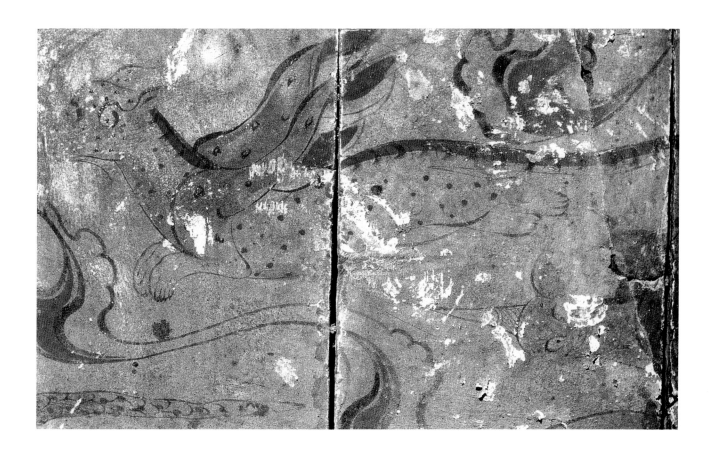

11.枭羊图

西汉（前206~25年）

1976年河南省洛阳市烧沟村西卜千秋墓出土。现存于洛阳古墓博物馆。

墓向100°。位于墓室顶脊部。画面绘枭羊两只，前者似麒麟而无角，头如羊，矮足，有紫色双翼和红色羽毛。脊染红色，并绘黑色斑纹。身躯晕染桔黄色，另点有红色斑纹。

（撰文：史家珍 摄影：蔡孟轲）

Owl-goat

Western Han (206 BCE-25 CE)

Unearthed from Bu Qianqiu's tomb at Shaogoucun in Luoyang, Henan, in 1976. Preserved in Museum of Ancient Tombs in Luoyang.

12. 白虎图

西汉（前206～25年）

1976年河南省洛阳市烧沟村西卜千秋墓出土。现存于洛阳古墓博物馆。

墓向100°。位于墓顶脊。白虎昂首张口，阔鼻瞪目。虎身饰褐色条纹，长尾。四肢腾起作奔跑状。

（撰文、摄影：高虎）

White Tiger

Western Han (206 BCE-25 CE)

Unearthed from Bu Qianqiu's tomb at Shaogoucun in Luoyang, Henan, in 1976. Preserved in Museum of Ancient Tombs in Luoyang.

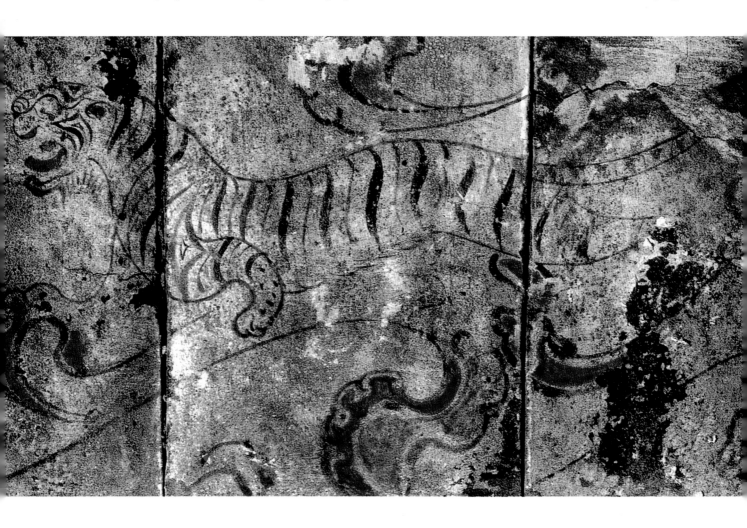

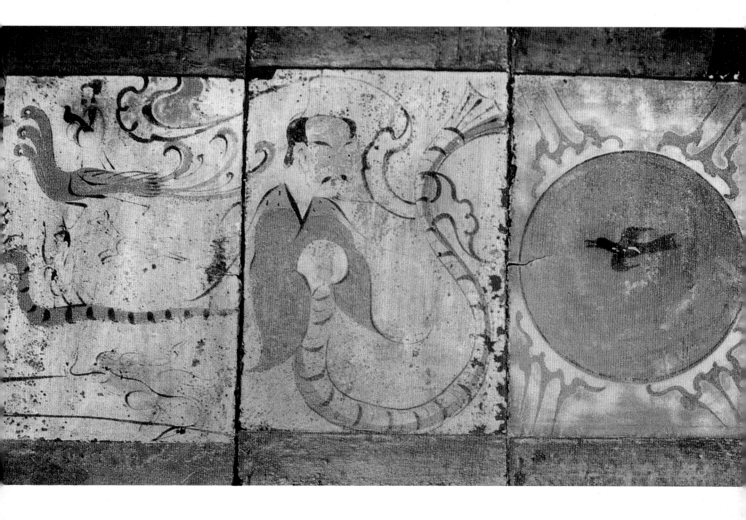

13.卜千秋夫妇升仙、伏羲、日轮图

西汉（前206～25年）

1976年河南省洛阳市烧沟村西卜千秋墓出土。现存于洛阳古墓博物馆。

墓向100°。位于墓室顶脊部。左上为女墓主乘三头鸟，手捧三足乌，面目不清晰；左下为男墓主乘舟形蛇，手持弓，闭目，后随奔一犬，旁有蟾蜍。中间为伏羲人首蛇尾，戴高冠，目威严。右侧为太阳圆形红色，内有疾飞的金乌，红绿光芒四射。

（撰文：史家珍 摄影：蔡孟轲）

Bu Qianqiu (the Tomb Occupant) and His Wife Ascending Fairyland, Fuxi, and the Sun

Western Han (206 BCE-25 CE)

Unearthed from Bu Qianqiu's tomb at Shaogoucun in Luoyang, Henan, in 1976. Preserved in Museum of Ancient Tombs in Luoyang.

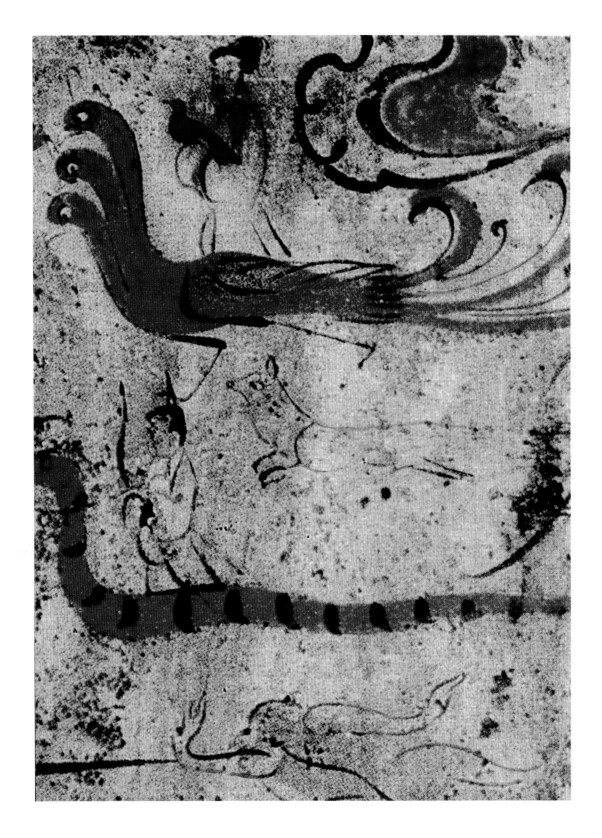

14. 卜千秋夫妇升仙

西汉（前206~25年）

1976年河南省洛阳市烧沟村西卜千秋墓出土。现存于洛阳古墓博物馆。

墓向100°。位于墓室顶脊部。上为女墓主乘三头鸟，手捧三足鸟，面目不清晰；下为男墓主乘舟形蛇，手持弓，闭目，后随奔一犬，旁有蟾蜍。

（撰文：史家珍 摄影：蔡孟轲）

Bu Qianqiu (the Tomb Occupant) and His Wife Ascending Fairyland

Western Han (206 BCE-25 CE)

Unearthed from Bu Qianqiu's tomb at Shaogoucun in Luoyang, Henan, in 1976. Preserved in Museum of Ancient Tombs in Luoyang.

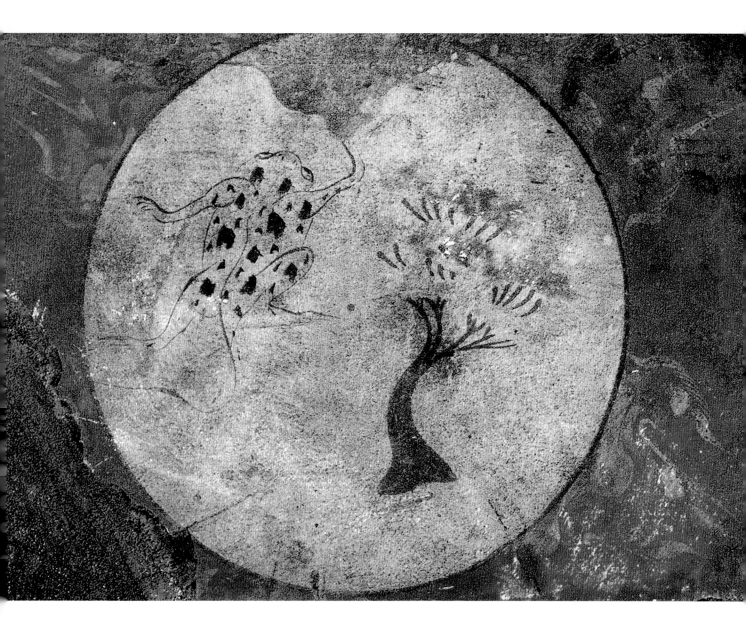

15. 月轮图

西汉（前206～25年）

1976年河南省洛阳市烧沟村西卜千秋墓出土。现存于洛阳古墓博物馆。

墓向100°。位于墓室顶脊部。圆规着墨绘出盈月，内绘蟾蜍和桂树，赭色绘树干，紫色平涂树叶，蟾蜍身有黑斑，外绘红绿气状光芒。

（撰文：史家珍 摄影：蔡孟轲）

Moon

Western Han (206 BCE-25 CE)

Unearthed from Bu Qianqiu's tomb at Shaogoucun in Luoyang, Henan, in 1976. Preserved in Museum of Ancient Tombs in Luoyang.

16. 伏兔图

西汉（前206～25年）

1976年河南省洛阳市烧沟村西卜千秋墓出土。现存于洛阳古墓博物馆。墓向100°。位于墓室顶脊部。画中绘一神兔嘴含仙草。兔圆头长耳，前腿和后腿扒立在山石上，弓背翘尾，作食草状。嘴旁用墨勾勒，加以红彩。仙草茎叶旺盛，斜伸上空，弯垂于兔脊之上。

（撰文：史家珍 摄影：蔡孟轲）

Squatting Rabbit

Western Han (206 BCE-25 CE)
Unearthed from Bu Qianqiu's tomb at Shaogoucun in Luoyang, Henan, in 1976. Preserved in Museum of Ancient Tombs in Luoyang.

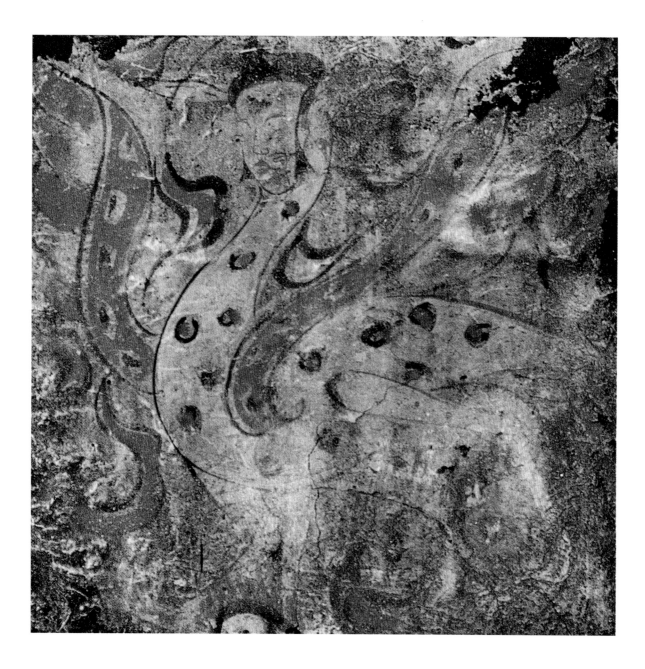

17. 勾芒图

西汉（前206～25年）

1976年河南省洛阳市烧沟村西卜千秋墓出土。现存于洛阳古墓博物馆。

墓向100°。位于墓门内上额。为东方之神勾芒图。勾芒人首鸟身，头绾髻，鬓垂长发，本为紫红色，上饰黑圈点红彩斑纹。长羽飞扬，双足作行进状。

（撰文：史家珍 摄影：蔡孟轲）

Goumang (the Spirit of the East)

Western Han (206 BCE-25 CE)

Unearthed from Bu Qianqiu's tomb at Shaogoucun in Luoyang, Henan, in 1976. Preserved in Museum of Ancient Tombs in Luoyang.

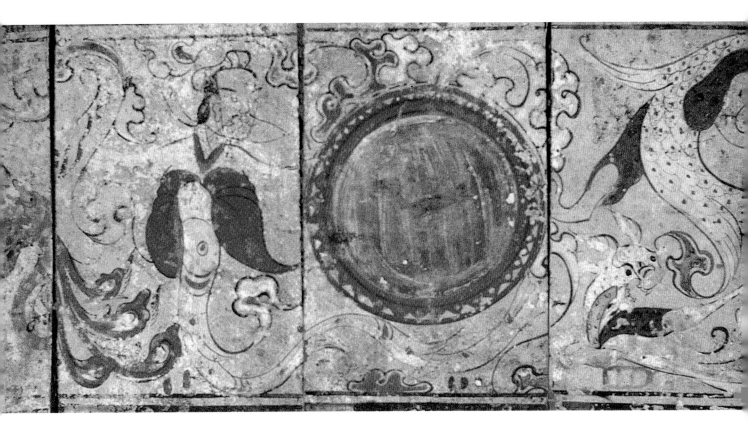

18.伏羲、太阳、白虎图（局部）

西汉（前206～25年）

1992年河南省洛阳市西郊浅井头汉墓出土。现存于洛阳古墓博物馆。

墓向190°。位于墓室顶脊部。共包括两部分：一是长卷天空景象，绘在十四块砖上；二是瑞云图，绘在七块砖上，紧连第一部分。该图是从南至北第二幅。伏羲：男身蛇躯，八字长须，头戴冠，肩有红披肩，点朱。太阳：赭色涂底，日中有一金乌，外缘涂朱，缀三角纹和圆点纹象征光芒。白虎：仅绘虎头，大耳、鼓目、昂首张口，黄色。

（撰文：史家珍 摄影：蔡孟轲）

Fuxi, the Sun and White Tiger (Detail)

Western Han (206 BCE-25 CE)

Unearthed from the Han tomb at Qianjingtou in western suburbs of Luoyang, Henan, in 1992. Preserved in Museum of Ancient Tombs in Luoyang.

19.羽人、朱雀图

西汉（前206～25年）

1992年河南省洛阳市西郊浅井头汉墓出土。现存于洛阳古墓博物馆。

墓向190°。位于墓室顶脊部。为瑞云图中第六幅。左为羽人图，羽人裸身，肩生双翼，长发后飘，双手前伸，立于一龙背上，作驾龙状。右为朱雀，鹰头凤尾，展翅飞翔，朱身绿翼，上加墨点，尾涂朱或绿色。

（撰文：史家珍 摄影：蔡孟轲）

Winged Immortal and Scarlet Bird

Western Han (206 BCE-25 CE)

Unearthed from the Han tomb at Qianjingtou in western suburbs of Luoyang, Henan, in 1992. Preserved in Museum of Ancient Tombs in Luoyang.

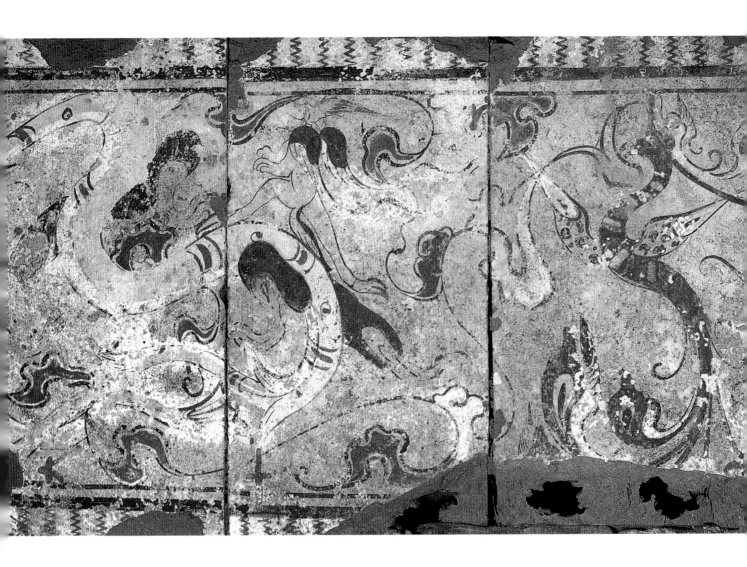

20.神人、月轮、女娲图

西汉（前206~25年）

1992年河南省洛阳市西郊浅井头汉墓出土。现存于洛阳古墓博物馆。

墓向190°。位于墓室顶脊部，为瑞云图由南至北第十幅。神人：人首龙驱，头戴冠，八字胡，绿色交领衣，有爪，龙身涂朱或红。月亮：双圈勾绘，外圈较粗，内圈较细，月中有蟾蜍、玉兔，均做跳跃状，涂红色。女娲人首蛇身，头戴冠，着交领红衫，黄色点绿。

（撰文：史家珍 摄影：蔡孟轲）

Dragon-bodied Immortal, the Moon and Nüwa

Western Han (206 BCE-25 CE)

Unearthed from the Han tomb at Qianjingtou in western suburbs of Luoyang, Henan, in 1992.
Preserved in Museum of Ancient Tombs in Luoyang.

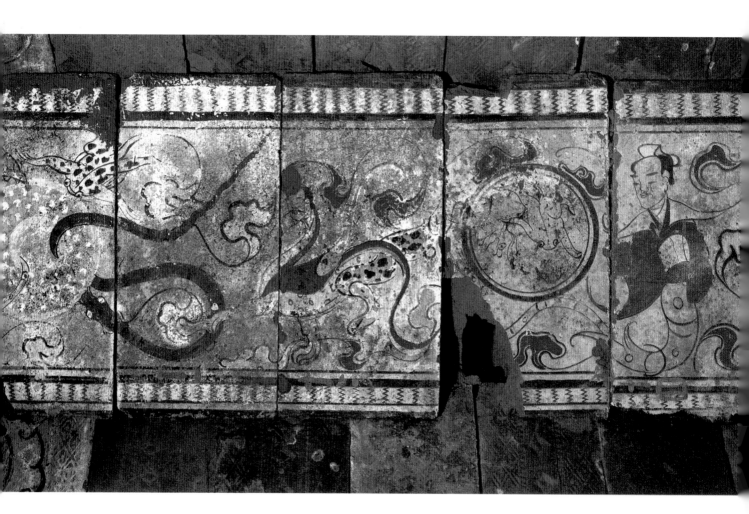

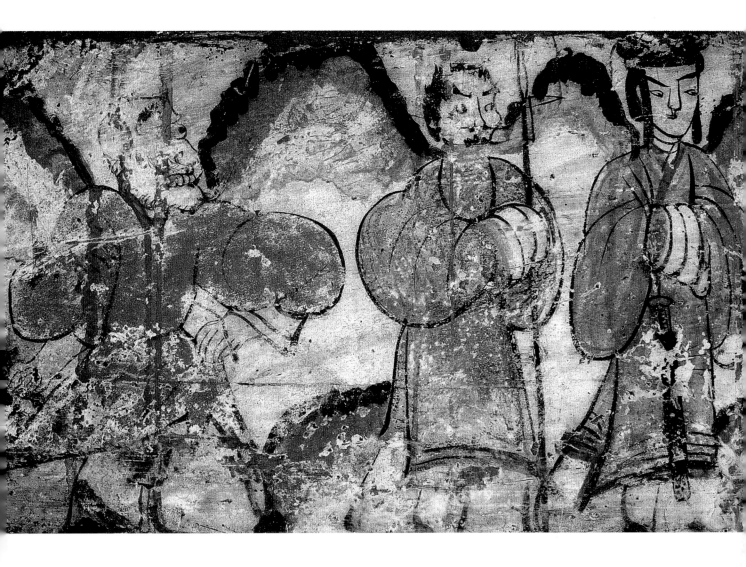

21.执戟持剑图

西汉（前206～25年）

1957年河南省洛阳市郊烧沟村61号墓出土。现存于洛阳古墓博物馆。

墓向100°。位于墓室后墙南段。图右侧一女子面部白皙，头梳双髻，鬓角垂发，身穿紫色长袍，下穿白裤，黑鞋。双手拱于胸前。中间一人留八字胡须，穿赭色长袍，黑鞋，双手执长戟拱于前胸。左侧一人秃发，浓眉圆眼，张口露齿，穿紫色长袍，白裤黑鞋，腰束带，左手叉腰，右手持短剑。

（撰文、摄影：高虎）

Attendants Holding Halberd and Sword

Western Han (206 BCE-25 CE)

Unearthed from Tomb 61 at Shaogoucun in Luoyang, Henan, in 1957. Preserved in Museum of Ancient Tombs in Luoyang.

22. 炙肉图（局部）

西汉（前206～25年）

1957年河南省洛阳市郊烧沟村东61号墓出土。现存于洛阳古墓博物馆。

墓向100°。位于墓室后墙北段。图中一人身紫色长袍跪坐在长方形四足烘烤炉边，手持长叉挑一牲正置于炉上灼烤。其身后一人面红发黑，穿紫衣褐裤，手持长叉，身体前倾，目盯所烤之肉。在白色墙上还悬挂着牛头、肉块等。

（撰文、摄影：高虎）

Roasting Meat (Detail)

Western Han (206 BCE-25 CE)

Unearthed from Tomb 61 at Shaogoucun in Luoyang, Henan, in 1957. Preserved in Museum of Ancient Tombs in Luoyang.

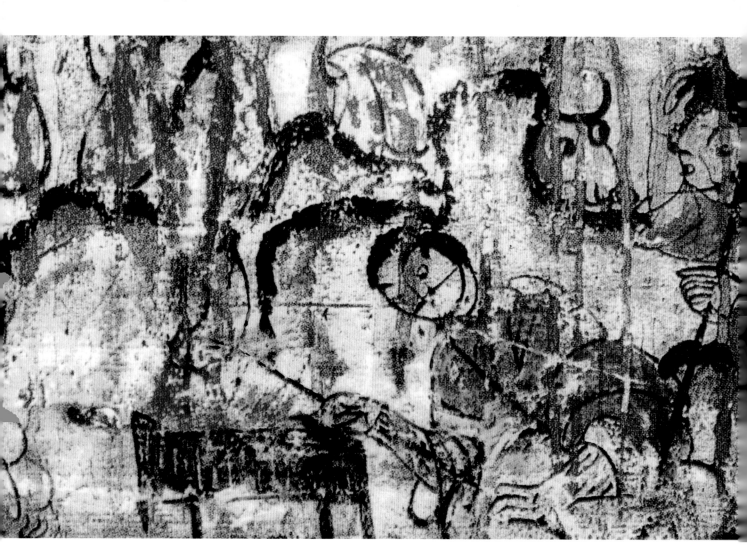

23. 大傩图

西汉（前206～25年）

1957年河南省洛阳市郊烧沟村东61号墓出土。现存于洛阳古墓博物馆。

墓向100°。位于前堂后室隔梁前壁。大傩图绘于由一块方形和两块三角形组成的梯形镂空图案的空心砖上。图正中一方相氏面如怪兽，穿黄衣红裙，作推拿状。其上一人头戴冠，束红裙，似正在念咒语，应为大傩的指挥者中黄门。方相氏两边各有一人手持圆形物，当是大傩时的辰子所持带柄的鼓。两侧三角形中各有二穿熊皮衣的神人，一前一后争夺悬挂的玉璧。

（撰文、摄影：高虎）

Scene of Great Nuo (Exorcising Evils) Ceremony

Western Han (206 BCE-25 CE)

Unearthed from Tomb 61 at Shaogoucun in Luoyang, Henan, in 1957. Preserved in Museum of Ancient Tombs in Luoyang.

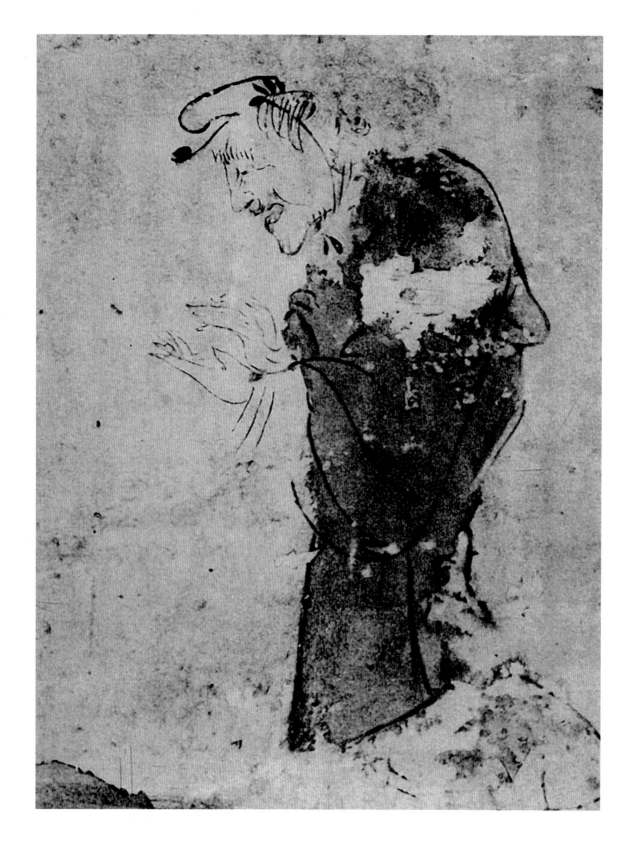

24.老者击掌图

西汉（前206～25年）

1957年河南省洛阳市郊烧沟村东61号墓出土。现存于洛阳古墓博物馆。墓向100°。位于墓室前堂后室的隔梁前壁。画面为老者，须发皆白，头围巾帻，插笄。长眉高鼻，眯着眼睛，张口，留有短须。身着宽袖长袍，躬身，双手相对扬起作鼓掌大笑状。

（撰文：史家珍 摄影：蔡孟轲）

Old Man Clapping Hands

Western Han (206 BCE-25 CE)
Unearthed from Tomb 61 at Shaogoucun in Luoyang, Henan, in 1957. Preserved in Museum of Ancient Tombs in Luoyang.

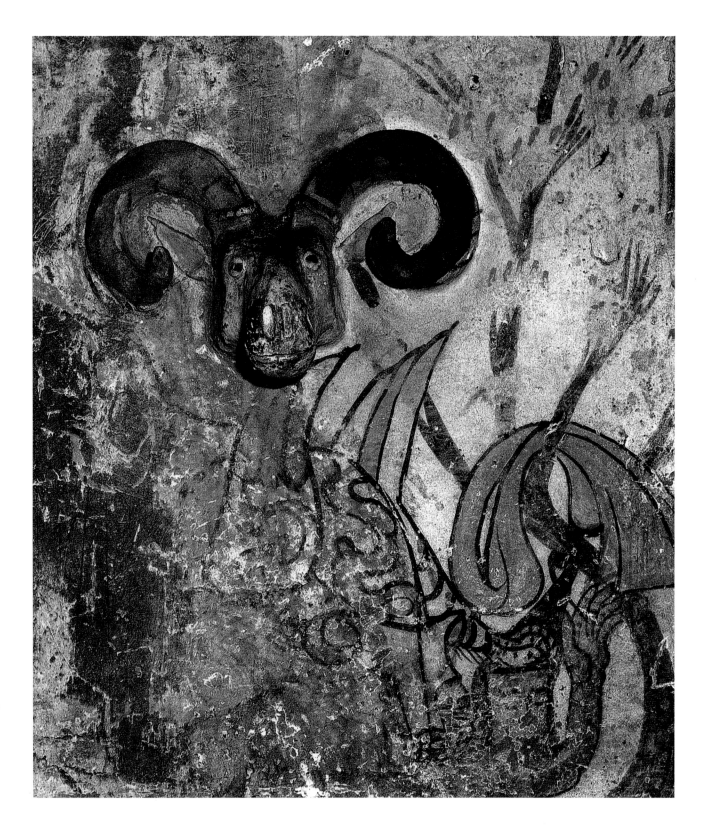

25.神虎食女魃图（局部）

西汉（前206～25年）

1957年河南省洛阳市郊烧沟村东61号墓出土。现存于洛阳古墓博物馆。墓向100°。位于墓门上额。高浮雕羊头下绘一女，裸露上体，肤色发紫，双目紧闭，长发悬挂于树上，树枝稀疏，叶呈红色，上飞一鸟，似不敢停落。树上挂一红衣，当为裸女之衣。裸女右边绘一猛虎，生双翼，前爪踏在裸女肩部，张口欲食。

（撰文：史家珍 摄影：蔡孟轲）

Spirit Tiger Eating Ba (Drought Evil) (Detail)

Western Han (206 BCE-25 CE)

Unearthed from Tomb at Shaogoucun in Luoyang, Henan, in 1957. Preserved in Museum of Ancient Tonbs in Luoyang.

26.对饮图（局部）

西汉（前206～25年）

1957年河南省洛阳市郊烧沟村东61号墓出土。现存于洛阳古墓博物馆。

墓向100°。位于墓室后室后山墙上。一人面左，赤足，跪踞，穿长衣，赭色袖口。一人回首右看，身穿赭色长衣，紫领边，紫袖口，白裤，赤足，左手执一弓状物，右手举物于前。

（撰文：史家珍　摄影：蔡孟轲）

Drinking (Detail)

Western Han (206 BCE-25 CE)

Unearthed from Tomb 61 at Shaogoucun in Luoyang, Henan, in 1957. Preserved in Museum of Ancient Tombs in Luoyang.

27.人首龙身神怪图

西汉（前206～25年）

高51、宽68.1～70.5厘米

2000年河南省新安县磁涧里河村砖厂汉墓出土。现存于洛阳博物馆。

位于三块空心砖上。神怪人首，头绾环形髻，两髻垂发，颈以下的龙身，并覆青鳞。腹、尾无鳞、紫背、青腹，双翼和四肢均为青色，昂胸屈颈，弓身作行进状。上侧绘有黄色流云，其左侧绘一青色玉璧。

（撰文：蔡强 摄影：洛阳古墓博物馆）

Mythical Being with Human Head and Dragon Body

Western Han (206 BCE-25 CE)

Height 51 cm; Width 68.1-70.5 cm

Unearthed from Han tomb at brickyard of Lihecun in Cijian of Xin'an, Henan, in 2000.
Preserved in Luoyang Museum.

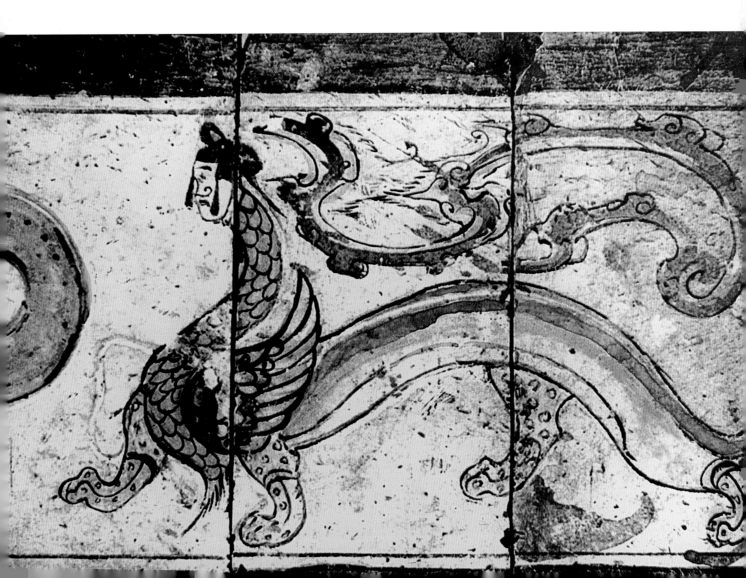

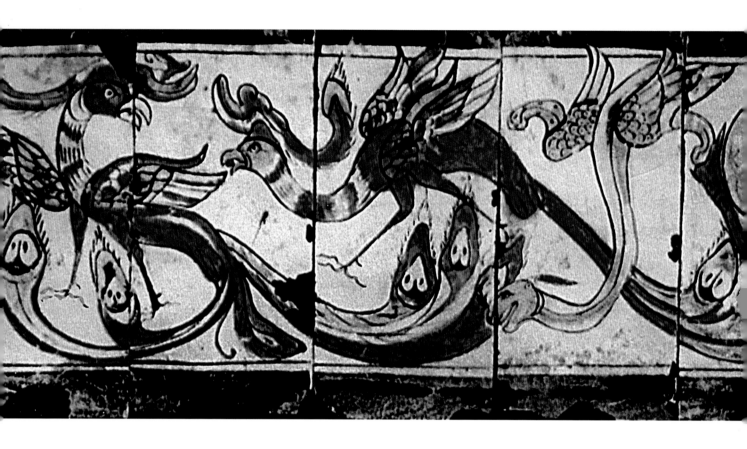

28.女娲月象图

西汉（前206～25年）

高51、宽204.3厘米

2000年河南省新安县磁涧里河村砖厂汉墓出土。现存于洛阳博物馆。

位于墓顶九块空心砖上。画面以女娲月象为中心，右侧绘有赤龙和黄龙，作盘缠相戏状。左侧绘二凤一凰，二凤在前作奔跑顾盼之态，尾随一凰，展翅紧追。整个画面充满动感，神秘而热烈。

（撰文：蔡强 摄影：洛阳古墓博物馆）

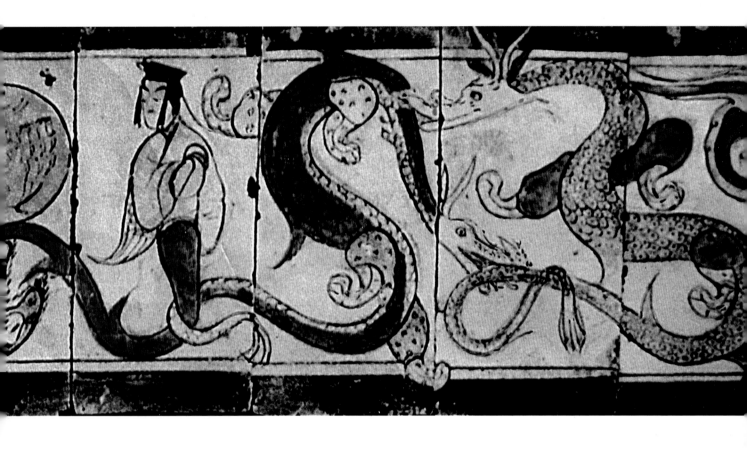

Nüwa, the Moon, Phoenix and Scuffling Dragons

Western Han (206 BCE-25 CE)

Height 51 cm; Width 204.3 cm

Unearthed from Han tomb at brickyard of Lihecun in Cijian of Xin'an, Henan, in 2000. Preserved in Luoyang Museum.

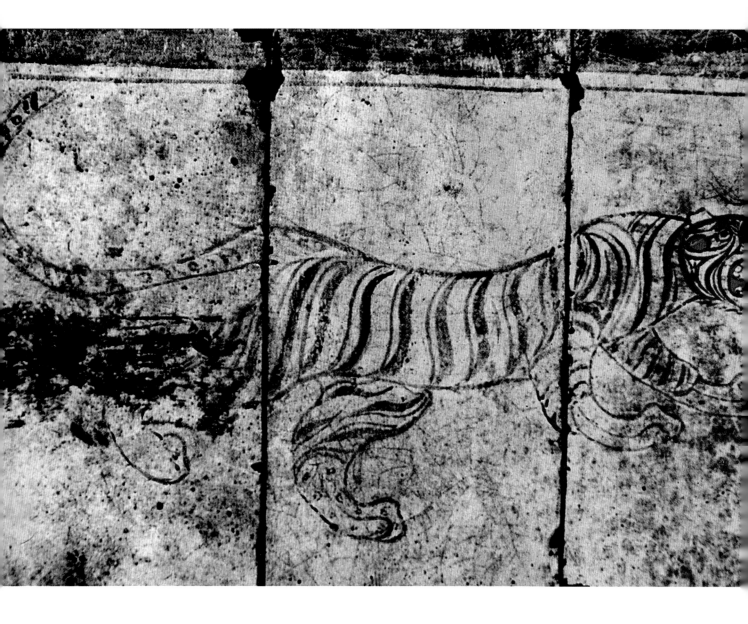

29. 白虎图

西汉（前206～25年）

高51、宽68.1～70.5厘米

2000年河南省新安县磁涧里河村砖厂汉墓出土。现存于洛阳博物馆。

位于墓顶三块空心砖上。白虎首张巨口，露出红舌白齿，虎须飘动，作长啸状。虎身绘黑白相间的条纹，长尾上卷，往前作欲扑状。

<div align="right">（撰文：蔡强　摄影：洛阳古墓博物馆）</div>

White Tiger

Western Han (206 BCE-25 CE)

Height 51 cm; Width 68.1-70.5 cm

Unearthed from Han tomb at brickyard of Lihecun in Cijian of Xin'an, Henan, in 2000. Preserved in Luoyang Museum.

30.伏羲日象图

西汉（前206～25年）

高51、宽68.1～70.5厘米

2000年河南省新安县磁涧里河村砖厂汉墓出土。现存于洛阳博物馆。

位于墓顶两块空心砖上。伏羲头戴冠，面目残损，漫漶不清，身着红色右衽宽袖袍服，肩生羽翼，拱手，露出青色内袖。下肢为青色蛇尾，在身左侧弯曲上卷。尾托一轮红日，内绘飞翔的金乌。

（撰文：蔡强 摄影：洛阳古墓博物馆）

Fuxi and the Sun

Western Han (206 BCE-25 CE)

Height 51 cm; Width 68.1-70.5 cm

Unearthed from Han tomb at brickyard of Lihecun in Cijian of Xin'an, Henan, in 2000. Preserved in Luoyang Museum.

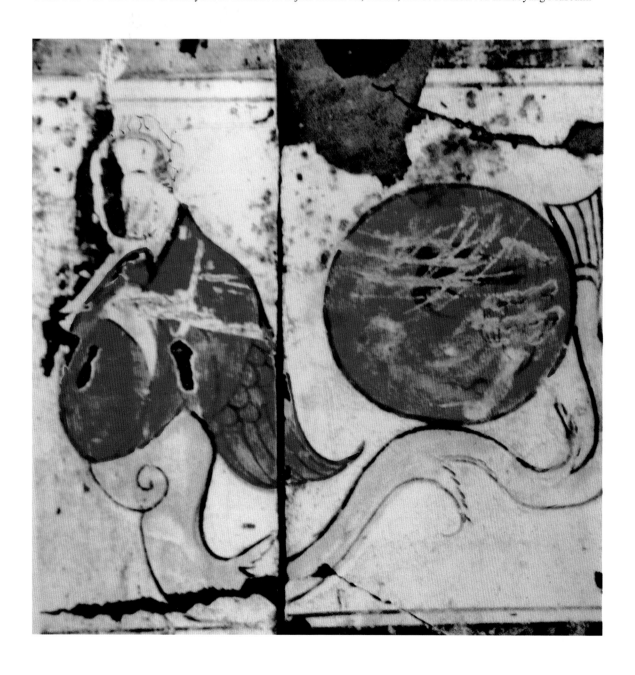

31.藻井日象图（局部）

新（9～23年）

1978年河南省洛阳市金谷园村汉墓出土。现存于洛阳古墓博物馆。

墓向135°。位于后室顶脊，由南向北第一幅。绘于三叠层藻井中，以红色绘出日轮，中间以黑彩描绘出金乌。藻井以单或双黑线绘出三层方框，并用红色勾出折线纹，外层三角处绘红色或紫色云气纹。

（撰文、摄影：高虎）

The Sun in the Center of Caisson Ceiling (Detail)

Xin (9-23 CE)

Unearthed from Han tomb at Jinguyuancun in Luoyang, Henan, in 1978. Preserved in the Museum of Ancient Tombs in Luoyang.

32.二龙穿璧图

新（9~23年）

1978年河南省洛阳市金谷园村汉墓出土。现存于洛阳古墓博物馆。

墓向135°。位于后室顶脊部，由南向北第二幅。图中上下左右绘有四个圆璧，上璧中有红穿，雌雄二龙身体盘绕各从左右圆璧中穿过，相对张口衔托上部圆璧。四周云气升腾。

<div align="right">（撰文、摄影：高虎）</div>

Double Dragon Intertwining through Bi-discs and Holding a Bi-disc with Mouths

Xin (9-23 CE)

Unearthed from Han tomb at Jinguyuancun in Luoyang, Henan, in 1978. Preserved in the Museum of Ancient Tombs in Luoyang.

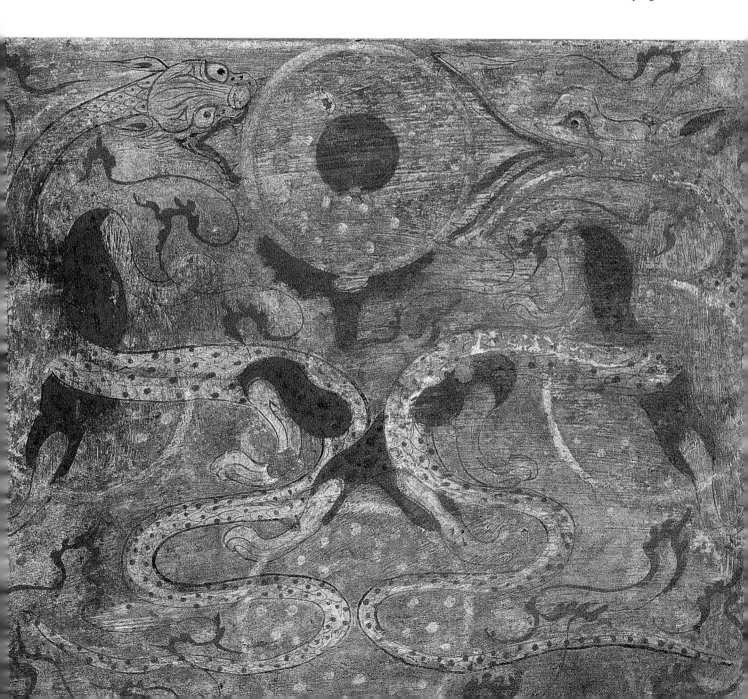

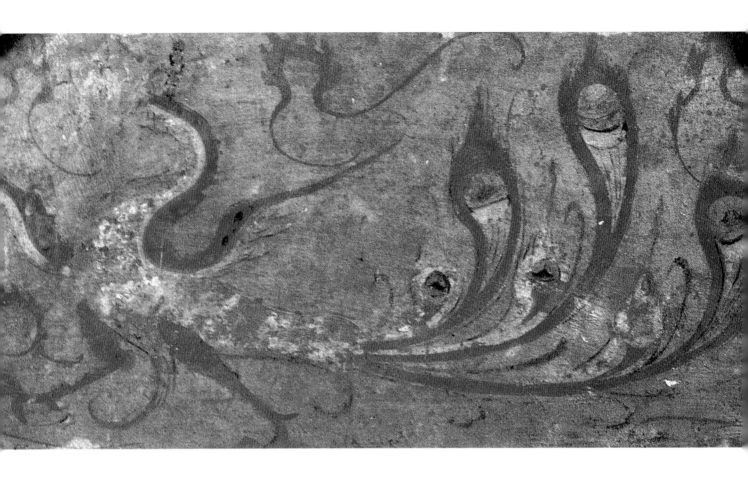

33.东方勾芒图

新（9~23年）

1978年河南省洛阳市金谷园村汉墓出土。现存于洛阳古墓博物馆。

墓向135°。位于后室东壁南部。图案作红、绿、黄、紫等色绘制。勾芒像人面鸟身，头戴冠（但漫漶不清），双翅振羽，凤尾上翘，作奔走状。

（撰文、摄影：高虎）

Goumang (the Spirit of the East)

Xin (9-23 CE)

Unearthed from Han tomb at Jinguyuancun in Luoyang, Henan, in 1978. Preserved in the Museum of Ancient Tombs in Luoyang.

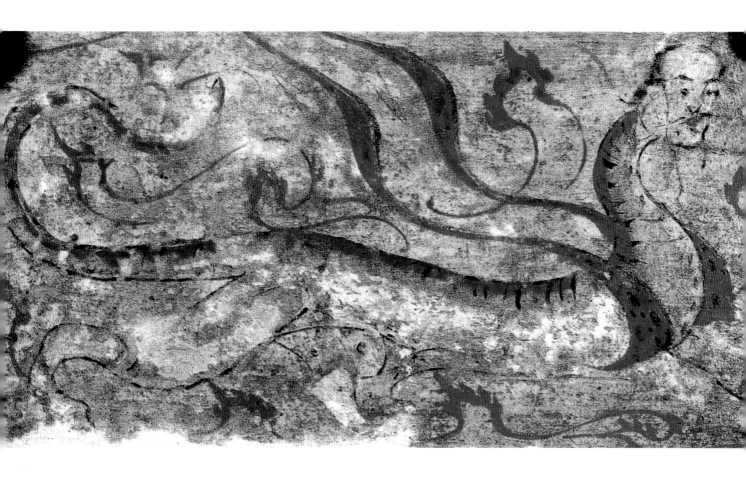

34.西方蓐收图

新（9～23年）

1978年河南省洛阳市金谷园村汉墓出土。现存于洛阳古墓博物馆。

墓向135°。位于后室东壁北部。蓐收像人面虎身，秃顶，粗眉，朱唇，八字胡须。身绘条形虎斑纹，双翅振羽，虎尾上翘，四爪作奔走状。

（撰文、摄影：高虎）

Rushou (the Spirit of the West)

Xin (9-23 CE)

Unearthed from Han tomb at Jinguyuancun in Luoyang, Henan, in 1978. Preserved in the Museum of Ancient Tombs in Luoyang.

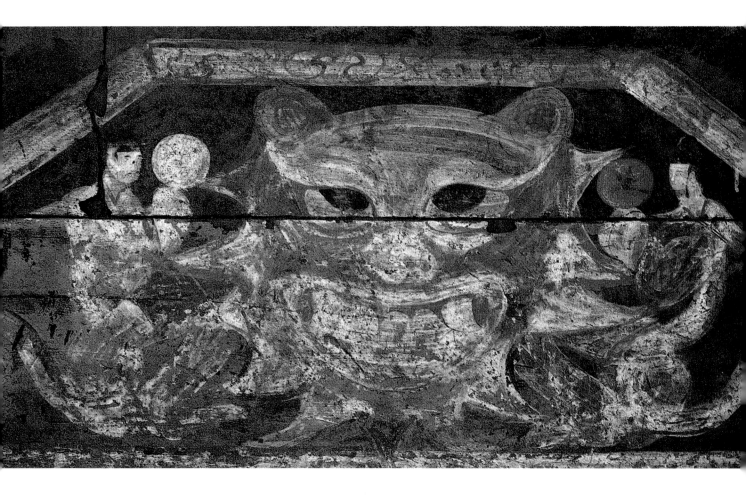

35.方相氏、伏羲、女娲图

新（9~23年）

高47、上宽55、下宽157厘米

1991年河南省偃师市高龙乡辛村西南汉墓出土。现存于偃师商城博物馆。

墓向169°。位于前室勾栏上方梯形横额上。中间用红、白、绿、黑等色绘方相氏，其巨口利齿，突目阔鼻，圆耳竖立，鬃发如刺。伏羲居右，人面蛇身，右手托日，日中绘有金乌。女娲居左，也为人面蛇身，左手托月，月中有桂。

（撰文、摄影：高虎）

Fangxiang Shi (Regional Inspector), Fuxi and Nüwa

Xin (9-23 CE)

Height 47 cm; Width at Top 55cm; Width at Bottom 157 cm

Unearthed from Han tomb at southwest of Xincun, Gaolong of Yanshi in Luoyang, Henan, in 1991. Preserved in Shangcheng Museum in Yanshi.

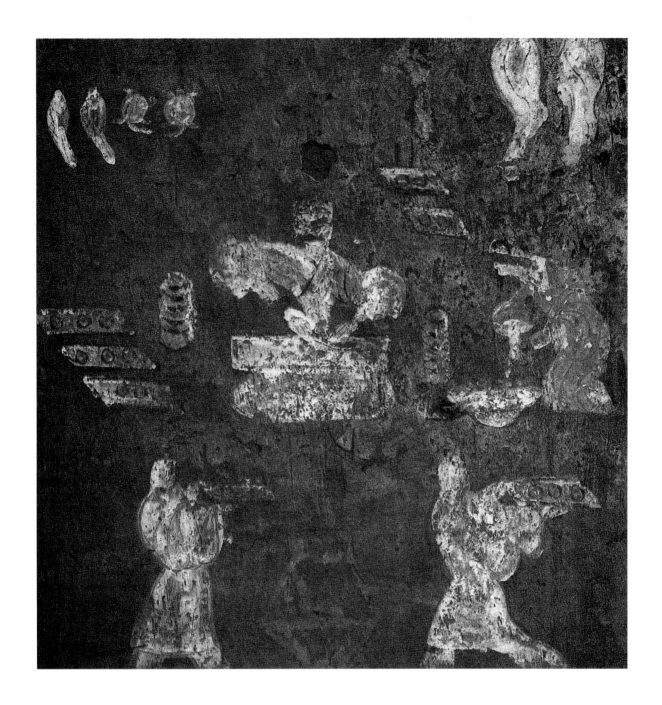

36.庖厨图

新（9~23年）

高44、宽40厘米

1991年河南省偃师市高龙乡辛村西南汉墓出土。现存于偃师商城博物馆。

墓向169°。位于中室西壁南侧。图中部一人为庖丁，头戴平巾帻，身穿右衽紫红色宽袖上衣，衣袖上挽，面前摆案，左手按物于案上，右手持刀作切割状。右侧为一穿红色宽袖长裙的侍女，跪地向前面盆中作取物状。南侧放置有托盘等物。庖丁背后墙上悬挂有豚腿、鱼、鳖等。庖丁身前有二男子手持托盘作行走状。

<div align="right">（撰文、摄影：高虎）</div>

Cooking

Xin (9-23 CE)

Height 44 cm; Width 40 cm

Unearthed from Han tomb at southwest of Xincun, Gaolong of Yanshi in Luoyang, Henan, in 1991. Preserved in Shangcheng Museum in Yanshi.

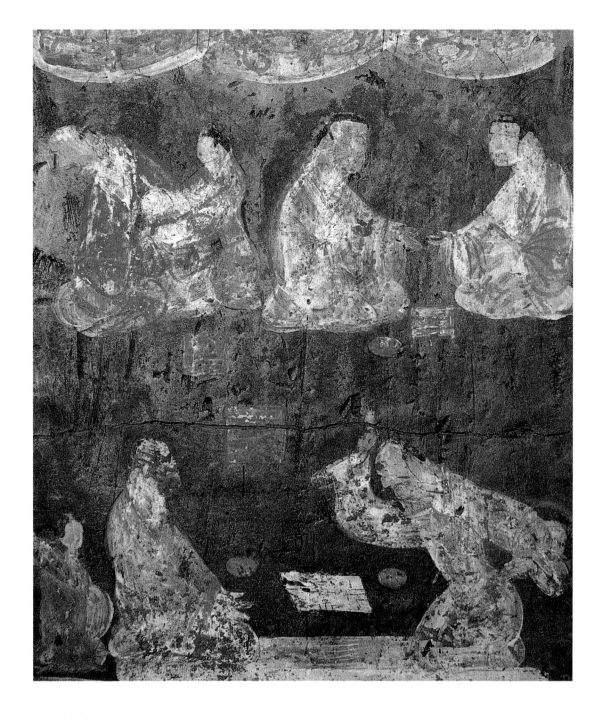

37. 六博宴饮图

新（9～23年）

高89、宽27厘米

1991年河南省偃师市高龙乡辛村西南汉墓出土。现存于偃师商城博物馆。

墓向169°。位于中室西壁。为六博宴饮图。上部吊有幔帐，帐下左侧跽坐一长者，着土黄色袍服，弓背，低首张口，双手下垂。其后站一紫衣小童，双手伸于长者身侧。右侧为两个男者，均着素袍，各伸出一手，相对跽坐。中部放置一樽和耳杯。下部绘三人，左侧跽坐一女侍，肩抱一金吾状物。右边绘二男者，左侧一人着紫色袍，右侧另一人着素袍，扬掌似投棋子状。两人间放一棋盘和耳杯。

（撰文、摄影：高虎）

Scenes of Drinking and Liubo Game Playing

Xin (9-23 CE)

Height 89 cm; Width 27 cm

Unearthed from Han tomb at southwest of Xincun, Gaolong of Yanshi in Luoyang, Henan, in 1991. Preserved in Shangcheng Museum in Yanshi.

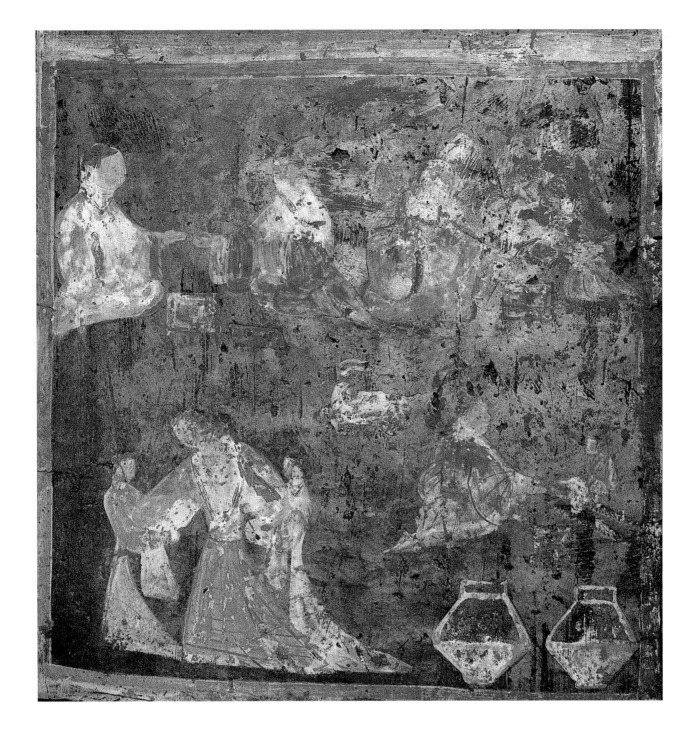

38.宴饮图

新（9～23年）

高41、宽48厘米

1991年河南省偃师市高龙乡辛村西南汉墓出土。现存于偃师商城博物馆。

墓向169°。位于中室东壁北侧。中间置一羊尊，上部四人分二组对饮，身边各放有樽、案等用具。右下角放有两个折腹大口瓮，瓮上部左为一老妪，妪前一侍女双手捧耳杯递上，老妪作欲接状。左下角三女子，中间一人穿宽袖翻领上衣，红色长裙，似醉酒状，左右各一侍女挽扶行进。

（撰文、摄影：高虎）

Feasting

Xin (9-23 CE)

Height 41 cm; Width 48 cm

Unearthed from Han tomb at southwest of Xincun, Gaolong of Yanshi in Luoyang, Henan, in 1991. Preserved in Shangcheng Museum in Yanshi.

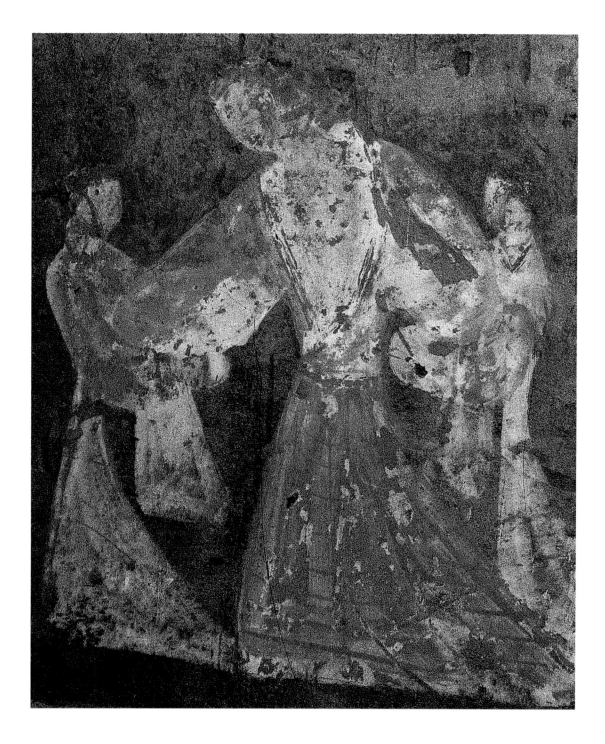

39.醉酒图

新（9～23年）

1991年河南省偃师市高龙乡辛村西南汉墓出土。现存于偃师商城博物馆。

墓向169°。位于中室东壁。画面中间为女主人，低头侧身，收腹，双臂撒开呈醉态，穿紫色宽袖翻领上衣，棕色细腰长裙，裙裾曳地。左右各一侍女，左者脸朝主人作扶状，右侧侍女站于女主人身后，扶持，两侍女黑发垂鬓，宽袖衣束细腰，皆穿曳地长裙。

<div align="right">（撰文：史家珍 摄影：蔡孟轲）</div>

Drunken Beauty Attended by Two Maids

Xin (9-23 CE)

Unearthed from Han tomb at southwest of Xincun, Gaolong of Yanshi in Luoyang, Henan, in 1991. Preserved in Shangcheng Museum in Yanshi.

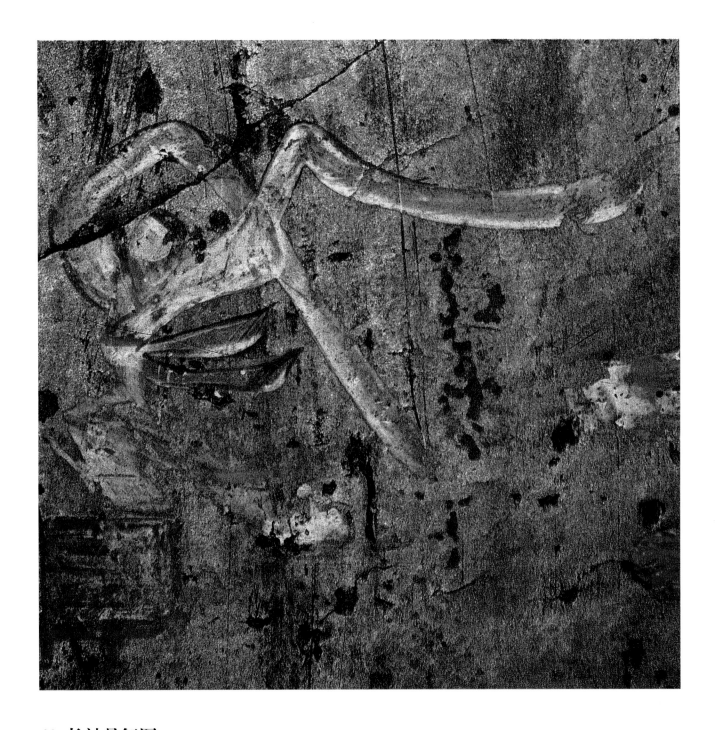

40.长袖曼舞图

新（9～23年）

1991年河南省偃师市高龙乡辛村西南汉墓出土。现存于偃师商城博物馆。

墓向169°。位于中室东壁。画中左侧绘一舞者着右衽长袖衣，为一少女，脸白皙圆润、细眉，眸子突出，双臂上举，舞动长袖，双袖为白色，由上而下飘落，衣边与领口、袖口边都染以橘黄色，下穿裤，束细腰，腰带飘曳。左腿前弓，右腿后蹬。人物下侧放置赭色尊。

<div style="text-align:right">（撰文：史家珍 摄影：蔡孟轲）</div>

Dancing with Long Sleeves

Xin (9-23 CE)

Unearthed from Han tomb at southwest of Xincun, Gaolong of Yanshi in Luoyang, Henan, in 1991. Preserved in Shangcheng Museum in Yanshi.

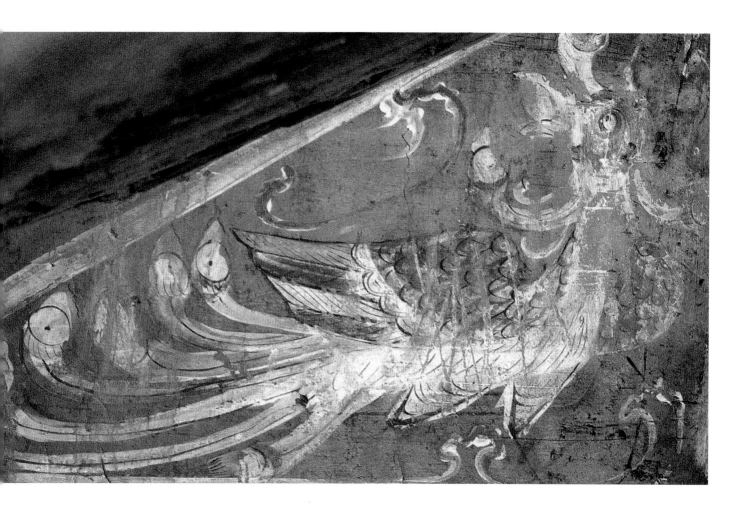

41. 凤鸟图（一）

新（9~23年）

1991年河南省偃师市高龙乡辛村西南汉墓出土。现存于偃师商城博物馆。

墓向169°。位于中后室间横额上。均绘于三角形空心砖上。两幅凤鸟图基本相同，皆为回首凤鸟图案。凤鸟尖喙，口中衔珠，长尾上翘，展翅振羽。

（撰文、摄影：高虎）

Phoenixes (1)

Xin (9-23 CE)

Unearthed from Han tomb at southwest of Xincun, Gaolong of Yanshi in Luoyang, Henan, in 1991. Preserved in Shangcheng Museum in Yanshi.

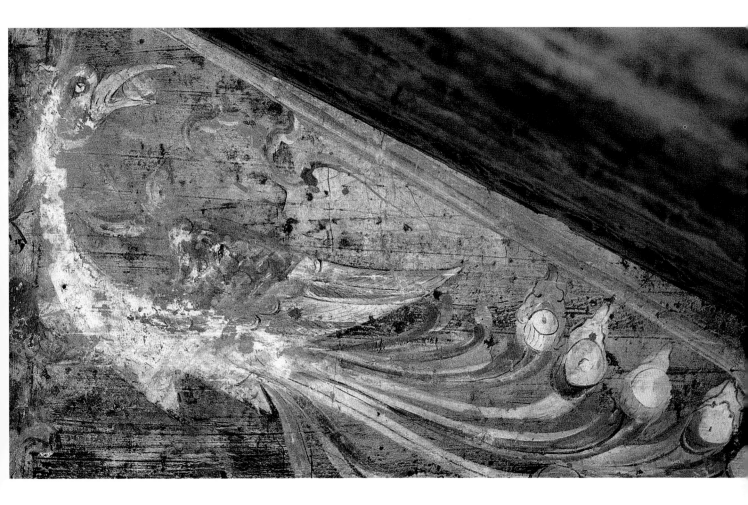

42. 凤鸟图（二）

新（9～23年）

1991年河南省偃师市高龙乡辛村西南汉墓出土。现存于偃师商城博物馆。

墓向169°。位于中后室间横额上。均绘于三角形空心砖上。两幅凤鸟图基本相同，皆为回首凤鸟图案。凤鸟尖喙，口中衔珠，长尾上翘，展翅振羽。

（撰文、摄影：高虎）

Phoenixes (2)

Xin (9-23 CE)

Unearthed from Han tomb at southwest of Xincun, Gaolong of Yanshi in Luoyang, Henan, in 1991. Preserved in Shangcheng Museum in Yanshi.

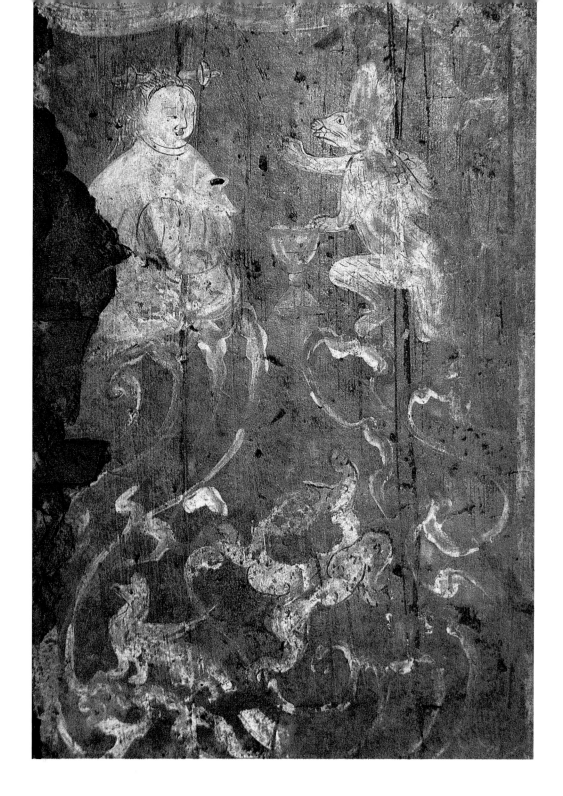

43. 西王母图

新（9~23年）

1991年河南省偃师市高龙乡辛村西南汉墓出土。现存于偃师商城博物馆。

墓向169°。位于中、后室之间横额正中。图中西王母于紫色帷幔中端坐云头，头戴胜。右侧为玉兔杵药，玉兔大耳，背生双翼。图下部祥云升腾，祥云笼罩着蟾蜍、长有双翼的九尾狐等。

（撰文、摄影：高虎）

Xiwangmu (Queen Mother of the West)

Xin (9-23 CE)

Unearthed from Han tomb at southwest of Xincun, Gaolong of Yanshi in Luoyang, Henan, in 1991. Preserved in Shangcheng Museum in Yanshi.

44. 日月祥云图

新（9～23年）

高75、宽140厘米

河南省宜阳县丰李镇尹屯村南汉墓出土。原址保存。

墓向0°。位于中室藻井东、西两区，分绘祥云环绕的日、月，日轮、月轮的轮廓为黑线，内涂黄色，直径19厘米。日中原应绘有三足乌，已遭破坏。月中有一蟾蜍，背部用墨点点缀，凸睛，四肢呈游动状。

<div align="right">（撰文：史家珍 摄影：蔡孟轲）</div>

The Sun and the Moon Surrounded by Auspicious Clouds (Ceiling)

Xin (9-23 CE)

Height 75 cm; Width 140 cm

Unearthed from Han tomb at south of Yituncun, Fengli in Yiyang, Henan. Preserved on the original site.

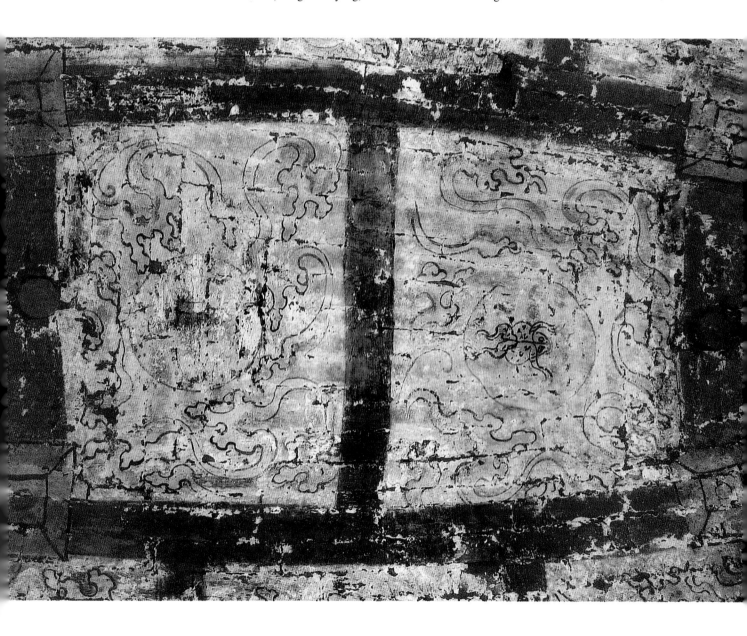

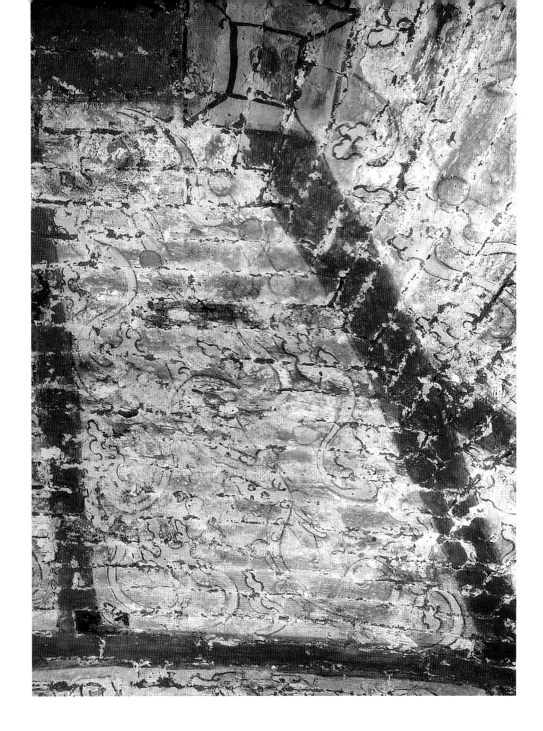

45.二十八宿东宫星宿图

新（9~23年）

高113、上宽30、下宽91厘米

河南省宜阳县丰李镇尹屯村南汉墓出土。原址保存。

墓向0°。位于中室东坡右侧。所绘壁画祥云间有一苍龙腾空，体呈弯曲状，有异化的四足，身部用墨点点缀有小圆形及"３"形鳞片，通长164厘米。周围绕有或相连或单独的21颗星，星径3~5厘米。此星象即苍龙星象与二十八宿东宫的箕宿。

<div align="right">（撰文：史家珍 摄影：蔡盂轲）</div>

Star Map of the Eastern Region of the 28 Mansions

Xin (9-23 CE)

Height 113 cm; Width at Top 30 cm; Width at Bottom 91 cm

Unearthed from Han tomb at south of Yituncun, Fengli in Yiyang, Henan. Preserved on the original site.

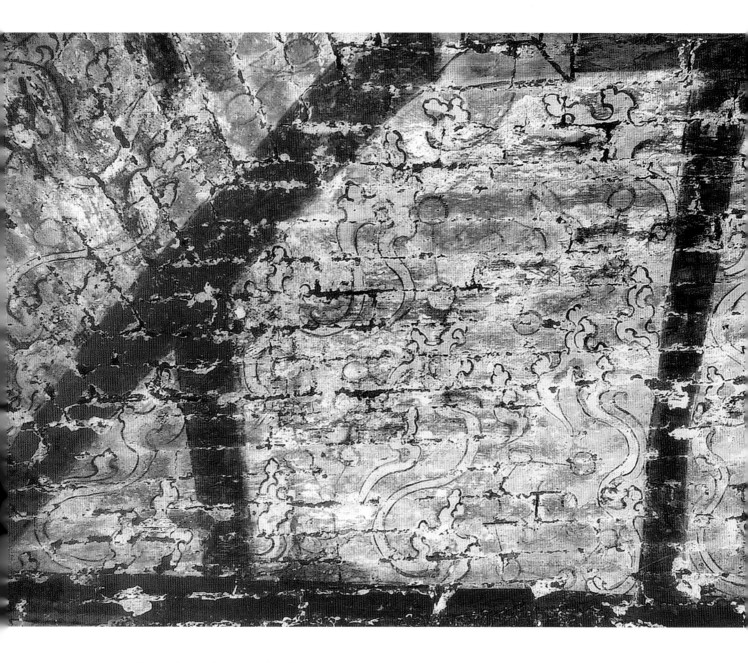

46.二十八宿西宫、南宫星宿图

新（9～23年）

高101、上宽42、下宽79厘米

河南省宜阳县丰李镇尹屯村南汉墓出土。原址保存。

墓向0°。位于中室南坡东侧。所绘祥云间其上部绘七星相连环绕一兔，横长24、竖高17、星径4～5厘米，即二十八宿西宫毕宿。其左下方绘一人首蛇身仙人托持相连呈"Y"形的七星，竖高49、星径4～5厘米。即二十八宿的南宫柳宿。其右侧绘一人首，周绕呈"C"形的相连六星，人首竖高14、横宽145厘米，星径4～5厘米。即二十八宿的南宫轸宿。

<div align="right">（撰文：史家珍 摄影：蔡孟轲）</div>

Star Map of the Western and Southern Regions of the 28 Mansions

Xin (9-23 CE)

Height 101 cm; Width at Top 42 cm; Width at Bottom 79 cm

Unearthed from Han tomb at south of Yituncun, Fengli in Yiyang, Henan. Preserved on the original site.

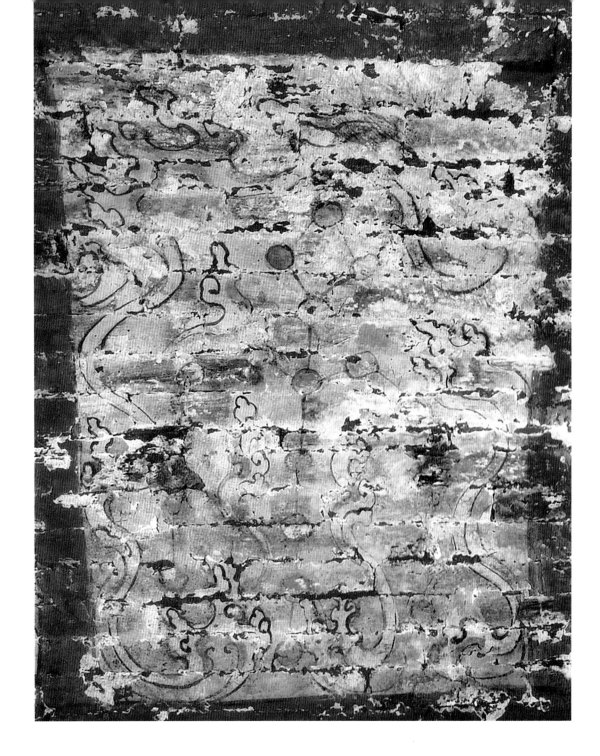

47.二十八宿南宫星宿图

新（9～23年）

高100、宽70厘米

河南省宜阳县丰李镇尹屯村南汉墓出土。原址保存。

墓向0°。位于中室南坡中部。祥云缭绕间绘有19颗星相连的星座，竖高75、横宽45、星径3.5~5厘米。此星象即二十八宿的南宫翼宿。

<div align="right">（撰文：史家珍　摄影：蔡孟轲）</div>

Star Map of the Southern Region of the 28 Mansions

Xin (9-23 CE)

Height 100 cm; Width 70 cm

Unearthed from Han tomb at south of Yituncun, Fengli in Yiyang, Henan. Preserved on the original site.

48.羲和擎日图

东汉（25～220年）

残高74厘米

1987年河南省洛阳市北郊石油站家属院689号墓出土。现存于洛阳古墓博物馆。

墓向177°。位于中室东壁上部。羲和人首蛇身，粗眉细目，朱唇，脑后垂髻，耳饰红色垂珥。内穿高领素衣，外套灰绿色右衽短衣，袖阔缘宽，双臂上举，捧太阳于头顶。日中有一飞翔的金乌。羲和下身蛇体色同外衣，右曲且向下垂，腰下部绘二兽肢，一肢上抬，一肢下伸。

（撰文、摄影：高虎）

Xihe Carrying the Sun on the Head

Eastern Han (25-220 CE)

Remaining Height 74 cm

Unearthed from Tomb 689 at the dwelling district of petrol dump in northern suburbs of Luoyang, Henan, in 1987. Preserved in Museum of Ancient Tombs in Luoyang.

49.常仪擎月图

东汉（25～220年）

残高75厘米

1987年河南省洛阳市北郊石油站家属院689号墓出土。现存于洛阳古墓博物馆。

墓向177°。位于中室西壁上部。常仪为人首蛇身，宽额方面，长眉长目，扁鼻，红唇，留有八字胡须。脑后垂髻。内穿长袖素衣，外穿黄褐色短衣，交领右衽，双臂上举，捧月亮于头顶。月中一赤色蟾蜍。下身蛇躯作浅灰绿色，下部渐细成蛇尾，腰部有二兽肢。

（撰文、摄影：高虎）

Changyi Carrying the Moon on the Head

Eastern Han (25-220 CE)

Remaining Height 75 cm

Unearthed from Tomb 689 at the dwelling district of petrol dump in northern suburbs of Luoyang, Henan, in 1987. Preserved in Museum of Ancient Tombs in Luoyang.

50.骑吏图（一）

东汉（25～220年）

1984年河南省偃师市杏园村首阳山电厂汉墓出土。现存于偃师商城博物馆。

墓向10°。位于墓室北壁。为车马出行图局部。骑吏头戴红色冠巾，面目圆润，留有胡须，着交领红袍，素色长裤，右手持马鞭，左手握缰绳，骑黑色奔马。

（撰文：史家珍 摄影：蔡孟轲）

Mounted Vanguard of Procession (1)

Eastern Han (25-220 CE)

Unearthed from Han tomb at the power plant of Shouyangshan, Xingyuancun in Yanshi, Henan, in 1984. Preserved in Shangcheng Museum in Yanshi.

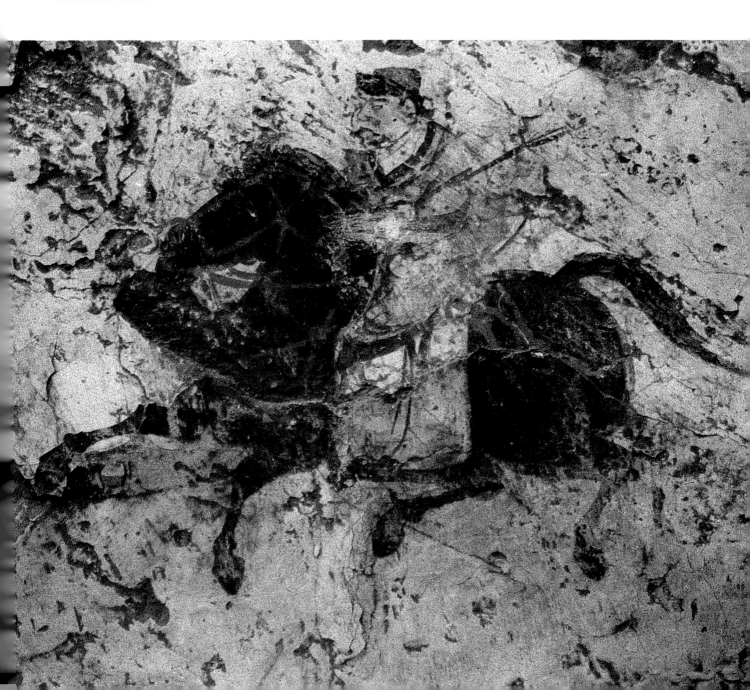

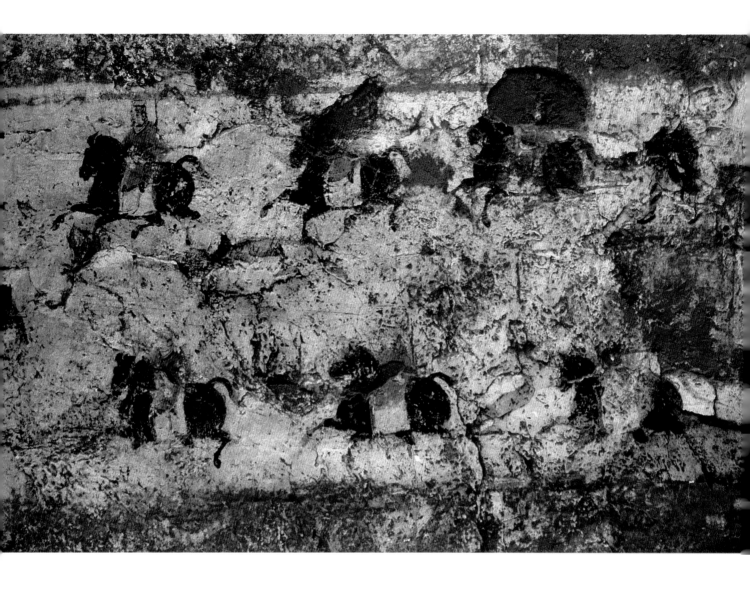

51.导骑图

东汉（25～220年）

高约60厘米

1984年河南省偃师市杏园村首阳山电厂汉墓出土。现存于偃师商城博物馆。

墓向10°。位于前横堂南壁。由六名骑吏组成，骑吏上下二列各三人，均头戴平巾帻，穿宽袖长袍骑于黑马之上，马均作奔走状。

（撰文、摄影：高虎）

Mounted Vanguards of Procession

Eastern Han (25-220 CE)

Height ca. 60 cm

Unearthed from Han tomb at the power plant of Shouyangshan, Xingyuancun in Yanshi, Henan, in 1984. Preserved in Shangcheng Museum in Yanshi.

52.骑吏图（二）

东汉（25～220年）

高约60厘米

1984年河南省偃师市杏园村首阳山电厂汉墓出土。现存于偃师商城博物馆。

墓向10°。位于前横堂南壁。骑吏头戴平巾帻，穿交领红色宽袖长袍，双目前视，留有胡须。胯下黑马红辔，有鞍无蹬，马四蹄腾起作奔跑状。

（撰文、摄影：高虎）

Mounted Vanguards of Procession (2)

Eastern Han (25-220 CE)

Height ca. 60 cm

Unearthed from Han tomb at the power plant of Shouyangshan, Xingyuancun in Yanshi, Henan, in 1984. Preserved in Shangcheng Museum in Yanshi.

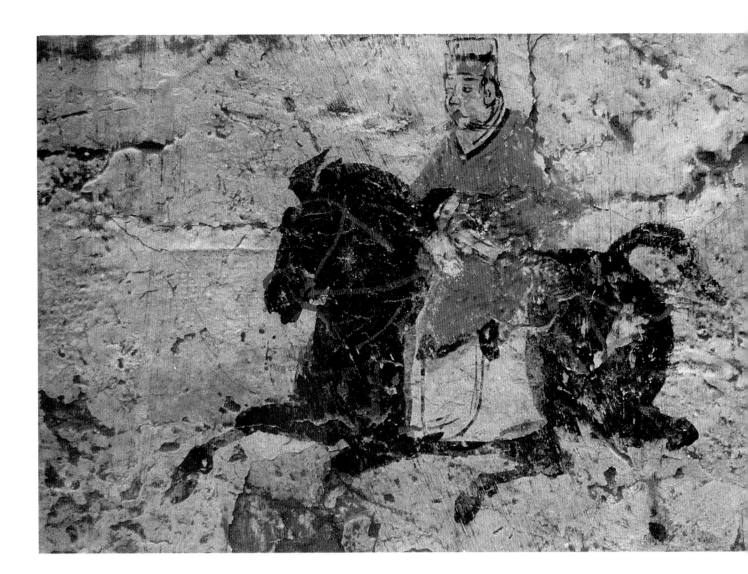

53.车前骑吏、伍佰图（局部）

东汉（25～220年）

高约60厘米

1984年河南省偃师市杏园村首阳山电厂汉墓出土。现存于偃师商城博物馆。

墓向10°。位于前横堂北壁。为第四车前骑吏和伍佰，骑吏红衣黑马，其中前排下部骑吏作回首状。后部两排伍佰均持杖作行走状。

（撰文、摄影：高虎）

Mounted Vanguards and Wubai (Infantry Vanguards) (Detail)

Eastern Han (25-220 CE)

Height ca. 60 cm

Unearthed from Han tomb at the power plant of Shouyangshan, Xingyuancun in Yanshi, Henan, in 1984. Preserved in Shangcheng Museum in Yanshi.

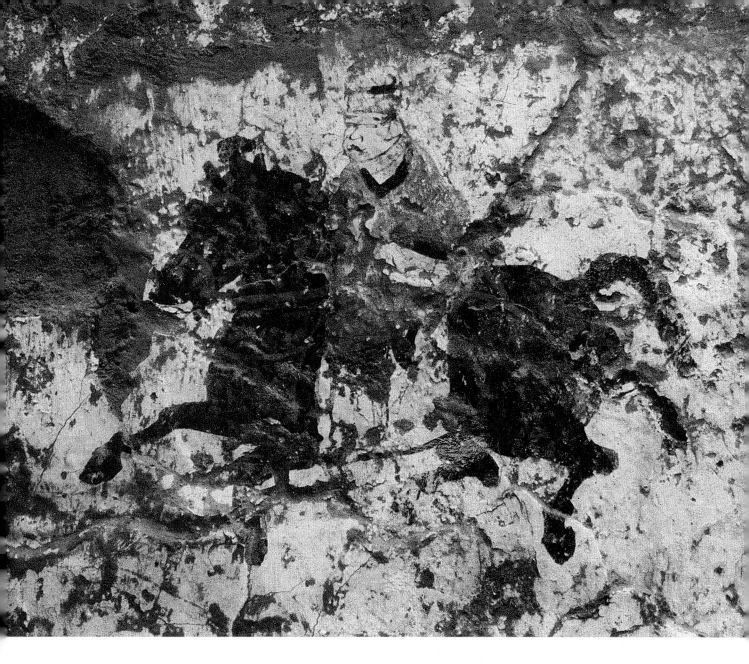

54.骑吏图（三）

东汉（25～220年）

高约60厘米

1984年河南省偃师市杏园村首阳山电厂汉墓出土。现存于偃师商城博物馆。

墓向10°。位于前横堂北壁。骑吏头戴平巾帻，身穿交领宽袖长袍，骑黑色马。马四蹄腾空作奔跑状。

（撰文、摄影：高虎）

Mounted Vanguard (3)

Eastern Han (25-220 CE)

Height ca. 60 cm

Unearthed from Han tomb at the power plant of Shouyangshan, Xingyuancun in Yanshi, Henan, in 1984. Preserved in Shangcheng Museum in Yanshi.

55.墓主安车出行图

东汉（25～220年）

高约60厘米

1984年河南省偃师市杏园村首阳山电厂汉墓出土。现存于偃师商城博物馆。

墓向10°。位于前横堂北壁。安车四维车幡，彩饰伞盖，装饰华贵。车主头戴平巾帻，身穿红色宽袖长袍坐于车舆右侧。御夫居左，手持缰绳。安车后部跟随有骑吏，骑吏皆红衣黑马。

（撰文、摄影：高虎）

Procession of the Tomb Occupant in Anche (Carriage with Canopy)

Eastern Han (25-220 CE)

Height ca. 60 cm

Unearthed from Han tomb at the power plant of Shouyangshan, Xingyuancun in Yanshi, Henan, in 1984. Preserved in Shangcheng Museum in Yanshi.

56. 墓主安车出行图（局部）

东汉（25～220年）

高约60厘米

1984年河南省偃师市杏园村首阳山电厂汉墓出土。现存于偃师商城博物馆。

墓向10°。位于前堂北壁。安车带彩饰伞盖，车主穿红色长袍居右，车夫戴褐色平巾帻居左，手持缰绳，驾红色马车作奔跑状。

（撰文、摄影：高虎）

Procession of the Tomb Occupant in Anche (Carriage with Canopy) (Detail)

Eastern Han (25-220 CE)

Height ca. 60 cm

Unearthed from Han tomb at the power plant of Shouyangshan, Xingyuancun in Yanshi, Henan, in 1984. Preserved in Shangcheng Museum in Yanshi.

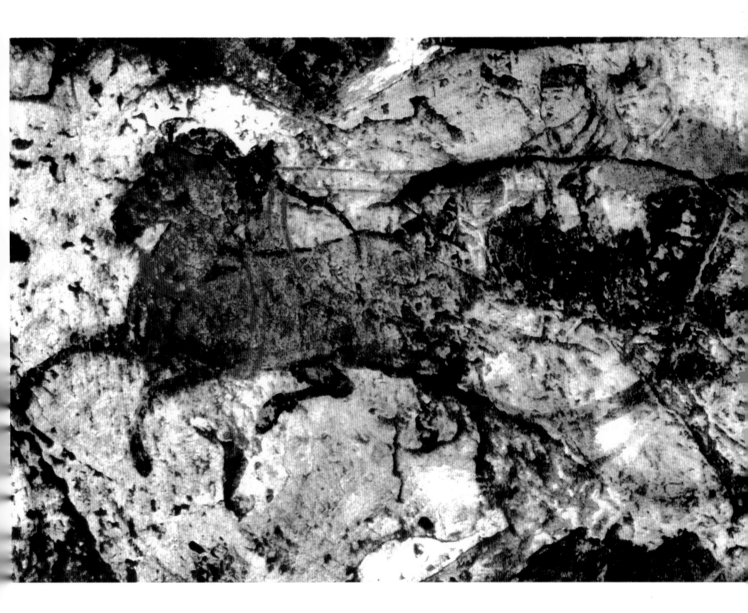

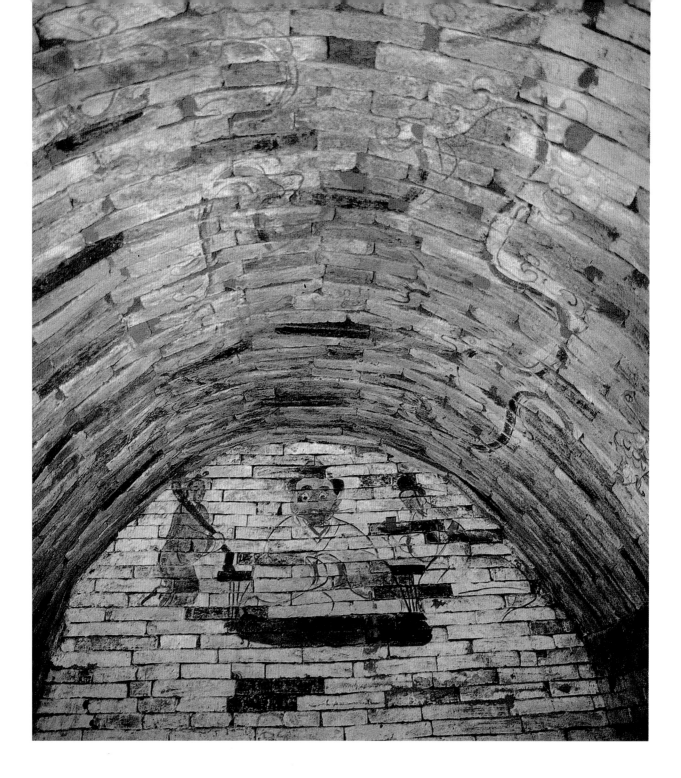

57.后壁墓主人图

东汉（25～220年）

1984年河南省新安县铁塔山汉墓出土。现存于洛阳古墓博物馆。

墓向0°。位于墓室券顶和后壁上部。券顶上用墨线勾勒瑞云图案，并填以紫色、橘黄色。后壁上部绘三人，中间墓主人拱手坐于几前，头顶发式奇特，呈"品"字形发髻，突目朱唇，络腮胡。左右分别跪坐男女各一人，左侧男子双手持物荷于肩上，右侧女子双手托盘。

（撰文、摄影：高虎）

Portrait of the Tomb Occupant on the Back Wall of the Tomb Chamber

Eastern Han (25-220 CE)

Unearthed from Han tomb at Tieta Hill of Xin'an in Luoyang, Henan, in 1984. Preserved in Museum of Ancient Tombs in Luoyang.

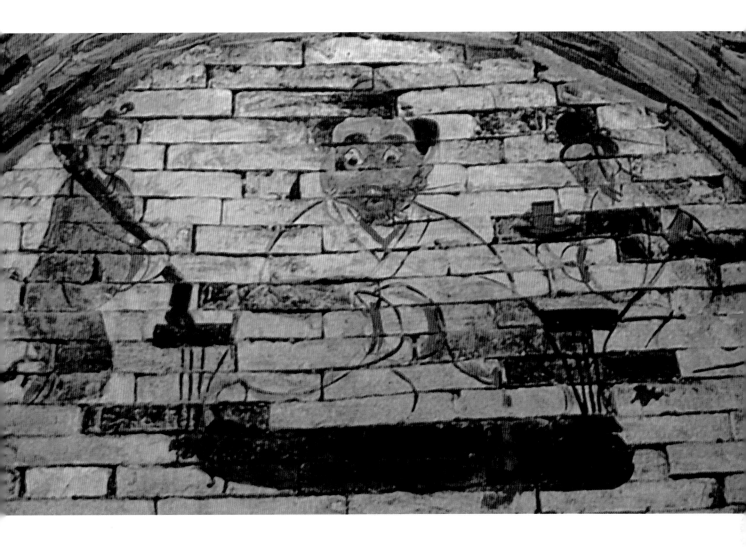

58.后壁墓主人图（局部）

东汉（25～220年）

1984年河南省新安县铁塔山汉墓出土。现存于洛阳古墓博物馆。

墓向0°。位于墓室券顶和后壁上部。券顶上用墨线勾勒瑞云图案，并填以紫色、橘黄色。后壁上部绘三人，中间墓主人拱手坐于几前，头顶发式奇特，呈"品"字形发髻，突目朱唇，络腮胡。左右分别跽坐男女各一人，左侧男子双手持物荷于肩上，右侧女子双手托盘。

（撰文、摄影：高虎）

Portrait of the Tomb Occupant on the Back Wall of the Tomb Chamber (Detail)

Eastern Han (25-220 CE)

Unearthed from Han tomb at Tieta Hill of Xin'an in Luoyang, Henan, in 1984. Preserved in Museum of Ancient Tombs in Luoyang.

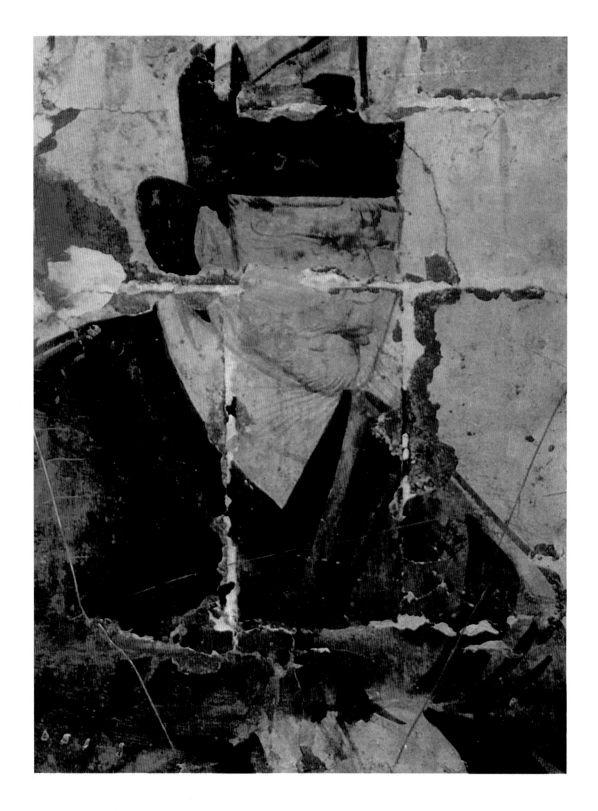

59. 男墓主图

东汉晚期—曹魏时期（220年前后）

1991年河南省洛阳市东北郊朱村2号墓出土。现存于洛阳古墓博物馆。

墓向5°。位于墓室北壁。壁画为夫妇宴饮图局部。男墓主人头戴赭色进贤冠，慈眉善目，高鼻梁，朱唇大耳。留八字须，颌下留长须。身穿黑袍。皂缘领，白袖口，右衽，双手笼袖中。

（撰文：史家珍 摄影：蔡孟轲）

Portrait of the Male Tomb Occupant (Detail)

Late Eastern Han-Early Three-Kingdom (around 220 CE)

Unearthed from Tomb 2 at Zhucun in estern suburbs of Luoyang, Henan, in 1991. Preserved in Museums of Ancient Tombs in Luoyang.

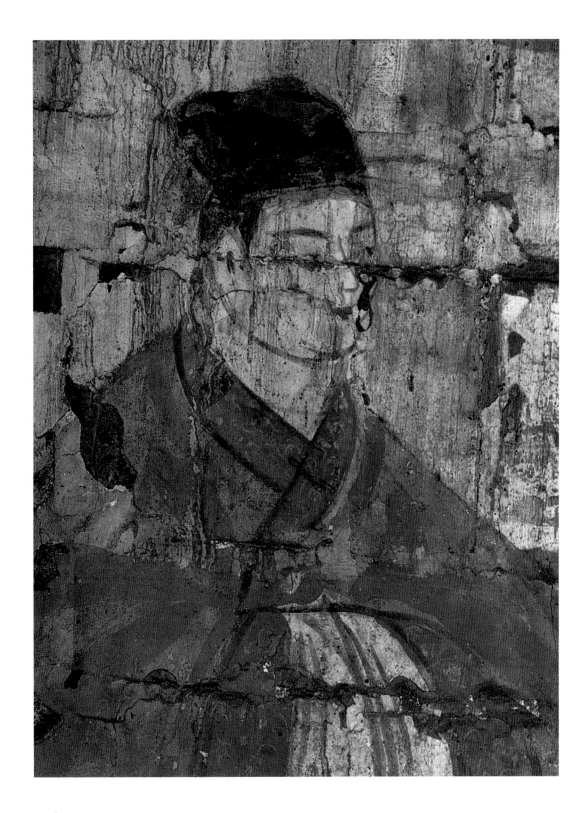

60. 女墓主图（局部）

东汉晚期－曹魏时期（220年前后）

1991年河南省洛阳市东北郊朱村2号墓出土。现存于洛阳古墓博物馆。

墓向5°。位于墓室北壁。为夫妇宴饮图局部，头戴黑色巾帻，面部丰满，柳眉秀目，朱唇小口，高鼻，容貌端庄，身穿右衽宽袖红袍，红领黑边，白袖口，双手笼袖中。

（撰文：史家珍　摄影：蔡孟轲）

Portrait of the Female Tomb Occupant (Detail)

Late Eastern Han-Early Three-Kingdom (around 220 CE)

Unearthed from Tomb 2 at Zhucun in estern suburbs of Luoyang, Henan, in 1991. Preserved in Museums of Ancient Tombs in Luoyang.

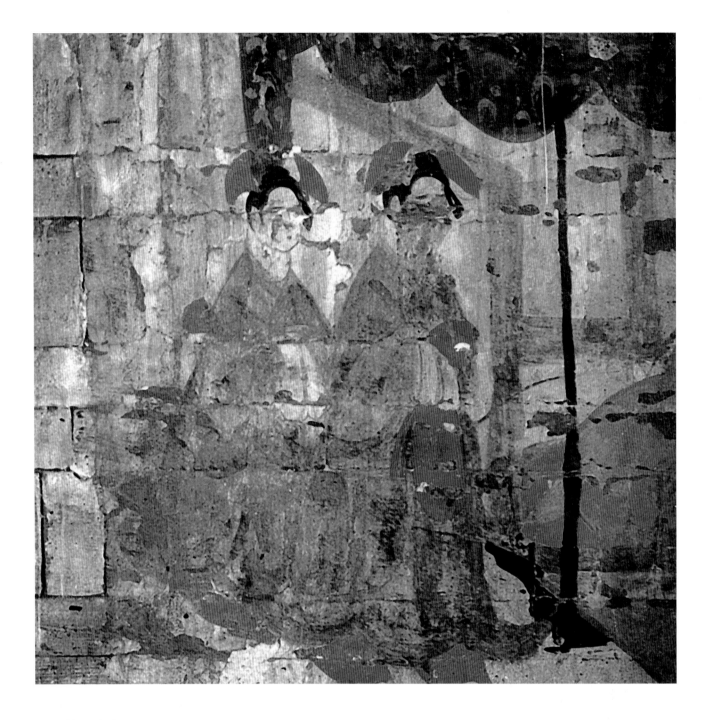

61.侍女图

东汉晚期—曹魏时期（220年前后）

1991年河南省洛阳市东北郊朱村2号墓出土。现存于洛阳古墓博物馆。

墓向5°。位于墓室北壁。所绘侍女，一先一后站于墓主人身后，头顶有赭色帐幔，均头梳双髻，戴红色饰物，身穿浅灰色长袍，皂缘领，白袖口，右衽，红裤，红鞋，双手拢于袖口。右侧侍女胳膊搭一红色团巾。

<div align="right">（撰文：史家珍 摄影：蔡孟轲）</div>

Maids

Late Eastern Han-Early Three-Kingdom (around 220 CE)

Unearthed from Tomb 2 at Zhucun in estern suburbs of Luoyang, Henan, in 1991. Preserved in Museums of Ancient Tombs in Luoyang.

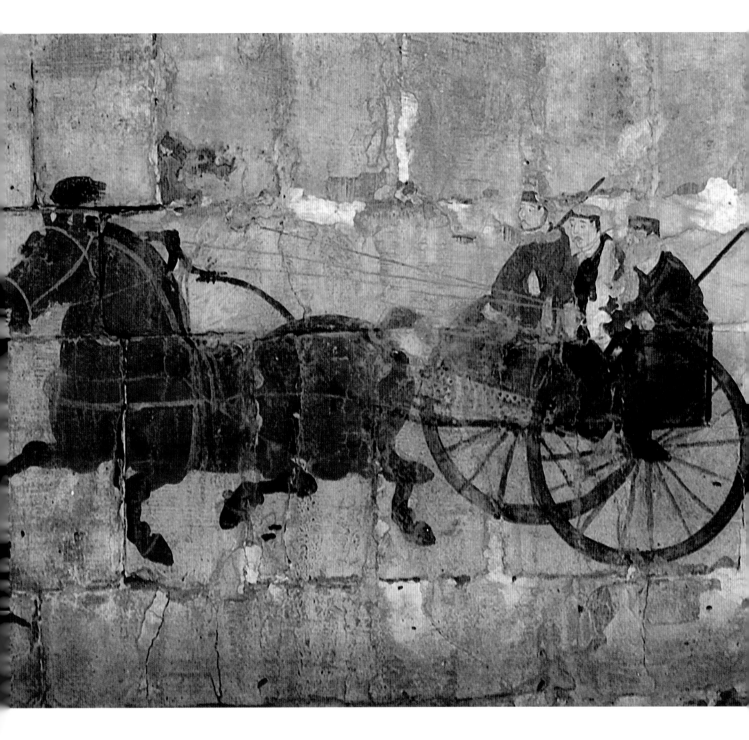

62.导车图

东汉晚期—曹魏时期（220年前后）

1991年河南省洛阳市东北郊朱村2号墓葬出土。现存于洛阳古墓博物馆。

墓向5°。位于墓室南壁。壁画为车马出行图之第一乘导车。枣红色马，黑鬃黑蹄，头戴黑缨，张口嘶鸣，奋蹄疾驰，形象逼真，车上三人，居中御者，八字胡，着黑袍，头戴黑色巾帻，目视前方，手握马缰。两侧二人戴平巾帻，长须，黑袍。

（撰文：史家珍 摄影：蔡孟轲）

Guiding Chariot

Late Eastern Han-Early Three-Kingdom (around 220 CE)

Unearthed from Tomb 2 at Zhucun in estern suburbs of Luoyang, Henan, in 1991. Preserved in Museums of Ancient Tombs in Luoyang.

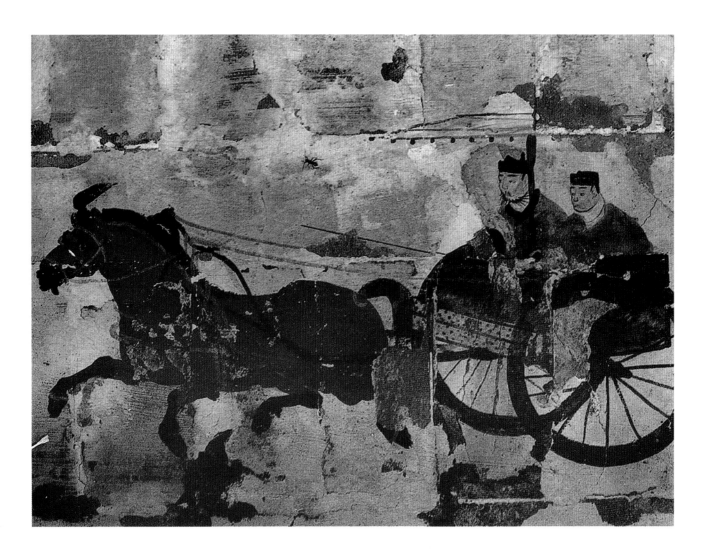

▲ 63.主车图

东汉晚期—曹魏时期（220年前后）

1991年河南省洛阳市东北郊朱村2号墓出土。现存于洛阳古墓博物馆。

墓向5°。位于墓室南壁。为车马出行图之第四车。车为曲辕，素盖，套单匹红马，黑鬃黑蹄，头戴黑缨，奋蹄疾驰，形象逼真。车上二人，御者居左，头戴黑巾帻，目视前方，手挽缰。右侧墓主人头戴进贤冠，颌下长须，着灰袍，皂缘领，作催马行进状。

（撰文：史家珍 摄影：蔡孟轲）

Master Chariot

Late Eastern Han-Early Three-Kingdom (around 220 CE)
Unearthed from Tomb 2 at Zhucun in estern suburbs of Luoyang, Henan, in 1991. Preserved in Museums of Ancient Tombs in Luoyang.

64.中室甬道券顶壁画全貌 ▶

东汉（25～220年）

东西长740、南北展开宽660厘米

1960年河南省新密市打虎亭村西2号墓出土。原址保存。

墓向172°。位于中室券顶。色彩鲜艳，形象生动、热烈而神奇。整体布局繁密，顶为长横幅分隔为七幅藻井图案，分别为规矩形、莲花形和窗棂形藻井图案。南北两侧各有七幅彩色瑞云和仙人神兽图。

（撰文：蔡全法 摄影：张建中等）

Full-view of the Murals on the Vaulted Ceiling of the Middle Chamber

Eastern Han (25-220 CE)
Length (E-W) 740 cm; Width (N-S, unfolded) 660 cm
Unearthed from Tomb 2 at west of Dahutingcun in Xinmi, Henan, in 1960. Preserved on the original site.

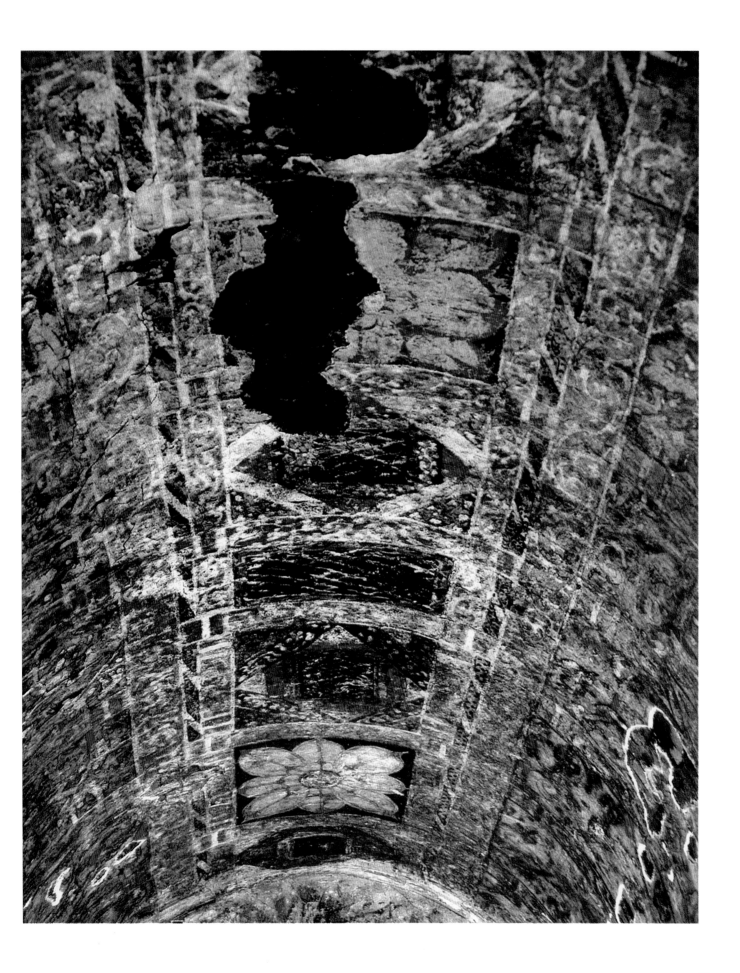

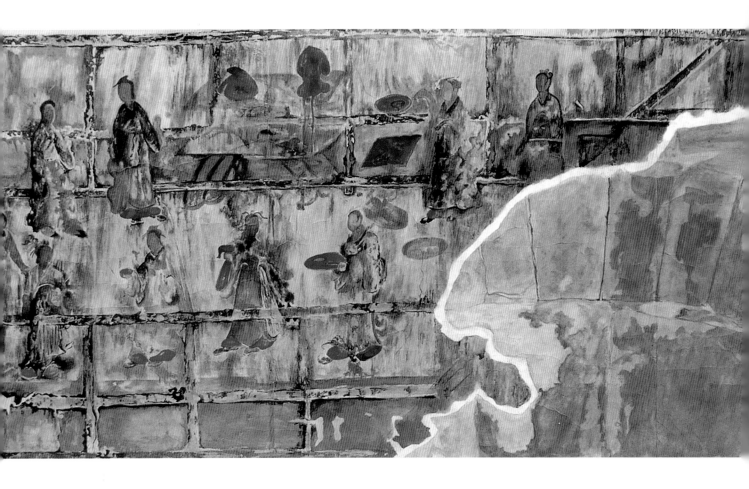

65. 迎宾图壁画（局部一）（摹本）

东汉（25～220年）

高64、长742厘米

1960年河南省新密市打虎亭村西2号墓出土。原址保存。

墓向172°。位于中室南壁东段上部。为迎宾图，东面上一排似为迎宾人物，具黑袍、红裤、鞋。下一排人员女性居多，头梳发髻，着长衣、红裤、黑鞋，携物或端盘行进。后有辎车、各色人物、马匹，主宾多戴平巾帻，穿红袍服、黑裤或白裤、黑鞋。穿红袍主宾的下侧有壶类杂器和绵羊等。

<div style="text-align: right">（临摹：刘建洲等　撰文、摄影：蔡全法）</div>

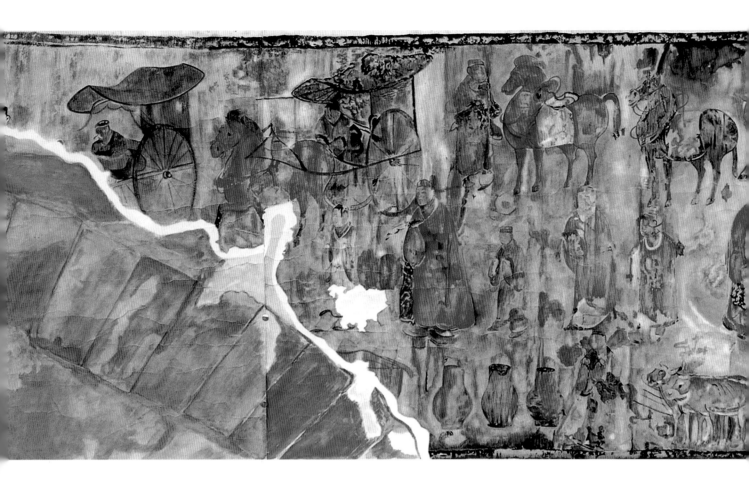

Greeting Guests (Detail 1) (Replica)

Eastern Han (25-220 CE)

Height 64 cm; Width 742 cm

Unearthed from Tomb 2 at west of Dahutingcun in Xinmi, Henan, in 1960. Preserved on the original site.

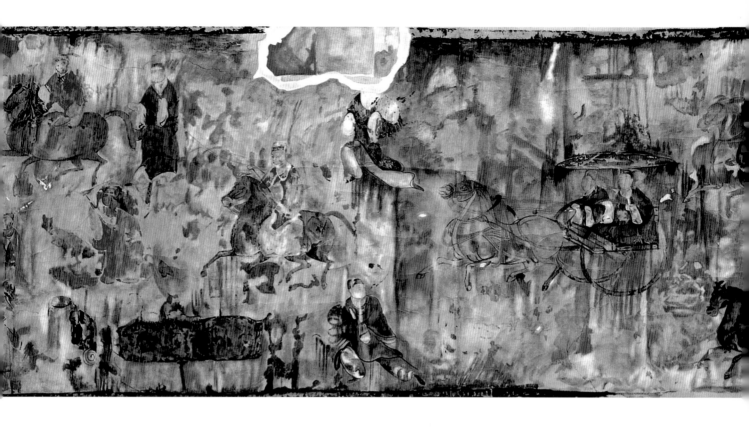

66. 迎宾图壁画（局部二）（摹本）

东汉（25~220年）

1960年河南省新密市打虎亭村西2号墓出土。原址保存。

墓向172°。位于中室南壁东段上部。为迎宾图，东面上一排似为迎宾人物，具黑袍、红裤、鞋。下一排人员女性居多，头梳发髻，着长衣、红裤、黑鞋，携物或端盘行进。后有辎车、各色人物、马匹，主宾多戴平巾帻，穿红袍服、黑裤或白裤、黑鞋。穿红袍主宾的下侧有壶类杂器和牛等。

（临摹：刘建洲等　撰文、摄影：蔡全法）

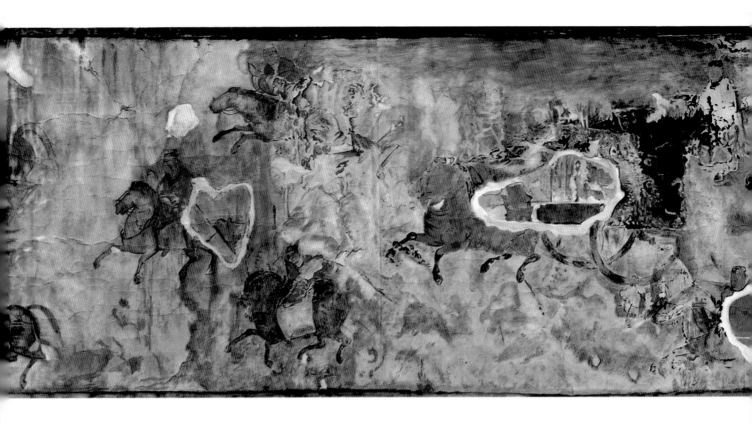

Greeting Guests (Detail 2) (Replica)

Eastern Han (25-220 CE)

Unearthed from Tomb 2 at west of Dahutingcun in Xinmi, Henan, in 1960. Preserved on the original site.

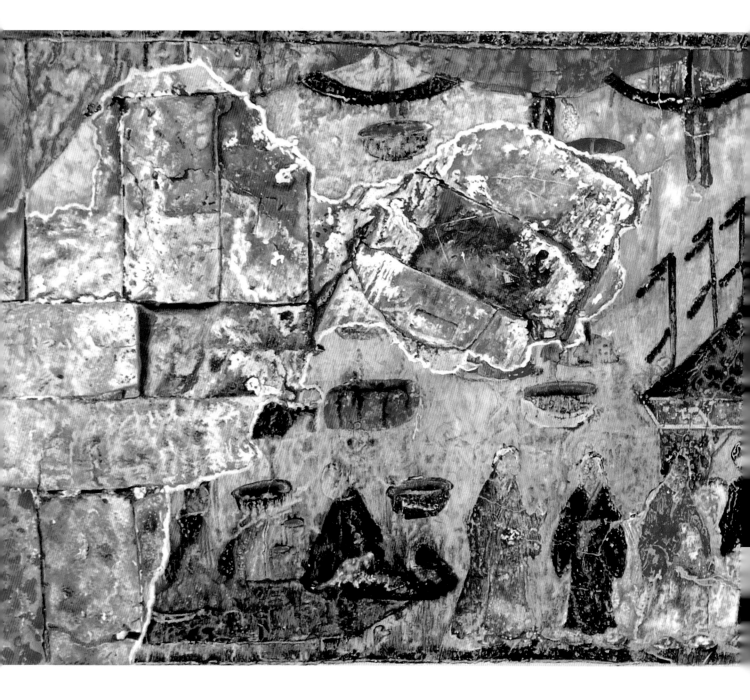

67. 宴乐百戏图（局部一）（摹本）

东汉（25~220年）

高70、宽约360厘米

1960年河南省新密市打虎亭村西2号墓出土。原址保存。

墓向172°。位于中室北壁东段上部，为宴乐图西半部。画面上悬红色和黑色幔帐和绥带，中间为一红顶，绘有绿色和黑色云气纹的帷帐，墓主人坐于几旁宴饮，前有跪、立的侍者十余人，帷帐后右侧，有四人，似为迎接宾客的情景。

（临摹：王定理、邓邦镇、卢波等 撰文、摄影：蔡全法）

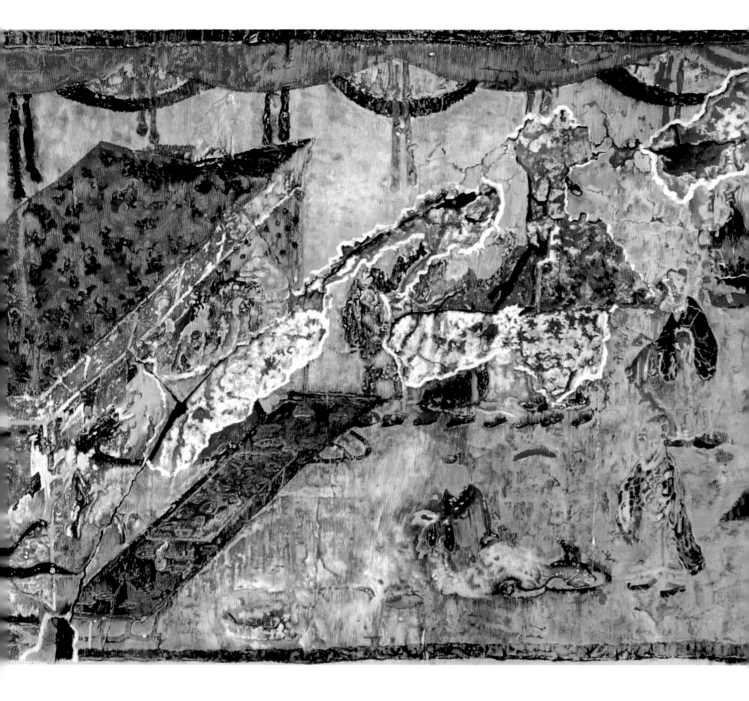

Feasting and Acrobatics Performance (Detail 1) (Replica)

Eastern Han (25-220 CE)

Height 70 cm; Width ca. 360 cm

Unearthed from Tomb 2 at west of Dahutingcun in Xinmi, Henan, in 1960. Preserved on the original site.

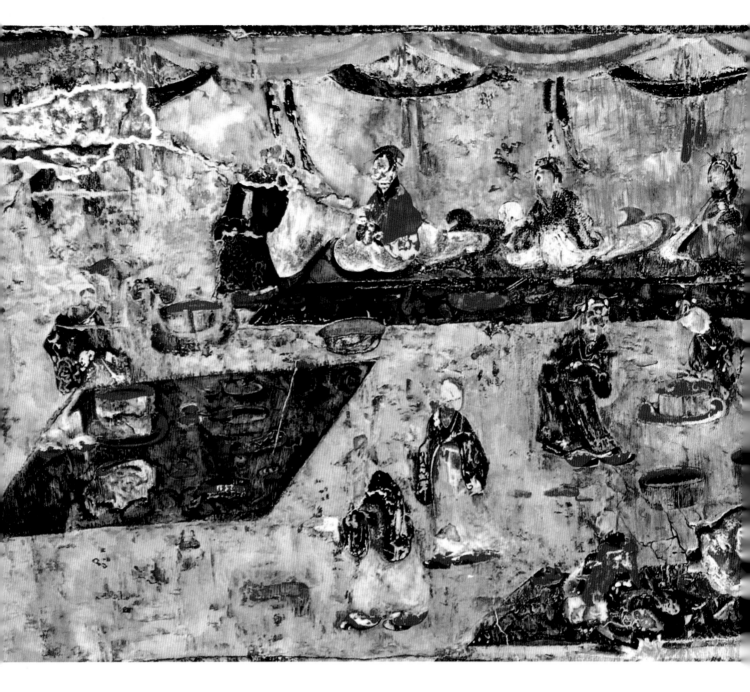

68.宴乐百戏图（局部二）（摹本）

东汉（25～220年）

1960年河南省新密市打虎亭村西2号墓出土。原址保存。

墓向172°。位于中室北壁东段上部，为宴乐图中部，位于前图的右侧。画面上悬红色和黑色幔帐和绶带。两侧宾客席坐几旁宴饮，观看乐舞表演。人物有的穿黑色袍，有的为灰袍，还有穿黑衣白裙或红衣白裙。

（临摹：王定理、邓邦镇、卢波等 撰文、摄影：蔡全法）

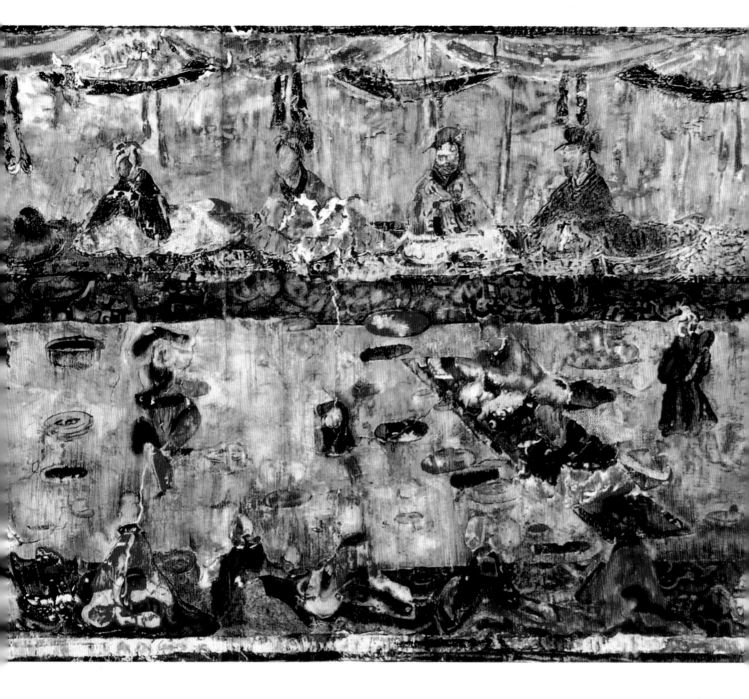

Feasting and Acrobatics Performance (Detail 2) (Replica)

Eastern Han (25-220 CE)

Unearthed from Tomb 2 at west of Dahutingcun in Xinmi, Henan, in 1960. Preserved on the original site.

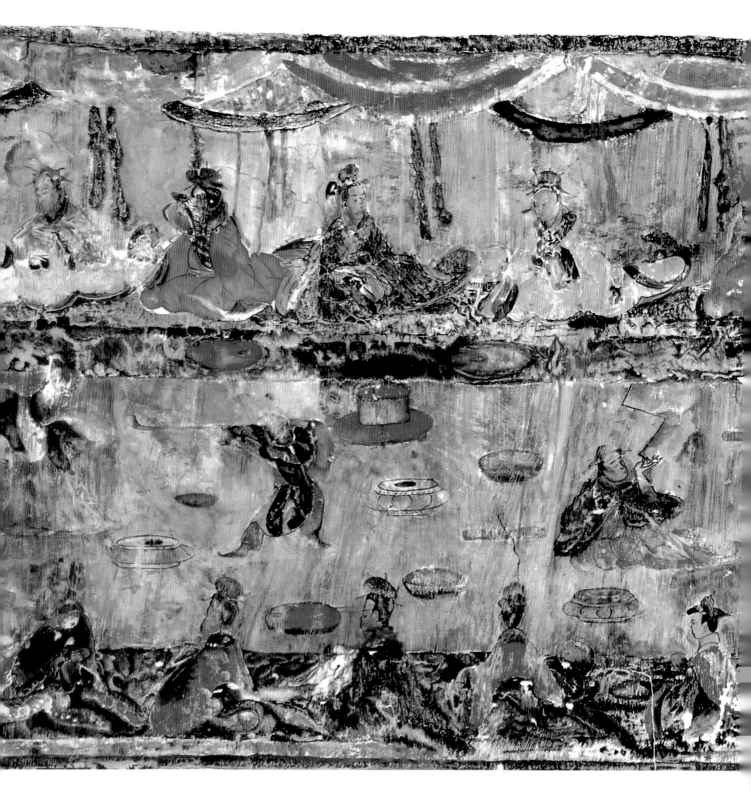

69.宴乐百戏图（局部三）（摹本）

东汉（25～220年）

高70、长约360厘米

1960年河南省新密市打虎亭村西2号墓出土。原址保存。

墓向172°。位于中室北壁东段上部，为宴乐图东半部，位于上图的右侧。两排佳宾席地坐于几旁宴饮和观看吹火、叠木、抛丸和舞蹈等百戏的表演，东半部壁画有较多的残缺。从残留的画面可看出，在宴乐图的东端未尽处，一横排席地而坐的四位宾客正观看舞蹈表演，其后仍保持着上下两排宾客直至尽头处。画中宾客多为女性，多是扇形高髻、插笄，着黑色、红色或黄色衣。

（临摹：王定理、邓邦镇、卢波等　撰文、摄影：蔡全法）

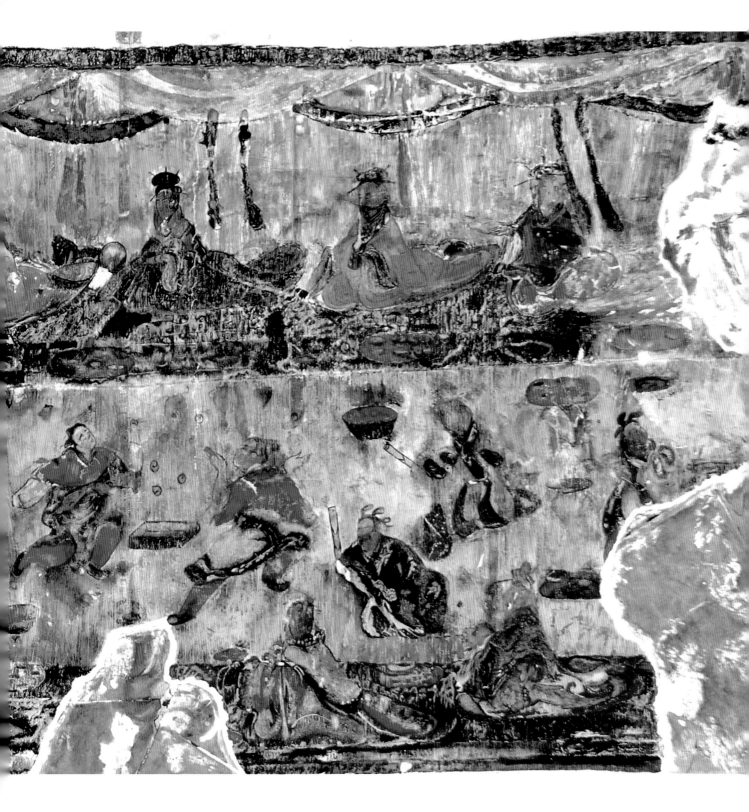

Feasting and Acrobatics Performance (Detail 3) (Replica)

Eastern Han (25-220 CE)

Height 70 cm; Width ca. 360 cm

Unearthed from Tomb 2 at west of Dahutingcun in Xinmi, Henan, in 1960. Preserved on the original site.

70. 莲花藻井图案壁画（摹本）

东汉（25～220年）

高104、宽208厘米

1960年河南省新密市打虎亭村西2号墓出土。原址保存。

墓向172°。位于中室券顶东段，西起第六幅藻井莲花图案。藻井外有方形外框，以橘红色为地，四边界格内用墨绘云气纹。藻井中间为白色莲花图案，莲心圆形，以黑色为地，花心用黑色和绿色点出莲籽，周环八个小形花瓣，花尖用红色点缀，外部是八个大莲花瓣，花瓣尖亦用红色绘成。莲花图案周围用深蓝色为地。

（临摹：张家泰 撰文、摄影：蔡全法）

The Lotus Motif on the Caisson Ceiling (Replica)

Eastern Han (25-220 CE)

Height 104 cm; Width 208 cm

Unearthed from Tomb 2 at west of Dahutingcun in Xinmi, Henan, in 1960. Preserved on the original site.

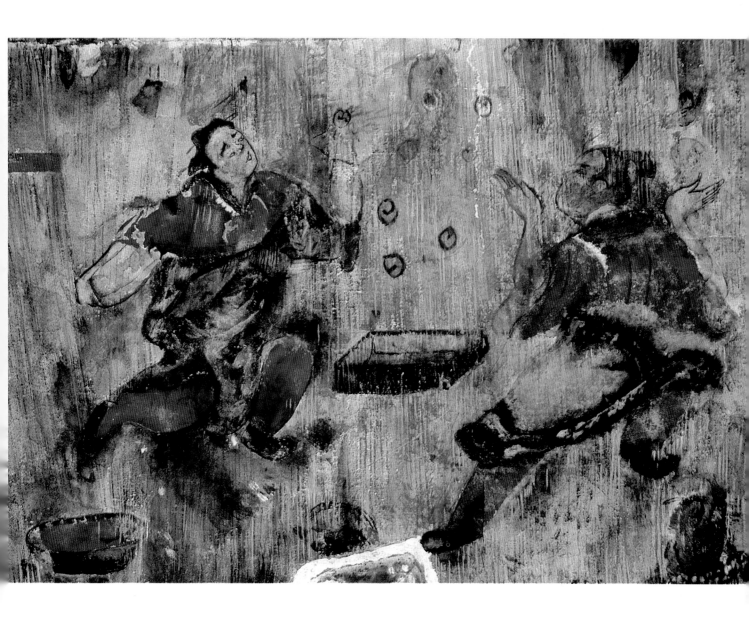

71. 抛丸图

东汉（25～220年）

高28、宽35厘米

1960年河南省新密市打虎亭村西2号墓出土。原址保存。

墓向172°。位于二号墓中室北壁东段上部。宴乐图中间偏东侧。左侧一人，绾独髻，插长簪，面为仰望状，穿黑色短袍，束腰，红斗篷，紧身裤，黑鞋，左前脚掌蹬起，右脚向后翘起，双手半举作接抛弹丸状。右边一人侧身，亦为独髻，身着红色衣，腰围黑色短裙，穿红色紧身裤，右腿作弓步，左腿斜蹬，双手半举抛接弹丸状。两人中间放一黑色盆，空中有十个弹丸。

（临摹、撰文、摄影：蔡全法）

Double-player Juggling

Eastern Han (25-220 CE)

Height 28 cm; Width 35 cm

Unearthed from Tomb 2 at west of Dahutingcun in Xinmi, Henan, in 1960. Preserved on the original site.

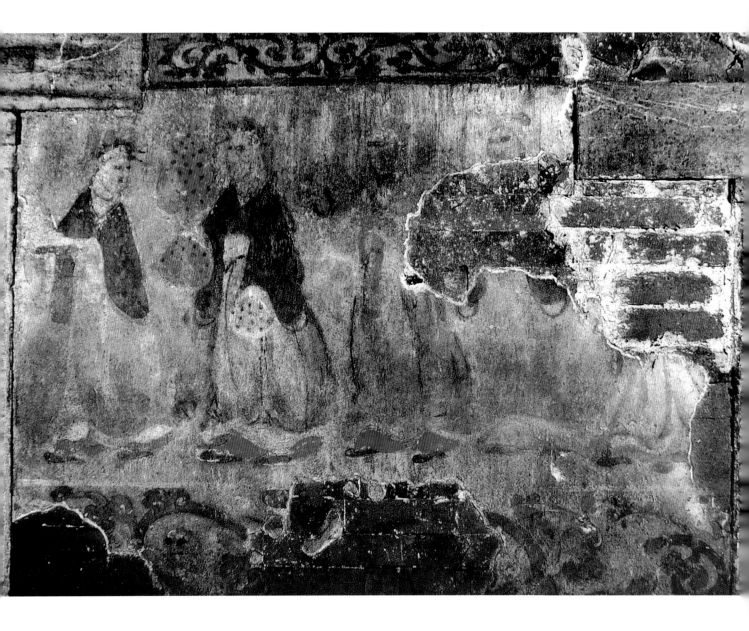

72.侍女图

东汉（25～220年）

高约117、宽212厘米

1960年河南省新密市打虎亭村西2号墓出土。原址保存。

墓向172°。位于中室北壁东段下部后室门东侧。画面绘五位侍女，均头梳扇形髻，插较多的发笄，着黑色或素短衣，围白色素裙，披斗篷，穿红裤，黑鞋。各持物作行进状。东面三人像各有不同程度的残缺。

（撰文：蔡全法 摄影：张建中等）

Attending Maids

Eastern Han (25-220 CE)

Height ca. 117 cm; Width 212 cm

Unearthed from Tomb 2 at west of Dahutingcun in Xinmi, Henan, in 1960. Preserved on the original site.

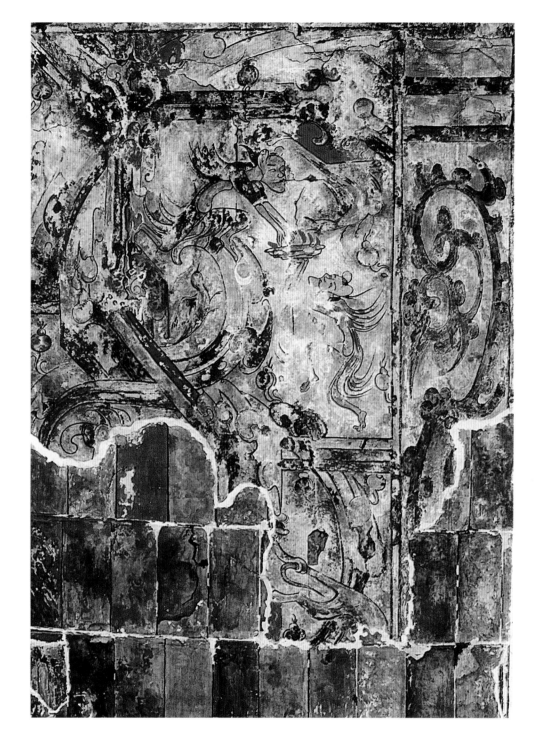

73.仙人及异禽瑞兽图（摹本）

东汉（25～220年）

高120、宽78厘米

1960年河南省新密市打虎亭村西2号墓出土。原址保存。

墓向172°。位于中室东段券顶藻井北侧，西起第二幅。以云气纹界为多层空间，下部壁画脱落较甚。内绘仙人和神禽异兽在云中飞翔跳跃的形像，画面以瑞云界为"S"形图案，上部空白的地方绘出二位仙人，一仙人在左上侧，人首兽耳，肩生双翼，上穿黑色蓝点短袖衣，赤脚跨步，作躬腹接物状。其右下方另一仙人，亦为人首兽耳，肩生双翼，身有长毛，右腿抬起，左腿前曲，双手托盘，递向上部仙人。

（临摹：不详　撰文、摄影：蔡全法）

Immortals and
Mystical Animals in
Cloud (Replica)

Eastern Han (25-220 CE)
Height 120 cm; Width 78 cm
Unearthed from Tomb 2 at
west of Dahutingcun in Xinmi,
Henan, in 1960. Preserved on
the original site.

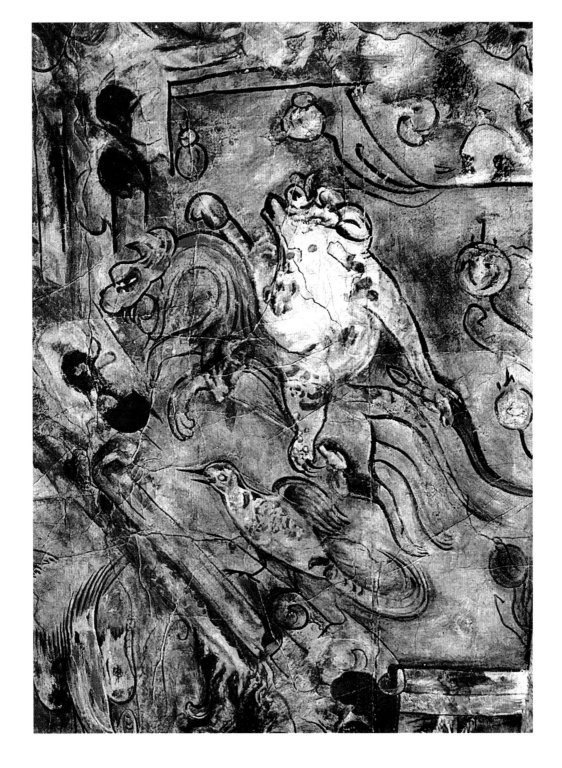

74. 异禽瑞兽图（摹本）

东汉（25～220年）

高25.3、宽15.4厘米

1960年河南省新密市打虎亭村西2号墓出土。原址保存。

墓向172°。位于中室东段券顶，西起第三幅藻井北侧右上角。画面四周用黑、红、蓝、赭诸色绘云气纹和仙草，长卷尾飞鸟和红冠短尾飞鸟。中上部绘一白熊，身上有较多的黑色和蓝色斑纹，头上部绘有鬃毛和两个硕大突出的眼睛，长而小的嘴巴，肥硕的身躯，右肢抬起，握爪向下，左肢撤后，紧握一赭色长鞭，横跨于猛虎腰脊。猛虎淡染红色，张巨口，翘双耳，长尾，四蹄腾空作飞奔状。

（临摹：不详　撰文、摄影：蔡全法）

Mystical Animals in Cloud (Replica)

Eastern Han (25-220 CE)

Height 25.3 cm; Width 15.4 cm

Unearthed from Tomb 2 at west of Dahutingcun in Xinmi, Henan, in 1960. Preserved on the original site.

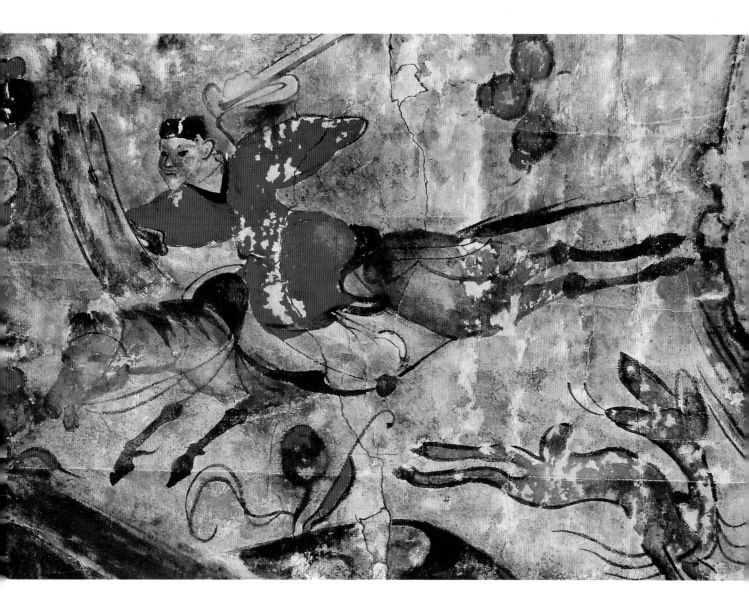

75.骑马武士图（摹本）

东汉（25～220年）

高35、宽55厘米

1960年河南省新密市打虎亭村西2号墓出土。原址保存。

墓向172°。位于中室东段券顶，西起第五幅藻井南侧。武士为头戴平巾帻青年男子，着交领宽袖短袍，白裤，黑鞋，左手持盾，右手挥舞带环长刀。坐下为飞奔的枣红马，鬃尾、腿蹄、马鞍、缰绳都是黑色。右下侧一只小鹿作回首奔逃之态。

（临摹:不详　撰文、摄影：蔡全法）

Warrior on Galloping Horse (Replica)

Eastern Han (25-220 CE)

Height 35 cm; Width 55 cm

Unearthed from Tomb 2 at west of Dahutingcun in Xinmi, Henan, in 1960. Preserved on the original site.

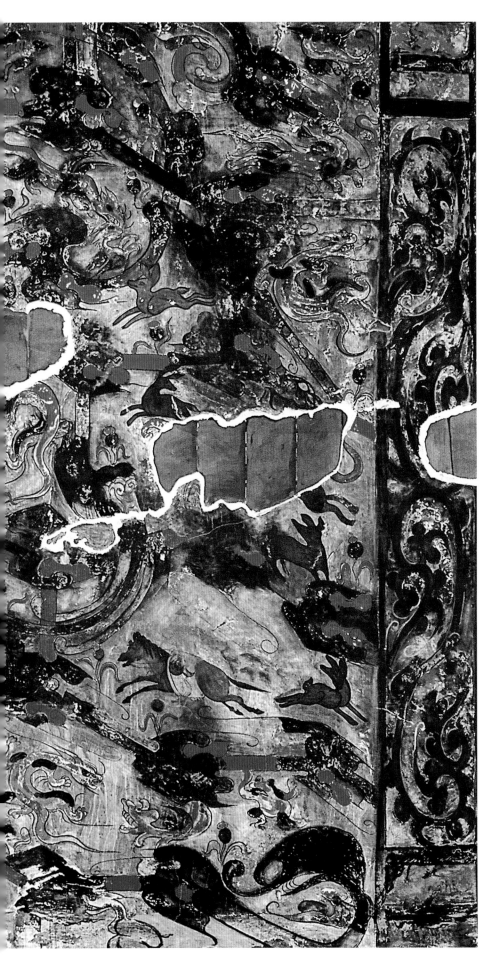

76. 仙人骑马异禽瑞兽图（摹本）

东汉（25～220年）

高197、宽85厘米

1960年河南省新密市打虎亭村西2号墓出土。原址保存。

墓向172°。位于墓中室东段券顶西起第六幅藻井南侧。该幅壁画中部稍有破损，四周以红色为地，黑色绘云气纹图案，中部用黑、赭、红诸色绘飞翔的红冠卷尾鸟。奔兔、奔鹿、带翼狼首怪兽、翼虎、飞腾的翼龙，一大一小相斗戏的飞虎、跳跃的蟾蜍等。空间之中还绘有奇异仙草、仙果等。

（临摹：不详　撰文、摄影：蔡全法）

Mounted Immortals and Mystical Animals in Auspicious Clouds (Replica)

Eastern Han (25-220 CE)

Height 197 cm; Width 85 cm

Unearthed from Tomb 2 at west of Dahutingcun in Xinmi, Henan, in 1960. Preserved on the original site.

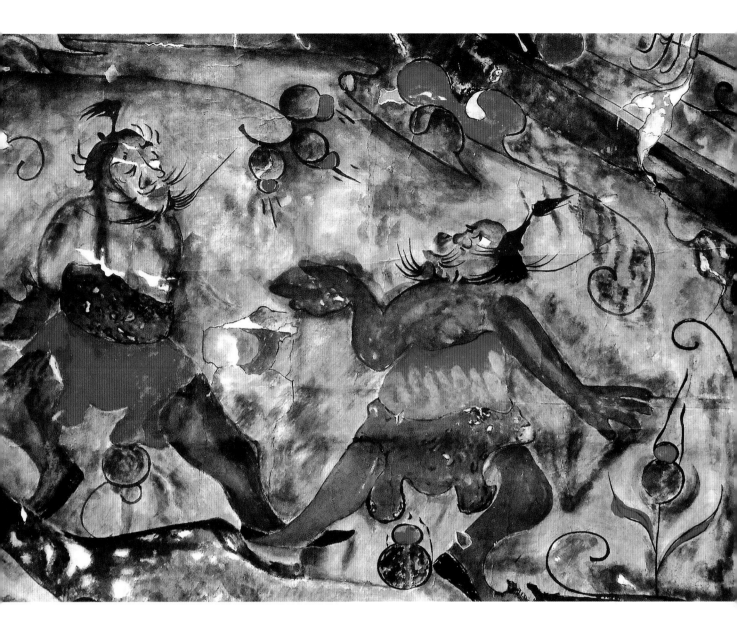

77. 角抵戏图（摹本）

东汉（25～220年）

高40、宽74厘米

1960年河南省新密市打虎亭村西2号墓出土。原址保存。

墓向172°。位于中室券顶北侧，西起第六幅藻井壁画中部偏下侧，所绘内容为角抵戏（相扑）。画幅的四周为墨色加红彩的云气纹，并点缀有仙草和仙果。中间为两力士，均顶绾独髻，粗眉大眼，宽鼻，长络腮胡，朱唇，上身裸露，下穿短裤，左一人双臂撤身后，右一人右手半举，左手斜垂，二人均一脚前蹬，一脚后弓，作搏击姿态。

<div align="right">（临摹：张家泰 撰文、摄影：蔡全法）</div>

Wrestling Scene (Replica)

Eastern Han (25-220 CE)

Height 40 cm; Width 74 cm

Unearthed from Tomb 2 at west of Dahutingcun in Xinmi, Henan, in 1960. Preserved on the original site.

78. 户内燕居图（一）

东汉（25～220年）

高约57、宽59厘米

1978年河南省新密市后士郭村西1号墓出土。原址保存。

墓向189°。位于中室北壁西侧。画像表现的是菱格窗内的室内燕居景象。菱格窗边框饰以云气纹。窗内左侧一男子，头戴白巾帻，着红衣，右手向上，左手捧包袱状物。中间女子，梳双髻，着绿衣，一手上举，一手隐于右边女子身后，与男子作交谈状。右边女子，双髻，红衣，手扶窗棂，背对以上两人。

（撰文：蔡全法 摄影：魏殿臣）

Family Life Seen through Rhombus-latticed Window (1)

Eastern Han (25-220 CE)

Height ca. 57 cm; Width 59 cm

Unearthed from Tomb M1 at West of Houshiguocun in Xinmi, Henan, in 1978. Preserved on the original site.

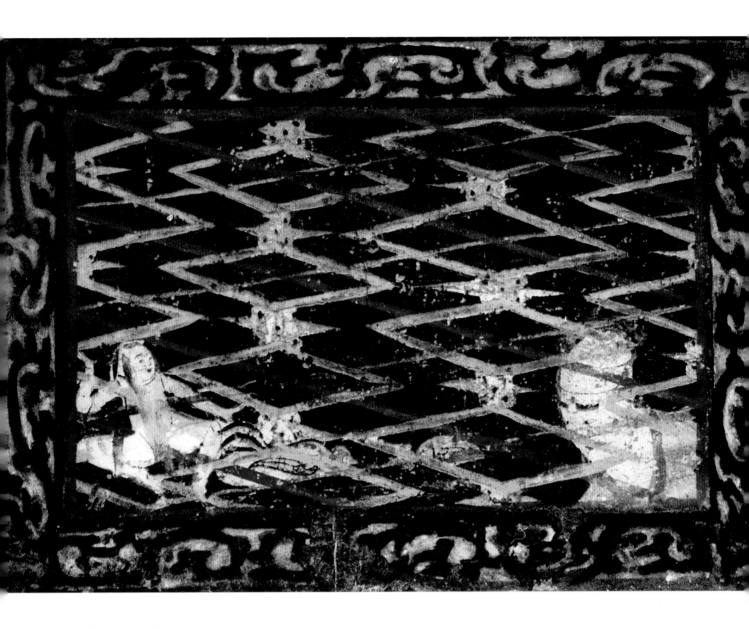

79.户内燕居图（二）

东汉（25～220年）

高62、宽86厘米

1978年河南省新密市后士郭村西1号墓出土。原址保存。

墓向189°。位于中室北壁中部，画面为一方形菱格窗，四框饰云纹。在窗内左绘一人，披发，着绿上衣，举右手，伸左手。下肢裸露，两腿跪曲，赤足，两眼斜视两鸡相斗。右边一人露半身，戴巾帻，着白袍，两眼凝视斗鸡。

（撰文：蔡全法 摄影：魏殿臣）

Family Life Seen through Rhombus-latticed Window (2)

Eastern Han (25-220 CE)

Height 62 cm; Width 86 cm

Unearthed from Tomb M1 at West of Houshiguocun in Xinmi, Henan, in 1978. Preserved on the original site.

80.猛禽哺蛇图

东汉（25～220年）

1978年河南省新密市后士郭村西3号墓出土。原址保存。

墓向南。位于墓前室东壁。画面以一对猛禽为主体。下部是由墨画出茂密的树盖，并加点绿彩，在树冠的顶部左侧落下黑色猛禽，尖翅，宽大的长尾，长腿，大爪，啄一条长蛇，目视右侧一鸟。右侧猛禽为赭色，张开长啄，展翅摆尾，双爪立于树冠上，屈腿欲飞，作待哺之状。

（撰文：蔡全法 摄影：魏殿臣）

Bird of Prey Feeding Nestling with Snake

Eastern Han (25-220 CE)

Unearthed from Tomb M3 at west of Houshiguocun in Xinmi, Henan, in 1978. Preserved on the original site.

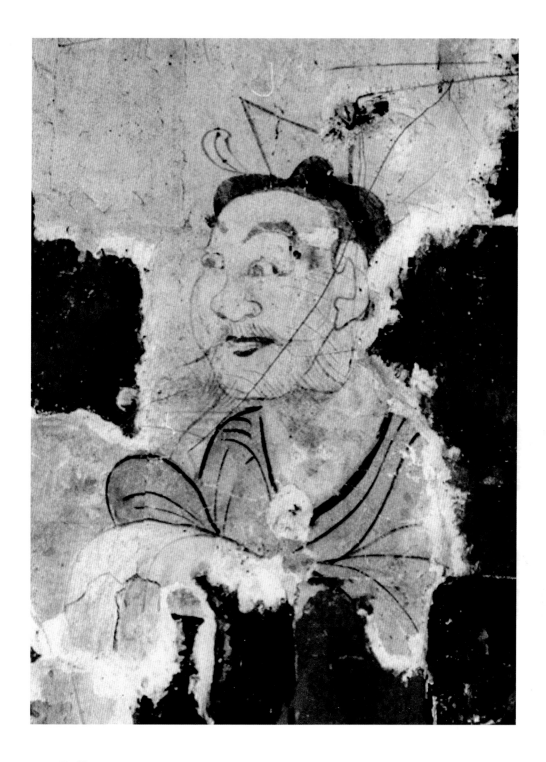

81. 人物像

东汉（25～220年）

1978年河南省新密市后士郭村西3号墓出土。原址保存。

墓向南。位于墓中室。中室壁画大部分残损，仅保留一人物的上半身，为男性，头戴巾帻，着红袍，脸颊丰颐，浓眉大眼，留疏散的胡须。作开口微笑之态。

（撰文：蔡全法 摄影：魏殿臣）

Portrait of a Man

Eastern Han (25-220 CE)

Unearthed from Tomb M3 at west of Houshiguocun in Xinmi, Henan, in 1978. Preserved on the original site.

82.绿袍人物图

东汉（25～220年）

1978年河南省新密市后士郭村西3号墓出土。原址保存。

墓向南。位于墓前室东壁。为一男子，头上绾绿巾，浓眉大眼，高鼻，红唇，身着绿袍，绿带束腰，作躬身状，下部残缺。

（撰文：蔡全法 摄影：魏殿臣）

Man in Green Robe

Eastern Han (25-220 CE)

Unearthed from Tomb M3 at west of Houshiguocun in Xinmi, Henan, in 1978. Preserved on the original site.

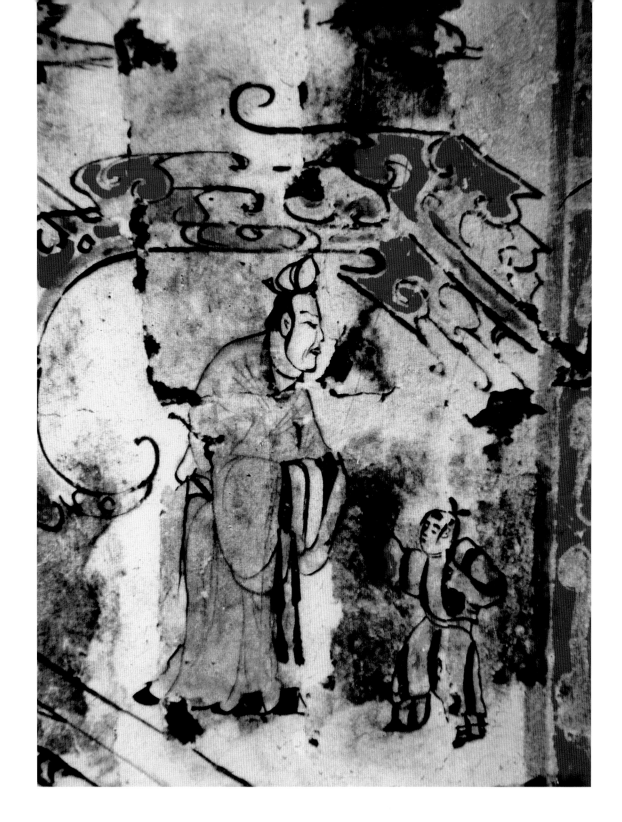

83.童叟对语图

东汉（25～220年）

高约61.2、宽35.2厘米

1995年河南省荥阳市王村乡苌村汉墓出土。原址保存。

墓向180°。位于前室上部。画幅都用祥云分隔。左为一长者，顶有小冠，面目慈善，着黄色长袍，腰缠丝带，穿黑色鞋，合双袖，躬身望右侧小童。小童面对长者跨步站立，前额留有一撮短发，两侧各留一撮长发，脑后绾倒"丫"字形小髻，着黄色黑道小袍，黑鞋，右手指长者，左手持物。

（撰文：蔡强　摄影：陈万卿等）

Old man and Child in Talking

Eastern Han (25-220 CE)

Height ca. 61.2 cm; Width 35.2 cm

Unearthed from Han tomb at Changcun of Wangcunxiang in Xingyang, Henan, in 1995. Preserved on the original site.

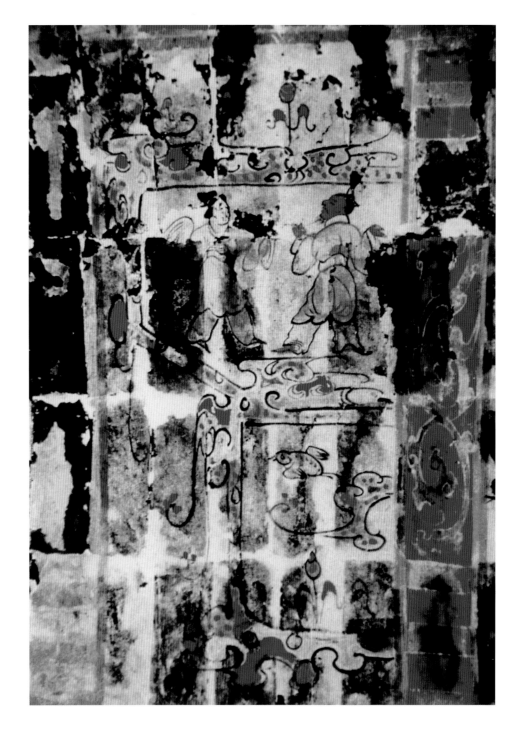

84. 人物飞鸟图

东汉（25～220年）

高约114.8、宽84厘米

1995年河南省荥阳市王村乡苌村汉墓出土。原址保存。
墓向180°。位于前室上部。上绘翁姬相对，下绘祥云
和飞鸟。图画上部左侧站一老姬，绾高髻，八字眉，
高颧骨，宽下腭，着右衽衣，腰间系带，长裤赤脚，
左手前伸指男翁，右手屈举。老翁跨步作侧立状，绾
髻戴冠，浓眉大眼，鹰勾鼻，山羊胡须。身着黄色短
袍，腰围带，穿素长裤，赤脚，撒开双手，与左侧老
妇相对而立。

（撰文：蔡强　摄影：陈万卿等）

Human Figures and Flying Birds

Eastern Han (25-220 CE)
Height ca. 114.8 cm; Width 84 cm
Unearthed from Han tomb at Changcun of Wangcunxiang in Xingyang, Henan, in 1995. Preserved on the original site.

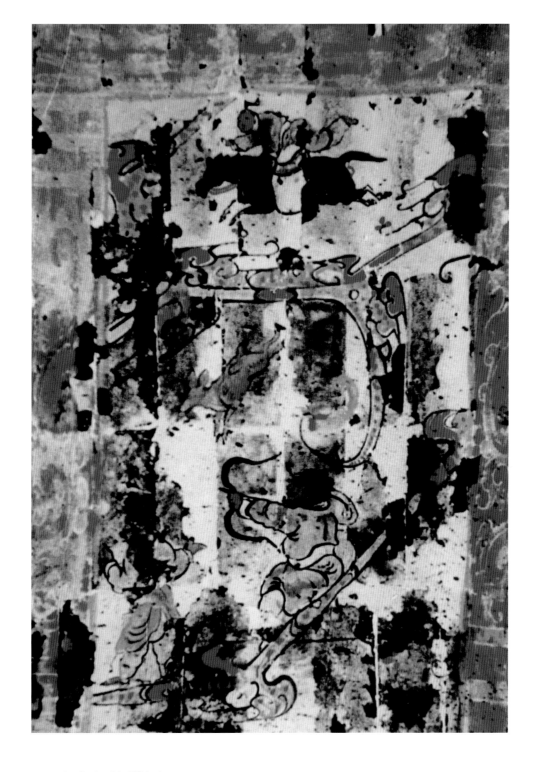

85.马戏和狩猎图

东汉（25～220年）

高约110.25、宽88.3厘米

1995年河南省荥阳市王村乡苌村汉墓出土。原址保存。墓向180°。位于前室上部。上图有一人单臂按于马背，双腿腾空，顶缩独髻，上部散开，颧骨突出，着小袖紧身衣，束腰，下穿青色紧身裤，并带有黄色护膝赤脚。下为射猎图，左下角一人，着豆青色短上衣，腰围黄色裙，着长裤，赤双脚。坦双臂顾盼奔兽。另一人短发，着蓝色长袍，腰间束白带，呈蹲跪状，拉弓欲射。

（撰文：蔡强 摄影：陈万卿等）

Equestrian Performance and Archery Scene

Eastern Han (25-220 CE)

Height ca. 110.25 cm; Width 88.3 cm

Unearthed from Han tomb at Changcun of Wangcunxiang in Xingyang, Henan, in 1995. Preserved on the original site.

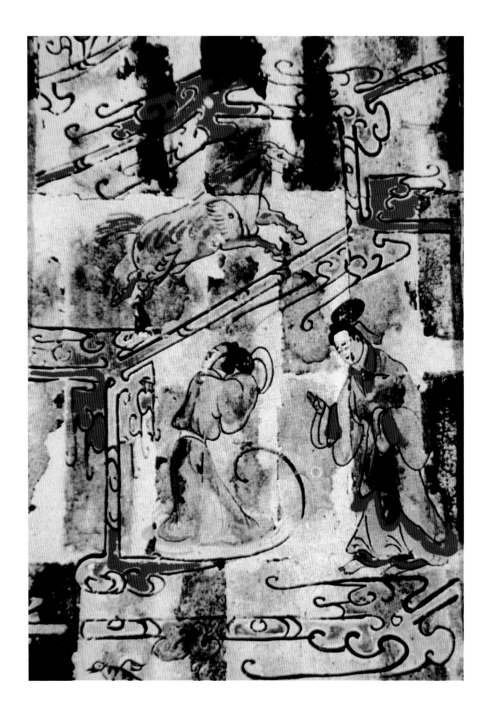

86．天马、人物图

东汉（25～220年）

高约104.45、宽76.3厘米

1995年河南省荥阳市王村乡苌村汉墓出土。原址保存。
墓向180°。位于前室上部。以云纹将画面分隔为"S"
形，上图绘黄色天马，马首前视，四蹄腾空，双肩生
羽，长鬃向后飘动，粗尾撅起，鬃尾、腹、四腿上都涂
染红色。下图绘二妇人，左侧一人，梳高髻，脸朝后，
合手作拜谒状。右侧女子，相似贵妇人，头梳环髻，面
目清秀，赤脚躬身，右手伸掌前摆，左手放于胸前，作
受礼状。

（撰文：蔡强 摄影：陈万卿等）

Heavenly Horse and Women Figures

Eastern Han (25-220 CE)
Height ca. 104.45 cm; Width 76.3 cm
Unearthed from Han tomb at Chang-cun of Wangcunxiang in Xingyang, Henan, in 1995. Preserved on the original site.

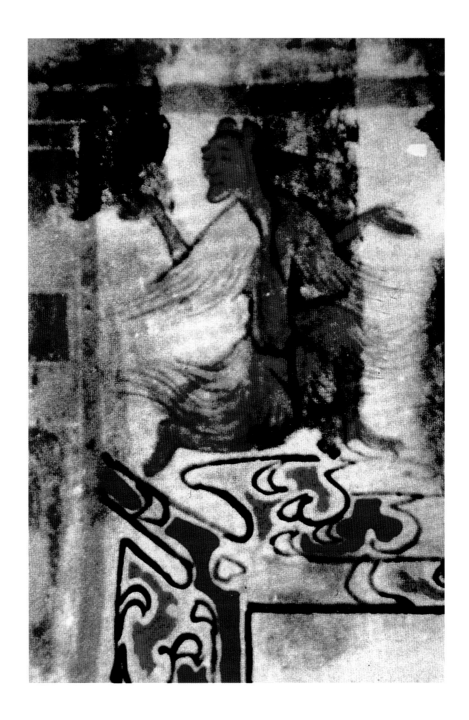

87. 仙人图

东汉（25～220年）

高约66、宽49厘米

1995年河南省荥阳市王村乡苌村汉墓出土。原址保存。

墓向180°。位于前室上部。羽人人首兽耳，毛发飘然，红色皮肤，双翼，一腿前蹲，另一腿单膝跪地，右手半举似托物于上，左手撒开前伸，身下有蓝色和红色瑞云。胸部有残缺。左上侧饰有飞鸟。

（撰文：蔡强 摄影：陈万卿等）

Winged Immortal

Eastern Han (25-220 CE)

Height ca. 66 cm; Width 49 cm

Unearthed from Han tomb at Changcun of Wangcunxiang in Xingyang, Henan, in 1995. Preserved on the original site.

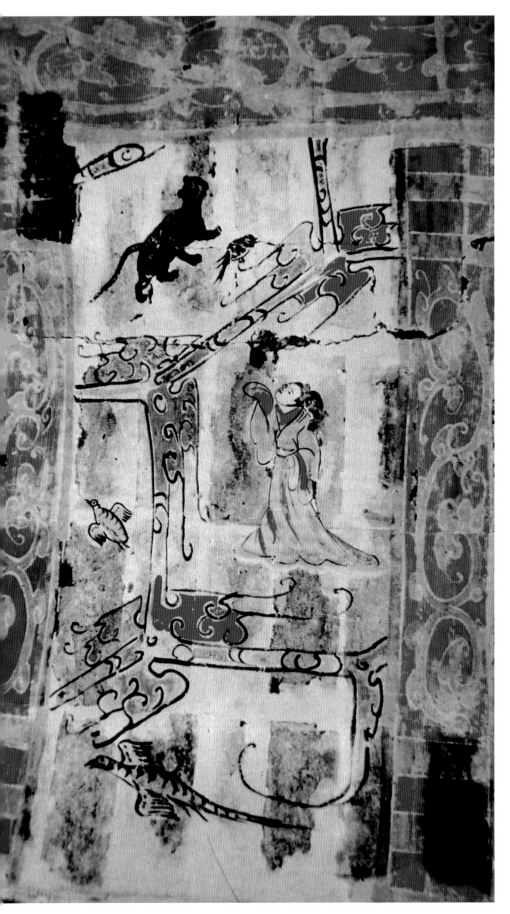

88.人物异禽瑞兽图
（一）

东汉（25～220年）

高约121.9、宽74.1厘米

1995年河南省荥阳市王村乡苌村汉墓出土。原址保存。

墓向180°。位于前室上部。画面以瑞云分界：上层有黑色颈腹拴系红绳的怪兽和黑色雀鸟。中部一青年女子，梳环形髻，面目清秀，着青色右衽宽袖衣，下围黄色红道拖地长裙，领及袖口镶红边，右臂折举，左臂微上屈，手半握放在腰间，作仰望之态。左侧有一展翅、秃尾、向上飞翔的黄色小鸟，下另有一黄色长尾鸟飞翔。

（撰文：蔡强　摄影：陈万卿等）

Mythical Animals and Human Figures (1)

Eastern Han (25-220 CE)

Height ca. 121.9 cm; Width 74.1 cm

Unearthed from Han tomb at Changcun of Wangcunxiang in Xingyang, Henan, in 1995. Preserved on the original site.

89.人物异禽瑞兽图
（二）

东汉（25～220年）

高约105.5、宽84.6厘米

1995年河南省荥阳市王村乡苌村汉
墓出土。原址保存。

墓向180°。位于前室上部。以云
气纹把壁画分界为六部分：上部绘
一黄色长尾飞鸟；中上部绘二贵妇
人，右上一妇人，项部以上残缺，
着黄色饰红道宽袖衣，腰束宽带，
掩足作行进状。左侧妇人梳环形高
髻，插长簪。面目清秀，着黄色饰
红道长衣，腰束宽带，长裙拖地掩
足，双臂微上屈，放于腰间，作蠢
立凝视之态。中下部绘黄色飞鸟与
带翼的奔兽。

（撰文：蔡强 摄影：陈万卿等）

Mythical Animals and Human Figures (2)

Eastern Han (25-220 CE)

Height ca. 105.5 cm; Width 84.6 cm

Unearthed from Han tomb at
Changcun of Wangcunxiang in
Xingyang, Henan, in 1995. Preserved
on the original site.

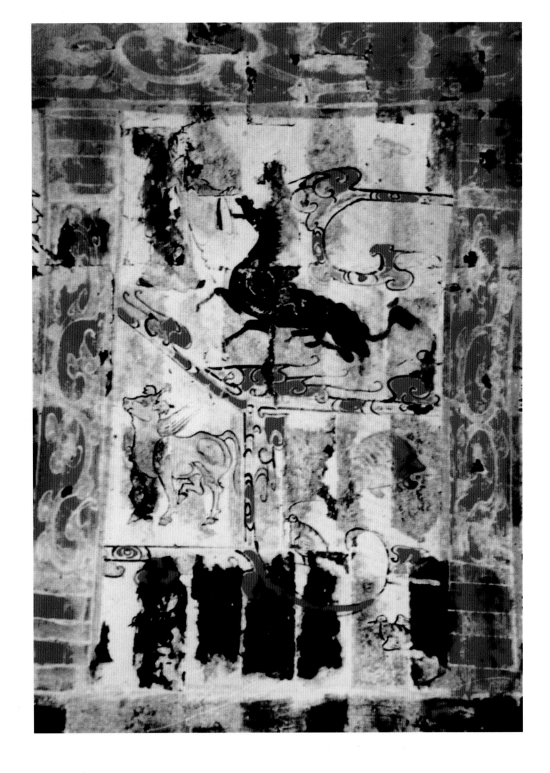

90. 驯马及异禽瑞兽图

东汉（25～220年）

高约152.2、宽109.9厘米

1995年河南省荥阳市王村乡苌村汉墓出土。原址保存。墓向180°。位于前室上部。云气纹的上部左立一男子，戴冠，着朱色长袍，左手持绳索，右手提鞭，穿黑屦，躬身作驯马之态。马为黑色，蹲卧，仰首，撅长尾，作惊恐嘶鸣状。中层左有独角兽，似鹿首，羊身，长尾，作站立仰望之状。右有红道黄色刺猬。下部有一立鸟。

（撰文：蔡强 摄影：陈万卿等）

Mythical Animals and Man Training Horse

Eastern Han (25-220 CE)

Height ca. 152.2 cm; Width 109.9 cm

Unearthed from Han tomb at Changcun of Wangcunxiang in Xingyang, Henan, in 1995. Preserved on the original site.

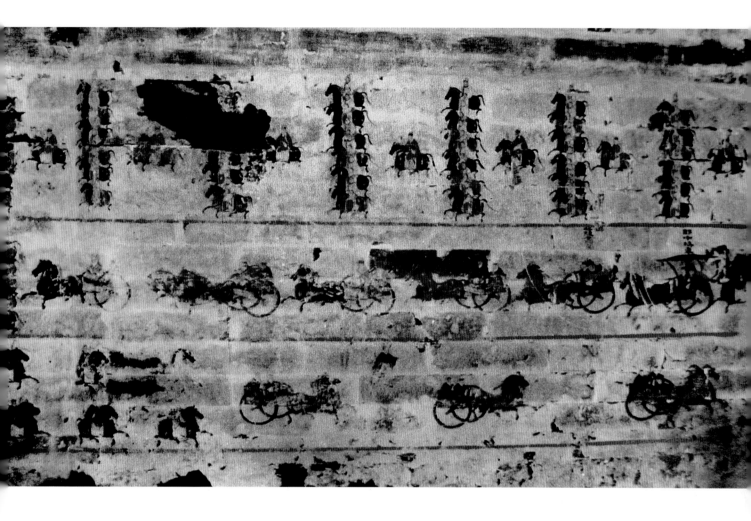

91. 车马出行图

东汉（25~220年）

高105、宽约121.3厘米

1995年河南省荥阳市王村乡苌村汉墓出土。原址保存。

墓向180°。位于前室中部。为车马出行图，分上、中、下三层，每层之间用红线相隔。中层各种车辆驾单马飞奔，主车上有题榜"供北陵令时车"，红马黑车，上坐二人，均戴平巾帻，右侧一人着黑袍驾车，左侧一人穿红袍躬身车内。其后一辆为"郎中时车"，黑马，红缰，黑车带盖，上坐二人。前面有四辆轺车同向奔驰。

（撰文：蔡强 摄影：陈万卿等）

Procession Scene

Eastern Han (25-220 CE)

Height 105 cm; Width ca. 121.3 cm

Unearthed from Han tomb at Changcun of Wangcunxiang in Xingyang, Henan, in 1995. Preserved on the original site.

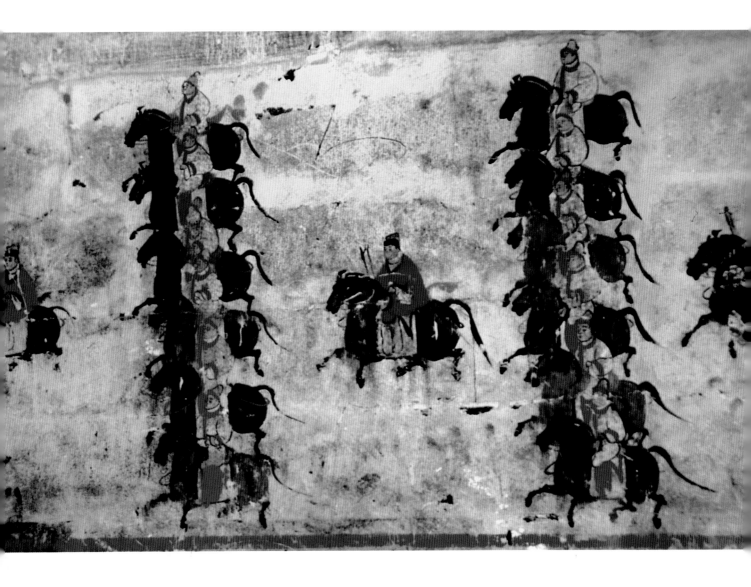

92.车马出行图（局部一）

东汉（25～220年）

高54.5、宽约80.1厘米

1995年河南省荥阳市王村乡苌村汉墓出土。原址保存。

墓向180°。位于前室中部。为骑吏队列局部，一前导骑吏，后从者六骑，重复数排布局。前面导骑，或黑马，或棕色马，骑吏均戴平巾帻，穿红色短袍，白长裤，黑屦。右手持鞭，左手握缰绳。骑吏均带白色尖顶小帽，着白短袍，穿红色长裤，帽口，衣领，衣襟袖口具镶红边。

（撰文：蔡强　摄影：陈万卿等）

Procession Scene (Detail 1)

Eastern Han (25-220 CE)

Height 54.5 cm; Width ca. 80.1 cm

Unearthed from Han tomb at Changcun of Wangcunxiang in Xingyang, Henan, in 1995. Preserved on the original site.

93.车马出行图（局部二）

东汉（25～220年）

高52.5、长约92厘米

1995年河南省荥阳市王村乡苌村汉墓出土。原址保存。

墓向180°。位于前室中部。为行进中骑吏队列。前部上、中、下三排，上、下二排各三骑，中排为二骑，再后一列六骑，此后为独骑。前三排八骑和后面独骑，马匹或红或黑，骑吏均戴平巾帻，着红短袍，白裤，黑鞋，右手执鞭，左手握缰，马作行进状。中间一列，马匹一黑一红，更递排列。骑吏均戴白色尖圆顶小帽，着白色短袍，穿红色裤，黑鞋。

<div align="right">（撰文：蔡强　摄影：陈万卿等）</div>

Procession Scene (Detail 2)

Eastern Han (25-220 CE)

Height 52.5 cm; Width ca. 92 cm

Unearthed from Han tomb at Changcun of Wangcunxiang in Xingyang, Henan, in 1995. Preserved on the original site.

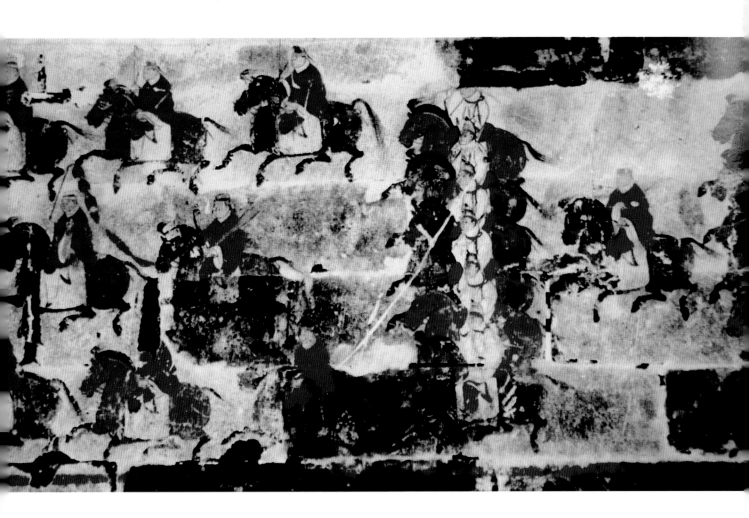

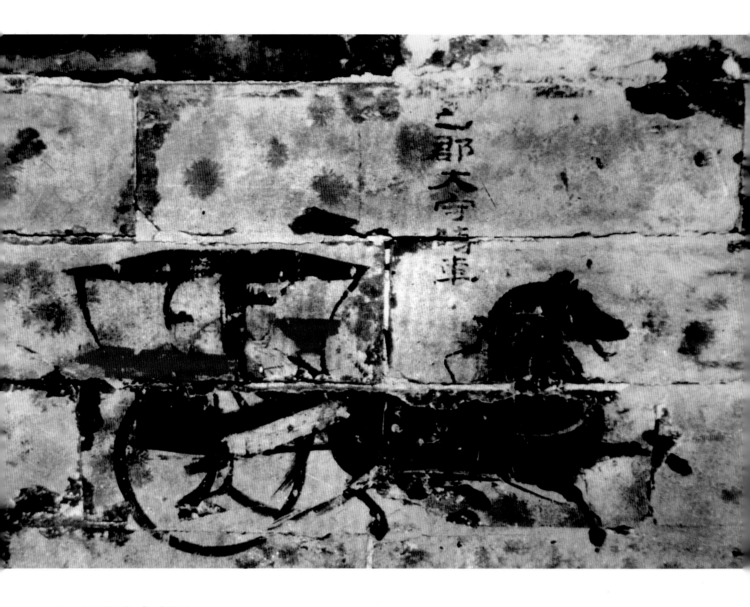

94. 巴郡太守车图

东汉（25～220年）

高40.36、宽约57.9厘米

1995年河南省荥阳市王村乡苌村汉墓出土。原址保存。

墓向180°。位于前室中部。为单匹乘驾的皂盖朱两幡轺车。车上坐二人，前为驭者，后为主人，均戴平巾帻，驭者着白袍，主人着黑袍。上有隶书题榜"巴郡太守时车"。

（撰文：蔡强　摄影：陈万卿等）

Carriage of the Tomb Occupant when He was the Governor of Ba Prefecture

Eastern Han (25-220 CE)

Height 40.36 cm; Width ca. 57.9 cm

Unearthed from Han tomb at Changcun of Wangcunxiang in Xingyang, Henan, in 1995. Preserved on the original site.

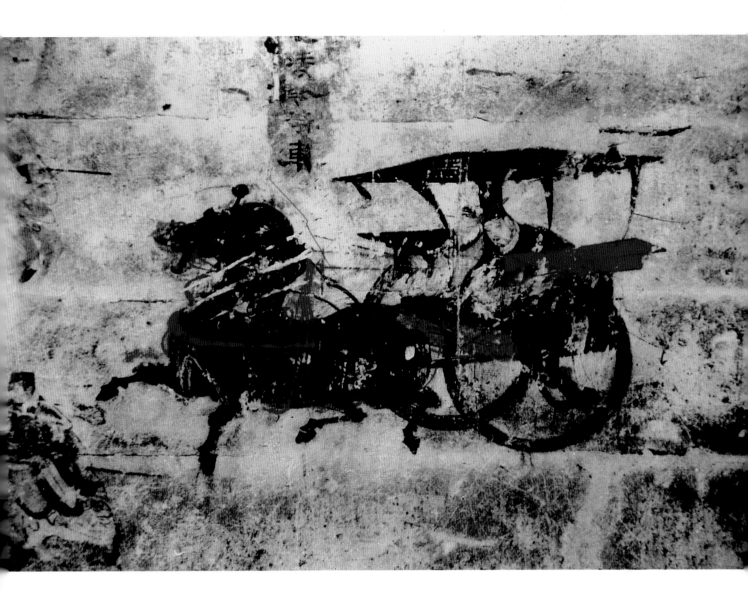

95. 北陵令车图

东汉（25～220年）

高35.5、宽约51厘米

1995年河南省荥阳市王村乡苌村汉墓出土。原址保存。

墓向180°。位于前室中部。为左行的四维皂盖朱左幡轺车。右侧为驭者，双手持缰驾车，左侧墓主端坐于车内，两人均戴平巾帻。上有隶书题榜"供北陵令时车"。

（撰文：蔡强　摄影：陈万卿等）

Carriage of the Tomb Occupant when He was the Commander of Beiling

Eastern Han (25-220 CE)

Height 35.5 cm; Width ca. 51 cm

Unearthed from Han tomb at Changcun of Wangcunxiang in Xingyang, Henan, in 1995. Preserved on the original site.

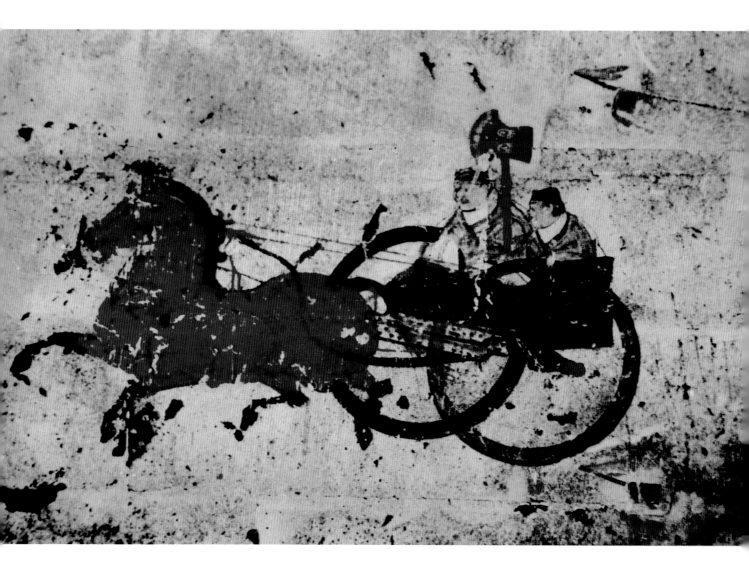

96. 斧车图

东汉（25~220年）

高32、宽约48厘米

1995年河南省荥阳市王村乡苌村汉墓出土。原址保存。

墓向180°。位于前室中部。为双人驾乘的红色斧车。车舆内右侧一人较高大，端坐凝视前方，左侧一人较矮小，双手执缰绳。乘者和驭者均戴平巾帻，着白领、白袖口，土黄色袍服。

（撰文：蔡强 摄影：陈万卿等）

The Ax Chariot (as a Herald)

Eastern Han (25-220 CE)

Height 32 cm; Width ca. 48 cm

Unearthed from Han tomb at Changcun of Wangcunxiang in Xingyang, Henan, in 1995. Preserved on the original site.

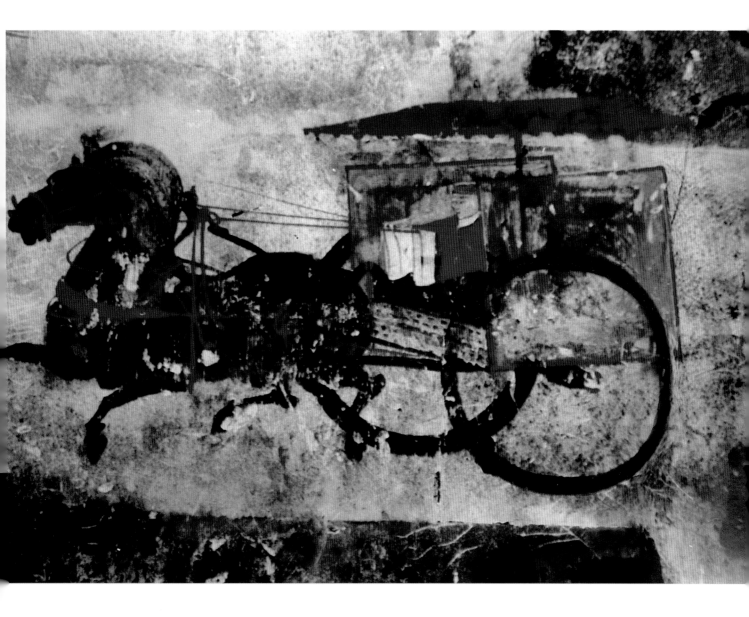

97.轩车图

东汉（25～220年）

宽32.2、宽约44厘米

1995年河南省荥阳市王村乡苌村汉墓出土。原址保存。

墓向180°。位于前室中部。车前为单匹黑马，系有红色套绳和笼头，拉一赤盖轩车。车内坐一驭者，戴平巾帻，着白领、白袖口、红袍服，右手执长鞭，左手拉缰绳，驾车作奔跑行进状。

<div align="right">（撰文：蔡强　摄影：陈万卿等）</div>

Canopied Carriage

Eastern Han (25-220 CE)

Height 32.2 cm; Width ca. 44 cm

Unearthed from Han tomb at Changcun of Wangcunxiang in Xingyang, Henan, in 1995. Preserved on the original site.

98.抚琴图

东汉（25～220年）

高44.4、宽约65.5厘米

1995年河南省荥阳市王村乡苌村汉墓出土。原址保存。

墓向180°。位于墓内甬道下部。为一女子，头绾椭圆形高髻，上插多根花笄。高额头，脸形圆润，秀目朱唇。着红衣，挽袖作踞坐状。身前斜放一琴，上有红色琴弦，女子右手在前，左手在后抚琴。

（撰文：蔡强　摄影：陈万卿等）

Musician Playing Zither

Eastern Han (25-220 CE)

Height 44.4 cm; Width ca. 65.5 cm

Unearthed from Han tomb at Changcun of Wangcunxiang in Xingyang, Henan, in 1995. Preserved on the original site.

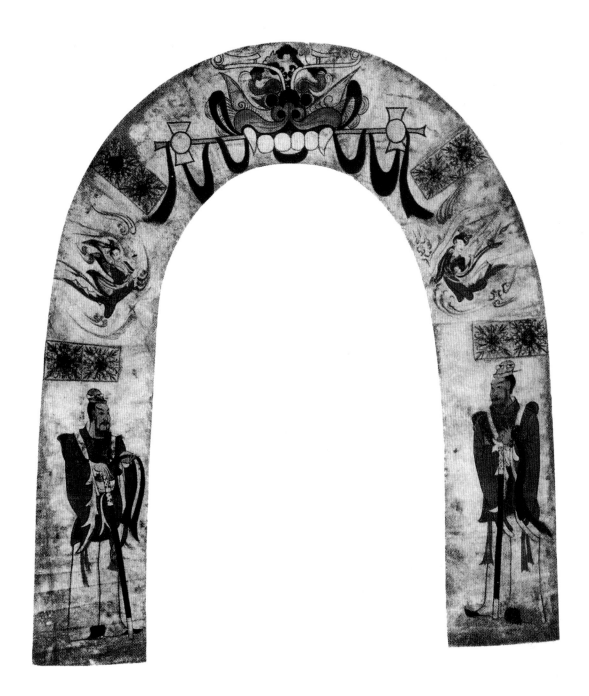

99. 墓券门壁画（摹本）

南朝（420～589年）

高300、宽270、两侧单幅宽60厘米

1957年河南省邓县张村西南南朝画像砖墓出土。现存于河南省文物考古研究所。

墓向175°。位于墓室券门正面。画面用朱红、黄、绿、蓝、紫、浅红、黑七种颜色绘成。上部绘一怪兽头，口衔一绕有紫色飘带的玉胜，向下两侧各绘一飞天，券门两侧各绘一守门武士，手按仪剑站立。在以上三类绘画之间都用两个四出草花图案相隔，似在表示着三种不同的世界。

（临摹：陈大章 撰文、摄影：蔡全法）

Façade of Tomb Entrance (Replica)

Southern Dynasties (420-589 CE)

Full Height 300 cm; Full Width 270 cm; Mural Width 60 cm

Unearthed from picture bricks tomb of the Southern Dynasties at southwest of Zhangcun in Dengxian, Henan, in 1957. Preserved in Henan Provincial Institute of Cultural Relics and Archaeology.

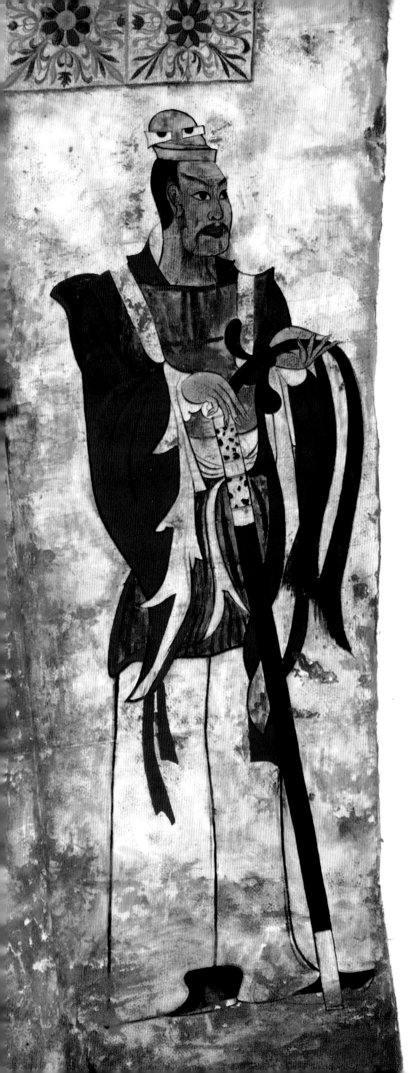

100. 守门武士（一）（摹本）

南朝（420～589年）

高85、宽60厘米

1957年河南省邓县张村西南南朝画像砖墓中出土。现存于河南省文物考古研究所。

墓向175°。位于券门正面西侧。守门武士，头戴蓝色小冠，插笄，浓长眉，凤目，垂鼻，留长须，上着朱色团领宽袖短袍，外套两裆衣，下着宽肥的长裤，黑色云头履。右手按剑于地，左手执赭色剑带，作侧立守候状。

（临摹：陈大章　撰文、摄影：蔡全法）

Door Guard (1) (Replica)

Southern Dynasties (420-589 CE)

Height 85 cm; Width 60 cm

Unearthed from picture bricks tomb of the Southern Dynasties at southwest of Zhangcun in Dengxian, Henan, in 1957. Preserved in Henan Provincial Institute of Cultural Relics and Archaeology.

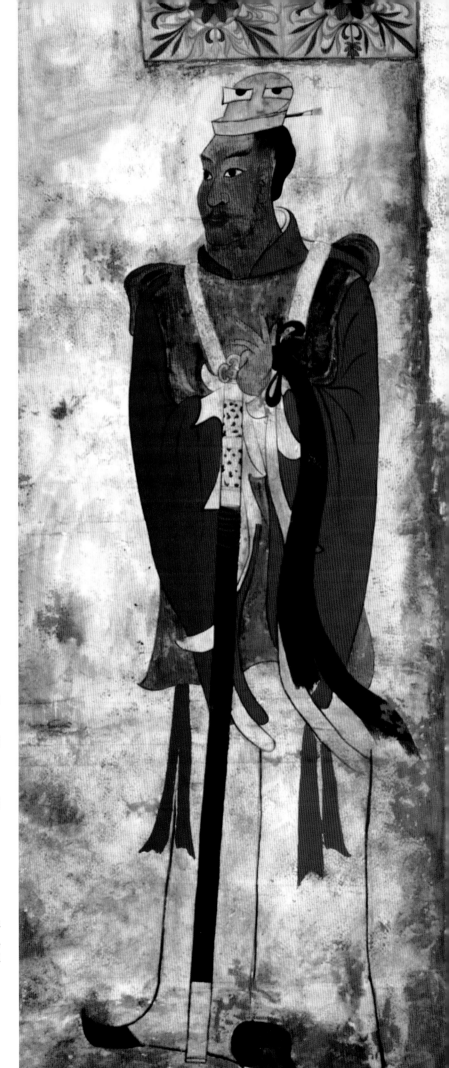

101.守门武士（二）（摹本）

南朝（420～589年）

高88、宽60厘米

1957年河南省邓县张村西南南朝画像砖墓中出土。现存于河南省文物考古研究所。

墓向175°。位于券门正面东侧。守门武士，头戴蓝色小冠，插笄，浓长眉，双目炯炯，高鼻，留有长胡须。穿朱色宽袖短袍，外套两裆甲，下着肥大的长裤，穿黑色云头屐，右手按长剑于地，目视门洞一侧，作守候防卫状。

（临摹：陈大章　撰文、摄影：蔡全法）

Door Guard (2) (Replica)

Southern Dynasties (420-589 CE)

Height 88 cm; Width 60 cm

Unearthed from picture bricks tomb of the Southern Dynasties at southwest of Zhangcun in Dengxian, Henan, in 1957. Preserved in Henan Provincial Institute of Cultural Relics and Archaeology.

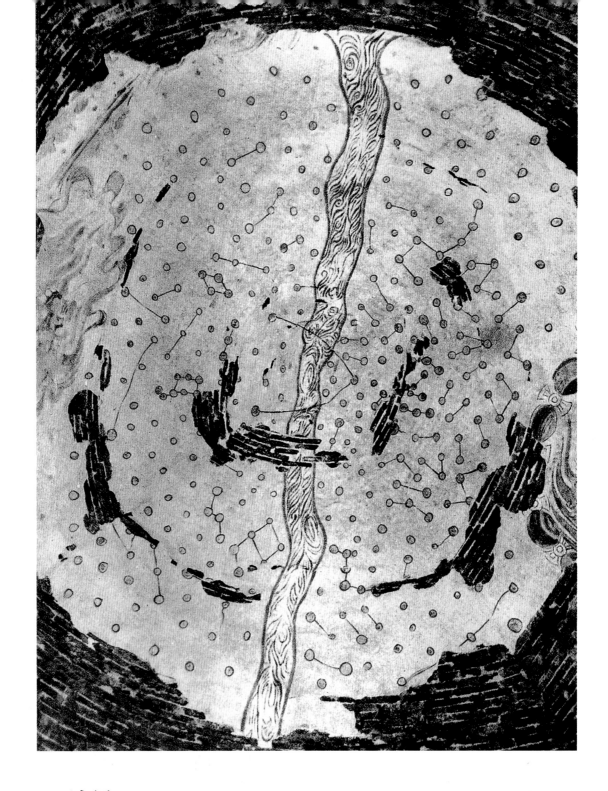

102.天象图

北魏（386～534年）

20世纪50年代以前河南省孟津县前海资村北魏元乂墓出土。现存于洛阳古墓博物馆。

墓向北。位于墓室顶部。所绘圆形天文图像，保存大部完好。图中间绘一道弯曲的银河，横贯南北。以朱线勾出银河的两道边缘，内绘淡蓝色波纹。银河东西两侧绘朱色星辰300余颗，有的星辰之间有连线，以表示星宿。据研究，大多星宿可以确认。这也是我国年代较早、幅面较大、星宿较多的"天象图"。

（撰文、摄影：蔡强）

Celestial Body Series

Northern Wei (386-534 CE)

Unearthed from Nothern Wei Yuan Yi's tomb at Qianhaizicun in Mengjin, Henan, in 1950s. Preserved in Museum of Ancient Tombs in Luoyang.

103.牵马图

唐神龙二年（706年）

高115厘米

2005年河南省洛阳市新区翠云路唐安国相王孺人唐氏墓出土。现存于洛阳古墓博物馆。

墓向183°。位于墓道东壁。牵马人头裹幞头，口涂朱，浓眉，大眼圆睁，身穿橙色交领窄袖短袍，腰束带，脚穿深灰色长筒靴，左手握拳指龙尾，右手挽马缰，若牵马行走状。

（撰文：史家珍 摄影：蔡盂轲）

Horse and Groom

2nd Year of Shenlong Era, Tang (706 CE)

Height 116 cm

Unearthed from the tomb of Ms. Tang, the Concubine of Imperial Prince Xiang of the Tang Dynasty at Cuiyun Road in new district of Luoyang, Henan, in 2005. Preserved in Museum of Ancient Tombs in Luoyang.

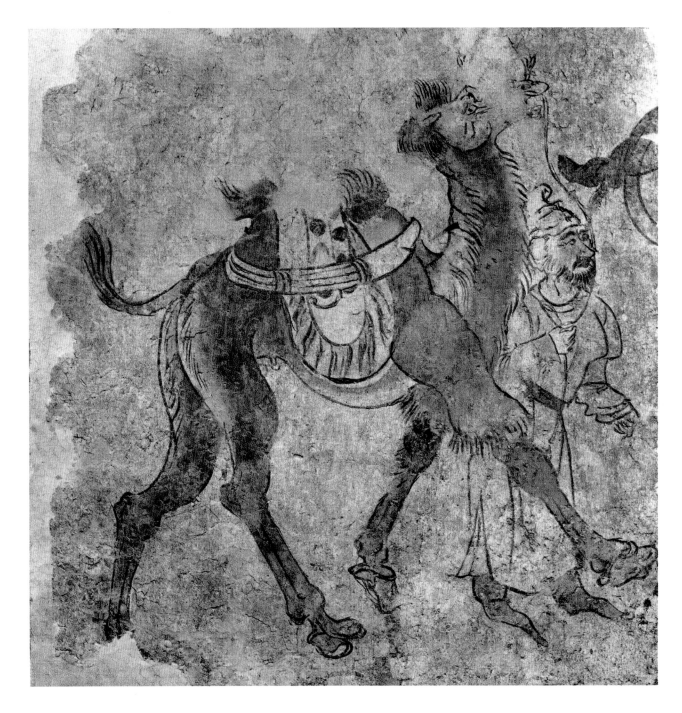

104. 胡人牵骆驼图（一）

唐神龙二年（706年）

高100厘米

2005年河南省洛阳市新区翠云路唐安国相王孺人唐氏墓出土。现存于洛阳古墓博物馆。

墓向183°。位于墓道东壁。胡人身材矮小，头戴尖顶帽，络腮胡，浓眉，高鼻，朱唇，身穿翻领束腰长袍，脚穿黑色布鞋，左手蜷缩身侧，右手置胸部，骆驼毛橙黄色，双峰，橙黄色鞍，作行走状。

（撰文：史家珍 摄影：洛阳古墓博物馆）

Camel and Central Asian Groom (1)

2nd Year of Shenlong Era, Tang (706 CE)

Height 100 cm

Unearthed from the tomb of Ms. Tang, the Concubine of Imperial Prince Xiang of the Tang Dynasty at Cuiyun Road in new district of Luoyang, Henan, in 2005. Preserved in Museum of Ancient Tombs in Luoyang.

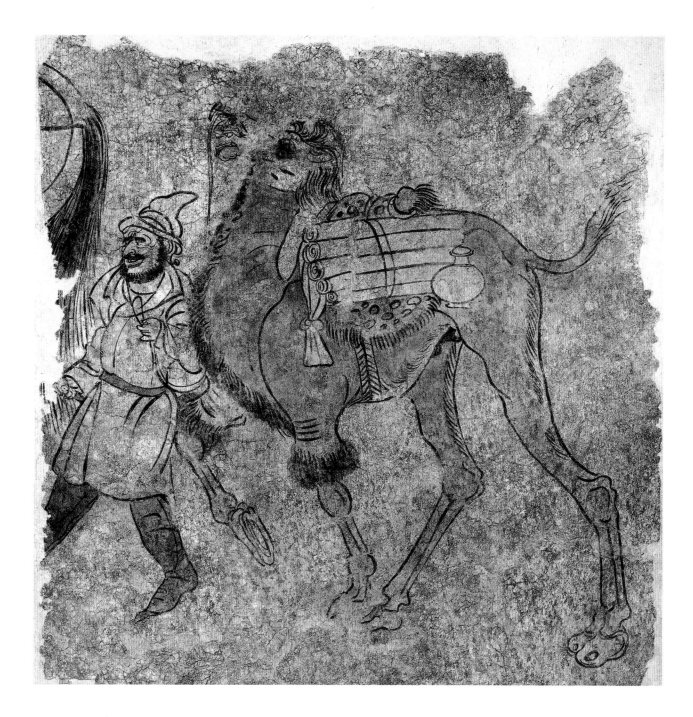

105.胡人牵骆驼图（二）

唐神龙二年（706年）

高110厘米

2005年河南省洛阳市新区翠云路唐安国相王孺人唐氏墓出土。现存于洛阳古墓博物馆。

墓向183°。位于墓道西壁。胡人身材矮小，头戴尖顶帽，络腮胡，浓眉，小眼，鹰鼻，张嘴，朱唇，身穿翻领束腰短袍，脚穿长筒靴，左手牵骆驼，右手执鞭，骆驼毛橙黄色，双峰，背悬一壶，尾上翘。

（撰文：史家珍 摄影：洛阳古墓博物馆）

Camel and Central Asian Groom (2)

2nd Year of Shenlong Era, Tang (706 CE)

Height 110 cm

Unearthed from the tomb of Ms. Tang, the Concubine of Imperial Prince Xiang of the Tang Dynasty at Cuiyun Road in new district of Luoyang, Henan, in 2005. Preserved in Museum of Ancient Tombs in Luoyang.

106.侏儒图（一）

唐神龙二年（706年）

高66厘米

2005年河南省洛阳市新区翠云路唐安国相王孺人唐氏墓出土。现存于洛阳古墓博物馆。

墓向183°。位于墓道东壁。侏儒头裹幞头，五官清晰，身穿团领束腰长袍，脚穿黑鞋。

（撰文：史家珍 摄影：蔡孟轲）

Midget (1)

2nd Year of Shenlong Era, Tang (706 CE)

Height 66 cm

Unearthed from the tomb of Ms. Tang, the Concubine of Imperial Prince Xiang of the Tang Dynasty at Cuiyun Road in new district of Luoyang, Henan, in 2005. Preserved in Museum of Ancient Tombs in Luoyang.

107. 侏儒图（二）

唐神龙二年（706年）

高66厘米

2005年河南省洛阳市新区翠云路唐安国相王孺人唐氏墓出土。现存于洛阳古墓博物馆。

墓向183°。位于墓道西壁。侏儒面部圆润，有胡须，蒜头鼻，左手举肩做招手之状，头裹幞头，右手握拳置腰部。

（撰文：史家珍　摄影：蔡孟轲）

Midget (2)

2nd Year of Shenlong Era, Tang (706 CE)

Height 66 cm

Unearthed from the tomb of Ms. Tang, the Concubine of Imperial Prince Xiang of the Tang Dynasty at Cuiyun Road in new district of Luoyang, Henan, in 2005. Preserved in Museum of Ancient Tombs in Luoyang.

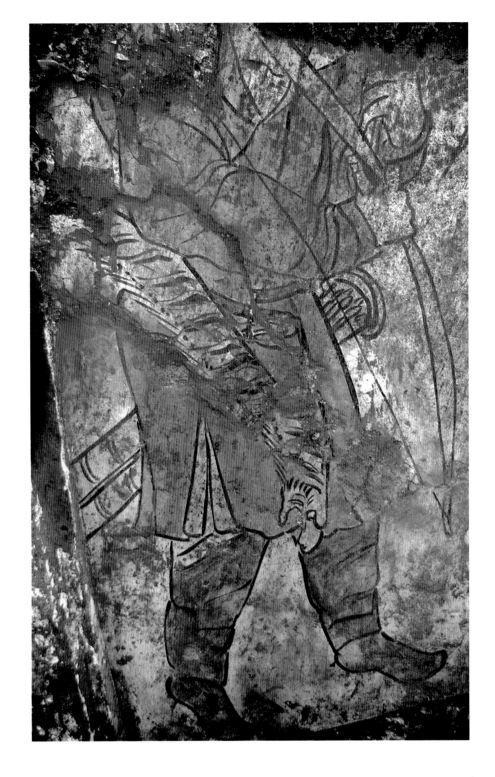

108.门吏图（一）

唐神龙年间（705~710年）

高140厘米

2005年河南省洛阳市新区翠云路唐安国相王孺
人崔氏墓出土。现存于洛阳古墓博物馆。

墓向183°。位于墓道东壁。门吏头部剥落，
身后有鹰头虎皮纹饰带，身穿橙色交领束腰短
袍，右手持弓，斜挎右肩，左手持剑，腰佩剑
囊，下着紧身长裤，穿黑长筒靴。

（撰文：史家珍 摄影：蔡孟轲）

Door Guard (1)

During Shenlong Era, Tang (705-710 CE)

Height 140 cm

Unearthed from the tomb of Ms. Cui, the Concubine of Imperial Prince Xiang of the Tang Dynasty at Cuiyun Road in new district of Luoyang, Henan, in 2005. Preserved in Museum of Ancient Tombs in Luoyang.

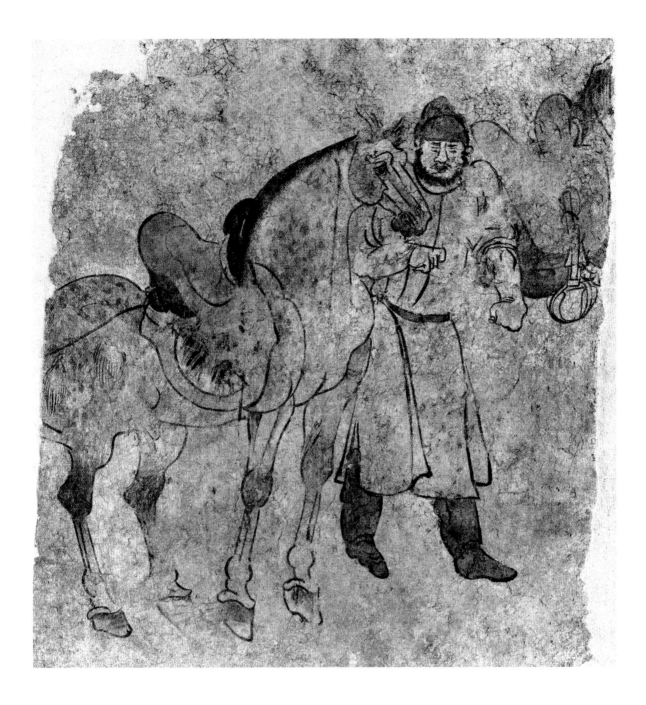

109.牵马图

唐神龙年间（705～710年）

高130厘米

2005年河南省洛阳市新区翠云路唐安国相王孺人崔氏墓出土。现存于洛阳古墓博物馆。

墓向183°。位于墓道东壁。牵马人头裹幞头，双目微下视，宽鼻，八字罗圈胡须，左手握拳，右手拉缰绳。穿团领白袍，腰束带，脚穿黑色长筒靴。人左侧立一高头大马，四足站地，通身有斑纹，上架马鞍。人右前方也立一马，后半部为人所遮挡，前半部损毁，仅留马鞍、马蹬部分。

（撰文：蔡全法　摄影：洛阳古墓博物馆）

Saddled Horse, Groom and Servants

2nd Year of Shenlong Era, Tang (706 CE)

Height 130 cm

Unearthed from the tomb of Ms. Cui, the Concubine of Imperial Prince Xiang of the Tang Dynasty at Cuiyun Road in new district of Luoyang, Henan, in 2005. Preserved in Museum of Ancient Tombs in Luoyang.

110.门吏图（二）

唐神龙年间（705～710年）

高160厘米

2005年河南省洛阳市新区翠云路唐安国相王孺人崔氏墓出土。现存于洛阳古墓博物馆。

墓向183°。位于墓道西壁。门吏头裹幞头，面部丰满，高鼻，大眼，无须，身穿团领红短袍，腰束带，紧身裤，脚穿黑色长筒靴，腰佩剑袋，双手挂弓贴胸部。

（撰文：史家珍 摄影：蔡孟轲）

Door Guard (2)

During Shenlong Era, Tang (705-710 CE)

Height 160 cm

Unearthed from the tomb of Ms. Cui, the Concubine of Imperial Prince Xiang of the Tang Dynasty at Cuiyun Road in new district of Luoyang, Henan, in 2005. Preserved in Museum of Ancient Tombs in Luoyang.

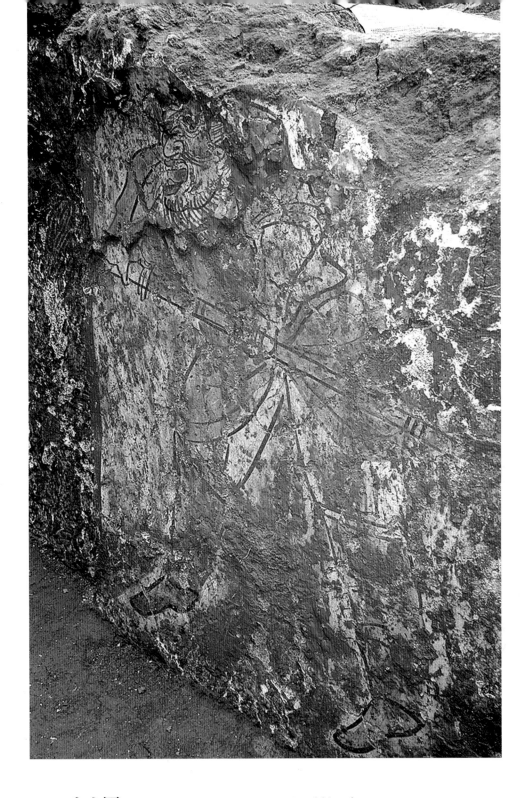

111. 武士图

唐神龙年间（705～710年）

高115厘米。

2005年河南省洛阳市新区翠云路唐安国相王孺人崔氏墓出土。现存于洛阳古墓博物馆。

墓向183°。位于墓内第一过洞西壁。武士头饰不清，络腮胡，厚唇涂朱，上穿浅黄束腰短袄，下穿红色豹纹紧身裤，黑色长筒靴，左手握长剑中部，右手握剑柄。

（撰文：史家珍 摄影：蔡孟轲）

Warrior

During Shenlong Era, Tang (705-710 CE)

Height 115 cm

Unearthed from the tomb of Ms. Cui, the Concubine of Imperial Prince Xiang of the Tang Dynasty at Cuiyun Road in new district of Luoyang, Henan, in 2005. Preserved in Museum of Ancient Tombs in Luoyang.

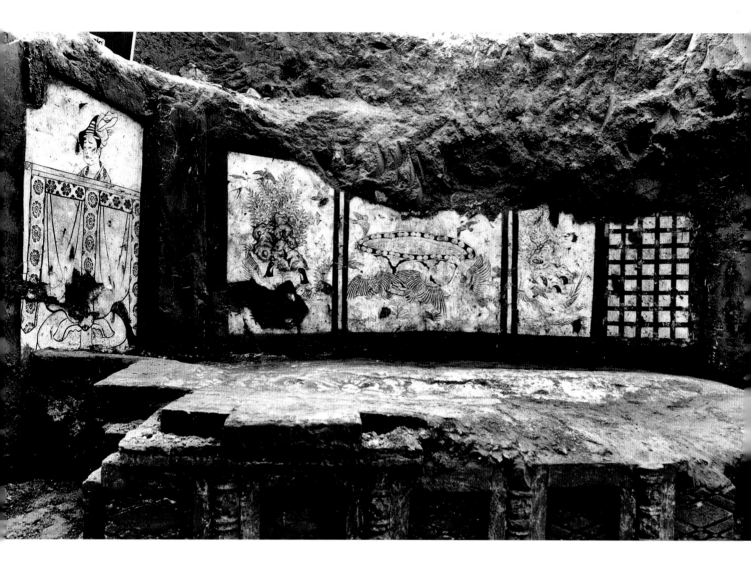

112. 墓室西壁全景

唐（618～906年）

2000年河南省安阳市果品公司家属楼基建工地唐墓出土。现存于安阳市文物考古研究所。

墓向南。位于墓室西壁。两侧用蓝色彩绘成柱状，中部绘三幅花鸟图。

（撰文：孔德铭 摄影：申明清）

Full-view of the West Wall of the Tomb Chamber

Tang (618-906 CE)

Unearthed from Tang tomb at building site of the dwelling house of Fruit Company in Anyang, Henan, in 2000. Preserved in Team of Cultural Relics in Anyang.

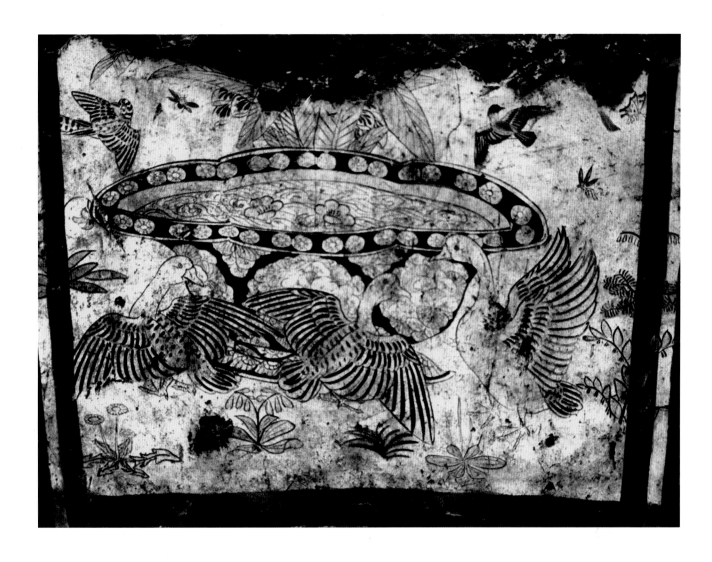

113. 鸭戏图

唐（618～906年）

高98、宽107厘米

2000年河南省安阳市果品公司家属楼基建工地唐墓出土。现存于安阳市文物考古研究所。

墓向南。位于墓室西壁。画面中间为一海棠花形水盆，外饰团花图案，内绘梅花。水盆旁地面上有三只鸭展翅欲飞，周围有蜜蜂、蝴蝶、雀鸟等自由飞翔。

（撰文：孔德铭 摄影：申明清）

Sporting Ducks

Tang (618-906 CE)

Height 98 cm; Width 107 cm

Unearthed from Tang tomb at building site of the dwelling house of Fruit Company in Anyang, Henan, in 2000. Preserved in Team of Cultural Relics in Anyang.

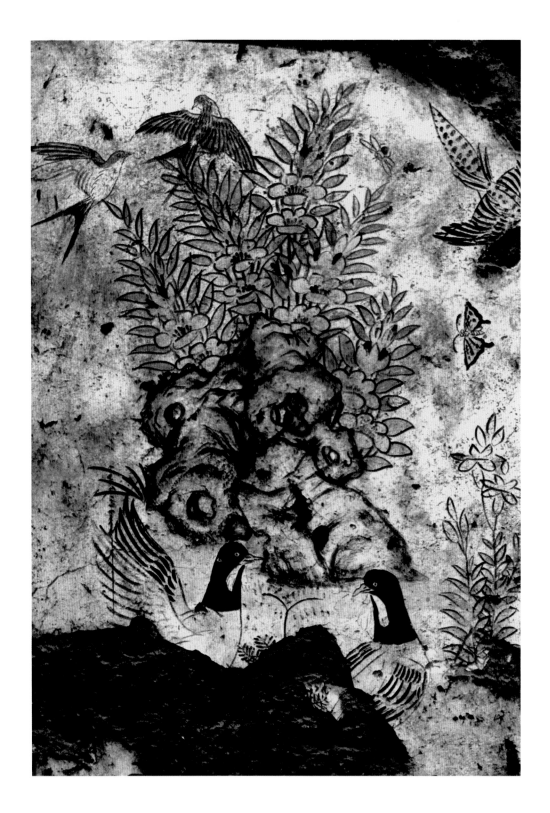

114. 花鸟图（一）

唐（618～906年）

高106、宽70厘米

2000年河南省安阳市果品公司家属楼基建工地唐墓
出土。现存于安阳市文物考古研究所。

墓向南。位于墓室西壁。画面下部两只鸟在互望，
鸟的身后有假山石，山石后种有花草。花草周围有
蜜蜂、雀鸟、蝴蝶在飞舞。

（撰文：孔德铭 摄影：申明清）

Bird-and-Flower Scene (1)

Tang (618-906 CE)

Height 106 cm; Width 70 cm

Unearthed from Tang tomb at building site
of the dwelling house of Fruit Company
in Anyang, Henan, in 2000. Preserved in
Team of Cultural Relics in Anyang.

115.花鸟图（二）

唐（618～906年）

高98、宽53厘米

2000年河南省安阳市果品公司家属楼基建工地唐墓出土。现存于安阳市文物考古研究所。

墓向南。位于墓室西壁。画面下部有两只鹦鹉，一只鹦鹉翅膀展开长尾拖地，回头张望；另一只鹦鹉低头觅食，尾巴上翘。画面上部为假山石、花草、有蜜蜂、蝴蝶飞向花丛。

（撰文：孔德铭 摄影：申明清）

Bird-and-Flower Scene (2)

Tang (618-906 CE)

Height 98 cm; Width 53 cm

Unearthed from Tang tomb at building site of the dwelling house of Fruit Company in Anyang, Henan, in 2000. Preserved in Team of Cultural Relics in Anyang.

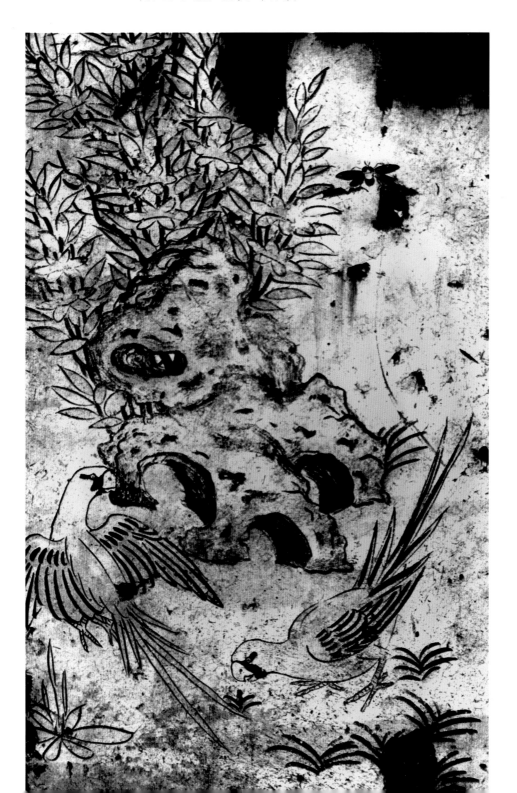

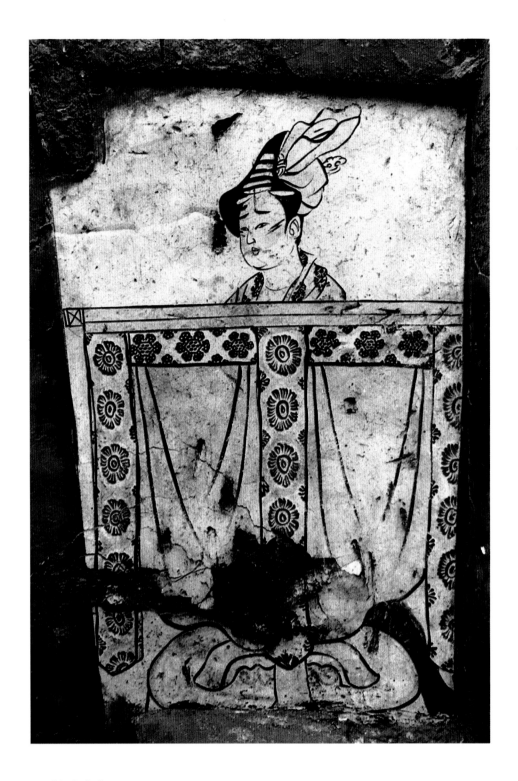

（撰文：孔德铭 摄影：申明清）

116.仕女图

唐（618～906年）

高120、宽77厘米

2000年河南省安阳市果品公司家属楼基建工地唐墓出土。
现存于安阳市文物考古研究所。

墓向南。位于墓室西南壁。一仕女站立在幔帷后，脸庞丰满，柳叶眉，杏仁目，面颊上有两条柳叶红。头梳高髻，系一方巾，身穿白地红团花图案长裙。

Beauty Behind Mantle

Tang (618-906 CE)
Height 120 cm; Width 77 cm
Unearthed from Tang tomb at building site of the dwelling house of Fruit Company in Anyang, Henan, in 2000. Preserved in Team of Cultural Relics in Anyang.

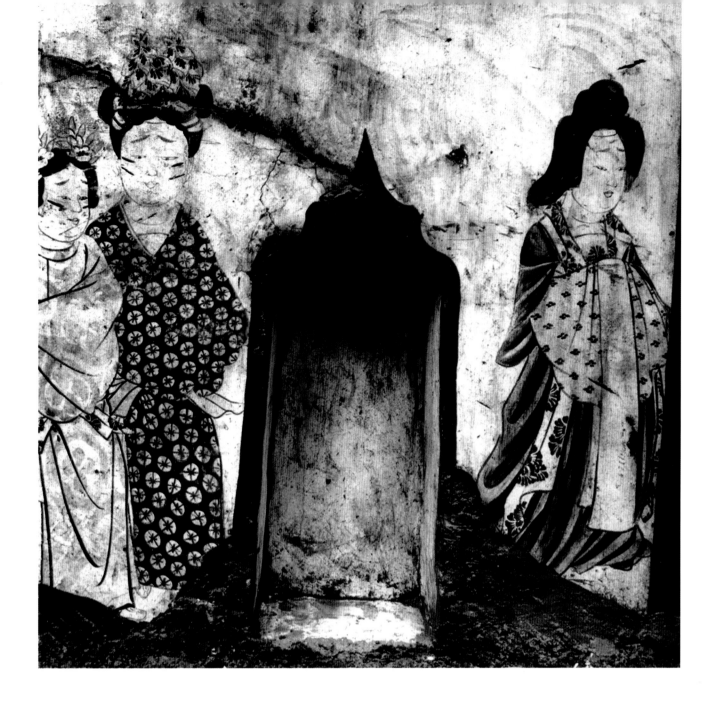

117. 女侍图

唐（618～906年）

高125、宽128厘米

2000年河南省安阳市果品公司家属楼基建工地唐墓出土。现存于安阳市文物考古研究所。

墓向南。位于墓室甬道东壁。中间为一尖顶壁龛，门边用红色刷饰。壁龛南边绘一仕女，头梳高髻，内穿衫襦，外著白地红团花宽袖拖地长裙，双手拱于胸前，作迎候状。壁龛北边绘有两名侍女，靠近壁龛者身穿褐红色白团花右衽宽袖襦，腰束黄带，足着尖头履。另一人身穿白色团领宽袖袍，腰束红带，足着尖头履。两人脸庞丰满，面颊绘有两条柳叶红，梳双髻，髻上插花，双手抱于胸前作拱立状。

（撰文：孔德铭 摄影：申明清）

Maids

Tang (618-906 CE)

Height 125 cm; Width 128 cm

Unearthed from Tang tomb at building site of the dwelling house of Fruit Company in Anyang, Henan, in 2000. Preserved in Team of Cultural Relics in Anyang.

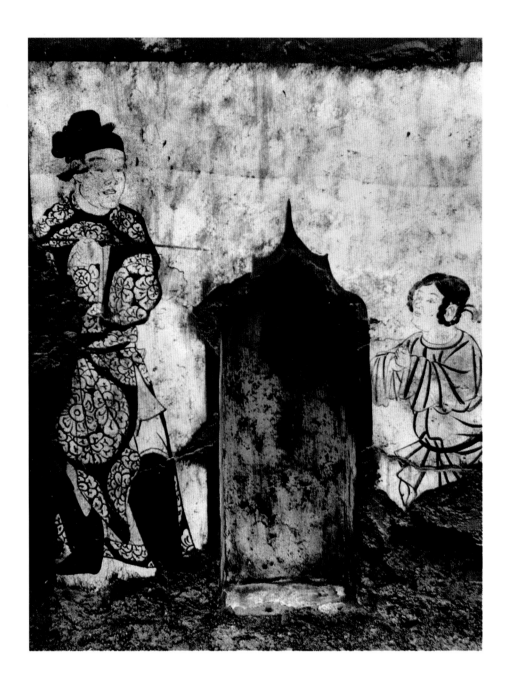

118.侍奉图

唐（618～906年）

高125、宽127厘米

2000年河南省安阳市果品公司家属楼基建工地唐墓出土。现存于安阳市文物考古研究所。

墓向南。位于墓室甬道西壁。中间为一尖顶壁龛，壁龛外四周用红色刷饰。壁龛南边绘一男侍，头戴幞头，身穿团领窄袖白地红团花图案长袍，腰束黑带，下穿白色长裤，脚穿黑色高筒靴，叉手而立。壁龛北边绘一女侍，头梳两条发辫向耳后束系，身穿白色团领窄袖袍，腰系黑带，向前弓身叉手。

（撰文：孔德铭　摄影：申明清）

Servant and Maid

Tang (618-906 CE)

Height 125 cm; Width 127 cm

Unearthed from Tang tomb at building site of the dwelling house of Fruit Company in Anyang, Henan, in 2000. Preserved in Team of Cultural Relics in Anyang.

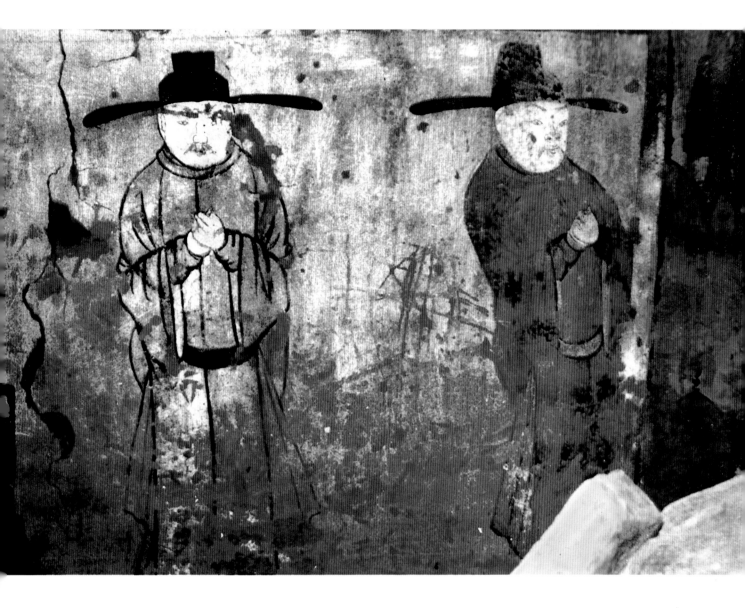

119.文吏图

北宋开宝元年（973年）

高140、宽170厘米

1991年河南省新郑市陵上村后周恭帝柴宗训墓出土。原址保存。

墓向南。位于墓内甬道东侧。绘有文吏两人，皆恭顺侍立。南侧一人头戴黑色展角幞头，身穿红色圆领袍服，腰间系玉带，两手握于胸前行叉手礼，目呈侧视状；北侧文吏呈正视状，衣着姿态同上，仅袍服为白色。

（撰文：孙锦　摄影：李书楷）

Civil Officials

1st Year of Kaibao Era, Northern Song (973 CE)

Height 140 cm; Width 170 cm

Unearthed from King Chai Zongxun's tomb of the Later Zhou Dynasty at Lingshangcun in Xinzheng, Henan, in 1991. Preserved on the original site.

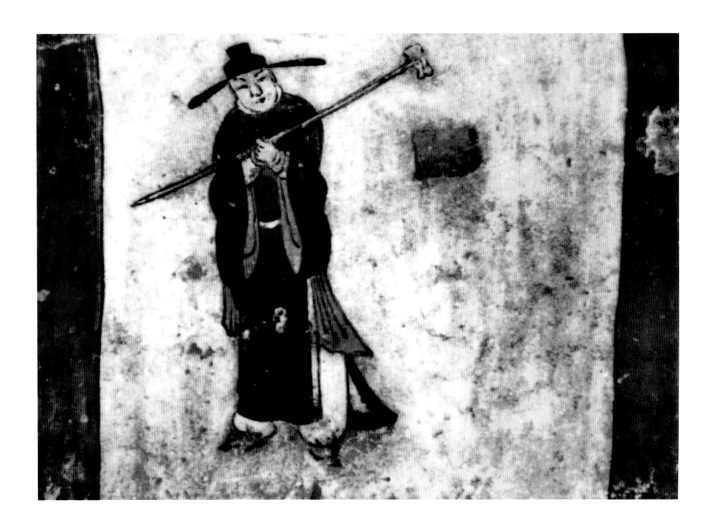

120.武吏图

北宋开宝元年（973年）

高190、宽160厘米

1991年河南省新郑市陵上村后周恭帝柴宗训墓出土。原址保存。

墓向南。位于墓内甬道西侧。武士头戴黑色展角幞头，身穿红色圆领广袖袍服，下穿白色裤，脚着云头靴。头稍倾斜，侧身侍立。手中横持一钺，为仪仗用具。

<div style="text-align:right">（撰文：孙锦　摄影：李书楷）</div>

Attending Military Official

1st Year of Kaibao Era, Northern Song (973 CE)

Height 190 cm; Width 160 cm

Unearthed from King Chai Zongxun's tomb of the Later Zhou Dynasty at Lingshangcun in Xinzheng, Henan, in 1991. Preserved on the original site.

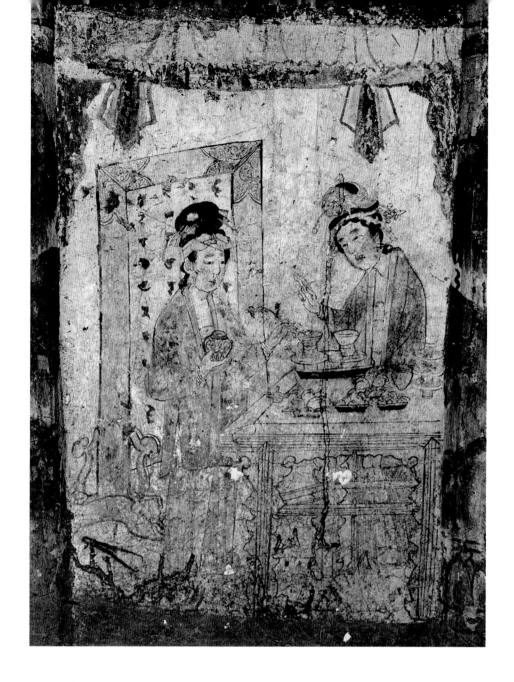

121.备茶图

北宋绍圣四年（1097年）

高138、宽79厘米

1999年河南省登封市黑山沟村北宋李守贵墓出土。原址保存。

墓向193°。位于墓室西南壁。上绘赭色幔帐、绿色横帐，绿、赭色组绶。帐下一方桌，桌饰云状牙条。桌上摆放盛桃子的四果盘和叠置的盏托等。桌左侧站立一妇人，头梳高髻，裹白色额帕，插步摇，戴耳环、手镯，外着褙子，内着抹胸，下着百褶裙，足着云头履，右手捧茶罐（茶入），左手持凤首茶匙向茶盏中添茶，表现点茶场景。桌后立一妇人，头梳包髻，戴白色额帕，外着褙子，下着百褶裙，面向桌左妇人抬手指点。左侧妇人身后置一屏风，屏风左侧地上置一火钳。

（撰文：张文霞　摄影：张松林）

Preparing for Tea

4th Year of Shaosheng Era, Northern Song (1097 CE)

Height 138 cm; Width 79 cm

Unearthed from Li Shougui's tomb of the Northern Song Dynasty at Heishangoucun in Dengfeng, Henan, in 1999. Preserved on the original site.

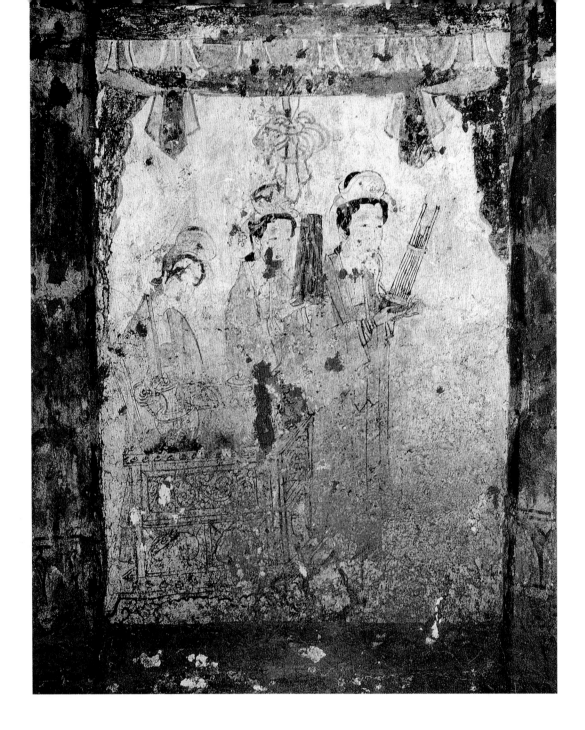

122.伎乐图

北宋绍圣四年（1097年）

高136、宽80厘米

1999年河南省登封市黑山沟村北宋李守贵墓出土。原址保存 。

墓向193°。位于墓室西壁。上绘赭色幔帐、绿色横帐，绿、赭色组绶。中垂一同心结。画面有三个女子，均头梳包髻，外着褙子，内着抹胸。右边两人为女乐，右一人手捧笙吹奏，左一人手执拍板。身后一侍女，站在一方桌后，桌上一风炉。炉上置两个点茶的汤瓶，侍女手执其中一个准备点茶。

（撰文：张文霞　摄影：张松林）

Music Performance

4th Year of Shaosheng Era, Northern Song (1097 CE)

Height 136 cm; Width 80 cm

Unearthed from Li Shougui's tomb of the Northern Song Dynasty at Heishangoucun in Dengfeng, Henan, in 1999. Preserved on the original site.

123.夫妇对坐图

北宋绍圣四年（1097年）

高134、宽77厘米

1999年河南省登封市黑山沟村北宋李守贵墓出土。原址保存。墓向193°。位于墓室西北壁。上绘赭色幔帐、绿色横帐，青、赭色组绶。帐下一方桌，桌上摆二茶盏、二果盘，桌旁对坐夫妇二人。左侧女主人头梳高髻，裹额帕，身穿褙子，束红抹胸，下着百褶裙，袖手坐于椅上。男主人头裹黑巾，着团领广袖袍，腰束黑带，足着靴，袖手坐椅上。二人背后各立一屏风，两屏风间立一侍女，梳包髻，戴耳环，双手端注碗和注子。

（撰文：张文霞 摄影：张松林）

Tomb Occupant Couple Seated Beside the Table

4th Year of Shaosheng Era, Northern Song (1097 CE)

Height 134 cm; Width 77 cm

Unearthed from Li Shougui's tomb of the Northern Song Dynasty at Heishangoucun in Dengfeng, Henan, in 1999. Preserved on the original site.

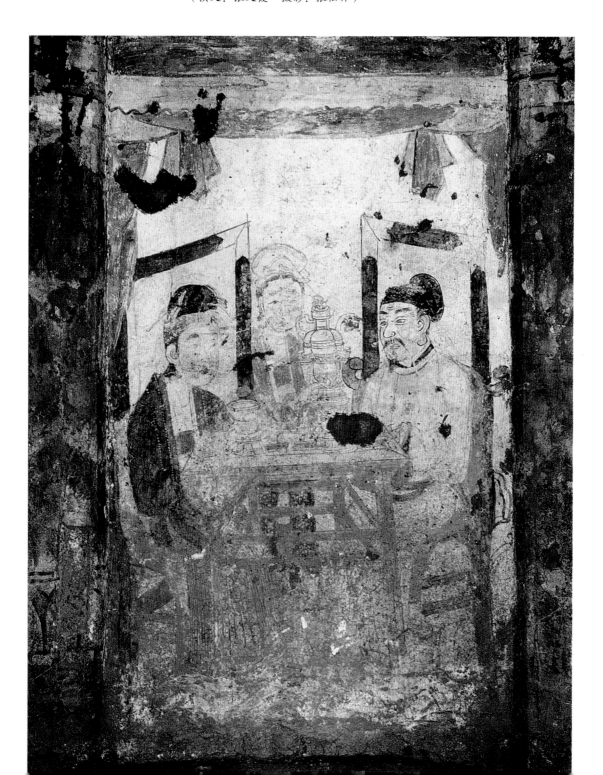

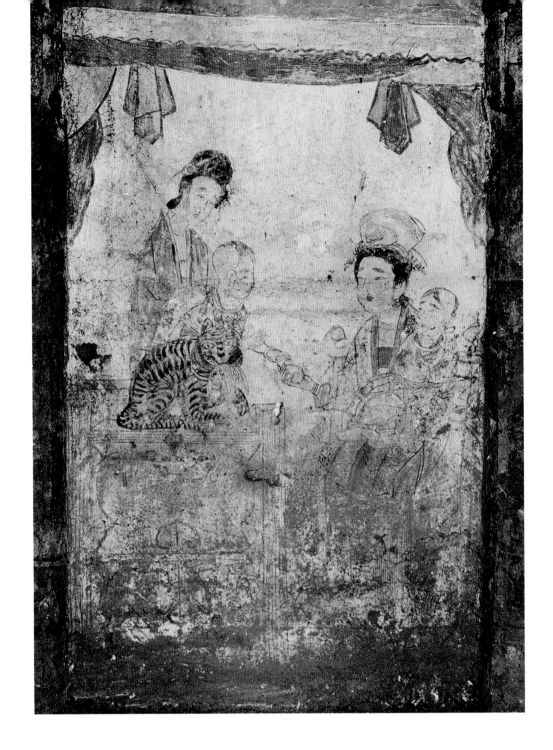

124. 戏儿图

北宋绍圣四年（1097年）

高135、宽82厘米

1999年河南省登封市黑山沟村北宋李守贵墓出土。原址保存。墓向193°。位于墓室东北壁。上绘赭色幔帐、青色横帐，赭、青色组绶。帐下绘两妇人，均外着褙子，内束抹胸。右侧妇人头梳包髻，坐于靠背椅上，左手抱孩童，右手持点心递与对面妇人的孩子。怀中幼童双手捧一桃。对面立一妇人，头梳云髻，双手捧红花白巾，欲披在身前孩童身上，孩童蹲于一橱上，伸手去接对面妇人手中的点心。左侧一橱，橱上蹲一狸猫，口衔一黄雀，为典型的猫蝶图，寓意寿考。

（撰文：张文霞　摄影：张松林）

Women Playing with Children

4th Year of Shaosheng Era, Northern Song (1097 CE)

Height 135 cm; Width 82 cm

Unearthed from Li Shougui's tomb of the Northern Song Dynasty at Heishangoucun in Dengfeng, Henan, in 1999. Preserved on the original site.

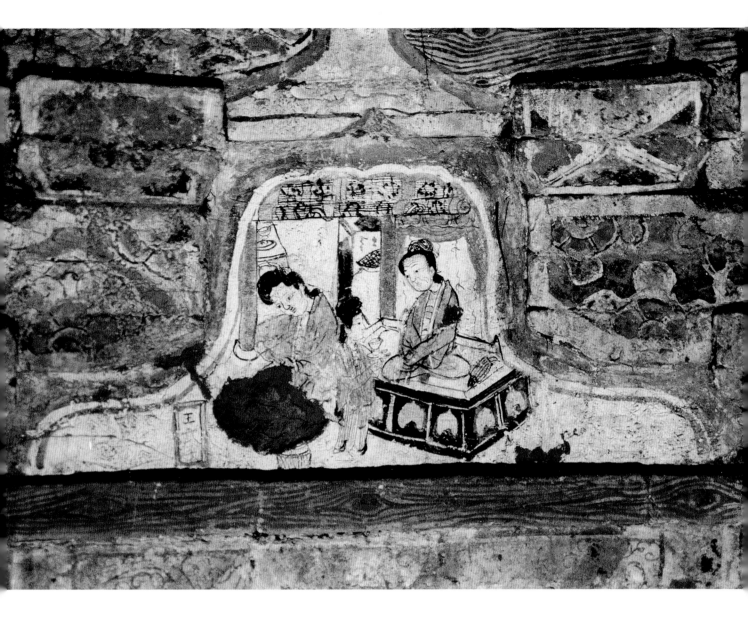

125. 王武子（妻）行孝图

北宋绍圣四年（1097年）

高30、上宽27、下宽69厘米

1999年河南省登封市黑山沟村北宋李守贵墓出土。原址保存。

墓向193°。位于墓室西壁上方拱眼壁。门口竹帘高卷，内间左侧置灶台一，上放锅、碗。右侧立一黑色屏风，屏风前绘一卧榻，一老妇人头梳高髻，身穿褙子，内着团领衫、束抹胸，下着裤，盘腿坐于榻上。榻前一侍女，梳高髻，身穿褙子，下着百褶裙，双手捧托盏递与榻上老妇人。左侧一中年妇人，头戴包髻，一手执小刀，屈一足，表现"割肉奉亲"的场景。壁画左下角题记"王武子"，画面表现的是"王武子行孝，乳姑不怠"的故事。

（撰文：张文霞　摄影：张松林）

Wang Wuzi's Wife, One of the "Twenty-Four Paragons of Filial Piety"

4th Year of Shaosheng Era, Northern Song (1097 CE)

Height 30 cm; Width at Top 27 cm; Width at Bottom 69 cm

Unearthed from Li Shougui's tomb of the Northern Song Dynasty at Heishangoucun in Dengfeng, Henan, in 1999. Preserved on the original site.

126.董永行孝图

北宋绍圣四年（1097年）

高30、上宽30、下宽68厘米

1999年河南省登封市黑山沟村北宋李守贵墓出土。原址保存。

墓向193°。位于墓室西北壁上方拱眼壁。画面绘一高台阶大门，板门半开。门前站一男子，头戴幞头，身着圆领窄袖长袍，腰束带，左手置胸前，右手遮于额际，正向上眺望。半空祥云之上立一女子，头梳蝶状髻，身穿交领广袖襦，下着百褶裙，双手合拢，回首俯望下方男子。此图无榜题，推测画面讲述的应是"董永行孝"故事，表现"槐荫分别"的场景。

<div align="right">（撰文：张文霞　摄影：张松林）</div>

Dong Yong, One of the "Twenty-Four Paragons of Filial Piety"

4th Year of Shaosheng Era, Northern Song (1097 CE)

Height 30 cm; Width at Top 30 cm; Width at Bottom 68 cm

Unearthed from Li Shougui's tomb of the Northern Song Dynasty at Heishangoucun in Dengfeng, Henan, in 1999. Preserved on the original site.

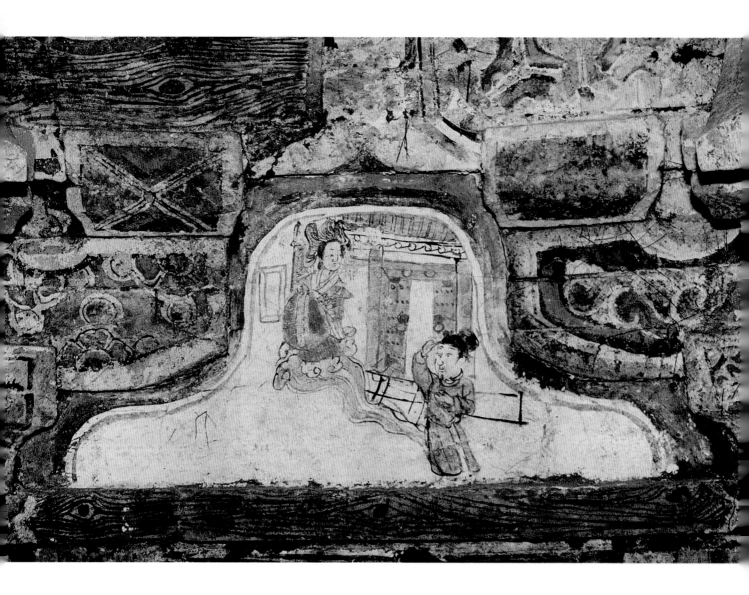

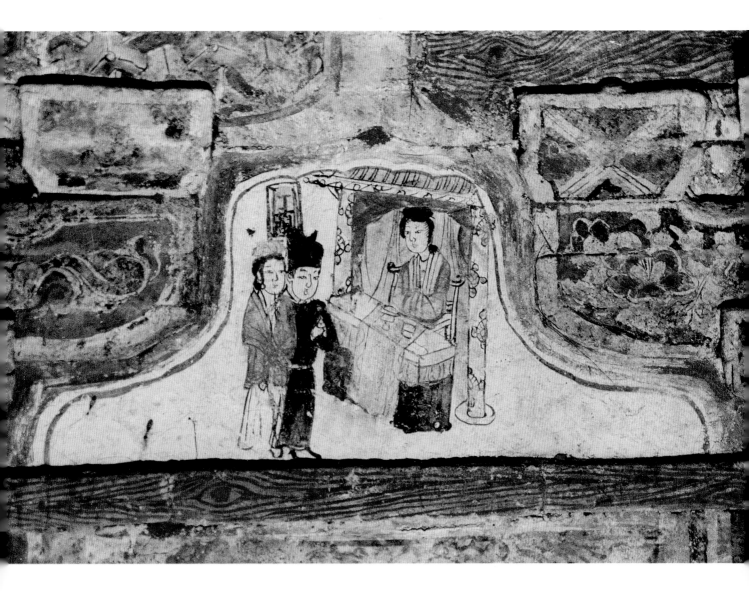

127. 丁兰行孝图

北宋绍圣四年（1097年）

高31、上宽30、下宽72厘米

1999年河南省登封市黑山沟村北宋李守贵墓出土。原址保存。

墓向193°。位于墓室北壁上方的拱眼壁。右侧绘一神龛，檐下设赭、青色幔帐，旁立二柱。柱间一中年妇人，头梳高髻，袖手坐于椅上。妇人前一长案，上搭一淡赭色长巾，巾上置碗、盏各一。案前站立男、妇二人，男头戴交脚幞头，身穿团领窄袖袍，行叉手礼；妇人头梳包髻，身穿褙子，下着白裙，袖手于腹部。图左上角题记"丁兰"二字，画面表现的是"丁兰刻木，事亲行孝"的故事。

<div align="right">（撰文：张文霞　摄影：张松林）</div>

Ding Lan, One of the "Twenty-Four Paragons of Filial Piety"

4th Year of Shaosheng Era, Northern Song (1097 CE)

Height 31 cm; Width at Top 30 cm; Width at Bottom 72 cm

Unearthed from Li Shougui's tomb of the Northern Song Dynasty at Heishangoucun in Dengfeng, Henan, in 1999. Preserved on the original site.

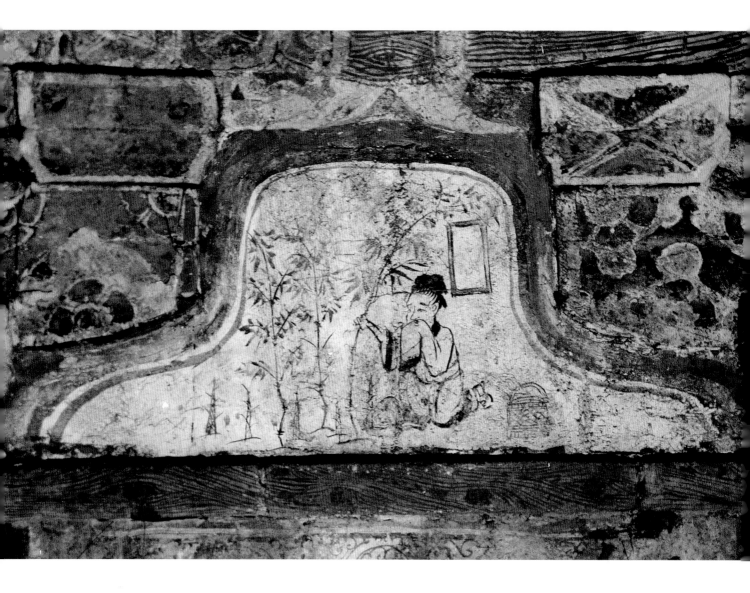

128.孟宗行孝图

北宋绍圣四年（1097年）

高29、上宽30、下宽69厘米

1999年河南省登封市黑山沟村北宋李守贵墓出土。原址保存。

墓向193°。位于墓室东壁上方拱眼壁。画面绘三棵修竹，竹周生出数枝竹笋。一人头扎黑巾，着白色团领广袖袍，左腿跪于地，右手抚竹，左手掩面而泣，身左侧放一竹篮。该图无榜题，表现的应是"孟宗哭竹"的故事。

（撰文：张文霞　摄影：张松林）

Meng Zong, One of the "Twenty-Four Paragons of Filial Piety"

4th Year of Shaosheng Era, Northern Song (1097 CE)

Height 29 cm; Width at Top 30 cm; Width at Bottom 69 cm

Unearthed from Li Shougui's tomb of the Northern Song Dynasty at Heishangoucun in Dengfeng, Henan, in 1999. Preserved on the original site.

129.持莲仙女图

北宋绍圣四年（1097年）

高48、上宽42、下宽52厘米

1999年河南省登封市黑山沟村北宋李守贵墓出土。原址保存。

墓向193°。位于墓室东北壁上部。两侍女立于云朵之上，均头梳双垂髻，着橙色交领广袖襦，手执莲枝，目向下视，寓意接引升仙。

（撰文：张文霞　摄影：张松林）

Fairies Holding Lotus Flowers

4th Year of Shaosheng Era, Northern Song (1097 CE)

Height 48 cm; Width at Top 42 cm; Width at Bottom 52 cm

Unearthed from Li Shougui's tomb of the Northern Song Dynasty at Heishangoucun in Dengfeng, Henan, in 1999. Preserved on the original site.

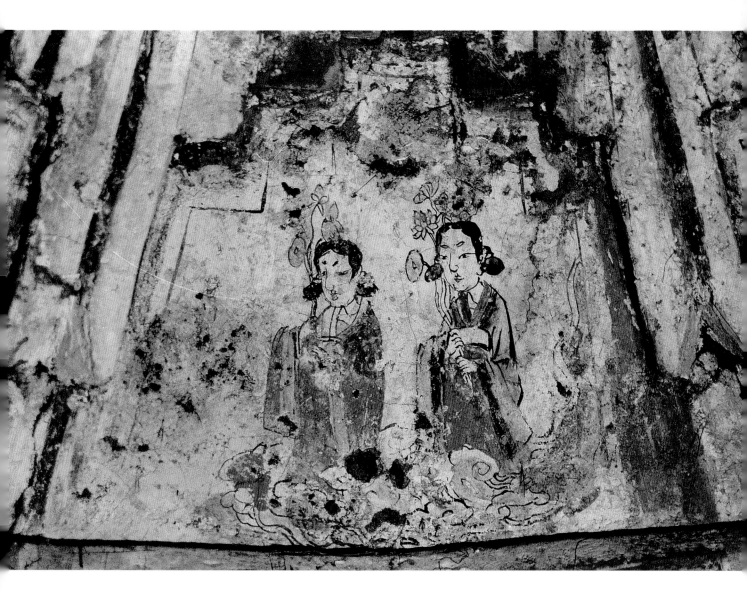

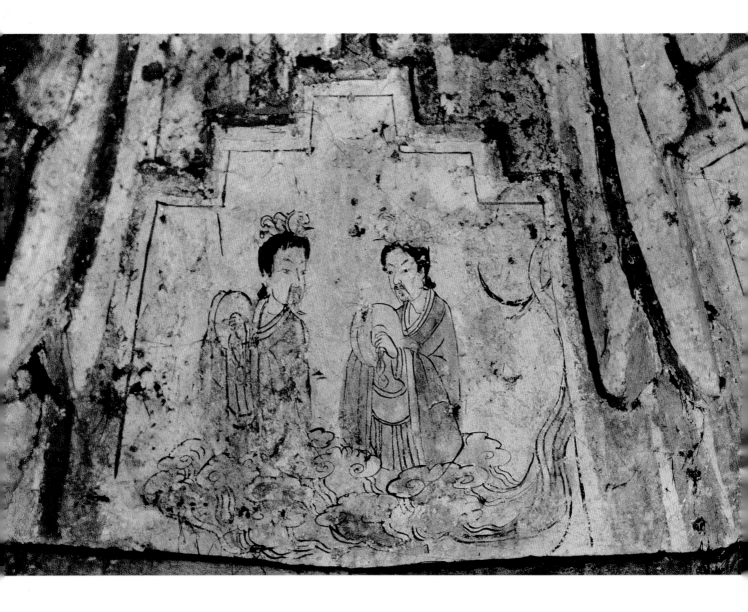

130.仙人击钹图

北宋绍圣四年（1097年）

高48、上宽44、下宽56厘米

1999年河南省登封市黑山沟村北宋李守贵墓出土。原址保存。

墓向193°。位于墓室东壁上部。两道士立于云朵之上，头戴花冠，双手击钹。前一人着皂色交领广袖袍，回首探望。后一人着黄色交领广袖袍，腰束带。

（撰文：张文霞　摄影：张松林）

Immortals Playing Cymbals

4th Year of Shaosheng Era, Northern Song (1097 CE)

Height 48 cm; Width at Top 44 cm; Width at Bottom 56 cm

Unearthed from Li Shougui's tomb of the Northern Song Dynasty at Heishangoucun in Dengfeng, Henan, in 1999. Preserved on the original site.

131. 持幡仙女图

北宋绍圣四年（1097年）

高47、上宽41、下宽56厘米

1999年河南省登封市黑山沟村北宋李守贵墓出土。原址保存。

墓向193°。位于墓室东南壁上部。两侍女立于云朵之上，均梳花髻，身着橙色交领广袖襦，双手持幡。表示接引升仙场景。

<div align="right">（撰文：张文霞　摄影：张松林）</div>

Fairies Holding Streamers

4th Year of Shaosheng Era, Northern Song (1097 CE)

Height 47 cm; Width at Top 41 cm; Width at Bottom 56 cm

Unearthed from Li Shougui's tomb of the Northern Song Dynasty at Heishangoucun in Dengfeng, Henan, in 1999. Preserved on the original site.

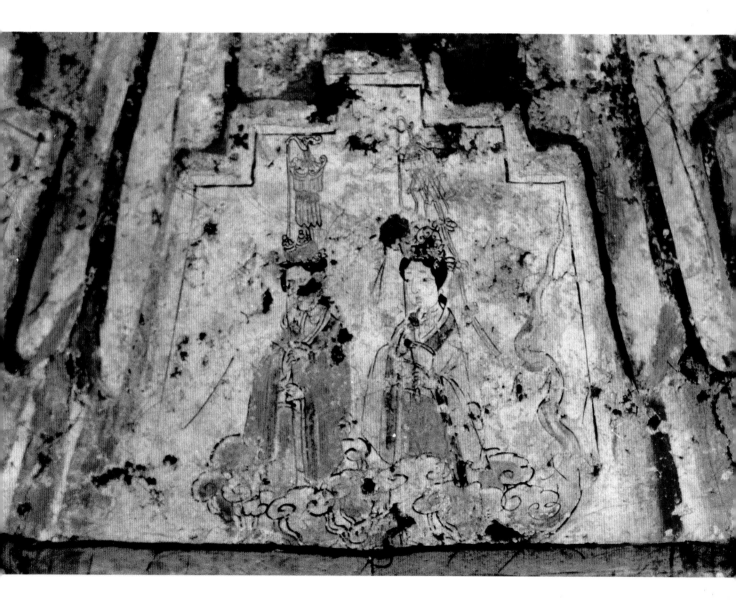

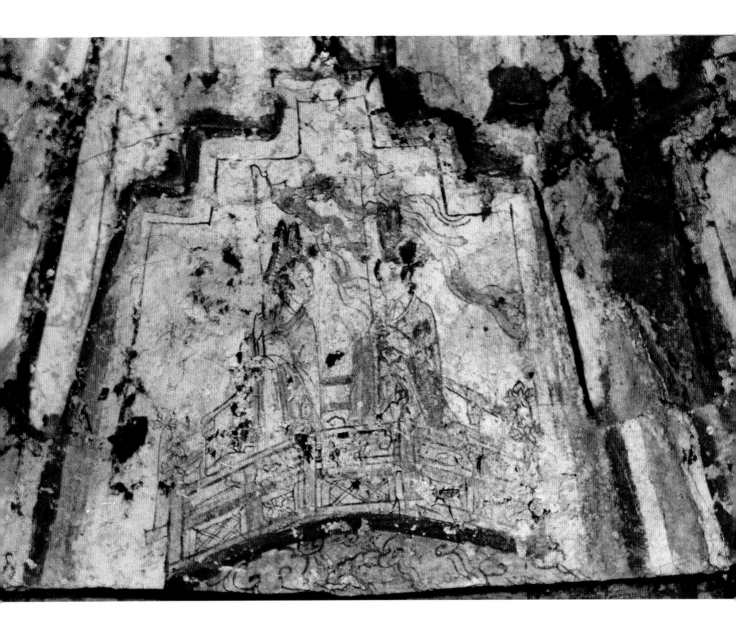

132. 导引图

北宋绍圣四年（1097年）

长48、上宽39、下宽50厘米

1999年河南省登封市黑山沟村北宋李守贵墓出土。原址保存。

墓向193°。位于墓室南壁上部。祥云上有仙桥一座，桥上两仙女，头梳蝶状高髻，手持招魂幡，正在行走。前者着淡青色交领广袖襦，下束白裙，正回首顾视。后者着淡赭色交领广袖襦，下束黄裙。从壁画的位置看，似表现导引墓主人升入天界。

（撰文：张文霞　摄影：张松林）

Fairies Guiding

4th Year of Shaosheng Era, Northern Song (1097 CE)

Height 48 cm; Width at Top 39 cm; Width at Bottom 50 cm

Unearthed from Li Shougui's tomb of the Northern Song Dynasty at Heishangoucun in Dengfeng, Henan, in 1999. Preserved on the original site.

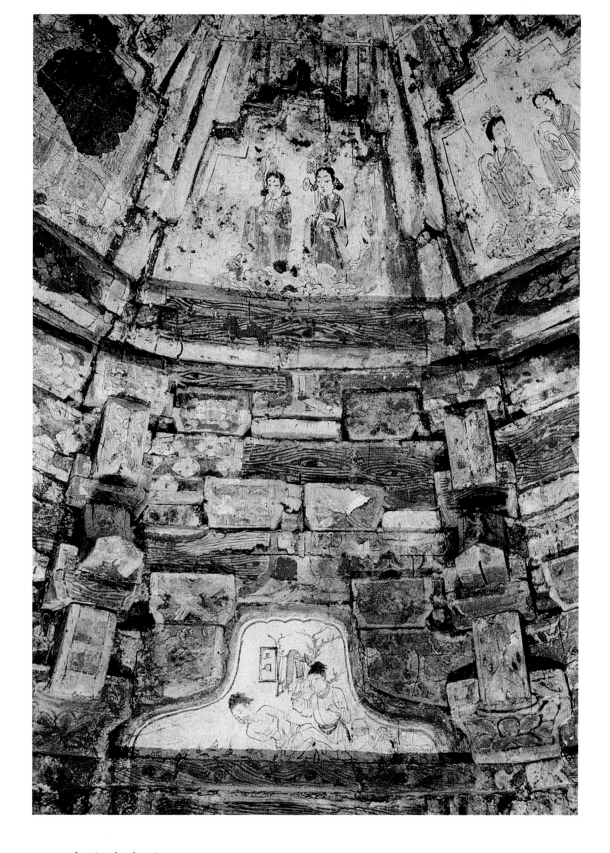

133. 东北壁壁画

北宋绍圣四年（1097年）

1999年河南省登封市黑山沟村北宋李守贵墓出
土。原址保存。

墓向193°。位于墓室东北壁。下方拱眼壁部为王
祥行孝图，上方为执幡仙女图。

（撰文：张文霞　摄影：张松林）

Mural on the Northeast Bay of the Tomb Chamber

4th Year of Shaosheng Era, Northern Song (1097 CE)
Unearthed from Li Shougui's tomb of the Northern
Song Dynasty at Heishangoucun in Dengfeng, Henan,
in 1999. Preserved on the original site.

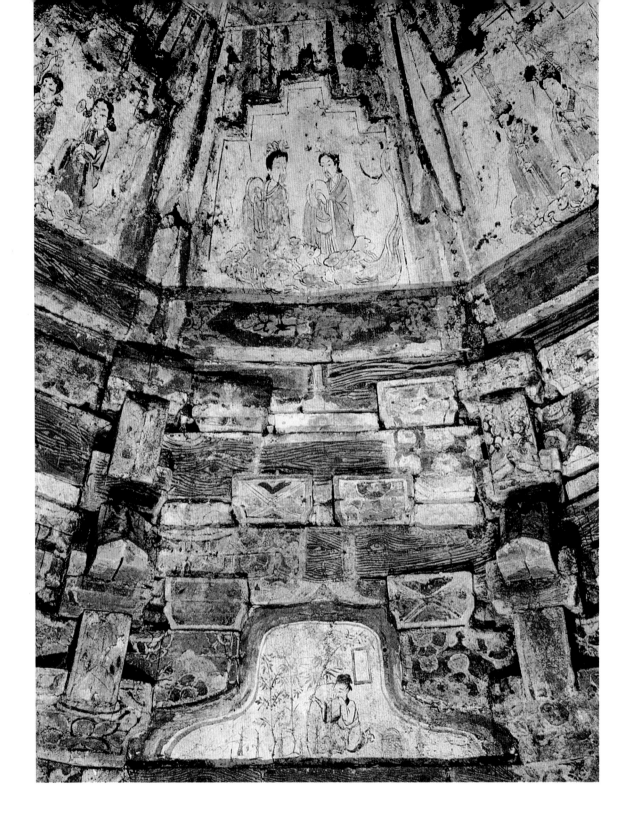

134. 东壁壁画

北宋绍圣四年（1097年）

1999年河南省登封市黑山沟村北宋李守贵墓出土。原址保存。

墓向193°。位于墓室东壁。下方拱眼壁部为孟宗行孝图，上方为仙人击钹图。

（撰文：张文霞　摄影：张松林）

Mural on the East Bay of the Tomb Chamber

4th Year of Shaosheng Era, Northern Song (1097 CE)

Unearthed from Li Shougui's tomb of the Northern Song Dynasty at Heishangoucun in Dengfeng, Henan, in 1999. Preserved on the original site.

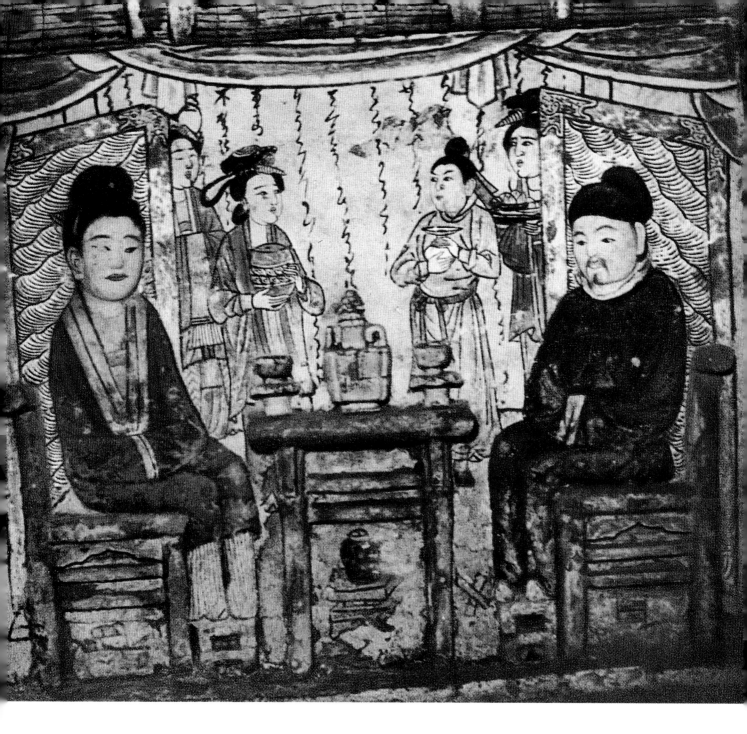

135.夫妇对坐图

北宋元符二年（1099年）

高92、宽132厘米

1951年河南省禹州市白沙北宋赵大翁墓出土。现存于中国国家博物馆。

墓向195°。位于前室西壁。上有卷帘，帘下绘绛色悬幔、蓝色组绶。帐幔下男墓主人袖手坐右侧，女墓主人袖手坐左侧，二人皆侧身面东观看东壁之乐舞。两人间置桌，桌上设一带碗注子、两托盏。男女墓主人之后，各画一屏风，后一女侍半出，双手捧一黑色果盘。其前一男，双手捧青白色渣斗。左侧屏右一女侍，双手捧一绛色圆盒，其后另一女侍双手持巾侍立。

（撰文：孙锦　摄影：彭华士）

Tomb Occupant Couple Seated Beside the Table

2nd Year of Yuanfu Era, Northern Song (1099 CE)

Height 92 cm; Width 132 cm

Unearthed from Zhao Daweng's tomb of the Northern Song Dynasty at Baisha in Yuzhou, Henan, in 1951. Preserved in National Museum of China.

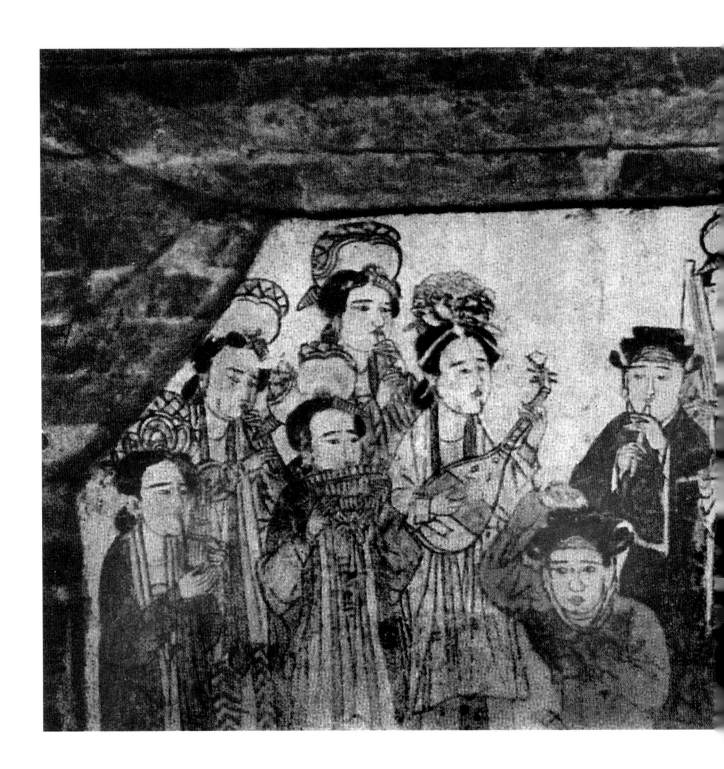

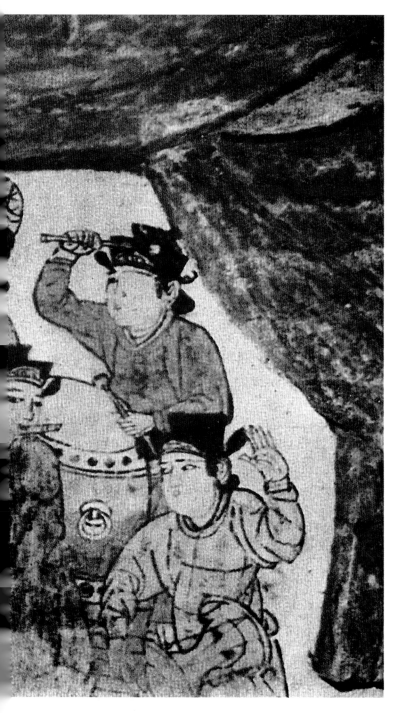

136.伎乐图

北宋元符二年（1099年）

高92、宽132厘米

1951年河南省禹州市白沙北宋赵大翁墓出土。现存于中国国家博物馆。

墓向195°。位于前室东壁。上部用砖砌成卷起的竹帘，着土黄色，帘下砖雕作悬幔，幔着绛色。幔下有女乐十一人。右侧五人分前后二排立，分别手持乐器，依次为大鼓、拍板、腰鼓、横笛和觱篥。左侧立五人，后排二人吹箫，前排三人分别吹笙、吹十二管排箫和弹琵琶。中间一女作男装，欠身扬袖作舞，为舞旋色。

（撰文：孙锦　摄影：彭华士）

Music Band Playing

2nd Year of Yuanfu Era, Northern Song (1099 CE)

Height 92 cm; Width 132 cm

Unearthed from Zhao Daweng's tomb of the Northern Song Dynasty at Baisha in Yuzhou, Henan, in 1951. Preserved in National Museum of China.

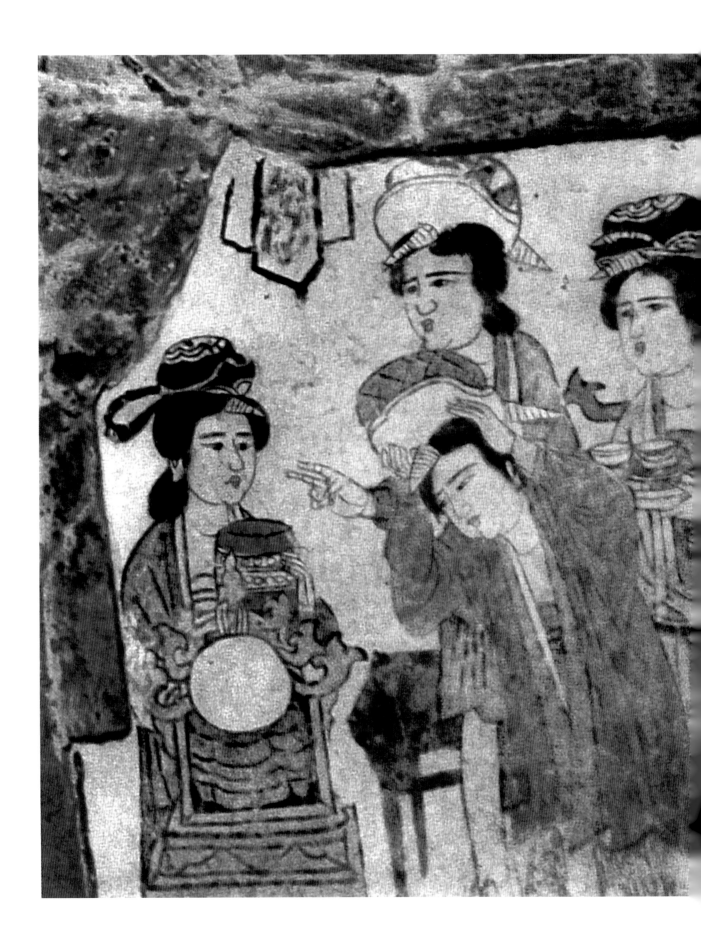

137.梳妆图

北宋元符二年（1099年）

高84、宽约100厘米

1951年河南省禹州市白沙北宋赵大翁墓出土。现存于中国国家博物馆。

墓向195°。位于后室西南壁。幔下左侧立一女，双手捧绛色圆盒，其前置一带架铜镜。右侧立四女，前面一女欠身临镜作着冠状；其后左侧立一女，手指左侧镜台后面的立女；此女之后立一女，双手捧一白色盘，盘中放置二托盏。其右一少女，双手捧盘，拱身侍立于临镜着冠的女子之后。

（撰文：孙锦 摄影：彭华士）

Dressing Up

2nd Year of Yuanfu Era, Northern Song (1099 CE)

Height 84 cm; Width ca. 100 cm

Unearthed from Zhao Daweng's tomb of the Northern Song Dynasty at Baisha in Yuzhou, Henan, in 1951. Preserved in National Museum of China.

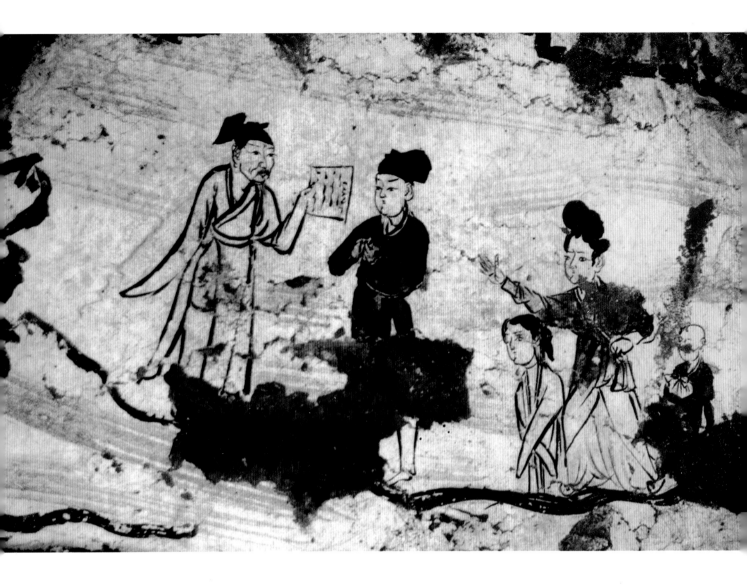

138.闵子骞行孝图

北宋大观二年（1108年）

高45、上宽56、下宽64厘米

1998年河南省新密市平陌村宋墓出土。原址保存。

墓向176°。位于墓室西壁上部。画面五人，骞父在左，头戴方巾，身穿白色交领窄袖长袍，左手举一纸休书，面对其妻。右侧骞母头梳高髻，着窄袖襦，下着白裙，足着凤头屐，左手叉腰，右手怒指其夫，身前身后随立两童，应为闵子骞的弟弟妹妹。闵子骞立于父母之间，头戴黑巾，身着圆领窄袖长袍，正作揖为继母求情。此图表现的是"闵子骞芦花套衣，父前留母"的故事。

（撰文：张文霞　摄影：张松林）

Min Ziqian, One of the "Twenty-Four Paragons of Filial Piety"

2nd Year of Daguan Era, Northern Song (1108 CE)

Height 45 cm; Width at Top 56 cm; Width at Bottom 64 cm

Unearthed from Song tomb at Pingmocun in Xinmi, Henan, in 1998. Preserved on the original site.

139. 夫妇对坐图

北宋大观二年（1108年）

高105、宽70厘米

1998年河南省新密市平陌村宋墓出土。原址保存。

墓向176°。位于墓室西壁。上绘赭色幔帐，帐下一桌，桌上置执壶、托盏。桌左侧一老妇人，上着褙子，下着白裙，袖手端坐于靠背椅上。右侧一男子，穿白色圆领窄袖袍，袖手坐于椅上。桌后站立一男二女三位侍者。

（撰文：张文霞　摄影：张松林）

Tomb Occupant Couple Seated Beside the Table

2nd Year of Daguan Era, Northern Song (1108 CE)

Height 105 cm; Width 70 cm

Unearthed from Song tomb at Pingmocun in Xinmi, Henan, in 1998. Preserved on the original site.

140. "四洲大圣度翁婆"图

北宋大观二年（1108年）

高45、上宽65、下宽75厘米

1998年河南省新密市平陌村宋墓出土。原址保存。

墓向176°。位于墓室西北壁上部。画面右侧一长方形幡，上覆荷叶盖，内书"四洲大圣度翁婆"字样。题记前一赭色地毯，上跪两老人，面对圣人作揖。画面左侧一团祥云，云心有壶门形开光，云上立三人，中间一人即为四洲大圣，头戴圆顶风帽，身穿交领广袖袍，外披铁锈红色袈裟，双手持法器，正向老人诵经超度。身旁一僧，手执锡杖；身后一侍女。

（撰文：张文霞　摄影：张松林）

The Scene of "Great Sage of Sizhou Preaching to the Tomb Occupant Couple"

2nd Year of Daguan Era, Northern Song (1108 CE)

Height 45 cm; Width at Top 65 cm; Width at Bottom 75 cm

Unearthed from Song tomb at Pingmocun in Xinmi, Henan, in 1998. Preserved on the original site.

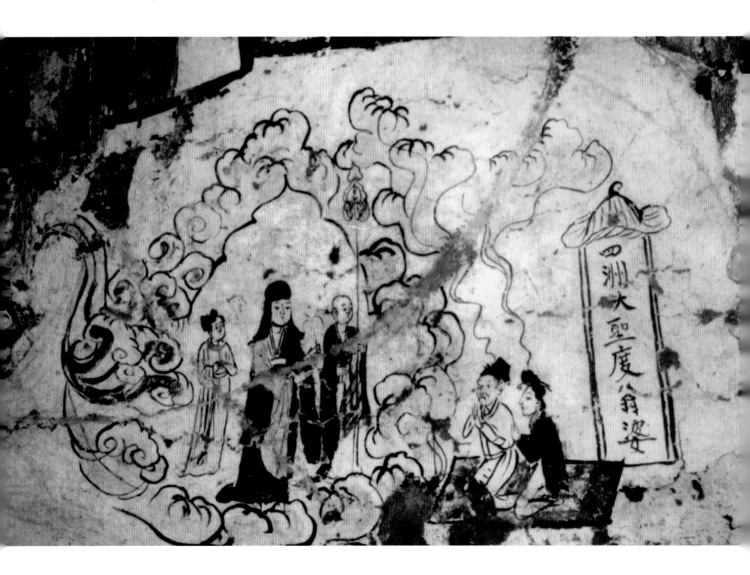

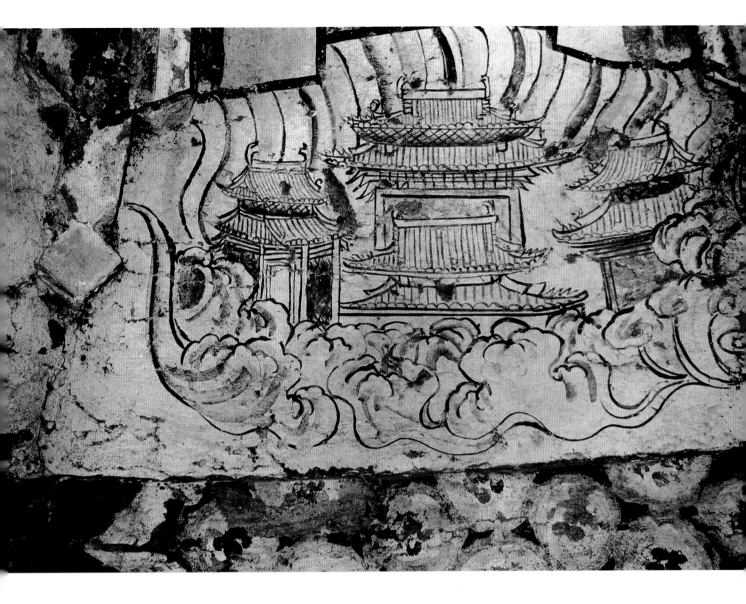

141.仙界楼宇图

北宋大观二年（1108年）

高45、上宽67、下宽95厘米

1998年河南省新密市平陌村宋墓出土。原址保存。

墓向176°。位于墓室北壁上部。前为门楼，两侧各一挟楼。后为一高大的垂檐楼宇，厅堂宽阔，下檐伸出许多昂头。楼均为重檐九脊顶，脊两端高起鸱吻，楼四周祥云缭绕，应是反映天上仙界楼阁的画面。

（撰文：张文霞　摄影：张松林）

Pavilions of the Fairyland

2nd Year of Daguan Era, Northern Song (1108 CE)

Height 45 cm; Width at Top 67 cm; Width at Bottom 95 cm

Unearthed from Song tomb at Pingmocun in Xinmi, Henan, in 1998. Preserved on the original site.

142.升仙图

北宋大观二年（1108年）

高45、上宽56、下宽84厘米

1998年河南省新密市平陌村宋墓出土。原址保存。

墓向176°。位于墓室东北壁上部。祥云中显出一桥，上有望柱、扶手、华板，四望柱上各立一鹤。桥上八人。前一人为导引者，梳高髻，手捧方盒，仙气盈溢，后一人执幡。身后二人为墓主夫妇，毕恭毕敬，合掌于胸前。墓主身后一执幢女子，侧首与身后两女童说话，身右也有一童。此当为导引升仙的场景。

（撰文：张文霞　摄影：张松林）

Ascending Fairyland

2nd Year of Daguan Era, Northern Song (1108 CE)

Height 45 cm; Width at Top 56 cm; Width at Bottom 84 cm

Unearthed from Song tomb at Pingmocun in Xinmi, Henan, in 1998. Preserved on the original site.

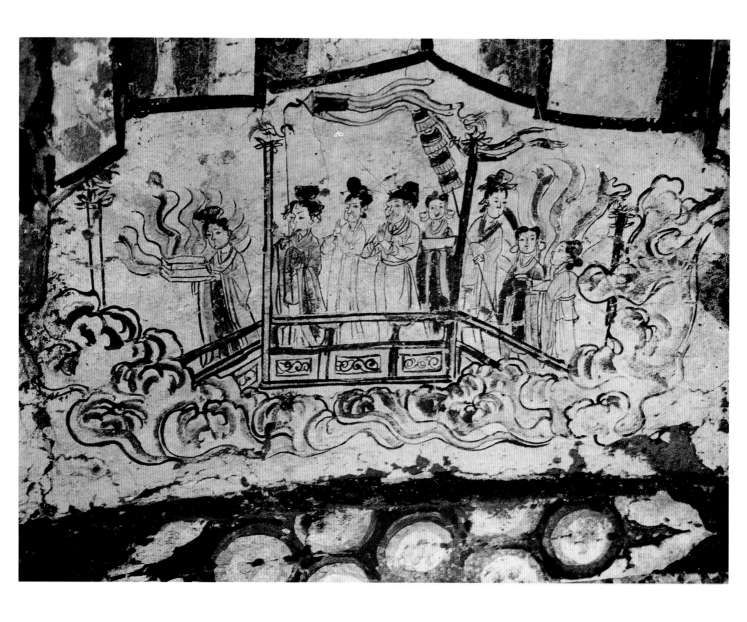

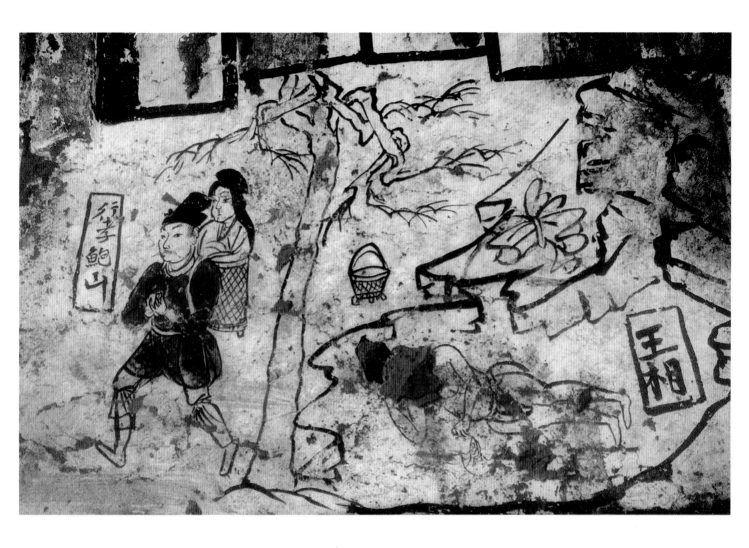

143. 鲍山、王祥孝行图

北宋大观二年（1108年）

高48、上宽62、下宽84厘米

1998年河南省新密市平陌村宋墓出土。原址保存。

墓向176°。位于墓室东壁上部。画面左侧题记"行孝鲍山"。鲍山头戴黑色幞头，着圆领窄袖短袍，下着白裤，身背一篓，内坐其母，正从山间走来。画面右侧，题"王相（祥）"二字，山中流出一河，河湾处王祥头戴黑巾，身穿短裤，侧身卧于冰上，身前冰已融化，两鱼正跃出水面。王祥身后岸上放着鱼篓、衣服。身前岸旁一树，干枝无叶，表示是严冬季节。

（撰文：张文霞　摄影：张松林）

Bao Shan and Wang Xiang, Two of the "Twenty-Four Paragons of Filial Piety"

2nd Year of Daguan Era, Northern Song (1108 CE)

Height 48 cm; Width at Top 62 cm; Width at Bottom 84 cm

Unearthed from Song tomb at Pingmocun in Xinmi, Henan, in 1998. Preserved on the original site.

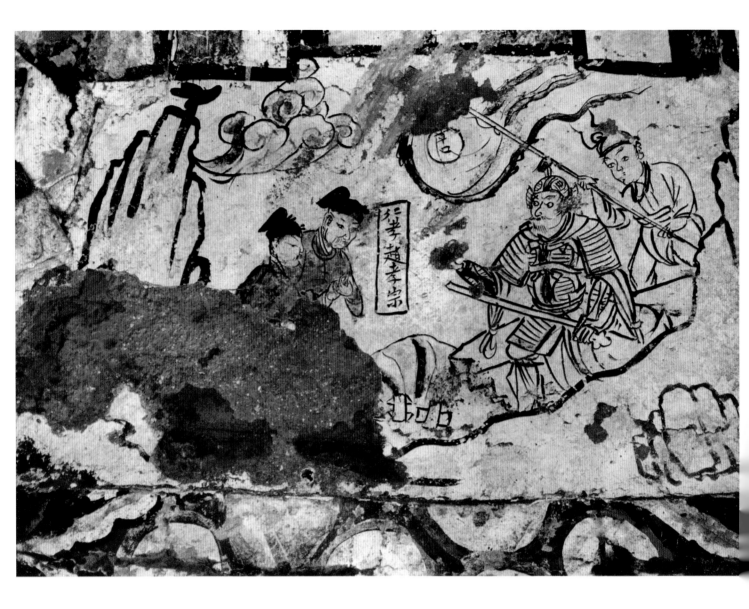

144.赵孝宗孝行图

北宋大观二年（1108年）

高45、上宽56、下宽84厘米

1998年河南省新密市平陌村宋墓出土。原址保存。

墓向176°。位于墓室东南壁上部。画中题记"行孝赵孝宗"。画面右边一将，头戴兜鍪，肩披披帛，身着铠甲，左手执剑，右手前指，正逼问对面二人。身后一年青军士，双手挑一大纛旗，上书"草口"二字。画面左侧，山前二人，头戴黑巾，身穿圆领窄袖袍，两人脸上有须，黄袍人似更年老。二人跪地施叉手礼，身前地上两块银铤，散出道道瑞气。

（撰文：张文霞　摄影：张松林）

Zhao Xiaozong, One of the "Twenty-Four Paragons of Filial Piety"

2nd Year of Daguan Era, Northern Song (1108 CE)

Height 45 cm; Width at Top 56 cm; Width at Bottom 84 cm

Unearthed from Song tomb at Pingmocun in Xinmi, Henan, in 1998. Preserved on the original site.

145.梳妆图

北宋大观二年（1108年）

高105、宽70厘米

1998年河南省新密市平陌村宋墓出土。原址保存。

墓向176°。位于墓室西南壁。上绘淡绿色幔帐，画面正中绘一直腿长方几，几上置一镜架，架上放一圆镜。一中年妇女侧坐几内，面镜，左手抚髻，右手拈笄插戴。

（撰文：张文霞　摄影：张松林）

Dressing Up

2nd Year of Daguan Era, Northern Song (1108 CE)

Height 105 cm; Width 70 cm

Unearthed from Song tomb at Pingmocun in Xinmi, Henan, in 1998. Preserved on the original site.

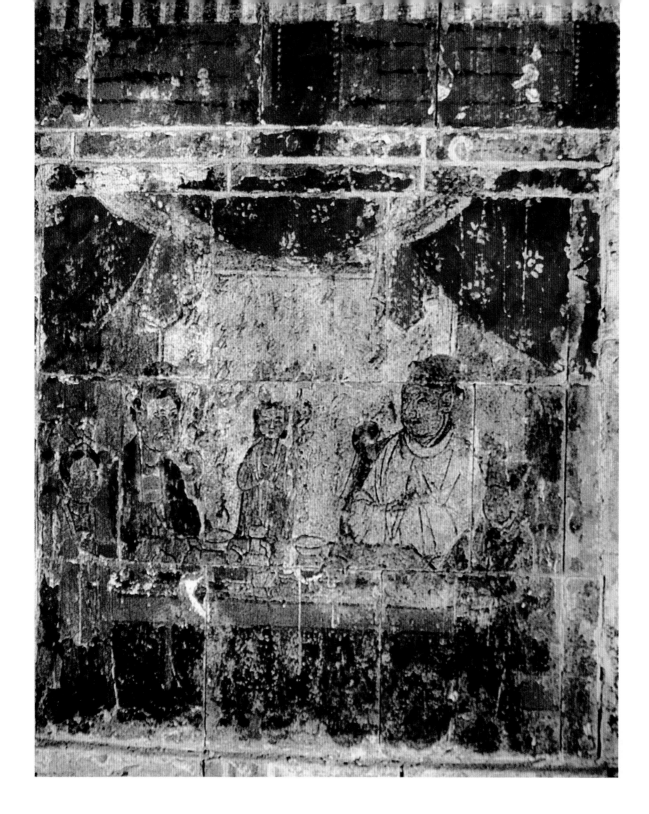

146.夫妇对坐图

北宋靖康元年（1126年）

1983年河南省新安县石寺乡李村北宋宋四郎墓出土。现存于洛阳市古墓博物馆。

墓向南。位于墓室东部，为夫妇对坐场面。夫妇二人左右端坐于红色帷幔内，背后有屏风，面前一方桌，桌上摆放果品和茶、酒具。三侍者站立一旁：男主人身旁为男侍，女主人身旁为女侍，另一女侍立于墓主夫妇之间的后方。

（撰文、摄影：高虎）

Tomb Occupant Couple Seated Beside the Table

1st Year of Jingkang Era, Northern Song (1126 CE)

Unearthed from Song Silang's tomb of the Northern Song Dynasty at Licun of Shisixiang in Xin'an, Henan, in 1983. Preserved in Museum of Ancient Tombs in Luoyang.

147. 夫妇对坐图

北宋（960～1127年）

高80、宽106厘米

1999年河南省新密市下庄河村宋墓出土。原址保存。

墓向190°。位于墓室西北壁。上有黄色幔帐高悬，下方置一长桌，桌上放碗、杯类器皿，桌后绘三人。左为一老妇人，侧坐于黄色靠背椅上，头顶梳高髻，身穿红色交领广袖襦。中坐一年轻女子，梳双垂髻，着淡赭色交领宽袖襦。右侧端坐一男，头戴黑色软巾，身穿白色圆领广袖袍。中间立一侍女，梳双髻，着绛色褙子，拱手而立。

<div align="right">（撰文：张文霞　摄影：张松林）</div>

Tomb Occupant Couple Seated Beside the Table

Northern Song (960-1127 CE)

Height 80 cm; Width 106 cm

Unearthed from Song tomb at Xiazhuanghecun in Xinmi, Henan, in 1999. Preserved on the original site.

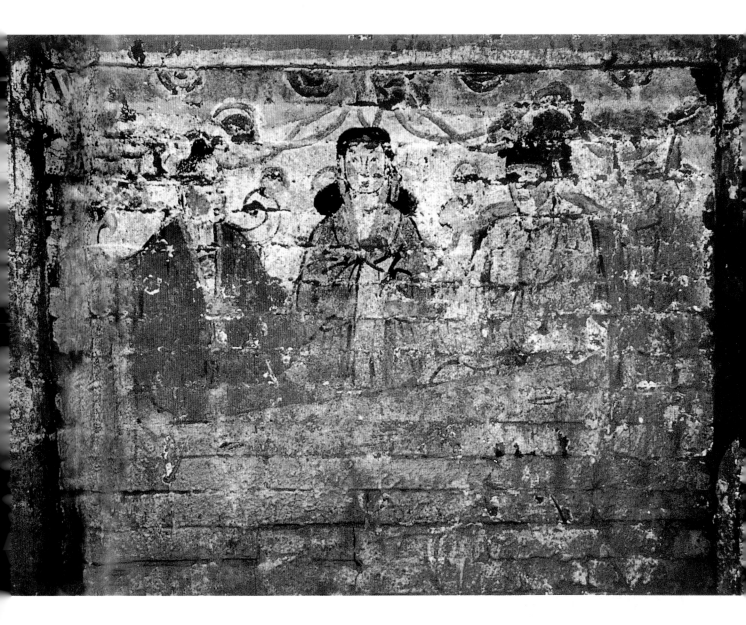

148.礼佛图

北宋（960～1127年）

1999年河南省新密市下庄河村宋墓出土。原址保存。

墓向190°。位于墓室北壁的拱眼壁。内绘一佛，结跏趺坐于须弥座上，后有很大的圆形背光。佛左侧站立一老僧，右侧绘二人，前一人跪地，戴黑巾，为供养人；后一人不明是跪是立，亦应为供养人。周围祥云环绕。

（撰文：张文霞　摄影：张松林）

Buddha Preaching

Northern Song (960-1127 CE)

Unearthed from Song tomb at Xiazhuanghecun in Xinmi, Henan, in 1999. Preserved on the original site.

149. 备宴图

北宋（960～1127年）

高106、宽80厘米

1999年河南省新密市下庄河村宋墓出土。原址保存。

墓向190°。位于墓室东壁。上绘淡黄色幔帐，帐下绘一长方桌。桌后绘一中年妇女，头梳坠马髻，身穿淡黄色交领窄袖襦，右手刀切物。桌前立一侍女，梳红巾包髻，身穿淡黄色窄袖开叉长袍，腰束带，双手捧一方盘，上置杯碗，躬身站立在一红衣妇人面前。此妇双手上举，揩拭鬓发，侧身前倾。桌右侧立一妇人，梳朝天髻，看交领广袖袍，双手抄于袖中。

<div align="right">（撰文：张文霞　摄影：张松林）</div>

Preparing for Feast

Northern Song (960-1127 CE)

Height 106 cm; Width 80 cm

Unearthed from Song tomb at Xiazhuanghecun in Xinmi, Henan, in 1999. Preserved on the original site.

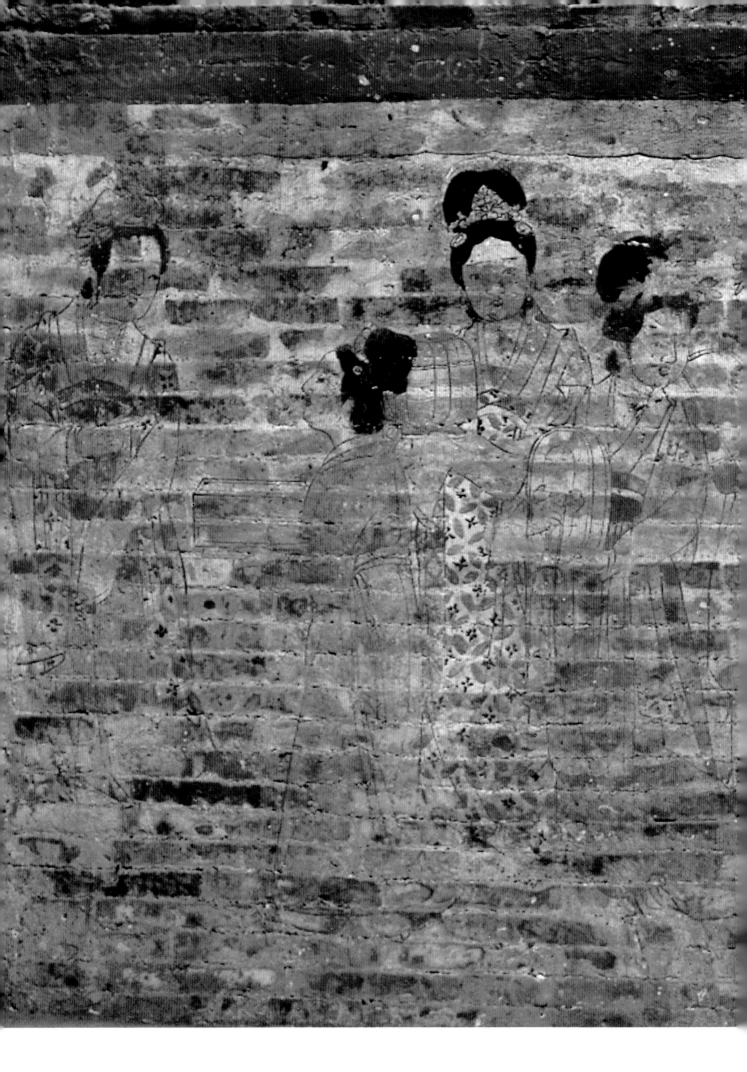

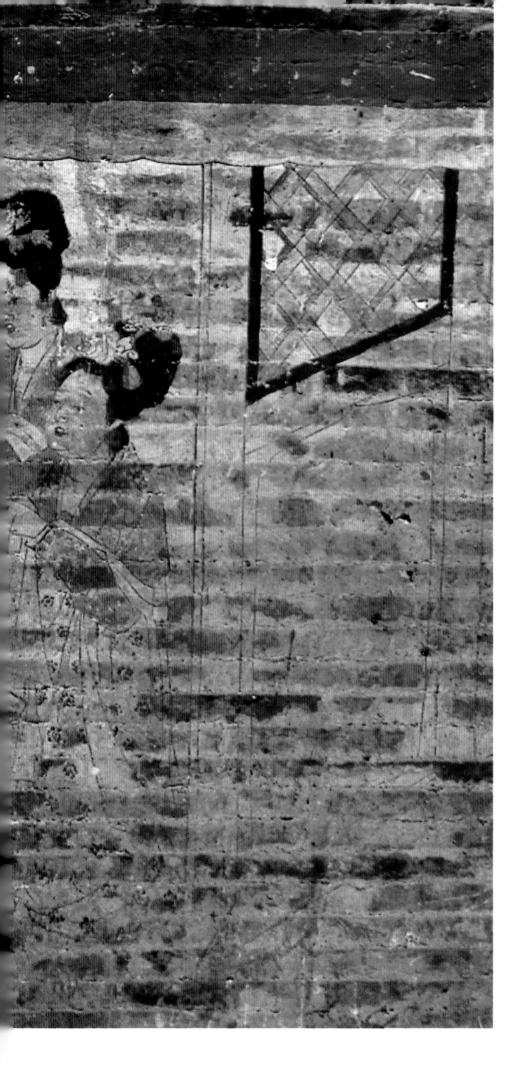

150.仕女图（一）

北宋（960~1127年）

高155、宽210厘米

2004年河南省济源市东石露头村宋墓出土。原址保存。

墓南向。位于墓室东壁中北段。画面共有六人，皆高髻，戴花冠，着窄袖长襦或褙子，有的围白、朱或花色长裙，臂佩巾，着云头鞋。左侧二仕女，一侧立，一捧盒状物；右侧四人，各持酒樽、带碗注壶、帨巾等物，相互顾盼，或作交谈应对状。

（撰文、摄影：蔡强）

Beauties (1)

Northern Song (960-1127 CE)

Height 155 cm; Width 210 cm

Unearthed from Song tomb at Lutoucun of Dongshi in Jiyuan, Henan, in 2004. Preserved on the original site.

161

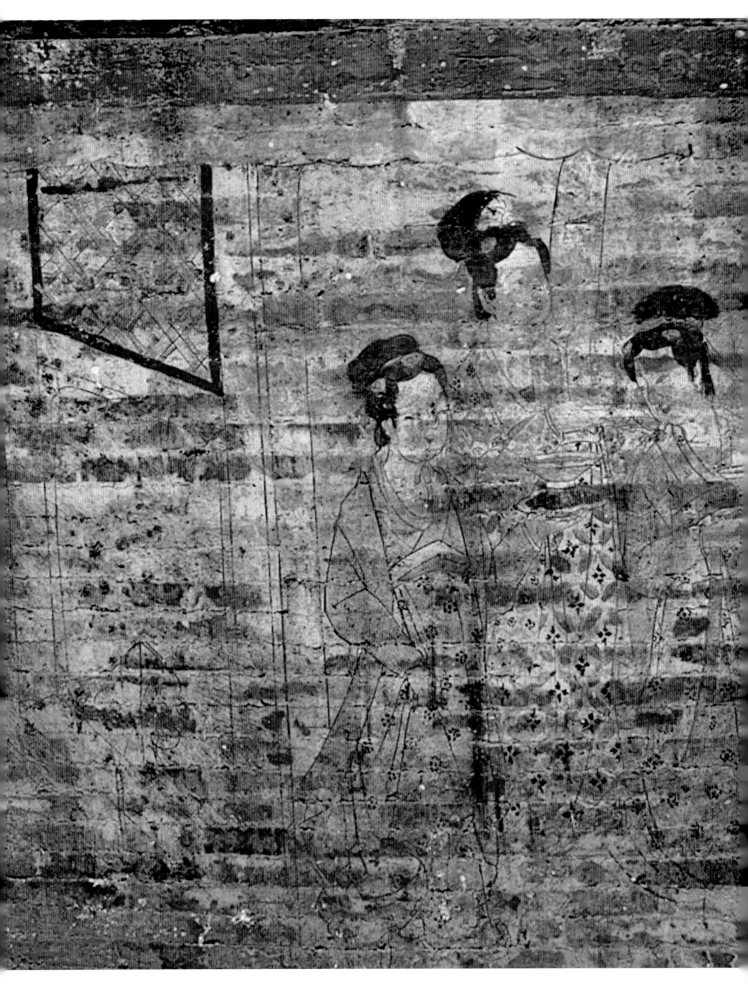

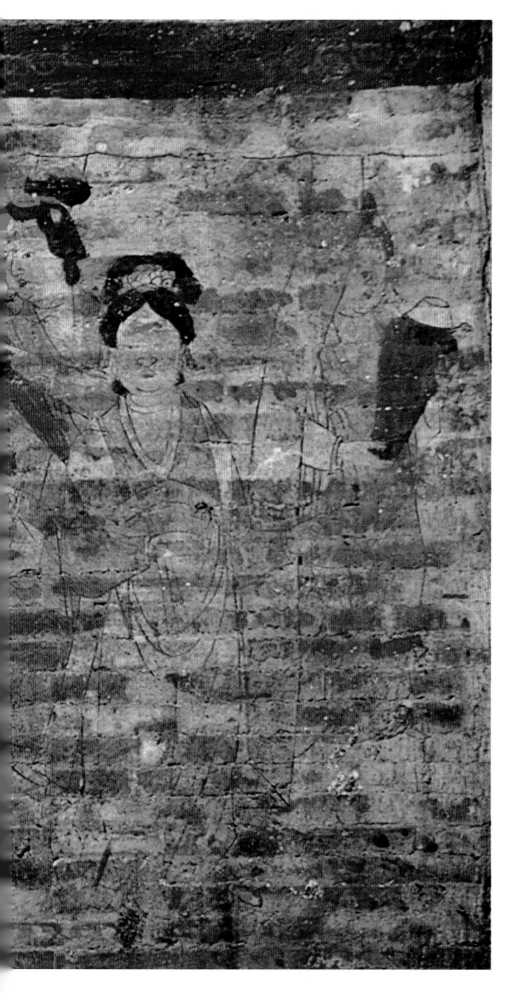

151. 仕女图（二）

北宋（960～1127年）

高155、宽210厘米

2004年河南省济源市东石露头村宋墓出土。原址保存。

墓向南。位于墓室西壁中北段。上部有红色悬帐，帐下饰白色垂幔，下有蓝绶四道。画中六人，皆高髻，多戴花冠，着窄袖长襦或褙子，或佩朱巾、围花，或素长裙，云头屐。六人各持酒瓶、劝盏、圆盒、筒囊、帨巾等物。有的正面前视，有的作顾盼状，左侧一人拱手而立。

（撰文、摄影：蔡强）

Beauties (2)

Northern Song (960-1127 CE)

Height 155 cm; Width 210 cm

Unearthed from Song tomb at Lutoucun of Dongshi in Jiyuan, Henan, in 2004. Preserved on the original site.

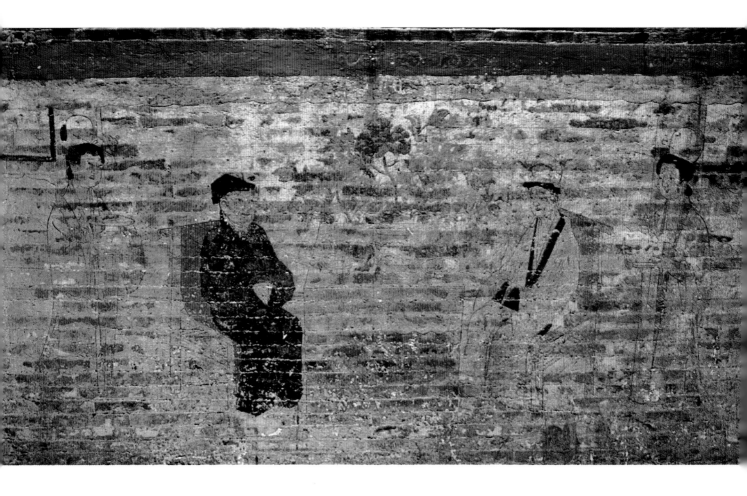

152.夫妇对坐图

北宋（960～1127年）

高155、宽300厘米

2004年河南省济源市东石露头村宋墓出土。原址保存。

墓向南。位于墓葬北壁，绘夫妇对坐场面。上部有红色幔帐，墓主人夫妇隔桌对坐，桌上置一方形盆栽牡丹花。外侧摆放着盛满食物的盘、碗以及壶与温碗等物。左一老翁，戴黑巾，留长须，着黑色袍服，抄手坐于靠椅上。右一老妇，高髻罩巾，着交领褙子，抄手坐于靠椅上。夫妇身后各站一侍女，均梳高髻，裹白巾，着褙子，穿白色鞋。左侍女双手捧渣斗，右侍女双手端温碗与注壶。两侍女身后各有一屏风。

<div style="text-align: right">（撰文、摄影：蔡强）</div>

Tomb Occupant Couple Seated Beside the Table

Northern Song (960-1127 CE)

Height 155 cm; Width 300 cm

Unearthed from Song tomb at Lutoucun of Dongshi in Jiyuan, Henan, in 2004. Preserved on the original site.

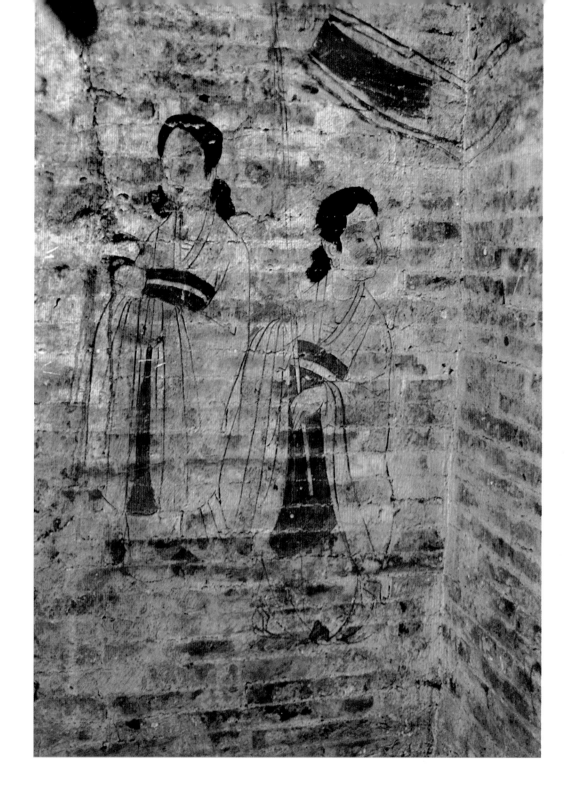

153.持幡仙人图

北宋（960～1127年）

高155、宽92厘米

2004年河南省济源市东石露头村宋墓出土。原址保存。

墓向南。位于墓室南壁墓门西侧，绘两仙女。右一人头梳垂髻，细弯眉，秀目高鼻，朱唇，面相丰满，着交领广袖长襦，内围白色裙，束腰垂朱色带，穿云头屐，手持幡旄。左一人，头梳双垂髻，面形丰腴，柳叶眉，高鼻朱唇，穿交领广袖襦，内围白色裙，垂朱宽带，穿朱色云头屐，作侧立状。

（撰文、摄影：蔡强）

Fairies Holding Streamers

Northern Song (960-1127 CE)
Height 155 cm; Width 92 cm
Unearthed from Song tomb at Lutoucun of Dongshi in Jiyuan, Henan, in 2004. Preserved on the original site.

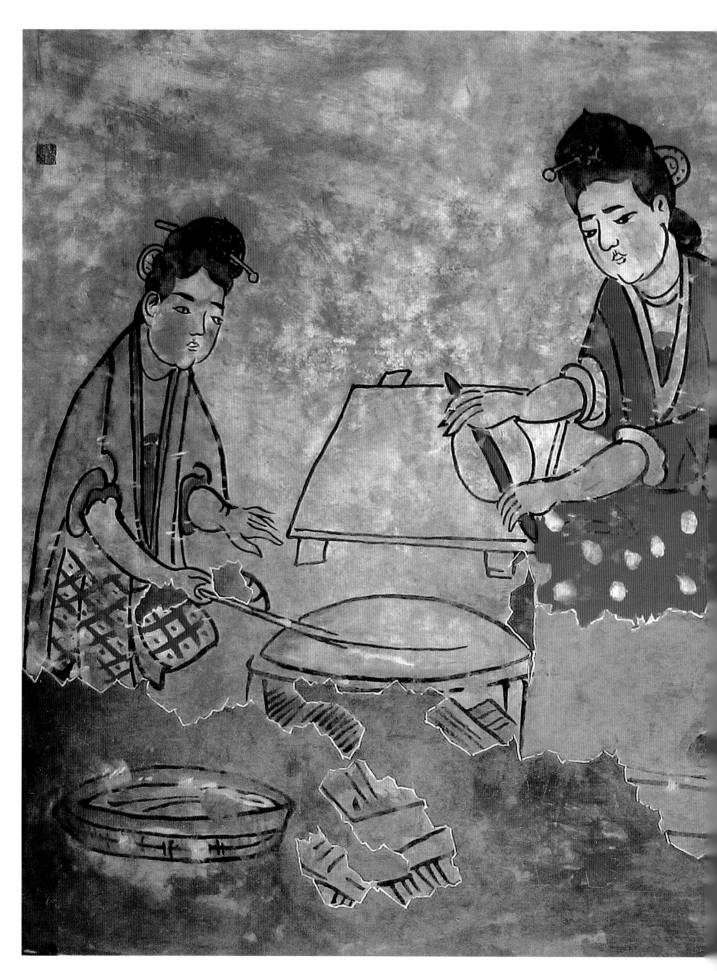

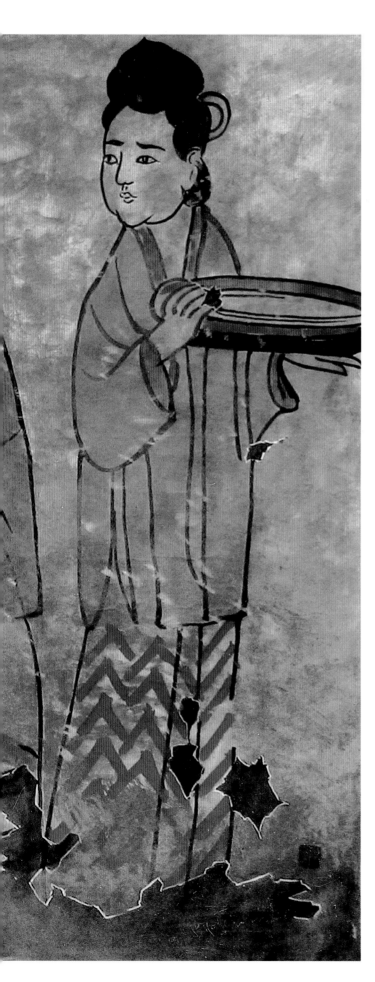

154.备厨图（摹本）

北宋（960～1127年）

高94、宽110厘米

2003年河南省登封市高村宋墓出土。原址保存。

墓向192°。位于墓内甬道西壁。绘三女子，头束高髻，插簪，身着褙子，下束长裙。南侧女子，坐于一鏊前，双袖挽起，右手持铁条翻饼。鏊下炉火正旺，鏊右侧放一托盘，内有烙饼。中坐一妇，身前一矮案，挽袖持杖，正擀面饼。北侧女子，双手托盘送餐，欲走而又回首。画面人物形象，生动逼真，具有浓厚的生活气息。

（临摹：不详　撰文：张文霞

摄影：张松林）

Cooking (Replica)

Northern Song (960-1127 CE)

Height 94 cm; Width 110 cm

Unearthed from Song tomb at Gaocun in Dengfeng, Henan, in 2003. Preserved on the original site.

155.升仙图

北宋（960～1127年）

高133、宽78厘米

2003年河南省登封市高村宋墓出土。原址保存。

墓向192°。位于墓室东南壁。上绘黄色横帐、红色幔帐，垂黄色组绶。帐下砖砌一耳室，从中飘出一团五彩祥云，其上站立两人。左侧男性（头及上身残缺），着红色窄袖袍，足着尖鞋，袖手。右侧一女，头梳高髻，着蓝色窄袖褙子，下束白裙，袖手。耳室两旁拱手而立两侍女，梳双垂髻，髻系红带，着褙子，下束裙，足着尖鞋。整幅图像似表现墓主人夫妇升仙的场面。

（撰文：张文霞　摄影：张松林）

Ascending Fairyland

Northern Song (960-1127 CE)
Height 133 cm; Width 78 cm
Unearthed from Song tomb at Gaocun in Dengfeng, Henan, in 2003. Preserved on the original site.

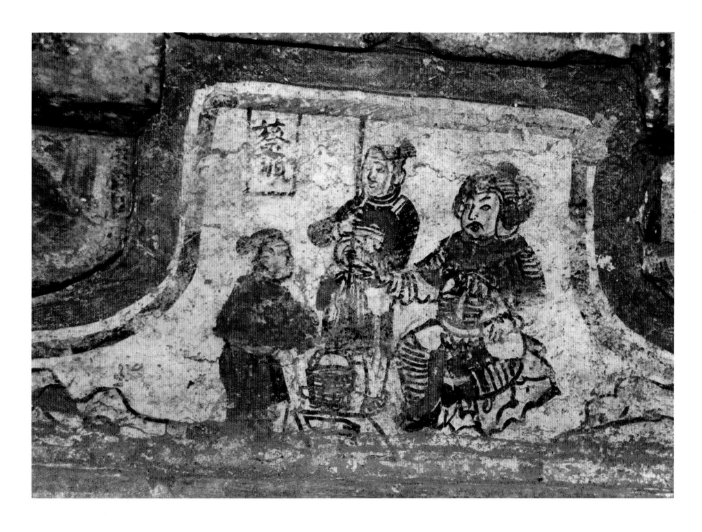

156.蔡顺行孝图

北宋（960～1127年）

高27、上宽28、下宽79厘米

2003年河南省登封市高村宋墓出土。原址保存。

墓向192°。位于墓室西南拱眼壁。画面中绘三人。左侧一人面右而跪，眼望对面军官，拱手施礼，身前地上放置一篮、一巾。军官头戴缨盔，身披铠甲，坐于一块岩石上，左手摁腰，右手前指。身旁站立一军士，头扎巾，身披两裆甲，手握一杆，注视施礼人。画左下角、右下角绘山峦，左上方题记"蔡顺"二字。此当是"蔡顺拾椹供亲"的故事。

（撰文：张文霞　摄影者：张松林）

Cai Shun, One of the "Twenty-Four Paragons of Filial Piety"

Northern Song (960-1127 CE)

Height 27 cm; Width at Top 28 cm; Width at Bottom 79 cm

Unearthed from Song tomb at Gaocun in Dengfeng, Henan, in 2003. Preserved on the original site.

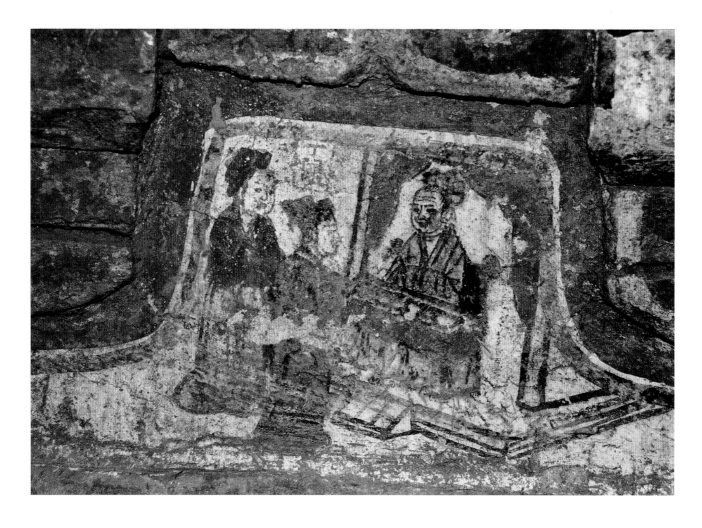

157. 丁兰行孝图

北宋（960～1127年）

高24、上宽27、下宽67厘米

2003年河南省登封市高村宋墓出土。原址保存。

墓向192°。位于墓室拱眼壁。右侧台基上立两檐柱，柱间悬红色幔帐，帐下一年老妇人，袖手坐于靠背椅上。身前一长方案，案上放有供品。案前站立两人，男头戴幞头，着圆领长袍，面向老妇人施礼。身左女子头梳高髻，上襦下裙，拱手，眼望男子。画左上方题记"丁兰"二字，此当是"丁兰刻木事亲"的故事。

（撰文：张文霞　摄影：张松林）

Ding Lan, One of the "Twenty-Four Paragons of Filial Piety"

Northern Song (960-1127 CE)

Height 24 cm; Width at Top 27 cm; Width at Bottom 67 cm

Unearthed from Song tomb at Gaocun in Dengfeng, Henan, in 2003. Preserved on the original site.

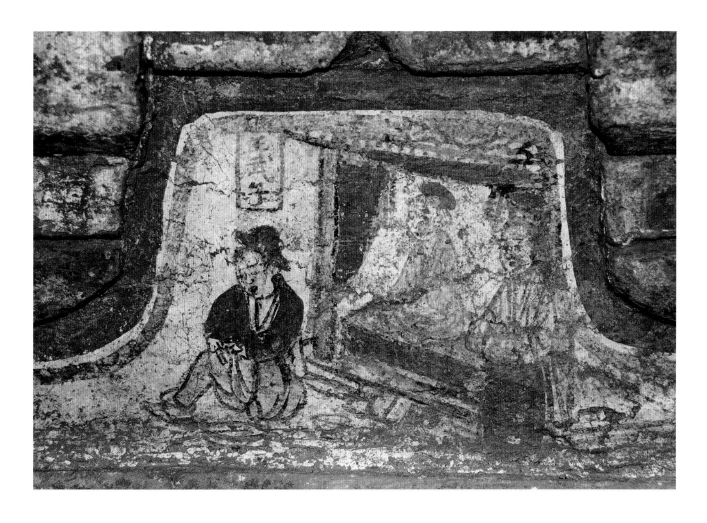

158. 王武子（妻）行孝图

北宋（960～1127年）

高25、上宽28、下宽68厘米

2003年河南省登封市高村宋墓出土。原址保存。

墓向192°。位于墓室北拱眼壁。画面右侧绘一低台建筑，青瓦覆顶，柱檐下红色幔帐高悬，柱间置一长方形榻。一老年妇人，袖手盘腿坐于榻上。阶前地上坐一年轻妇人，左手撩裙，露出右腿，右手拿刀，正欲割肉。身后柱前袖手立一侍女，默默注视妇人。画左上方题"王武子"三字，此当是"王武子妻割股奉亲"的故事。

<div align="right">（撰文：张文霞　摄影：张松林）</div>

Wang Wuzi's Wife, One of the "Twenty-Four Paragons of Filial Piety"

Northern Song (960-1127 CE)

Height 25 cm; Width at Top 28 cm; Width at Bottom 68 cm

Unearthed from Song tomb at Gaocun in Dengfeng, Henan, in 2003. Preserved on the original site.

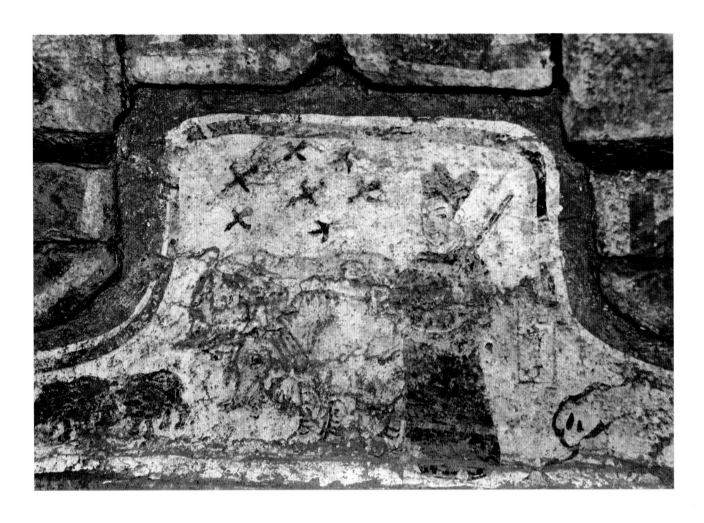

159.舜行孝图

北宋（960～1127年）

高25、上宽29、下宽72厘米

2003年河南省登封市高村宋墓出土。原址保存。

墓向192°。位于墓室东北拱眼壁。画面右绘一男子，头戴幞头，身着团领窄袖袍，内着交领衫，腰束带，袖手，腋下挟一鞭。男子右前方并排二象，象前有两头黑猪。空中七鸟飞翔。画右下角绘山石，并题记"尧舜子"，画面表现的是"舜孝感动天，大象耕田"故事。

<div align="right">（撰文：张文霞　摄影：张松林）</div>

Shun the Great, One of the "Twenty-Four Paragons of Filial Piety"

Northern Song (960-1127 CE)

Height 25 cm; Width at Top 29 cm; Width at Bottom 72 cm

Unearthed from Song tomb at Gaocun in Dengfeng, Henan, in 2003. Preserved on the original site.

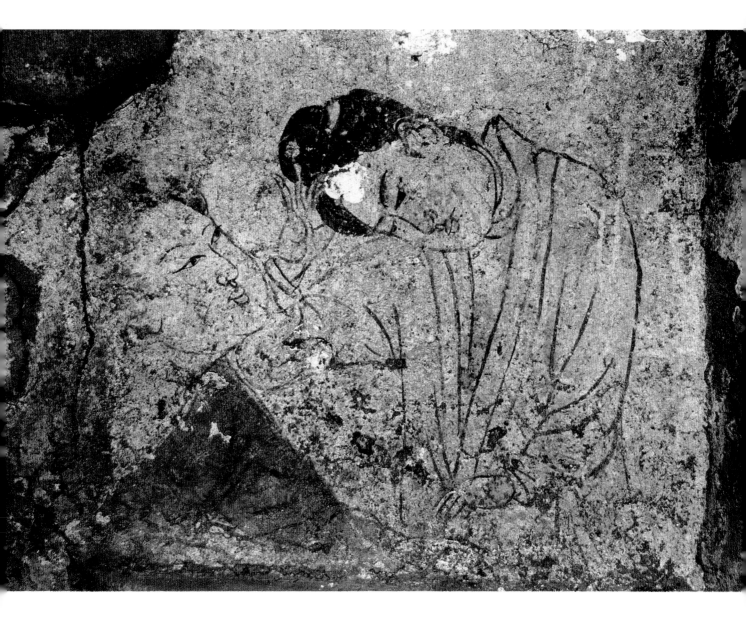

160.梳妆图（局部）

北宋（960~1127年）

高25、宽43厘米

1982年河南省登封市城南庄宋墓出土。原址保存。

墓向192°。位于墓室西南壁。画面人物为半身，左为一少妇头梳高髻，身着红色交领窄袖襦，下着白裙，右手垂于体侧，左手前探，仰面注视右侧女子。右女头梳高髻，髻系丝带，身着白色褙子，左手接左侧女子递过之物，右手抬举额际，作理鬓状。

（撰文：张文霞　摄影：张松林）

Dressing Up (Detail)

Northern Song (960-1127 CE)

Height 25 cm; Width 43 cm

Unearthed from Song tomb at Chengnanzhuang in Dengfeng, Henan, in 1982. Preserved on the original site.

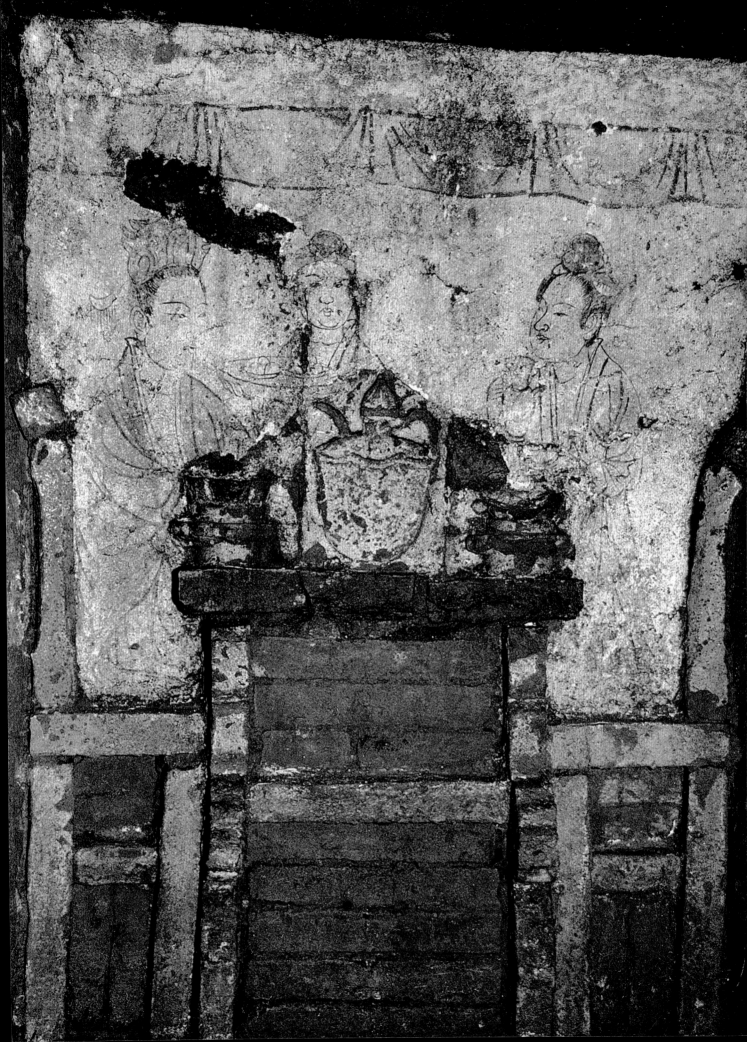

◀161.夫妇对坐图

北宋（960～1127年）

高94、宽87厘米

1982年河南省登封市城南庄宋墓出土。原址保存。

墓向192°。位于墓室西壁。上绘横帐，横帐下砌一直足方桌和两靠背椅。桌上放置托盏二、带碗注子一。左侧椅上袖手坐一妇人，头戴莲花冠，插步摇，目光祥和。桌旁站立两侍女，左女头梳高髻，束粉红色额带，手捧一劝盘，内放酒盏二。右女头梳高髻，左手平端茶盏，右手提举注子至胸前。右椅空位，为男墓主"虚位以待"。

（撰文：张文霞　摄影：张松林）

Tomb Occupant Couple Seated Beside the Table

Northern Song (960-1127 CE)

Height 94 cm; Width 87 cm

Unearthed from Song tomb at Chengnanzhuang in Dengfeng, Henan, in 1982. Preserved on the original site.

▼162.婴戏图（局部）

北宋（960～1127年）

高26、宽38厘米

1982年河南省登封市城南庄宋墓出土。原址保存。

墓向192°。位于墓室西南间壁。周绘折枝牡丹，花丛中一幼儿，光头，圆脸，高鼻，大耳，嘴眼较小，面露憨相，两臂前伸，似扑地上一蝶。

（撰文：张文霞　摄影：张松林）

Boy Catching Butterfly (Detail)

Northern Song (960-1127 CE)

Height 26 cm; Width 38 cm

Unearthed from Song tomb at Chengnanzhuang in Dengfeng, Henan, in 1982. Preserved on the original site.

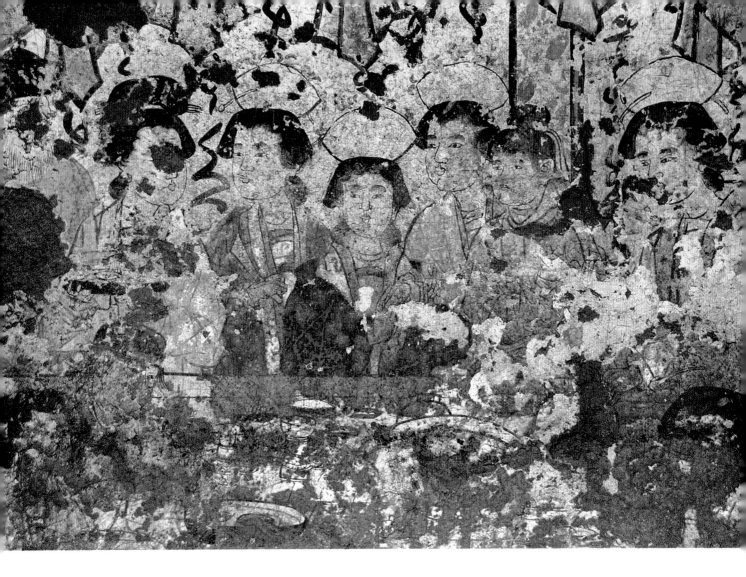

▲163.奉侍图（局部）

北宋（960～1127年）

高91、宽98厘米

1984年河南省登封市箭沟村宋墓出土。原地保存。

墓向192°。位于墓室东北壁。上绘横帐，帐下一长案，上置盘、盏、碗、盒等物。案后七人，中间坐一女子，头戴簪花团冠，双手持一冠。女身旁站六人，左起第一人为一老年男子。左二女子梳高髻，双手端劝盏。左三女子戴簪花团冠，右手持折扇，眼视左侧女子。左五女子簪花团冠。左六为一少年，袖手。左七女子，簪花团冠，左手按于案边。众人背后墙上满书行草文字。

（撰文：张文霞　摄影：张松林）

Hostess and Attendants (Detail)

Northern Song (960-1127 CE)

Height 91 cm; Width 98 cm

Unearthed from Song tomb at Jiangoucun in Dengfeng, Henan, in 1984. Preserved on the original site.

164.伎乐图 ▶

北宋（960～1127年）

高138、宽106厘米

1984年河南省登封市箭沟村宋墓出土。原址保存。

墓向192°。位于墓室东壁。上绘横帐，帐下绘有17人，均男性，头戴短脚幞头，着各色团领窄袖袍。前排四人为一组，袍均蓝色，似为舞旋之人。左后五人为一组，手持乐器。有方响、箫、笙和觱篥。右方八人一组，以鼓为中心站立。手持鼓槌、觱篥、拍板等。

（撰文：张文霞　摄影：张松林）

Music Band Playing

Northern Song (960-1127 CE)

Height 138 cm; Width 106 cm

Unearthed from Song tomb at Jiangoucun in Dengfeng, Henan, in 1984. Preserved on the original site.

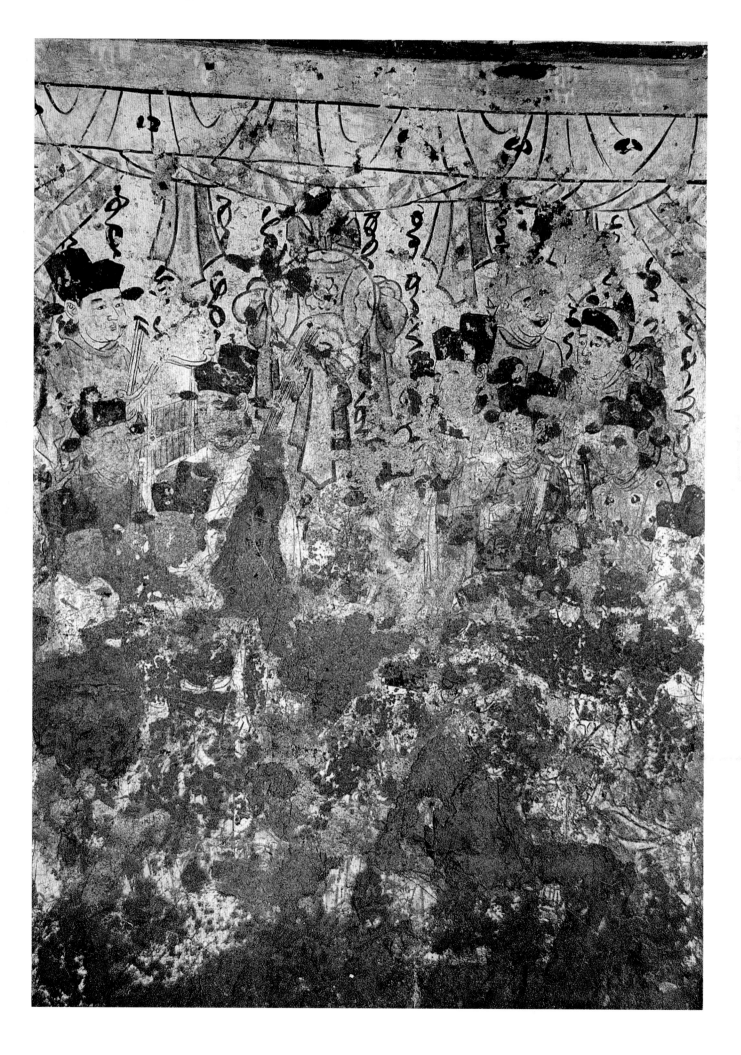

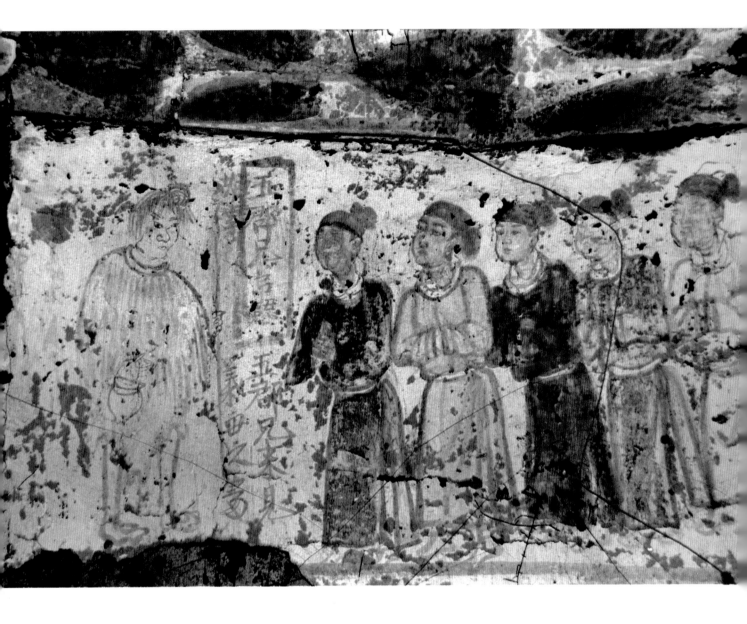

165. "五郡兄弟认娘"图

北宋（960～1127年）

高82、宽78厘米

2002年河南省巩义市涉村宋墓出土。原址保存。

墓向190°。位于墓室北壁上部左侧，绘六人。左一老妇，顶梳单髻，发披散，上着蓑衣，赤腿，左手拄杖，右手提罐。右五人，皆头戴黑巾，着团领窄袖袍，下着裤，身略前倾，头半仰望向老妇人。前一人，着红袍，施叉手礼；后四人，分着粉红、红、黄、灰色袍，袖手。妇人与男子之间两处题记，上为"五郡兄弟认娘处"，下为"五郡兄来见义母之处"。

<div align="right">（撰文：张文霞　摄影：张松林）</div>

The Scene of "Five Sworn Brothers Respecting the Adoptive Mother"

Northern Song (960-1127 CE)

Height 82 cm; Width 78 cm

Unearthed from Song tomb at Shecun in Gongyi, Henan, in 2002. Preserved on the original site.

166. "五郡兄弟"图

北宋（960～1127年）

高76、宽92厘米

2002年河南省巩义市涉村宋墓出土。原址保存。

墓向190°。位于墓室西壁上部右侧。自左至右绘五人，皆头戴黑色软巾，着圆领窄袖袍，足着靴，袖手，目左前视。左一穿黄袍，左二穿粉红袍，左三穿淡蓝袍，左四穿白袍，左五穿红袍。红袍人头侧有题记"义君处"。

（撰文：张文霞　摄影：张松林）

The Scene "Five Sworn Brothers from Five Prefectures"

Northern Song (960-1127 CE)

Height 76 cm; Width 92 cm

Unearthed from Song tomb at Shecun in Gongyi, Henan, in 2002. Preserved on the original site.

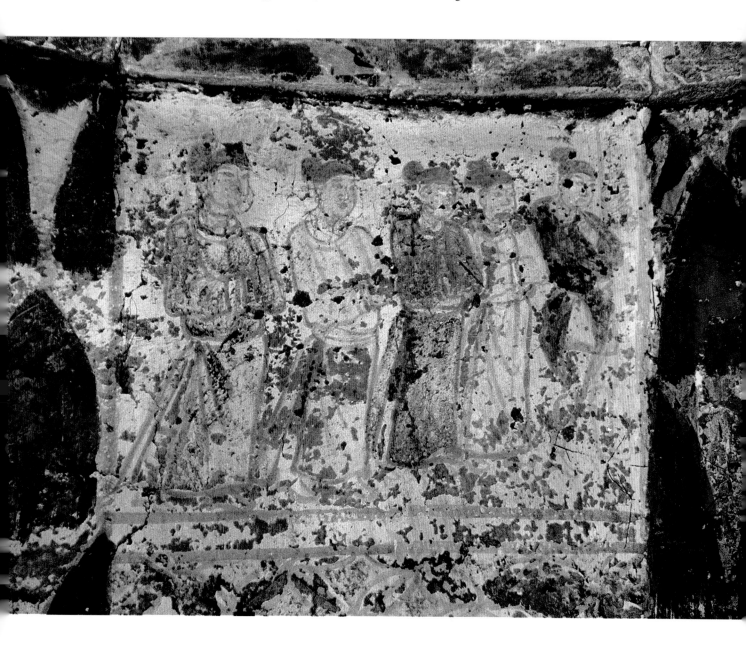

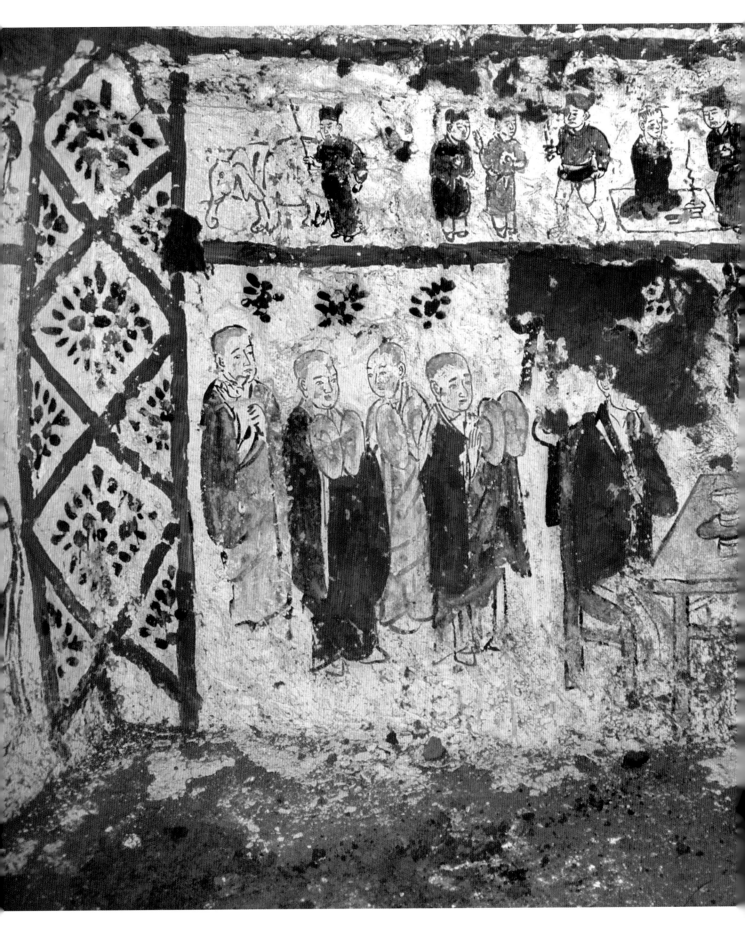

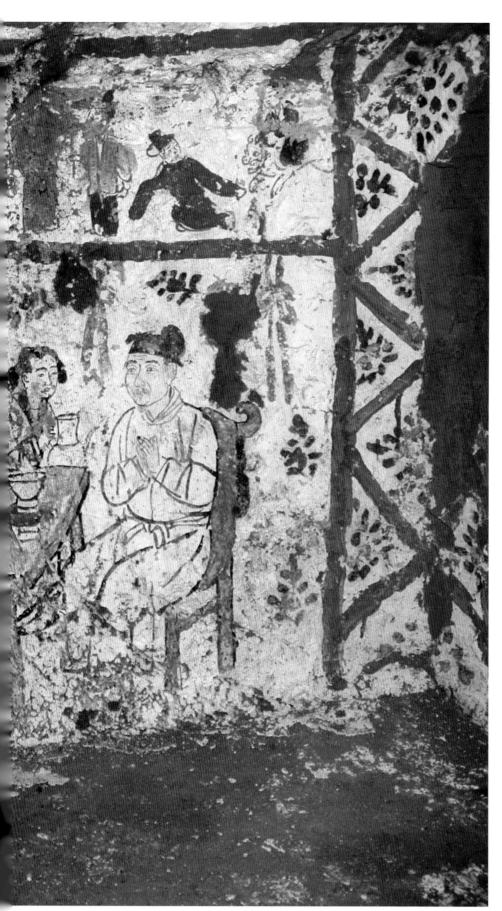

167.墓室西壁图

北宋（960～1127年）

高86、宽127厘米

2008年河南省荥阳市槐西村宋墓出土。原址保存。

墓向183°。位于墓室西壁。画面以红线隔开分成上下两部分，下部绘墓主人夫妇对坐僧人作法图，上部绘行孝图五组。下部画面上悬赭褐色与红色组绶与碎花幔帐，帐下右半部绘墓主人夫妇对坐图。画面左半部绘四位僧侣，除左三僧人面向右侧张望外，其余三位僧人均面向右侧的男女墓主人。前三人持钹演奏。从画面分析，应为墓主人作法事活动。

（撰文：于宏伟 摄影：刘良超）

Mural on the West Wall of the Tomb Chamber

Northern Song (960-1127 CE)

Height 86 cm; Width 127 cm

Unearthed from a Song tomb at Huaixicun in Xingyang, Henan, in 2008. Preserved on the original site.

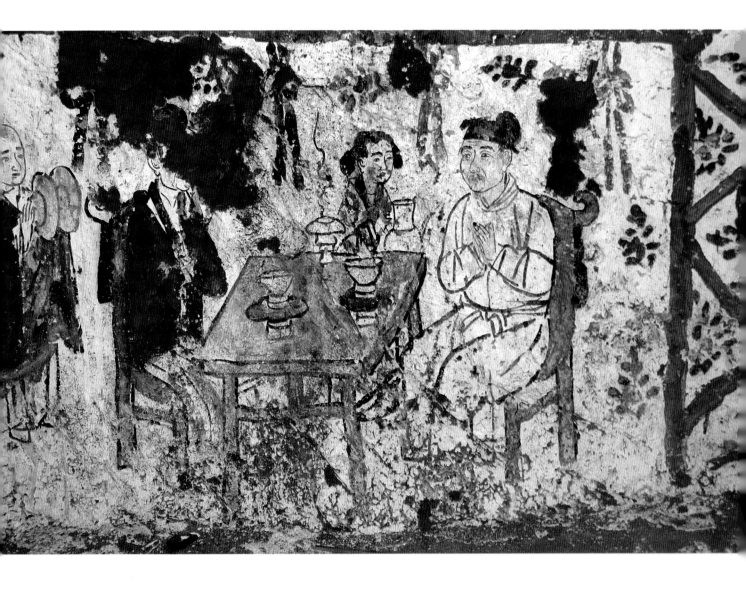

168. 夫妇对坐图

北宋（960~1127年）

高86、宽78厘米

2008年河南省荥阳市槐西村宋墓出土。原址保存。

墓向183°。位于墓室西壁下部右侧，画面为男女主人对坐。左侧女主人头梳高髻，戴耳环，面部满是皱纹。身着红色褙子，内着白衫，下束白裙。双手环抱胸前，端坐于靠背椅上。右侧男主人头戴黑色软巾，着白色圆领窄袖袍，双手合什，坐于搭脑上翘的椅上。二人中间是一直足直枨的方桌，上置托盏一对，香炉一只，桌后站立一侍女，头梳双垂髻，着白色交领褙子，双手持一白色注子，面向男主人。

（撰文：于宏伟　摄影：刘良超）

Tomb Occupant Couple Seated Beside the Table

Northern Song (960-1127 CE)

Height 86 cm; Width 78 cm

Unearthed from a Song tomb at Huaixicun in Xingyang, Henan, in 2008. Preserved on the original site.

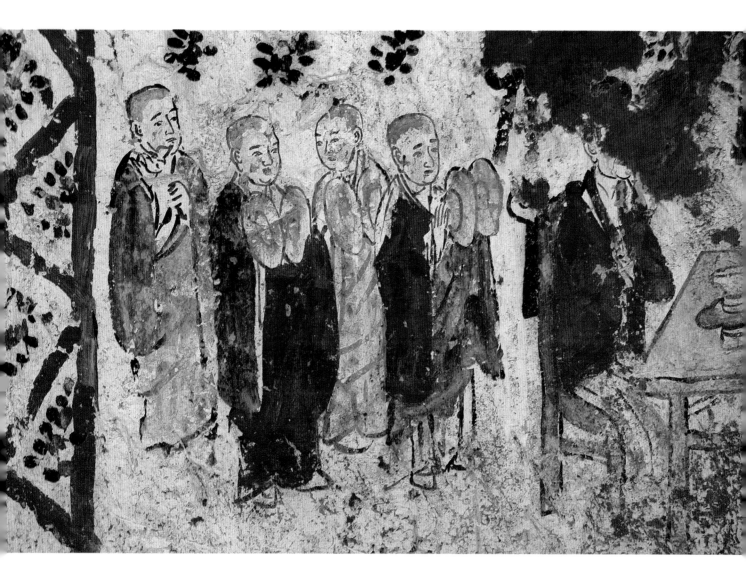

169. 僧人作法图

北宋（960～1127年）

高62、宽49厘米

2008年河南省荥阳市槐西村宋墓出土。原址保存。

墓向183°。位于墓室西壁下部左侧，画面绘四位僧侣。左一僧人，内着赭黄色僧袍，外披淡黄色袈裟，双手托一朵莲花于胸前。左二僧人，内着赭黄色僧袍，外披红色袈裟，双手击钹。左三僧人，身披浅黄色袈裟，双手击钹，左四僧人，内着红色僧袍，身披赭黄色袈裟，双手击钹。

（撰文：于宏伟　摄影：刘良超）

Buddhist Monks in Religious Ceremony

Northern Song (960-1127 CE)

Height 62 cm; Width 49 cm

Unearthed from a Song tomb at Huaixicun in Xingyang, Henan, in 2008. Preserved on the original site.

170.奉酒图

北宋（960~1127年）

高62、宽54厘米

2008年河南省荥阳市槐西村宋墓出土。原址保存。

墓向183°。位于墓室北壁下部左侧。画面绘二侍女，均梳高髻，插簪，外穿红黑花纹交领褙子，左边侍女下束淡黄色百褶长裙，右边侍女下束百褶碎花长裙，左侧侍女双手端一黑色梅瓶，面向前方，右侧侍女双手托一花边形劝盘，内置一杯。正回首张望。

（撰文：于宏伟　摄影：刘良超）

Serving Wine

Northern Song (960-1127 CE)
Height 62 cm; Width 54 cm
Unearthed from a Song tomb at
Huaixicun in Xingyang, Henan, in
2008. Preserved on the original site.

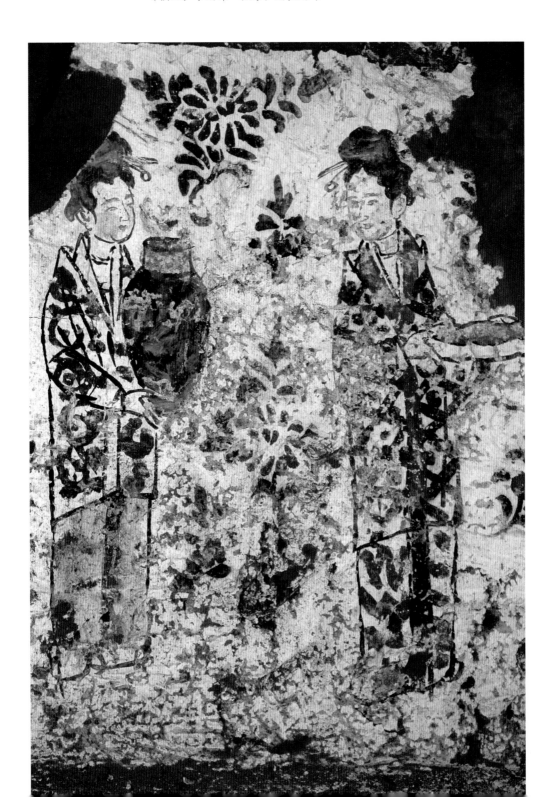

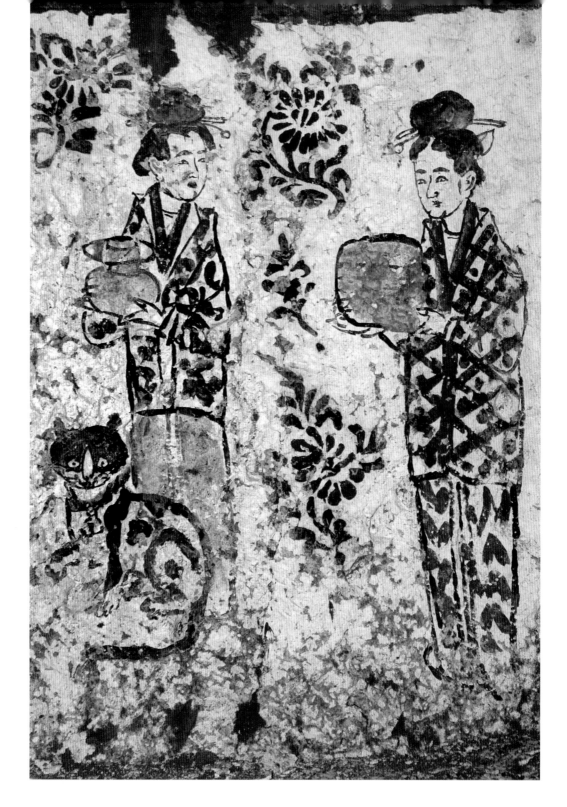

171.奉茶图

北宋（960～1127年）

高62、宽48厘米

2008年河南省荥阳市槐西村宋墓出土。原址保存。

墓向183°。位于墓室北壁下部右侧。画面绘二侍女，均束高髻，插簪，着装同左半部侍女，左侍女双手端一黄色渣斗、口部放一小罐，回首面向对面侍女，身下半蹲一黑狸猫，右侧女子双手托一圆形盛物，似为盒子之类。

（撰文：于宏伟 摄影：刘良超）

Serving Tea

Northern Song (960-1127 CE)

Height 62 cm; Width 48 cm

Unearthed from a Song tomb
at Huaixicun in Xingyang,
Henan, in 2008. Preserved on the
original site.

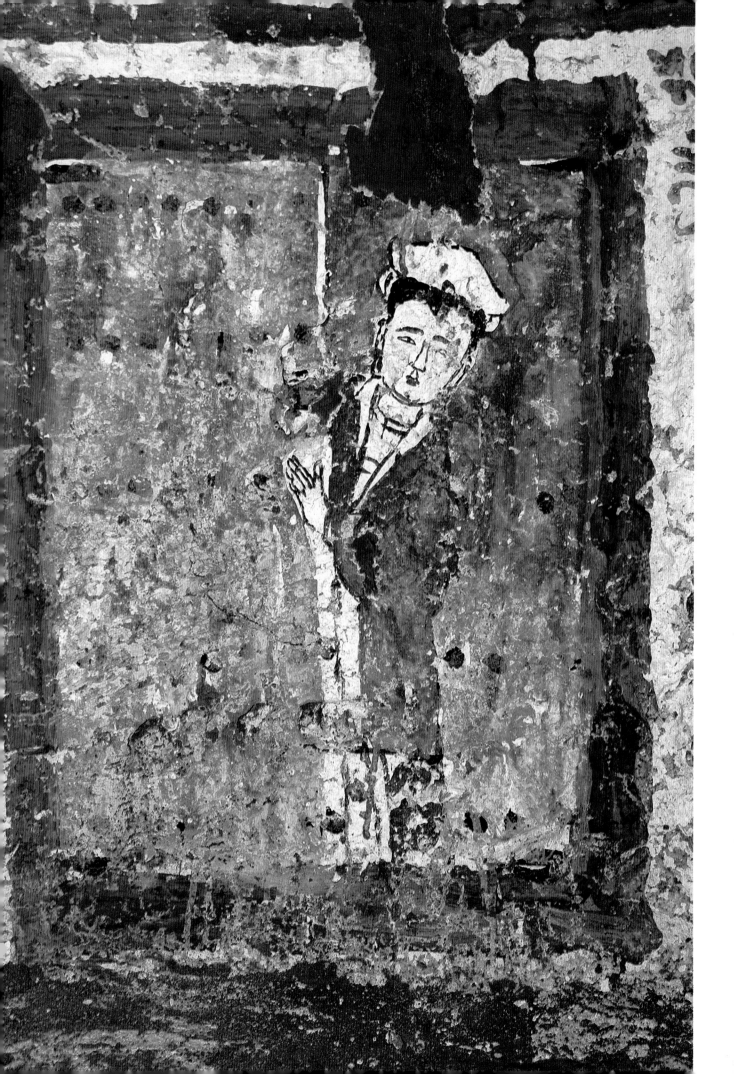

◀172. 妇人启门图

北宋（960～1127年）

高62、宽46厘米

2008年河南省荥阳市槐西村宋墓出土。原址保存。

墓向183°。位于墓室北壁下部正中。中间绘一朱红色板门，门绘五路门钉，一侍女头束白帕，外穿红色褙子，下束百褶裙，左手抚门，上半身探出门外张望。

（撰文：于宏伟　摄影：刘良超）

Lady Opening the Door Ajar

Northern Song (960-1127 CE)

Height 62 cm; Width 46 cm

Unearthed from a Song tomb at Huaixicun in Xingyang, Henan, in 2008. Preserved on the original site.

▼173. 墓室东壁图

北宋（960～1127年）

高86、宽127厘米

2008年河南省荥阳市槐西村宋墓出土。原址保存。

墓向183°。位于墓室东壁。画面以红线隔开分成上下两部分，下部绘梳妆图，上部绘行孝图。下部画面在人物、物品间空隙绘赭红色小碎花。左半幅绘尺、剪、熨斗各一，其右绘一柜，直足，直根，正面设锁钥各一，柜后立一衣架。右半幅绘二女子，作梳妆状。

（撰文：于宏伟　摄影：刘良超）

Mural on the East Wall of the Tomb Chamber

Northern Song (960-1127 CE)

Height 86 cm; Width 127 cm

Unearthed from a Song tomb at Huaixicun in Xingyang, Henan, in 2008. Preserved on the original site.

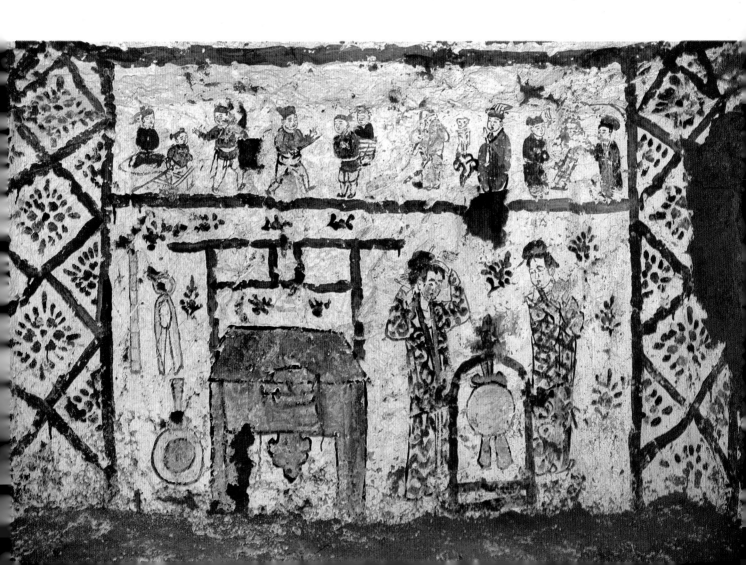

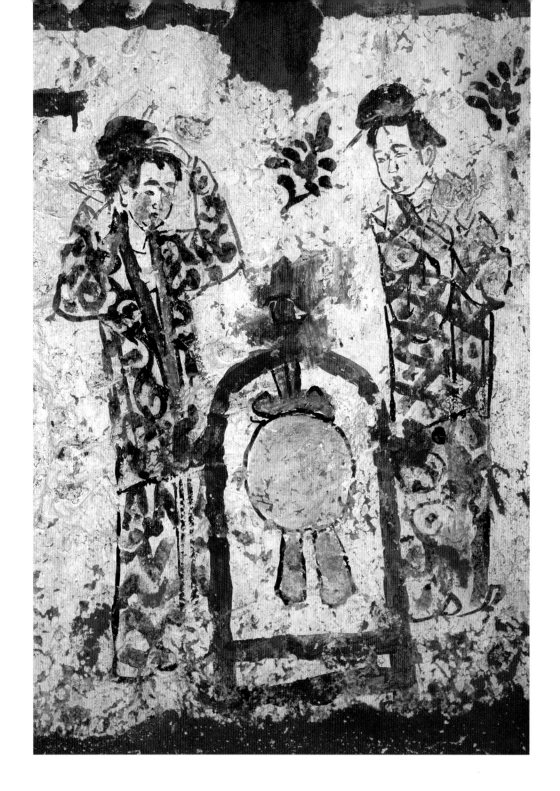

174.梳妆图

北宋（960～1127年）

高62、宽57厘米

2008年河南省荥阳市槐西村宋墓出土。原址保存。

墓向183°。位于墓室东壁下部右侧。中间绘红色镜架，镜架上悬一圆镜。镜架左边女子梳高髻，外穿黑色花纹褙子，下束百褶裙，作理鬓状，正对镜梳妆。右边女子头梳高髻，外穿赭黄花纹褙子，下束百褶裙，双手合什，回眸望镜。

<div style="text-align:right">（撰文：于宏伟　摄影：刘良超）</div>

Dressing Up

Northern Song (960-1127 CE)
Height 62 cm; Width 57 cm
Unearthed from a Song tomb at Huaixicun in Xingyang, Henan, in 2008. Preserved on the original site.

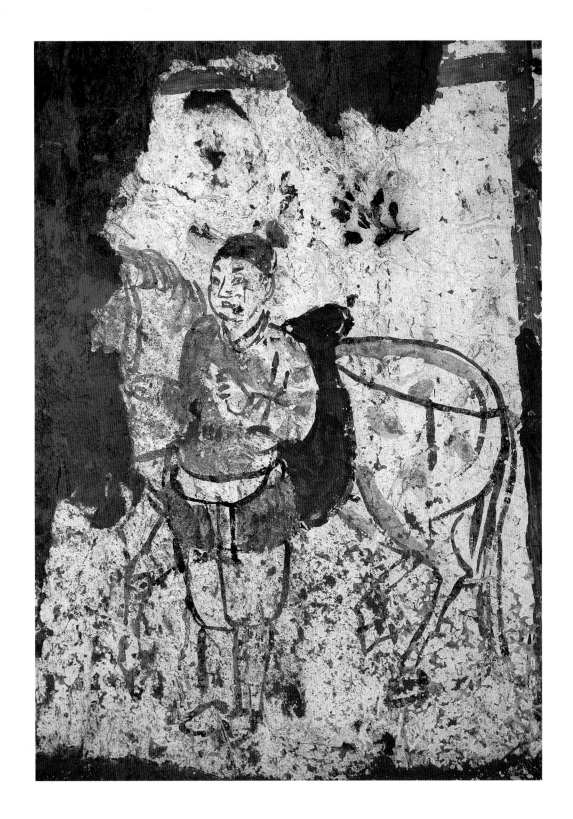

175. 出行图

北宋（960～1127年）

高68、宽48厘米

2008年河南省荥阳市槐西村宋墓出土。原址保存。

墓向183°。位于墓室南壁西下部。绘一人一马。男子头戴黑巾，上穿白色团领窄袖袍，下着裤，右手牵缰。马抬足正行，背上配红色马鞍，胸有攀胸，臀有鞦。

（撰文：于宏伟　摄影：刘良超）

Saddled Horse and Groom Waiting for Travel

Northern Song (960-1127 CE)

Height 68 cm; Width 48 cm

Unearthed from a Song tomb at Huaixicun in Xingyang, Henan, in 2008. Preserved on the original site.

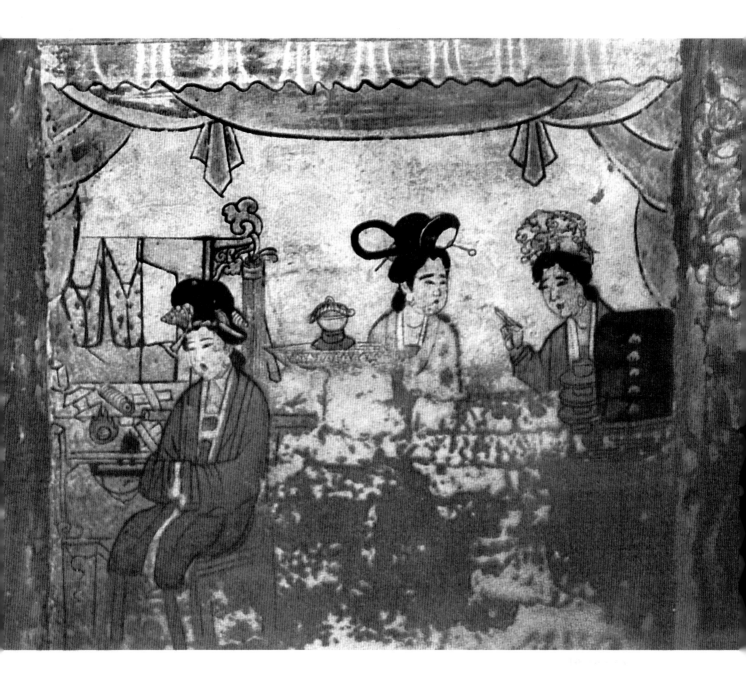

176.仕女图

北宋（960～1127年）

高80、宽100厘米

1951年河南省禹州市白沙二号宋墓出土。现存于中国国家博物馆。

墓向180°。位于墓室东南壁。阑额下画绛色悬帐、蓝色组绶，帐下三女。左侧一女，头戴团冠，身着绛红色褙子，袖手坐于椅上；背后置一高足柜，高足柜之后为一朱色衣架。右侧二女；前者梳双鬟髻，着淡蓝褙子，双手捧白色莲花大盘，盘中置一香炉。后者着花冠，绛红色褙子。左手戟指其前女人，似与之作谈话状。

（撰文：孙锦　摄影：彭华士）

Beauties

Northern Song (960-1127 CE)

Height 80 cm; Width 100 cm

Unearthed from the Song tomb No.2 at Baisha in Yuzhou, Henan, in 1951. Preserved in National Museum of China.

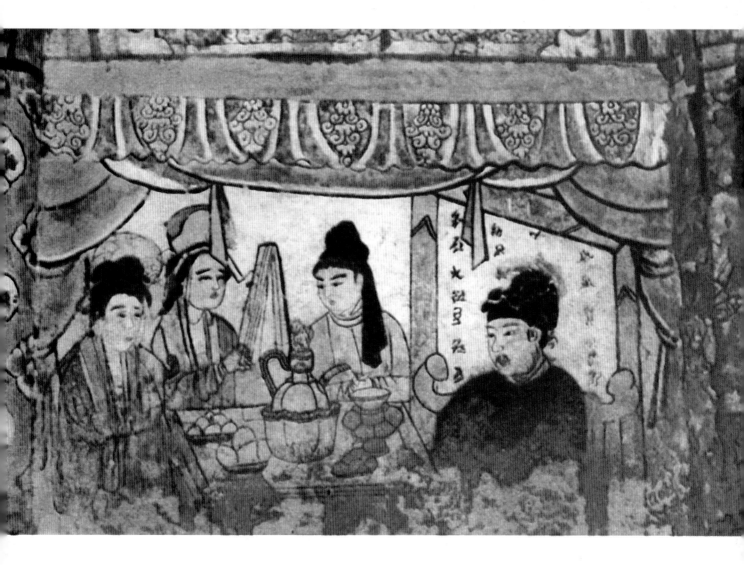

177.夫妇对坐图

北宋（960～1127年）

高80、宽100厘米

1951年河南省禹州市白沙二号宋墓出土。现存于中国国家博物馆。

墓向180°。位于墓室西南壁，阑额下画绛色帐，帐下二男二女。右侧男墓主人著圆领皂袍，袖手坐于椅上，其后一屏风，屏心书文字四行。男像之左设朱色桌，桌上置托盏、带碗注子和果盘。桌左侧女墓主人着青色褙子，袖手坐于椅上。桌后右侧立一叉手男侍，头戴巾，着圆领窄袖袍；应为小唱者；其左侧立一女伎，梳包髻，着褙子，双手击拍板。

（撰文：孙锦　摄影：彭华士）

Tomb Occupant Couple Seated Beside the Table

Northern Song (960-1127 CE)

Height 80 cm; Width 100 cm

Unearthed from the Song tomb No.2 at Baisha in Yuzhou, Henan, in 1951. Preserved in National Museum of China.

178.墓门彩画

北宋（960～1127年）

高80、宽100厘米

1951年河南省禹州市白沙二号宋墓出土。现存于中国国家博物馆。

墓向180°。位于墓室南壁。在券门入口处的两侧影作立颊、门额，皆衬以淡蓝、淡赭两色地，地上墨绘连续忍冬纹。门额下券门上画牡丹一朵，两侧饰飞翔的禽鸟各一，其间填以云朵。

（撰文：孙锦　摄影：彭华士）

Decorations of the Tomb Entrance

Northern Song (960-1127 CE)

Height 80 cm; Width 100 cm

Unearthed from the Song tomb No.2 at Baisha in Yuzhou, Henan, in 1951. Preserved in National Museum of China.

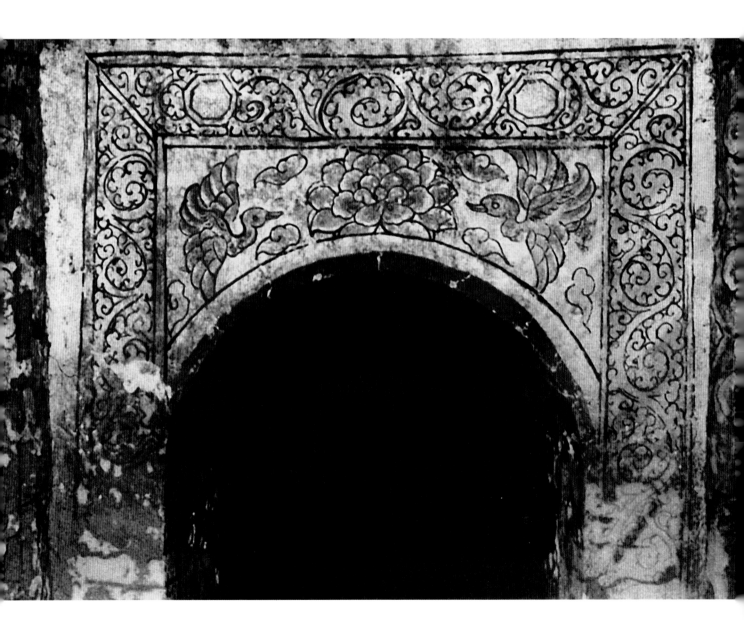

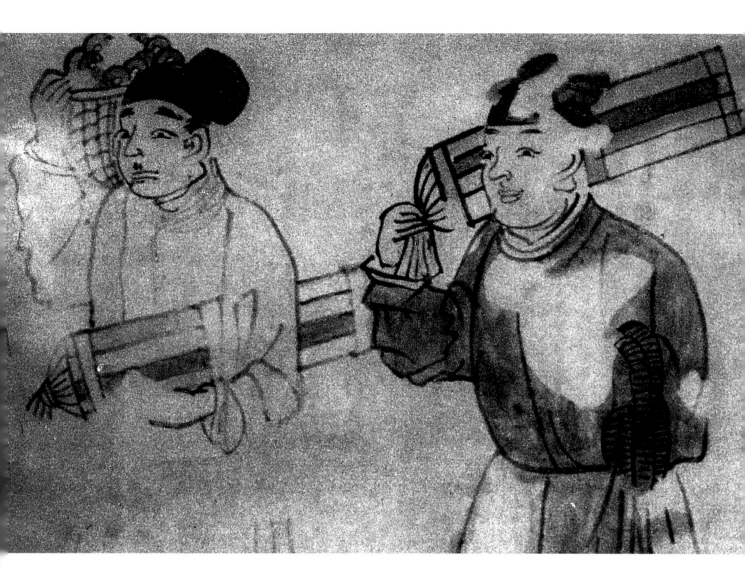

179.贡纳钱物图

北宋（960～1127年）

高60、宽80厘米

1951年河南省禹州市白沙三号宋墓出土。现存于中国国家博物馆。

墓向160°。位于墓内甬道东壁，画面二男。左男头戴巾，着圆领浅黄袍、腰束带，左腋下夹一筒囊，右手上持置于右肩上的黄色筐蓝，筐蓝内置有青色钱贯。右男头戴黑巾，着蓝色圆领窄袖袍，腰束带，左手握钱贯，右手上持负于右肩的筒囊。

（撰文：孙锦　摄影：彭华士）

Paying Tributes

Northern Song (960-1127 CE)

Height 60 cm; Width 80 cm

Unearthed from the Song tomb No.3 at Baisha in Yuzhou, Henan, in 1951. Preserved in National Museum of China.

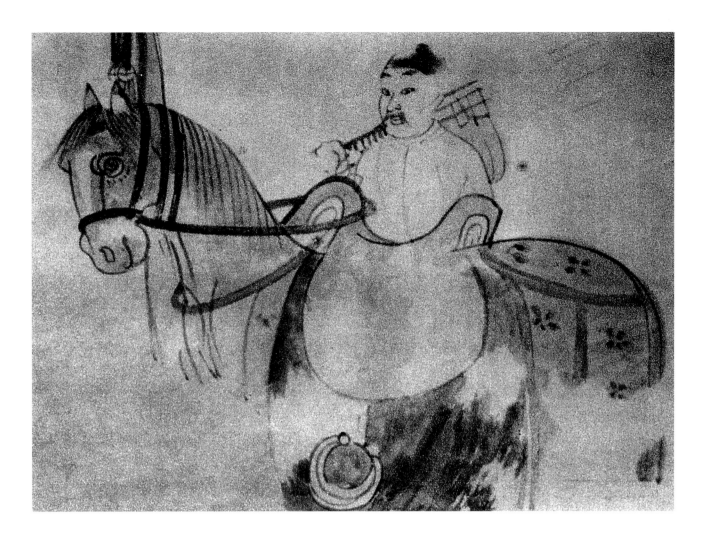

▲180.鞍马图

北宋（960～1127年）

高60、宽80厘米

1951年河南省禹州市白沙三号宋墓出土。现存于中国国家
博物馆。

墓向160°。位于墓内甬道西壁，绘一人一马。马色浅蓝，
备赭鞍黑鞯、浅黄镫。马后立一人，留短胡，着浅黄色圆
领窄袖袍，右手上持负于右肩上的交椅（胡床）。

（撰文：孙锦　摄影：彭华士）

Horse and Groom

Northern Song (960-1127 CE)

Height 60 cm; Width 80 cm

Unearthed from the Song tomb No.3 at Baisha in Yuzhou,
Henan, in 1951. Preserved in National Museum of China.

181.建筑彩画图▶

金（1115～1234年）

2006年河南省林州市桂林镇三井村金墓出土。现存于林州
市博物馆。

墓向南。位于墓室北壁。该墓砖砌单室，平面基本上作圆
形，壁面作上、下两层。下层壁面为砖雕板门、棂花窗，
上层壁面及顶部皆有彩画，立柱、斗栱用红、黄两色刷
饰，彩绘都绘于浅雕的小龛内，人物每个独立成幅，但两
两合成一组。

（撰文、摄影：申明清）

Color-painted Imitation Wooden Architecture

Jin (1115-1234 CE)

Unearthed from the Jin tomb at Sanjingcun of Guilin in
Linzhou, Henan, in 2006. Preserved in Museum of Linzhou.

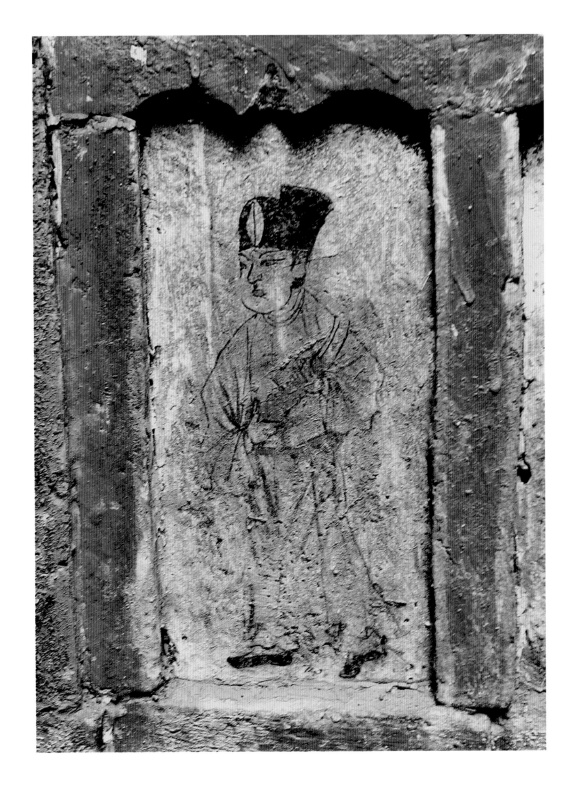

182.文吏图

金（1115～1234年）

2006年河南省林州市桂林镇三井村金墓出土。现存于林州市博物馆。

墓向南。位于墓室北壁上层，在砖雕壶门形小龛内一男吏站立，头戴黑色幞头，身穿黄色圆领窄袖长袍，腰系红色束带，双手斜持一笏板。足穿黑色履。

（撰文、摄影：申明清）

Civil Official

Jin (1115-1234 CE)

Unearthed from the Jin tomb at Sanjingcun of Guilin in Linzhou, Henan, in 2006. Preserved in Museum of Linzhou.

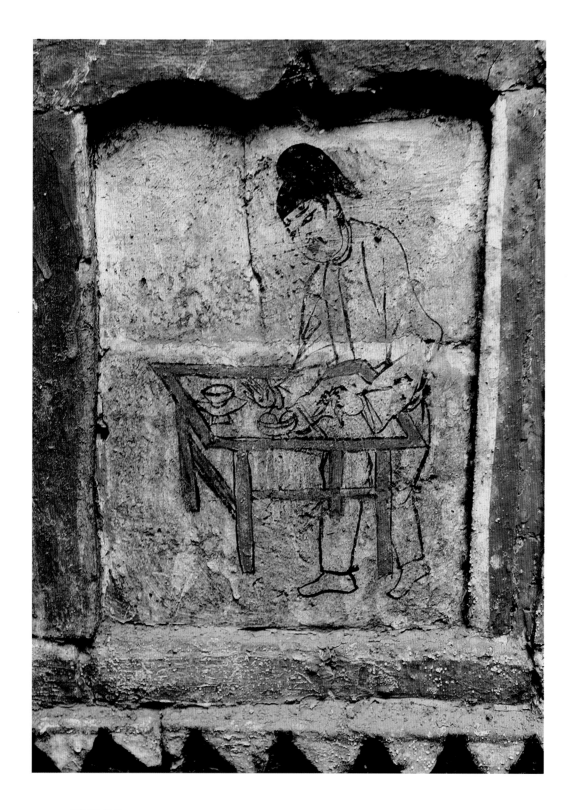

183. 男侍图

金（1115～1234年）

2006年河南省林州市桂林镇三井村金墓出土。现存于林州市博物馆。

墓向南。位于墓室北壁上层，为一男侍站在一方桌子边，桌上有托盏一付及果盘、茶匙，男侍头裹黑巾，身穿白色团领窄袖短衫，下穿白色长裤，正在桌子上摆放食物。

（撰文、摄影：申明清）

Servant

Jin (1115-1234 CE)

Unearthed from the Jin tomb at Sanjingcun of Guilin in Linzhou, Henan, in 2006. Preserved in Museum of Linzhou.

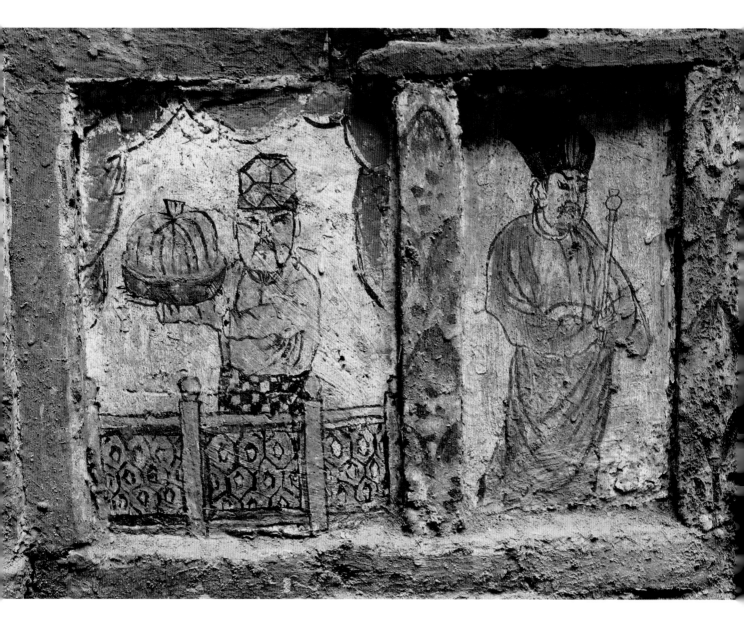

184. 男侍及门吏图

金（1115～1234年）

2006年河南省林州市桂林镇三井村金墓出土。现存于林州市博物馆。

墓向南。位于墓室南壁上层，左侧画面为一男侍站于围栏内，头戴八棱帽，身穿圆领短衫，腰系黑白方格围裙，双手托一圆盘，盘上似扣一纱罩。右侧画面为另一男侍，头戴黑色幞头，身穿红色团领窄袖长袍，腰束宽带，双手持骨朵。

<div align="right">（撰文、摄影：申明清）</div>

Servant and Door Guard

Jin (1115-1234 CE)

Unearthed from the Jin tomb at Sanjingcun of Guilin in Linzhou, Henan, in 2006. Preserved in Museum of Linzhou.

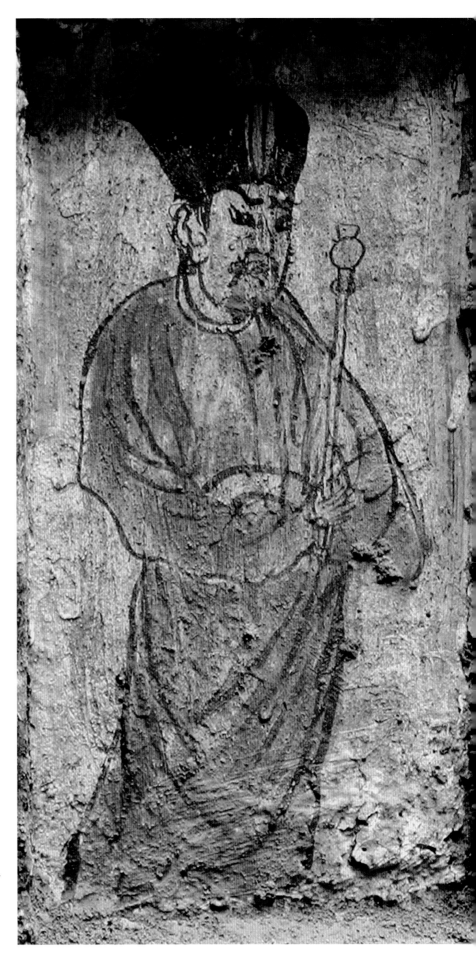

185.门吏图（局部）

金（1115～1234年）

2006年河南省林州市桂林镇三井村金墓出土。现存于林州市博物馆。

墓向南。位于墓室南壁上层。为"男侍及门吏图"之局部"门吏。"男侍头戴黑色幞头，身穿红色团领窄袖长袍，腰束宽带，双手持骨朵。

（撰文、摄影：申明清）

Door Guard (Detail)

Jin (1115-1234 CE)

Unearthed from the Jin tomb at Sanjingcun of Guilin in Linzhou, Henan, in 2006. Preserved in Museum of Linzhou.

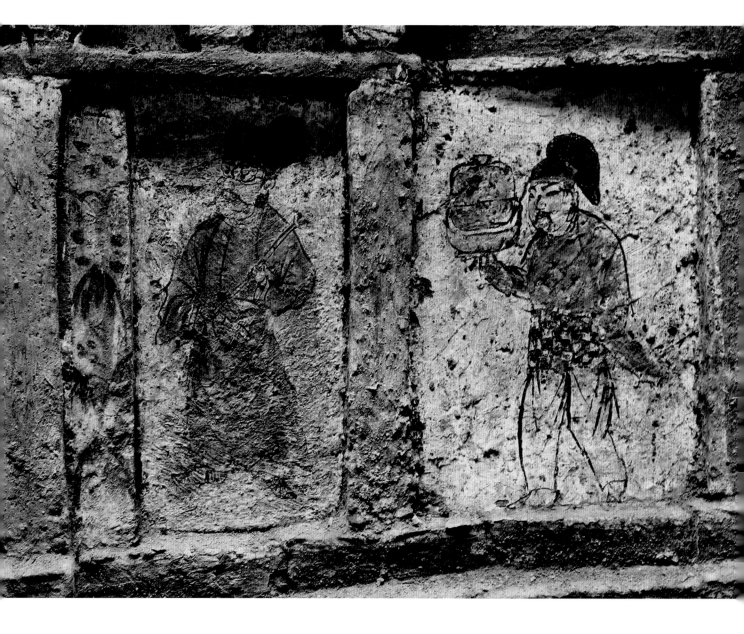

186.门吏与男侍图

金（1115～1234年）

2006年河南省林州市桂林镇三井村金墓出土。现存于林州市博物馆。

墓向南。位于墓室东壁上层，左侧画面为一男侍，头戴黑色幞头，身穿红色圆领窄袖长袍，腰束带，双手斜持一骨朵。右侧画面一男侍头戴黑色巾子，身穿黄色短衫，腰系黑白方格围裙，右手托一鸟笼状物作行走状。

<div style="text-align: right">（撰文、摄影：申明清）</div>

Door Guard and Servant

Jin (1115-1234 CE)

Unearthed from the Jin tomb at Sanjingcun of Guilin in Linzhou, Henan, in 2006. Preserved in Museum of Linzhou.

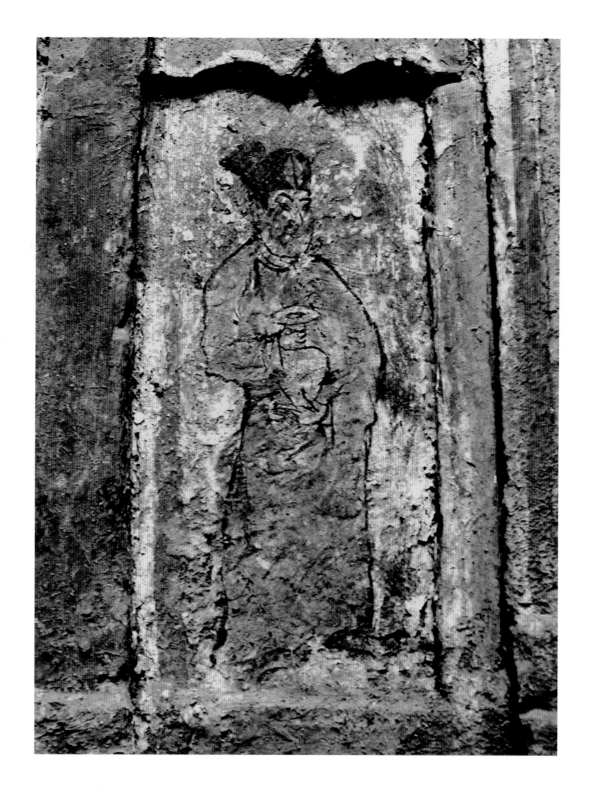

187. 男侍图

金（1115～1234年）

2006年河南省林州市桂林镇三井村金墓出土。现存于林州市博物馆。

墓向南。位于墓室西壁上层。画面上一男子站立，头裹黑巾，身穿皂色圆领窄袖长袍，腰束带，双手握一盘口瓶放在腰部。

（撰文、摄影：申明清）

Servant

Jin (1115-1234 CE)

Unearthed from the Jin tomb at Sanjingcun of Guilin in Linzhou, Henan, in 2006. Preserved in Museum of Linzhou.

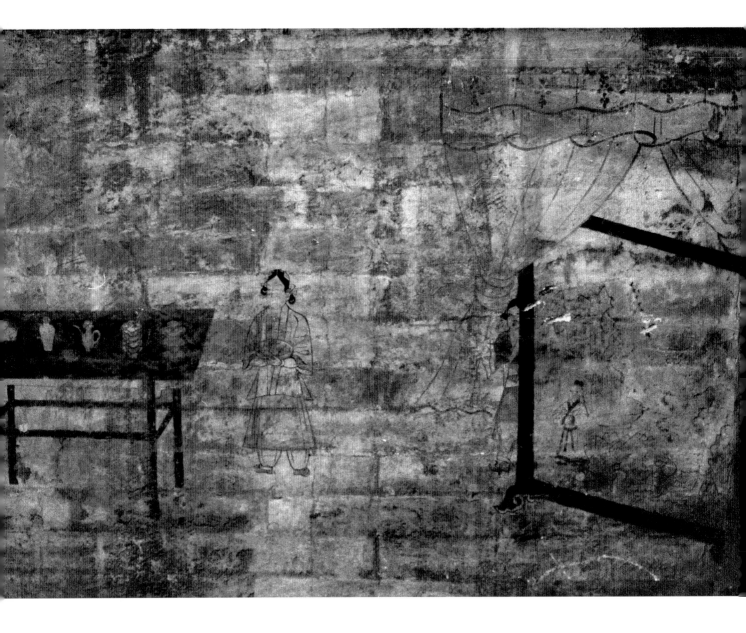

188.厅堂图

金—元（1115～1368年）

高约76、宽120厘米

1986年河南省禹州市坡街村壁画墓出土。原址保存。

墓向190°。位于墓室东南壁。画面右侧为一屏风，屏心绘有山水人物；屏风之上绘有悬幔，屏风后一青年侍女手推悬幔探身欲进。画面左侧绘一桌，在长方桌面上置有白色的盘、瓶、注子、花口碟和茶托等物。近桌处立一侍女，双手捧一圆盘，内盛黄色果品。

<div align="right">（撰文：孙锦　摄影：王兆文）</div>

Front Hall

Jin to Yuan (1115-1368 CE)

Height ca. 76 cm; Width 120 cm

Unearthed from the Jin-Yuan tomb at Pojiecun in Yuzhou, Henan, in 1986. Preserved on the original site.

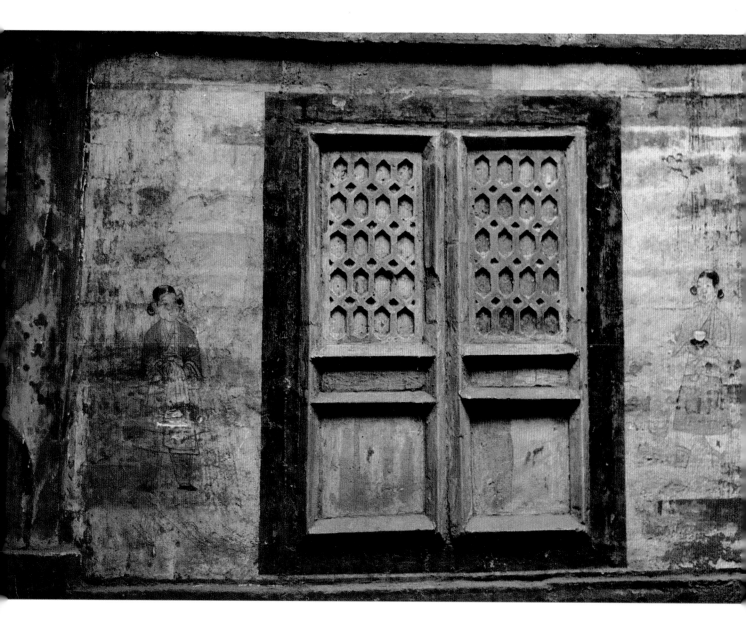

189.实榻砖雕假门与侍女图

金—元（1115～1368年）

高约76、宽120厘米

1986年河南省禹州市坡街村壁画墓出土。原址保存。

墓向190°。位于墓室西北壁。中部用雕砖砌两扇三抹格扇门，格扇门绘成朱红色，门外四周涂以黑边。门两侧各绘一侍女，其中左侧侍女腰扎白色护围，袖手持币和盒子；右侧侍女双手捧一黑托白盏的托盏，二人均梳双髻，着褙子。

（撰文：孙锦　摄影：王兆文）

Brick-laid Door and Maids

Jin to Yuan (1115-1368 CE)

Height ca. 76 cm; Width 120 cm

Unearthed from the Jin-Yuan tomb at Pojiecun in Yuzhou, Henan, in 1986. Preserved on the original site.

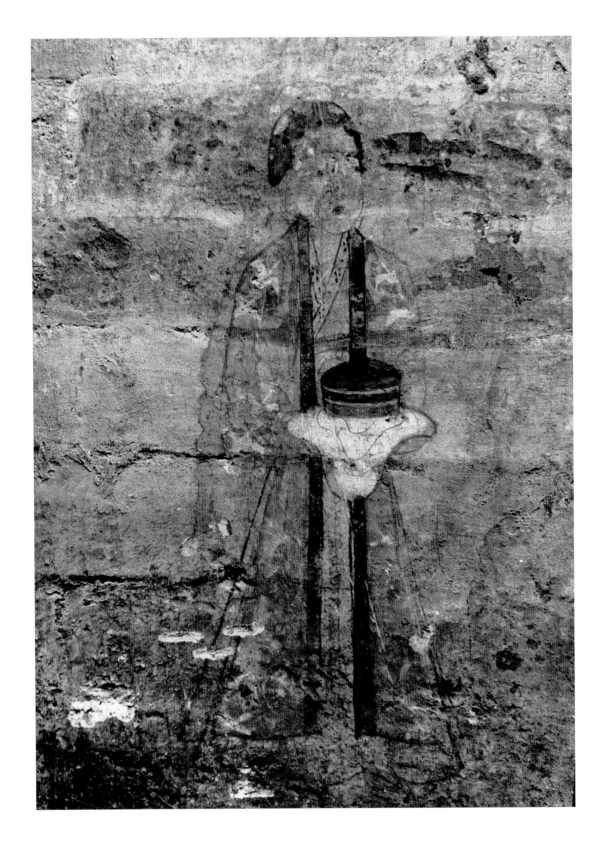

190.侍女图

金—元（1115～1368年）

1986年河南省禹州市坡街村壁画墓出土。原址保存。

墓向190°。位于墓室北壁格子门左侧。侍女内着交领淡青襦裙，外套黑边红色褙子，足穿红色翘头履，双手捧一用白巾托裹的红色漆盒。

（撰文：孙锦　摄影：王兆文）

Maid

Jin to Yuan (1115-1368 CE)

Unearthed from the Jin-Yuan tomb at Pojiecun in Yuzhou, Henan, in 1986. Preserved on the original site.

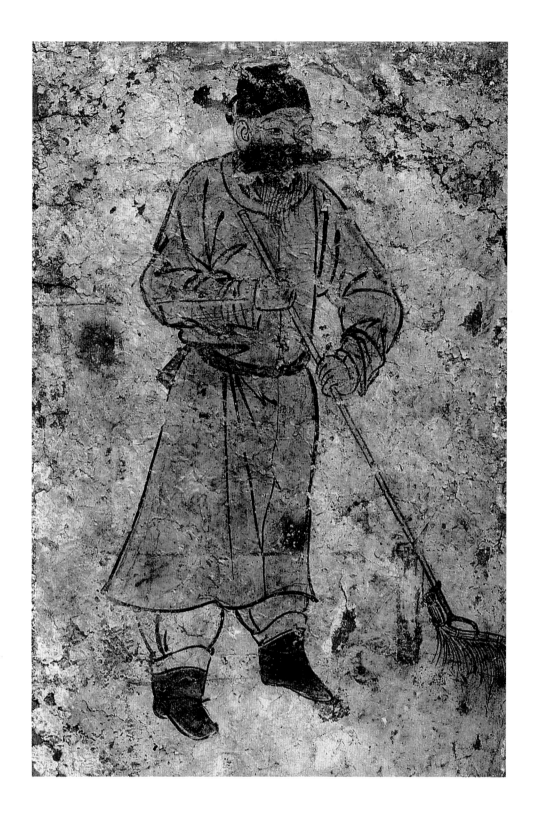

191. 男侍图（摹本）

元（1206～1368年）

人物高86厘米

1993年河南省登封市王上村元墓出土。现存于郑州市文物考古研究院。

墓向190°。位于墓内甬道东壁。画面绘一男侍，头戴黑色牛耳幞头，外着蓝色圆领领窄袖袍，腰系黑带，内着淡褐色交领内衣，下着裤，足着尖头靴。双手斜持长帚扫地。

（临摹：不详　撰文：张文霞　摄影：张松林）

Servant (Replica)

Yuan (1206-1368 CE)

Figure Tall 86 cm

Unearthed from the Yuan tomb at Wangshangcun in Dengfeng, Henan, in 1993. Preserved in Zhengzhou Municipal Institute of Cultural Relics and Archaeology.

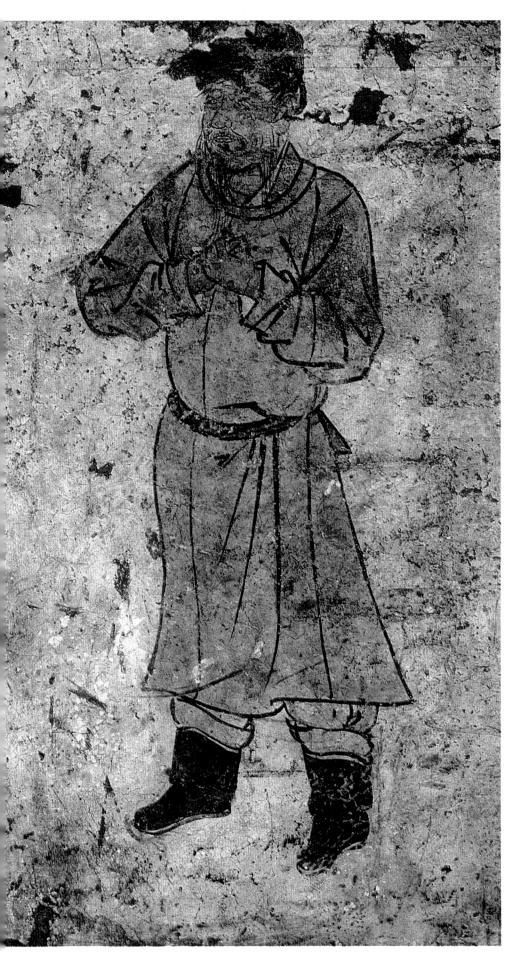

192. 男侍图

元（1206～1368年）

人物高89厘米

1993年河南省登封市王上村元墓出土。现存于郑州市文物考古研究院。

墓向190°。位于墓内甬道西壁。男侍头戴黑色牛耳幞头，外着皂色圆领窄袖袍，腰系黑带，内着淡褐色交领内衣，下着门裤，足着尖头靴。叉手而立。

（撰文：张文霞　摄影：张松林）

Servant

Yuan (1206-1368 CE)

Figure Tall 89 cm

Unearthed from the Yuan tomb at Wangshangcun in Dengfeng, Henan, in 1993. Preserved in Zhengzhou Municipal Institute of Cultural Relics and Archaeology.

193.侍女图

元（1206～1368年）

高102、宽85厘米

1993年河南省登封市王上村元墓出土。现存于郑州市文物考古研究院。

墓向190°。位于墓室东南壁，绘三侍女。左侧侍女身形高大，头梳圆髻，外着深蓝色褙子，足着尖头鞋，手捧一白盘，内盛两托盏。身旁一女，梳圆髻，戴耳环，着右衽窄袖襦，外罩半臂，下束曳地长裙，足着尖头鞋，执一团扇。此女身后一女，梳圆髻，左衽窄袖襦，外罩半臂，下束曳地长裙，足着尖头鞋，双手抱一葵花镜。身后一童，左手持一玩偶，躲在大人身后。

（撰文：张文霞　摄影：张松林）

Attending Maids

Yuan (1206-1368 CE)

Height 102 cm; Width 85 cm

Unearthed from the Yuan tomb at Wangshangcun in Dengfeng, Henan, in 1993. Preserved in Zhengzhou Municipal Institute of Cultural Relics and Archaeology.

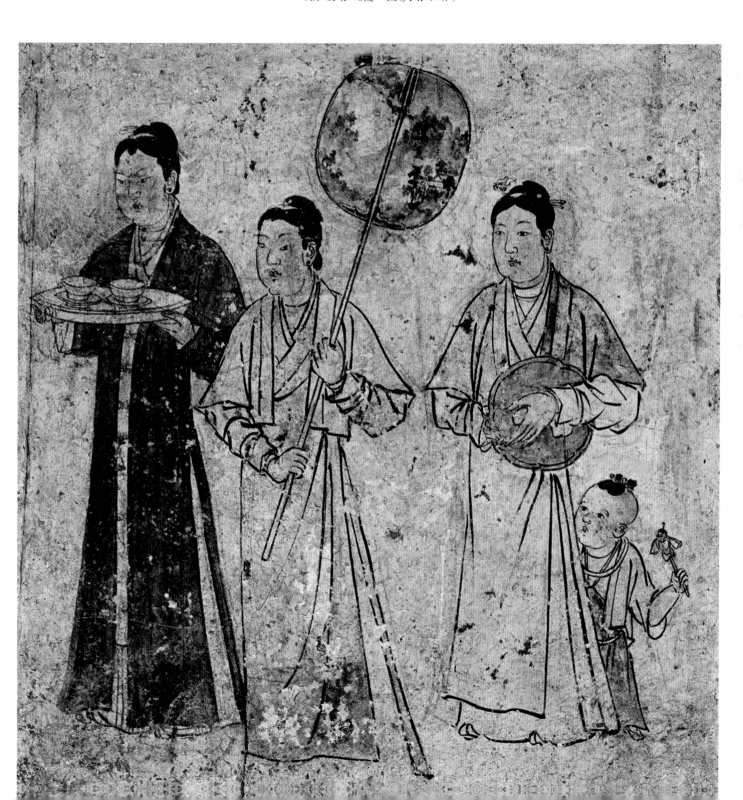

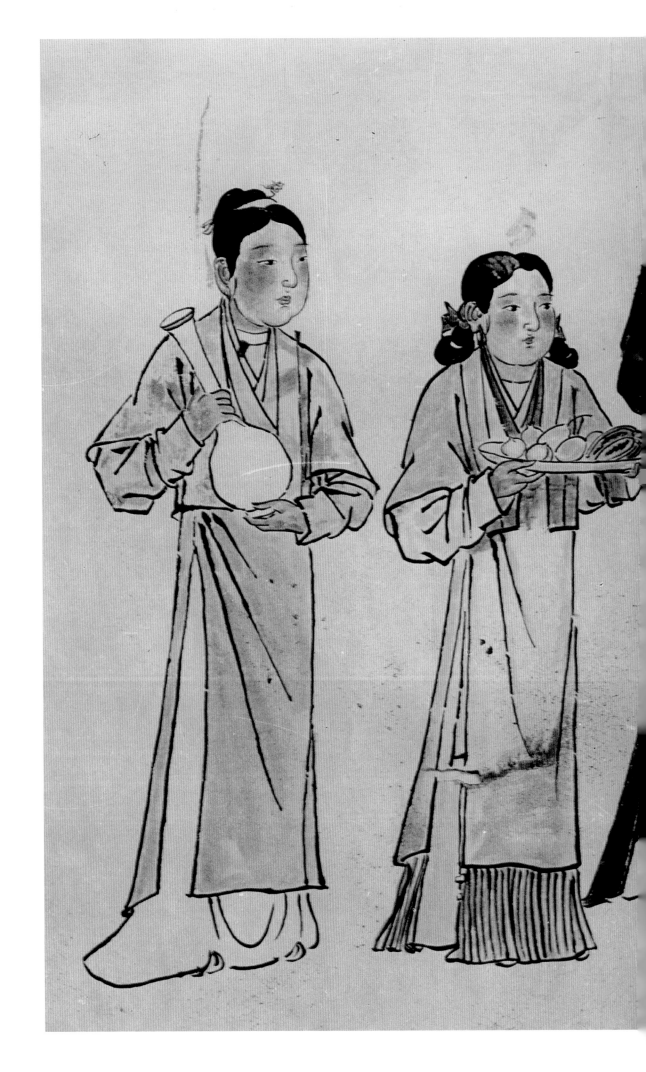

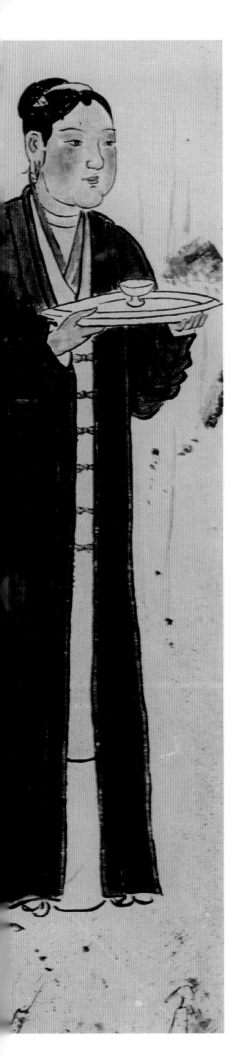

194.奉酒图（摹本）

元（1206～1368年）

高102、宽85厘米

1993年河南省登封市王上村元墓出土。现存于郑州市文物考古研究院。

墓向190°。位于墓室西南壁，画右一女侍身形高大，头梳圆髻，外着蓝色褙子，足着尖头鞋，手捧白色劝盘，中放一小酒杯。中间侍女，梳双垂髻，着淡黄色左衽窄袖襦，外罩浅绿色半臂，下着百褶裙，足着尖头鞋，手捧黄色盘子，内盛杏、梨、瓜三种水果。右一女，梳圆髻，外着左衽窄袖襦，外罩白色半臂，下着曳地白裙，足着尖头鞋，双手抱一白色玉壶春瓶。

（临摹：刘智有　撰文：张文霞　摄影：张松林）

Attending Maids (Replica)

Yuan (1206-1368 CE)

Height 102 cm; Width 85 cm

Unearthed from the Yuan tomb at Wangshangcun in Dengfeng, Henan, in 1993. Preserved in Zhengzhou Municipal Institute of Cultural Relics and Archaeology.

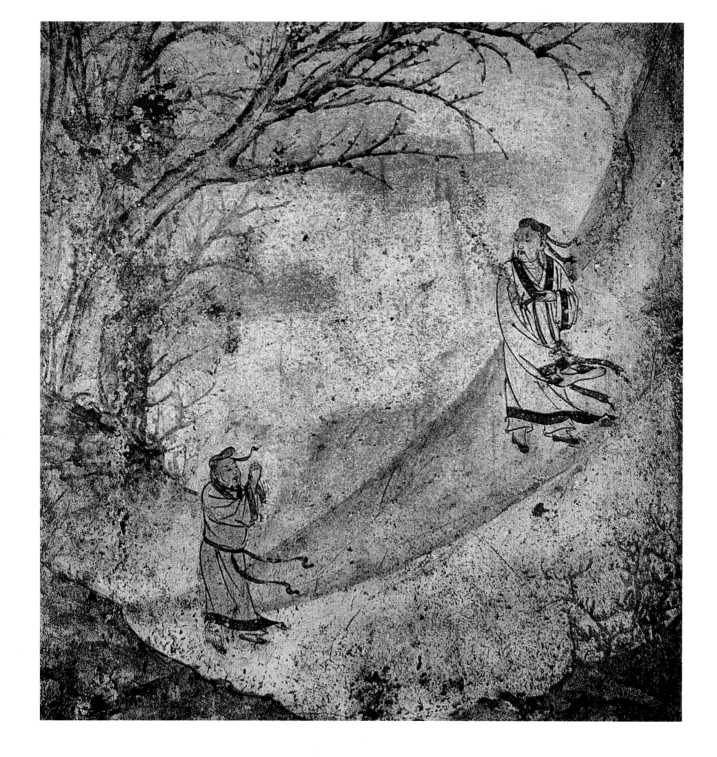

195. 升仙图

元（1206～1368年）

高104、宽84厘米

1993年河南省登封市王上村元墓出土。现存于郑州市文物考古研究院。

墓向190°。位于墓室西壁。画面绘一山涧，白雾弥漫，隐约可见峰峦起伏。涧左林木密集。涧边站立一人，拱手抱拳施礼。身侧一道云气，云气中一人凌空，黑巾、白袍、白衫、白裤，面右，右手垂于袖内，与黄衣人依依惜别。

（撰文：张文霞　摄影：张松林）

Ascending Fairyland

Yuan (1206-1368 CE)

Height 104 cm; Width 84 cm

Unearthed from the Yuan tomb at Wangshangcun in Dengfeng, Henan, in 1993. Preserved in Zhengzhou Municipal Institute of Cultural Relics and Archaeology.

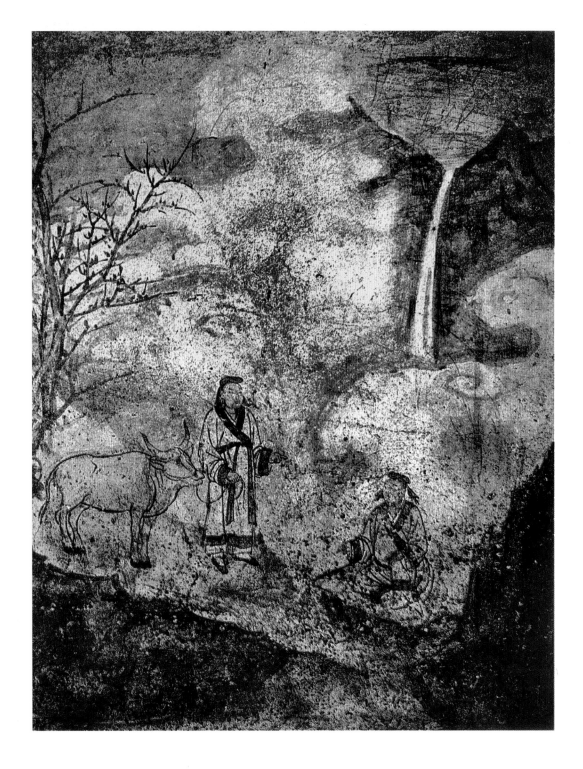

196. 讲道图

元（1206～1368年）

高99、宽82厘米

1993年河南省登封市王上村元墓出土。现存于郑州市文物考古研究院。

墓向190°。位于墓室东壁。远处淡霭笼罩，空旷而深远；近处两峰对峙，峰间瀑布如练，注入幽潭。潭前两男子，一人头系蓝色方巾，外着白袍，腰系蓝带，右手牵一黄牛，问询对面岩上盘坐之人。该人装束同牵牛人，目视来人，右手侧出两指，左手抚膝，施礼作欲起伏。

（撰文：张文霞　摄影：张松林）

Discussing Scriptures

Yuan (1206-1368 CE)

Height 99 cm; Width 82 cm

Unearthed from the Yuan tomb at Wangshangcun in Dengfeng, Henan, in 1993. Preserved in Zhengzhou Municipal Institute of Cultural Relics and Archaeology.

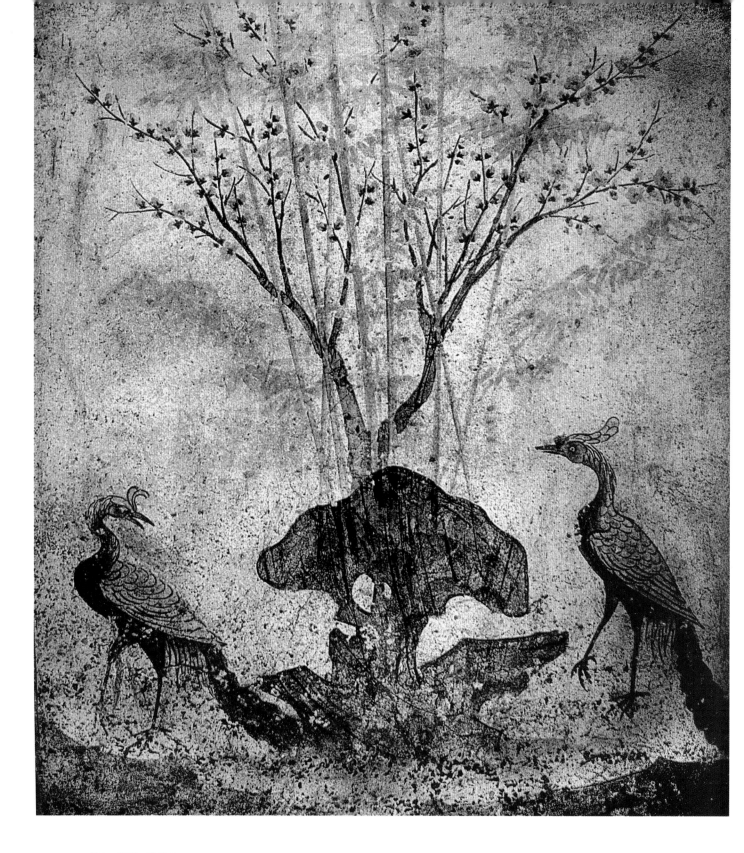

197.梅石孔雀图

元（1206～1368年）

高105、宽89厘米

1993年河南省登封市王上村元墓出土。现存于郑州市文物考古研究院。
方向190°。位于墓室北壁。画面上背景为白色，竹梅相拥，前有灵石一
块，两孔雀信步石旁，悠闲自得。

（撰文：张文霞　摄影：张松林）

Plum, Bamboo and Peacocks

Yuan (1206-1368 CE)

Height 105 cm; Width 89 cm

Unearthed from the Yuan tomb at Wangshangcun
in Dengfeng, Henan, in 1993. Preserved in
Zhengzhou Municipal Institute of Cultural Relics
and Archaeology.

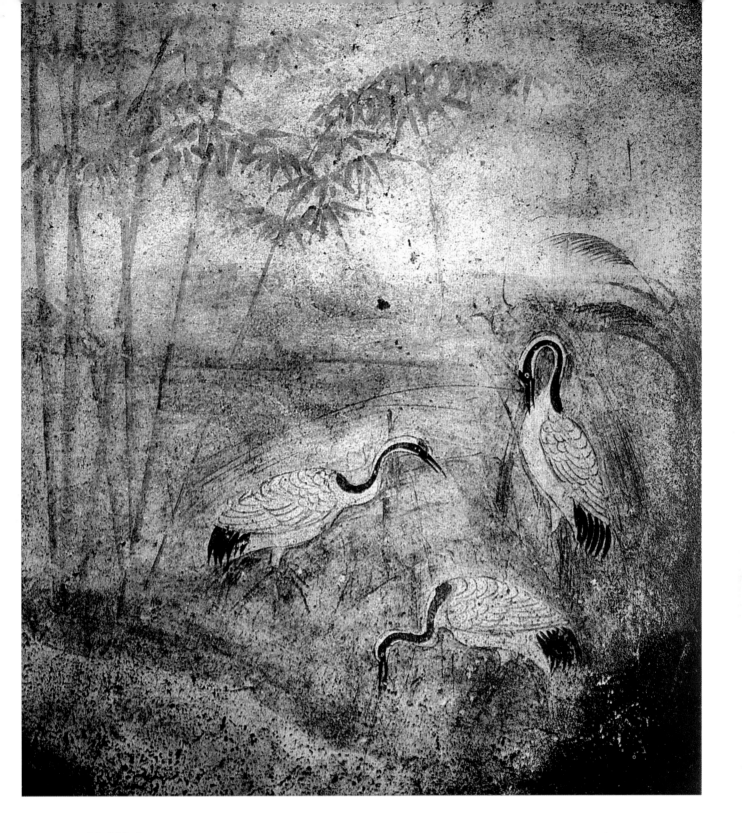

198. 竹鹤图

元（1206～1368年）

高105、宽88厘米

1993年河南省登封市王上村元墓出土。现存于郑州市文物考古研究院。方向190°。位于墓室东北壁，画面上远处烟雾迷濛，翠渚隐现；近处泓水一湾，水势浩大；岸边竹叶扶疏，芦花摇坠。浅水中站立三鹤，皆丹顶、黑颈、白羽、黑尾。一鹤引颈注视，一鹤自理胸羽，神情怡然。

（撰文：张文霞　摄影：张松林）

Bamboos, Reeds and Cranes

Yuan (1206-1368 CE)

Height 105 cm; Width 88 cm

Unearthed from the Yuan tomb at Wangshangcun in Dengfeng, Henan, in 1993. Preserved in Zhengzhou Municipal Institute of Cultural Relics and Archaeology.

199.女墓主人像

元（1206～1368年）

高120、宽90厘米

2000年河南省尉氏县后大村元墓出土。现存于河南博物院。

墓向180°。位于墓室北壁西面，与北壁东面的男墓主人对坐。画像中的女墓主人头戴圆形尖顶黑帽，身着黄色左衽窄袖上衣，下系浅色长裙，双手交于袖间，端坐于一红布衬椅之上。女墓主人身后右侧立一侍女，侍女上身着对襟小袄，下着曳地长裙，双手捧一圆桶状漆奁。

<div align="right">（撰文：孙锦　摄影：王三营）</div>

Portrait of the Female Tomb Occupant

Yuan (1206-1368 CE)

Height 120 cm; Width 90 cm

Unearthed from the Yuan tomb at Houdacun in Weishi, Henan, in 2000. Preserved on the original site.

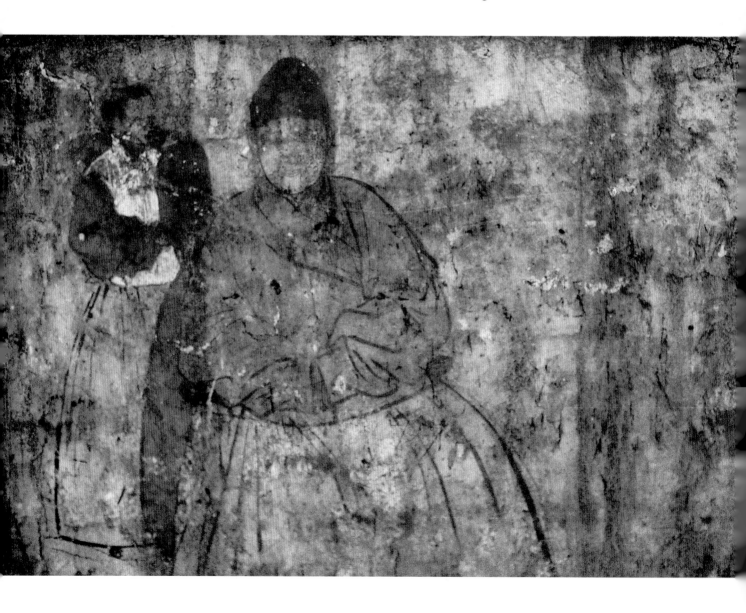

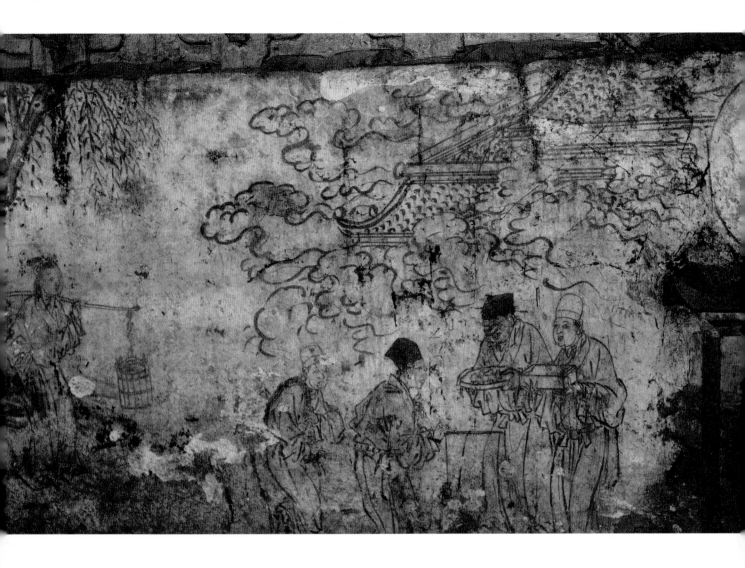

200. 入库图

元（1206～1368年）

高100、宽130厘米

2000年河南省尉氏县后大村元墓出土。现存于河南博物院。

墓向180°。位于墓室西壁南面，画面右侧上部有歇山顶屋宇数间，祥云缭绕。下部绘有四人：一人捧托盘，盘内似有货币银铤，并排一人手捧方盒；对面二人，一人持秤，做称量状；另一人则面露期待神情。画面左侧绘有垂柳，柳树下一挑水女子缓步走来。此图与东壁的"东仓"对应，应为"西库"。

（撰文：孙锦　摄影：王三营）

Levying Silver (as Money Rent)

Yuan (1206-1368 CE)

Height 100 cm; Width 130 cm

Unearthed from the Yuan tomb at Houdacun in Weishi, Henan, in 2000. Preserved on the original site.

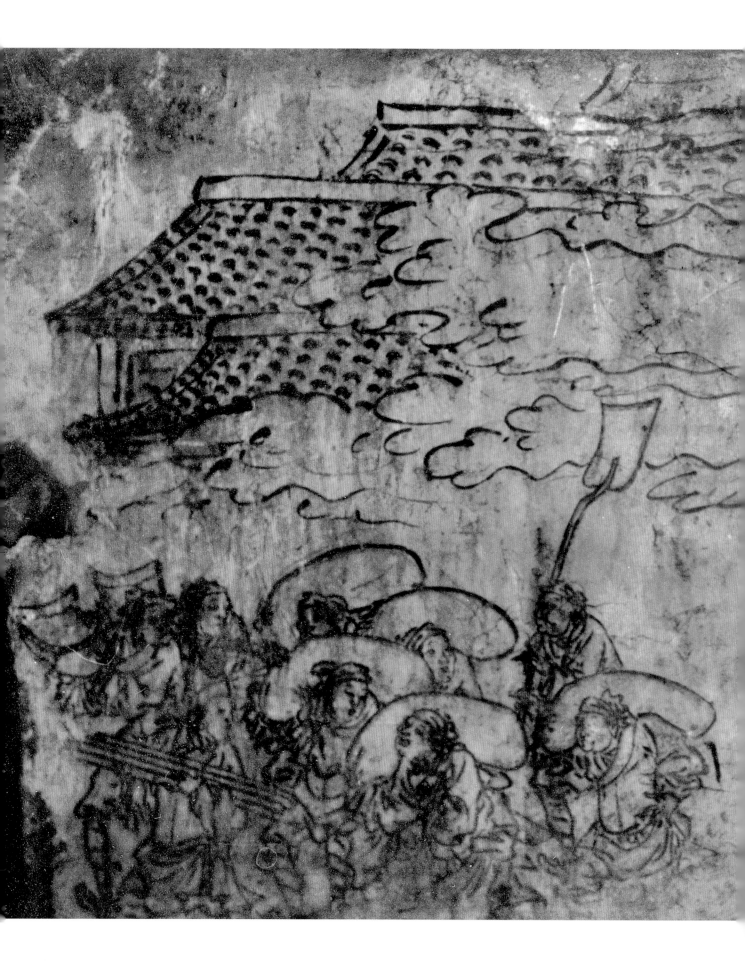

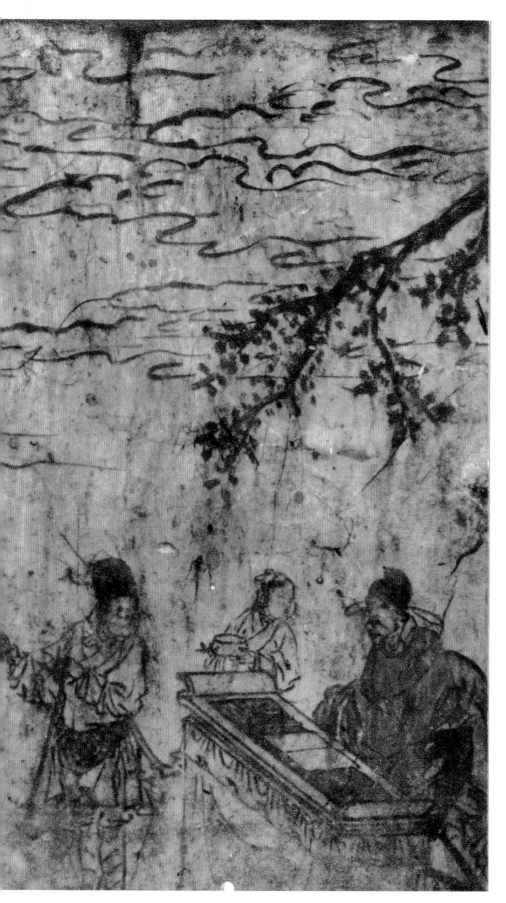

201.进仓图

元（1206～1368年）

高100、宽130厘米

2000年河南省尉氏县后大村元墓出土。现存于河南博物院。

墓向180°。位于墓室东壁南面。画面上部绘歇山顶屋宇数间，笼罩在祥云中。有一群农民装扮的人，肩负粮袋奔向砖雕壁龛"东仓"门口。右侧绘有四人，其中一人身著红袍坐于椅上，面前置有一张朱红桌案；右侧站立一手捧洗的侍童；左侧站立一人，手执纸张，似做登记状；案前一人，手指农夫，侧身向著红袍主人做禀报状。

（撰文：孙锦 摄影：王三营）

Levying Grains into Granary

Yuan (1206-1368 CE)

Height 100 cm; Width 130 cm

Unearthed from the Yuan tomb at Houdacun in Weishi, Henan, in 2000. Preserved on the original site.

202.董永行孝图

元（1206～1368年）

高100、宽130厘米

2000年河南省尉氏县后大村元墓出土。现存于河南博物院。

墓向180°。位于墓室东壁北面。画面上两人。一男子头戴白色圆形孝帽，身着交领广袖长袍，似向对面一上身着红色褡子、外罩半臂、下着长裙的女子施礼。男子身后三个坟丘，其中一个坟丘前矗立一墓碑，碑文为"童（董）永父墓"。表现董永行孝的故事。

<div align="right">（撰文：孙锦　摄影：王小秋）</div>

Dong Yong, One of the "Twenty-Four Paragons of Filial Piety"

Yuan (1206-1368 CE)

Height 100 cm; Width 130 cm

Unearthed from the Yuan tomb at Houdacun in Weishi, Henan, in 2000. Preserved on the original site.

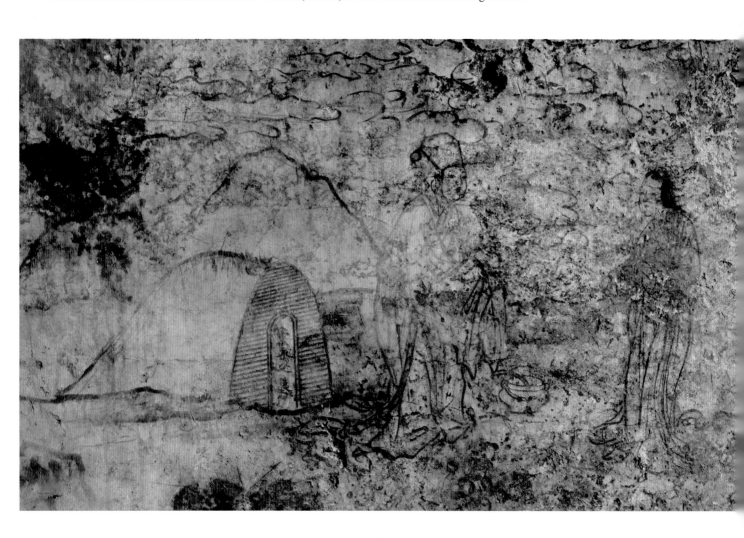

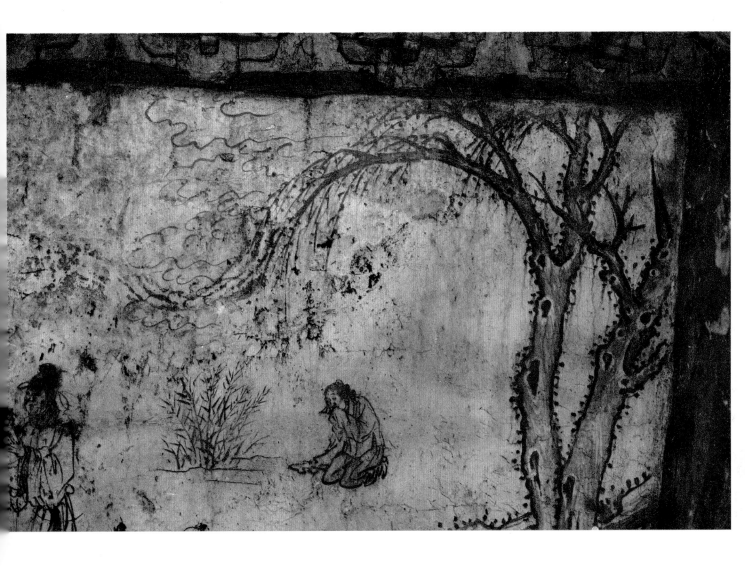

203.焦花女行孝图

元（1206～1368年）

高100、宽130厘米

2000年河南省尉氏县后大村元墓出土。现存于河南博物院。

墓向180°。位于墓室西壁北面。画面右侧有树两株，树下一人双膝脆地，面对地上一簇植物掩面拭泪，画面中央题有"焦花女哭□"字样。应为"焦花女哭麦"的故事。

（撰文：孙锦　摄影：王小秋）

Jiao Huanü, One of the "Twenty-Four Paragons of Filial Piety"

Yuan (1206-1368 CE)

Height 100 cm; Width 130 cm

Unearthed from the Yuan tomb at Houdacun in Weishi, Henan, in 2000. Preserved on the original site.

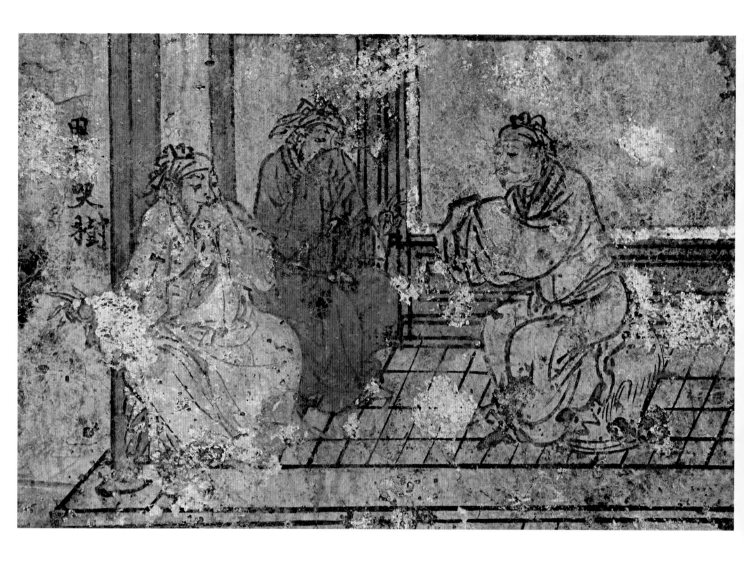

204.田真行孝图

元（1206～1368年）

2000年河南省尉氏县后大村元墓出土。现存于河南博物院。

墓向180°。位于墓室北壁东面上方。画面正中绘一厅堂，灰瓦红柱，方砖铺地，左侧有一枯树，天空祥云缭绕。厅堂内坐有三人，中间一人著红色宽袖袍，两侧二人着白色宽袖袍；二人掩面哭泣，一人似在劝说。画面中间书有"田真哭树"四字。

（撰文：孙锦　摄影：王小秋）

Tian Zhen, One of the "Twenty-Four Paragons of Filial Piety"

Yuan (1206-1368 CE)

Unearthed from the Yuan tomb at Houdacun in Weishi, Henan, in 2000. Preserved on the original site.

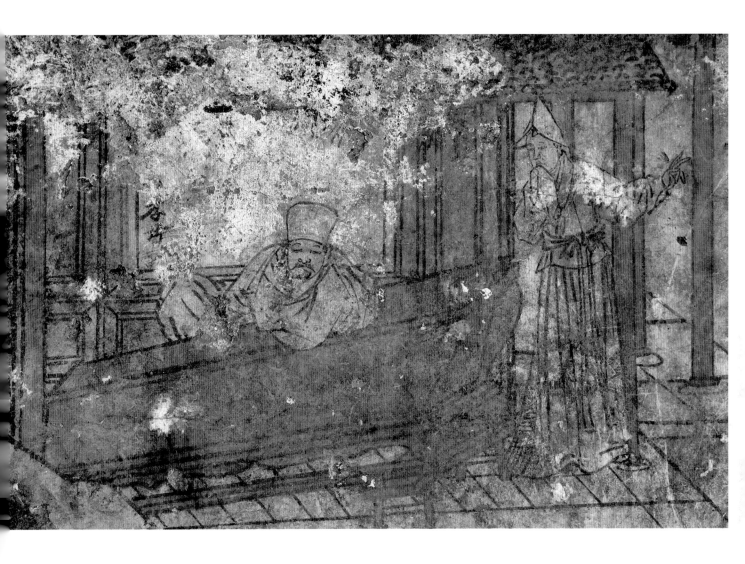

205.孝行图

元（1206～1368年）

2000年河南省尉氏县后大村元墓出土。现存于河南博物院。

墓向180°。位于墓室北壁西面上方。灰瓦红柱厅堂内，正中放置一红色棺木。一人身着孝衣，戴圆形孝帽伏于棺木之上；棺木一端站立一人，头戴尖顶孝帽，上身着紧袖短衣，腰中系带，下着长裙，左手外指，右手持巾，掩口作悲痛状。

（撰文：孙锦　摄影：牛爱红）

Scenes of Filial Deeds

Yuan (1206-1368 CE)

Unearthed from the Yuan tomb at Houdacun in Weishi, Henan, in 2000. Preserved on the original site.

206. 妇人图（局部）

明（1368～1644年）

1998年河南省登封市芦店镇明墓出土。原址保存。

墓向183°。位于墓室北壁右侧，画面绘一妇人，头梳圆髻，戴白色额帕，上插白角梳，戴耳坠，身穿淡褐色左衽宽袖袄。妇人瓜子脸，眉清目秀，神情端庄。

（撰文：张文霞　摄影：张松林）

Portrait of a Woman (Detail)

Ming (1368-1644 CE)

Unearthed from the Ming tomb at Ludian in Dengfeng, Henan, in 1998. Preserved on the original site.

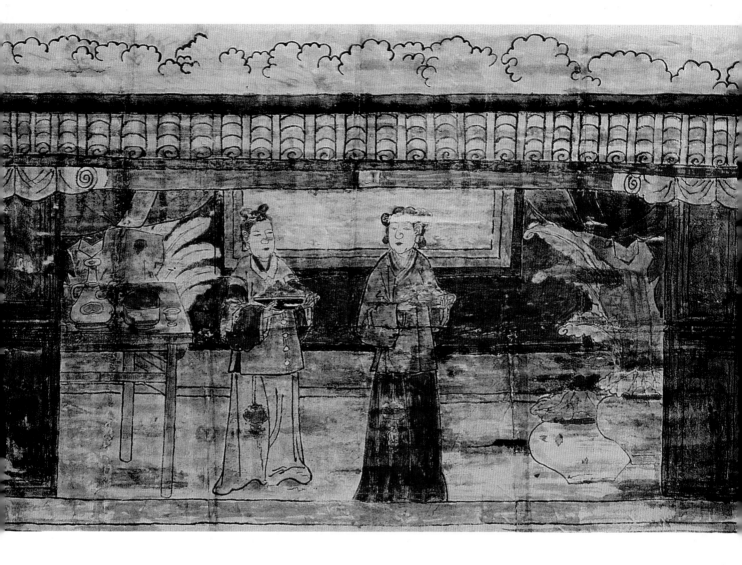

207.女侍（摹本）

明（1368～1644年）

人物高75厘米

1998年河南省登封市芦店镇明墓出土。原址保存。

墓向183°。位于墓室西壁。双线勾出边框，框内绘厢房一座。两侧格扇门敞开，左侧绘一方桌，桌上置注子、高足杯、圆盒。右侧绘两酒坛，上置荷叶状盖，坛后为芭蕉叶。中部立有两侍女，左侧侍女手捧一黑盘，盘上堆满红果；右侧侍女也手捧一盘，内盛寿桃。

（临摹：刘智有　撰文：张文霞　摄影：张松林）

Maids (Replica)

Ming (1368-1644 CE)

Figures Tall 75 cm

Unearthed from the Ming tomb at Ludian in Dengfeng, Henan, in 1998. Preserved on the original site.

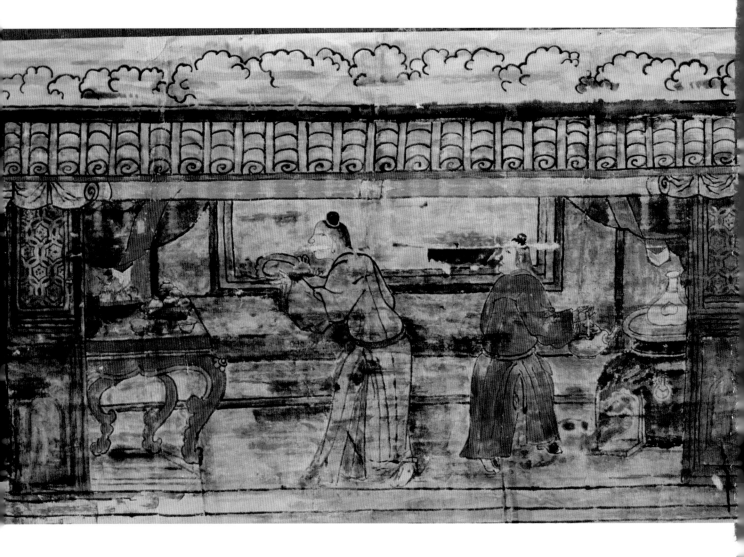

208. 男侍（摹本）

明（1368～1644年）

人物高75厘米

1998年河南省登封市芦店镇明墓出土。原址保存。

墓向183°。位于墓室东壁。双线勾出边框，框内绘厢房一座。右侧绘一黑色炉灶，炉上置一浅盘，盘内放一小口垂腹瓶。炉左侧一男子，着红色圆领广袖长袍，腰束绿带，足穿软底黑靴，右手提一酒壶，边向温酒炉边回首张望。壁画左侧绘一曲腿方桌，桌面右侧黑漆盆内放四只石榴，黑漆方盘内覆置五只小碗，盘前放三只小碗。桌右侧一男子，梳圆髻，着黄色领广袖袍，腰束红带，足蹬软底靴，躬身捧一黑漆盘，盘内盛一黄色瓜状物。

（临摹：刘智有　撰文：张文霞　摄影：张松林）

Servants (Replica)

Ming (1368-1644 CE)

Figures Tall 75 cm

Unearthed from the Ming tomb at Ludian in Dengfeng, Henan, in 1998. Preserved on the original site.